The Graffiti Subculture

The Graffiti Subculture

Youth, Masculinity and Identity in London and New York

Nancy Macdonald

First published in hardcover 2001

First published in paperback 2002 by
PALGRAVE MACMILLAN
Houndmills, Basingstoke, Hampshire RG21 6XS and
175 Fifth Avenue, New York, N. Y. 10010
Companies and representatives throughout the world

PALGRAVE MACMILLAN is the global academic imprint of the Palgrave Macmillan division of St. Martin's Press, LLC and of Palgrave Macmillan Ltd. Macmillan® is a registered trademark in the United States, United Kingdom and other countries. Palgrave is a registered trademark in the European Union and other countries.

ISBN 0–333–78190–2 hardback
ISBN 0–333–78191–0 paperback

This book is printed on paper suitable for recycling and made from fully managed and sustained forest sources.

A catalogue record for this book is available from the British Library.

The Library of Congress has cataloged the hardcover edition as follows:
Macdonald, Nancy, 1969–
 The graffiti subculture : youth, masculinity, and identity
 in London and New York / Nancy Macdonald.
 p. cm.
 Originally published: New York : Palgrave, 2001
 Includes bibliographical references and index.
 ISBN 0–333–78191–0 (pbk.)
 1. Graffiti—New York (State)—New York. 2. Graffiti—England–
 –London. 3. Youth—New York (State)—New York—Social
 conditions. 4. Youth—England—London—Social conditions.
 I. Title.

 GT3913.N72 N457 2002
 306'.1—dc21

 2002068333

10 9 8 7 6 5 4 3 2
11 10 09 08 07 06 05 04 03

Printed in Great Britain by
Antony Rowe Ltd, Chippenham and Eastbourne

For my godson Ned Prevezer and Mark, my *phenomenally* special friend

Contents

List of Figures ix
Shout Outs (As They Say) x
Glossary xi

1 Introduction 1
 Chapter outline 8

2 Climbing Down off the Fence: Locating Our Standpoint
 and Values 10
 Shedding the positivist past – the ethogenic theory 12
 Accounts – action through talk or a talk through action? 17
 Authority, power and postmodernism: a game of hide and
 seek 20
 A culturally oriented approach to research 27

3 Are Theories of Subculture Too Class Oriented? 32
 The Functionalist 'anomie' or 'strain' approach 33
 The Marxist New Wave approach – work by the CCCS group 37
 Missing links 44

4 I Woz 'Ere: Tales from the Field 49
 The fields 50
 Informants 50
 Methods, means and madness 51
 Unpacking my personal baggage 57

5 Going Underground: A Journey into the Graffiti Subculture 63
 All work and no play – graffiti as a career 63

6 Constructive Destruction: Graffiti as a Tool for Making
 Masculinity 94
 Masculinity: it can be a crime 97
 Urban warfare: blowing up masculinity 107
 In among the boys – involvement as the female 'other' 127

7 Keeping Its Distance: The Subculture's Separation from the
 'Outside World' 151
 Worlds apart – the subculture's publicly private parade 153

Distance makes the art grow stronger – the legal
vs illegal debate 163

8 Making a World of Difference: The Personal Benefits of
Subcultural Membership 179
New world, new life: passage to independence 180
New world, new life, new persona: passport to potential 187
The name is the fame of the game – missing bodies 193
The rise and fall of the subcultural identity 217

Conclusion 228

Afterword: Writers Talk Back 234

Bibliography 241

Author Index 251

Subject Index 254

List of Figures

5.1	I am 'Known'	66
5.2	A throwup	78
5.3	Using a crown to claim the title 'king'	79
5.4	The piecing of one's name	80
5.5	A whole car top to bottom	85
6.1	'Atak' on the London Underground	110
6.2	Revs and Cost's sticker messages	133
7.1	The superior society	155
7.2	'Wildstyle'	159
7.3	Pictorial aerosol art	168
8.1	'Skore'	199
8.2	Blockbuster letters	200
8.3	'Revs' and 'Cost'	202
8.4	Saying hello	204
8.5	I'm as good as you	205
8.6	I'm better than you	206
8.7	I'm so much more than you	207
8.8	I'm bigger than you	208
8.9	You mean nothing	209
8.10	A dub placed over a piece	210
8.11	A weapon of assault	211
8.12	'Drax' lined out	212
8.13	A writer's dedications	214
8.14	A creative display of strength and dominance	215

Shout Outs (As They Say)

I could not have conducted this research nor written this book without the generous help and support of many people. My sincere thanks go to Inspector Chris Connell, Henry Chalfant, Martha Cooper and Dave Holloway for their help both during and after my fieldwork. Several other people came to my rescue at varying points in time. My academic supervisors, Ros Gill and Karen Henwood, come top of the list. Their direction and encouragement helped me find the light at the end of an often very dark PhD tunnel. Karen Howes was a star, as were Rowan, Fred, Sophie, Damon, Annabel, Wink, Hil, Jane, Jessie, Tory, Alio, Julian, Megan, Mum, Myles, Ephraim, Edie, Andy and my grandmother, Anne Macdonald. DDB NY, thank you for my sabbatical. My colleagues Bill Hoofatt, Judy, Craig, Shana and Stupot deserve a special mention. Jonathan Perchal, Sue from Posman and the team at Palgrave were also immensely generous with their knowledge, time and guidance.

My biggest and most heartfelt thanks, however, go to all the writers who shared their thoughts and stories and gave me a vivid and treasured insight into their world. They are: Mear, Drax, Zaki, Stylo, Ego, Proud 2, Rate, Acrid, Series, Akit, Juice, Kilo, Lee, Prime, Elk, Dane, Junk, Skore, Part 2, Rough, Robbo, Dondi, Col, Futura 2000, Lady Pink, Smith, Claw, Az, Sed, Sein 5, Sae 6, Jel, Iz, Lee Q., Flint 707, Freedom, Key 1 and Sar. A special 'shout out' goes to Steam and Kirs for the use of their photos and to Cavs for taking an eager novice on her first, and long-awaited, train yard trip.

Glossary

Active: A writer who currently paints.
All city: A writer whose work can be found in many different locations.
Bad: Something which is great or fantastic.
Battle: A competition between writers using pieces or tags.
Bite: To copy another writer's work.
Black book: A sketchbook containing writers' graffiti designs.
Bomb, cane, destroy, kill: To completely cover something in graffiti.
Buff: To chemically clean graffiti from the surface of a train.
Bumpkin: A writer who does not live in London.
Burn: To paint exceptionally well.
Burner: A well-executed piece.
Cap; fat or skinny: Spray can nozzles which make the spray width wide or narrow.
Catch tags: To tag one's name here and there.
Cheap fame: A profile that has not been earnt through hard work.
Crew: A group of affiliated writers.
Cross out, dog out, line out: To put a line through another writer or crew's name.
Cross out war: A dispute between writers who are lining out each others' names.
Diss, cuss: To disrespect or insult another writer.
Down: A writer who is part of a crew or highly respected.
Drop: To paint a piece.
Dry, lame, wak: Something which is bad or of substandard quality.
Dub: A quick outline of a writer's name with a silver or gold painted interior.
End to end: A piece covering the entire length of a train carriage.
Fanatic, hardcore: A highly active or reckless writer.
Fill-in: The interior shade of a piece, throwup or dub.
Freights, BR's: Overland trains which travel across the country.
Give props: To give a writer credit.
Go over: To write over another writer's name with your own.
Grass: A police informant.
Hall of fame: A legal or semi-legal walled painting site.
Hot: A risky yard or area which is being monitored by the police.

Inactive: A writer who has temporarily stopped painting.
Jock: A sycophant or wannabe.
King: The most accomplished or prolific writer.
Line: A line on the underground or subway.
Mission: An illegal painting trip.
New jack: A new or recent writer.
New school: A newer generation of writers.
Old school: An older generation of writers.
On tour: A trip abroad to do graffiti and/or steal paint.
Outline: The line silhouetting a piece, throwup or dub.
Pay one's dues: To show one's dedication through a full and active illegal career.
Piece: A painting, short for masterpiece. To paint a word or image with more than two colours.
Props: A writer's credits.
Rack: To steal.
Rads: Police.
Rep: A writer's reputation.
Retire: To give up painting graffiti on a regular basis.
Safe: Something which is 'good' or without risk.
Scar: Graffiti that is still faintly visible after having been chemically cleaned.
Sell out: A writer who renounces illegal work and works commercially for money.
Shout out: To thank or acknowledge someone.
Tag: A writer's name or signature.
Tagging, hitting, getting up: Writing one's name or signature.
Third rail: The electrified rail on a train track.
Three-stroke: A throwup with the first letter of a writer's name.
Throw down: To put a writer in a crew.
Throwup: A quick outline of a writer's name with a black or white painted interior.
Top to bottom: A piece reaching from the top of a train carriage to the bottom.
Toy: A young, inexperienced or artistically incompetent writer.
Train jam: An organized group graffiti attack on the underground system.
Up: A prolific writer.
Whole car: A piece covering the entire surface of a train carriage.
Whole train, worm: A piece or series of pieces extending the entire length of a train.

Wildstyle: A complex writing style characterized by its angular interlocking letters.

Window down: A piece painted below the windows of a train carriage.

Writer: Someone who writes graffiti. A member of the subculture.

Yard, depot, lay up: A place where trains are berthed.

1
Introduction

The fight kicks off in the usual way. Outside a bar on a Saturday night, a minor insult is offered and met and a scuffle ensues. Two men battle it out in the name of honour, and it's not long before the fight steps up in pace and starts to weave its way steadily down the street. At one point, one of the men begins to struggle; he is getting tired and floundering. Looking like he is getting ready to throw in the towel and admit defeat, his friends jump in to support the side – he's not going down that easily! The opposing side swells to match them and the conflict escalates. Assault meets assault and blow layers on blow, over and over and over . . . until tensions reach their peak and things finally start to wind down. The instigator, satisfied with the damage he and his boys have done and a little bored with the whole event, decides to call a truce. The undisputed victor, he pulls out leaving his opponent with the shame of defeat and a tarnished reputation.

You might have been in the neighbourhood when all this was going on. You may have even walked down the same street. But you'd be forgiven for missing it. While driven by the same fuel as any other fight – challenge and male bravado – this one draws no crowd and leaves no wounded. Its weapons are sprayed words and its war wounds amount to nothing more than a few dented egos. This fight is between two graffiti writers and it takes place on the wall.

It amazes me that we walk past all this day after day without any idea that it's happening. We don't take a second look. Of course, there are some people who are obsessed with graffiti, but these are usually the ones who write it or dedicate their lives to fighting it – this 'rash on the skin of our city'. Most of us are just plain indifferent. It's background scenery, an urban white noise which is recognized but rarely registered. Not surprising really. Graffiti is not one to share its stories.

It's cheeky like that. It flirts in the public eye, as Hebdige (1988) might say 'hiding in the light', revealing all and yet revealing absolutely nothing. We are unaware that the city walls are alive with its social drama. We have no clue that the tangled mass of names crawling across their surfaces speak. We don't hear the intricate commentaries they have to offer us about the lives, relationships and identities of those who wrote them. And why should we even care? Because, as I found out when I plucked graffiti from its hiding place and took a closer look, this drama, these commentaries and the vibrant subculture that lies behind them have a great deal to tell us about the culture we live in and some of the people who share it with us.

Street, 'hip hop' or subcultural graffiti is just over 30 years old. Originally from New York, it has evolved synergistically with hip hop's dance and music cultures and now enjoys status as a global phenomenon. Given its age and impact, one would expect it to be the focus of a large body of work. Yet, our understanding is still basic, research has been thin. A small and scattered collection of formal and informal books and papers have been written (see for example Brewer & Miller, 1990; Castleman, 1982; Chalfant & Prigoff, 1987; Cooper & Chalfant, 1984; Feiner & Klein, 1982; Ferrell, 1996; Kohl, 1972; Lachmann, 1988; Mailer et al., 1974; Phillips, 1999; Powers, 1999; Romanowski & Flinker, 1986; Walsh, 1996). And a couple of films have been made: *Wildstyle* (1983) and *Style Wars* (1985). However, an analytically detailed account of this subculture as it stands in America and elsewhere is lacking. I conducted this study in both London and New York in the hope of filling this gap. This is not intended to be a conclusive study of the subculture as a whole. There are many other 'scenes' in other countries and cities worldwide and they may not fit the analytic portrait I have painted here. Nor is it a comparative study of graffiti in these two cities. Without wanting to flatten their distinctions, I found it more interesting to look at the features that unite these 'scenes' and their members. These are more prominent and, put together, they point us in the direction of reasons; reasons why thousands of young men pick up spray cans and spend the best part of their teenage years writing all over their environments.

Reasons, motives, meanings; all too often these are missing from the picture, and all too often this leaves graffiti carrying its label as 'mindless, senseless vandalism'. I am not going to get out the violins and over-romanticize things here. Graffiti is 'vandalism' no matter how you look at it. It is defacement of property which costs the transport authorities money, the taxpayer money, and the people who write it,

sometimes, their lives. It is dangerous, uninvited and illegal. But it is far from mindless or senseless. There is a point and purpose behind what graffiti writers do, and this, as the graffiti writer below recognizes, still needs to be explained to people:

> There's a lot of misunderstanding about it and a lot of graffiti writers can't work out what all this aggression and hatred is for what they're doing. I think it's just people not understanding. If people understood a little bit more about it, then some might say, 'No, no, I don't like it because it's illegal', but other people would go, 'Oh right, I see now.'
>
> (Zaki)

Graffiti writers or 'writers' as they usually call themselves, do not get much chance to straighten out this 'misunderstanding' or talk people through the reasoning behind their activities. As 'kids' and 'folk devils' (Cohen, 1987), they tend to get spoken for, spoken over or silenced altogether. The 'outside world' is not the only place where young people's voices are muted. Readers with backgrounds in cultural studies will no doubt be familiar with the subcultural research carried out by Marxist theorists at the Centre for Contemporary Cultural Studies (CCCS) in Birmingham during the 1970s. The CCCS's work was important because it introduced the subculture as a worthy topic of inquiry, heralding a new era of study and providing the field with its most theoretically focused analysis to date. However, it did have its flaws. One was their claim that all subcultures stem from 'working-class' origins; a claim which is not borne out by my study. Another, and the more relevant here, was a tendency to 'speak for themselves'. For all their interest in what was going on out there on the subcultural streets, very few of these theorists actually ventured out there to talk to or consult the young people involved. Members' voices and insights are sidestepped, making more room for 'theory', and the complexities of their life-worlds are pretty much lost because of this. Widdicombe & Wooffitt's more recent book *The Language of Youth Subcultures* (1995) could be accused of similar faults. Using a discourse analytic approach, the authors look at the varying ways members of subcultures construct their identities – a popular new direction in subcultural research – through talk. The problem here is that they access 'voice', but they do not really listen to it. Members' accounts are externally deconstructed and they are not given any opportunity to contribute to this process or comment on the insights that come out of it. In short, they lose their

voice and Widdicombe & Wooffitt lose their chance to learn more about aspects of members' life-worlds and the ways *they* might perceive and explain them.

Breaching this chasm between the researcher and the researched is one of my main objectives, and one of the reasons why I used ethnographic method. Voice may be a faint and distant murmur using other approaches, but with ethnography you can feel the breath of its whisper. Ethnography makes the 'emic', the insider's standpoint, its guiding light. Accessing the meanings people apply to their experiences and viewing their life-worlds from their perspective are ethnographic priorities. Researchers immerse themselves in 'real life' settings and, through exploration and discovery, try to get a 'rich and intimate familiarity with the kind of conduct that is being studied' (Blumer, 1940: 718–19, as quoted by Hammersley, 1989: 154). Naturally, in research, as in life, one's knowledge or understanding of something is going to be enriched by one's experience of it (Ferrell, 1996). This is one of the principles guiding ethnographic research and one I made every effort to adhere to. The CCCS theorists, or a large number of them, used armchairs to formulate their theoretical propositions. I got the seat of my pants a little more dirty using in-depth interviews and some fence climbing, track walking, train dodging, police fobbing, adrenalin-fuelled participant encounters as my tools of investigation. I talked to the writers I met, but I also listened to and consulted them as active and creative agents of meaning. By this I mean two things. First, I asked for their analytic insights and interpretations during our meetings, as well as sharing my own. Second, I gave them back my thesis once it was finished so they could react to and comment on my portrayal of them (see Afterword for details). All in all, I worked very hard at making writers audible, at turning up the volume on what they have to say. Not just because they deserve it, but because we, as theorists, 'adults' and outsiders also need to hear it. The previously silenced voice of the 'other' dominates this book, and the (other side of the) story it tells will, I hope, add a few new angles to the picture. If the jury is still out on graffiti, I want them to deliberate with a deeper understanding of it as lived experience.

This ethnography uncovers (my snapshot of) the 'world of graffiti', but it will not, I imagine, make readers feel like they are 'really' there. It is not going to submerge them under depths of descriptive detail or drench them in the emotional, sensory, bodily experience of graffiti writing. I leave that to those who do it best – the writers. There is a wealth of rich, unbridled reflection out there in their videos, news-

letters and magazines. If readers want a personal and vivid commentary on the graffiti experience, I would go there for it. My approach is a little more composed. Rather than jump in with both feet, I dip in and out, casting an analytic eye over features and events as I talk back to the literatures that influenced or framed my study. I am an ethnographer realistic about my limitations. I was not a blank slate. I went into this study with a (theoretically) open mind, but not an empty one. I had questions I wanted to answer, areas I wanted to look at and analytic gaps I wanted to fill. A quick outline of these will give the reader a clearer idea of the roots, aims and arguments of this book.

Traditionally class has been used as the key to unlock subcultural meanings. The CCCS group, and the Functionalists before them, both used working-class 'problems' to explain the point and purpose of subcultural membership. Concentration on this structural factor, however, left other areas and features of the subculture analytically undernourished. For example, relatively little attention has been paid to the youthful make-up of subcultures. The CCCS group chose 'working-class resistance' as their analytic angle. Although they acknowledged youth as the enactors of this, they failed to explain why so few adults join in this class-based crusade. In effect, they leave us with the question – why youth? What adolescent/youth interests are met by the subculture and why do these seemingly diminish as members get older and give up their involvements? Some theorists are beginning to explore this using notions of identity as their guiding light (see for example Epstein, 1998). This is a powerful new analytic direction and additional work will help to develop it.

The issue of 'deviance' also needs revisiting. A number of subcultures are organized around activities that are illegal or have been criminalized. Delinquency theories of the past noted this (see for example Cloward & Ohlin, 1961; Cohen, 1955; Miller, 1958), but they chose to portray the subculture's illegal activities as a 'hit back mechanism' – that is, a knee-jerk reaction as opposed to a meaningful action. Rather than re-examine this feature from a more agentic or positive angle, theorists since then have tended to ignore or evade it. They may be trying to steer us away from viewing 'youth as trouble'. But by glossing over illegality, they also steer us away from a potentially important theoretical insight. Questions about the role of illegality within subcultures remain, and many of these may be linked to questions about gender.

Of all the issues neglected in the study of subcultures those surrounding gender are the most glaring. An overwhelming number of

GENDER

subcultures appear to be dominated by men, and yet, astoundingly, very few theorists have grappled with the question why. The androcentric yardstick which previously posited the male as 'norm' can be used to explain this oversight in the past. But today questions about men and masculinities are being problematized – except, it seems, in the context of subcultures. This omission demands attention. Women's experiences as members of these male-dominated subcultures also need to be examined. Theorists have studied women within all female subcultures (see for example Blackman, 1998; Kearney, 1998), but they have yet to explore the gender dynamics that emerge when women infiltrate subcultures that are predominantly male.

There are gaps in the subcultural landscape here and I do my best to address them in this book. I question why most graffiti writers are boys. I question why most 'active' writers (those writing regularly) are young, around their teens or early twenties. And I question why most of their activities are illegal, dangerous, and celebrated for being so. In addition, I explore how the small smattering of girls writing graffiti experience and carve space within this male-dominated environment. I also ask whether they get involved for the same reasons as the boys.

The result of all this questioning? A much more *individual* understanding of the subcultural experience. The material that follows touches on a few key themes: adolescence, identity, masculinity, power and independence. Put together, they take us beyond notions of class into the realm of more personal rewards – graffiti as a way of building masculinity, communicating independence, being a 'nobody' and becoming a 'somebody'. The CCCS group presented us with some highly sophisticated arguments concerning subcultures and their functions, but they left one very important detail out of the picture – the passion. Over and over I meet writers and every time I am struck by the intensity of feeling they have for graffiti and the massively important place it has in their lives. It quite literally captivates them. There has to be something more personally enriching behind this emotional bond than class resistance or symbolic solutions to unsolvable problems (Clarke et al., 1976). Life and liberty are being risked here and it cannot be for the sake of hegemony alone! Taking this as its premise, this book will move beyond class-based theories of subculture to explore the relationship between graffiti and identity. More specifically, it will look at how illegal graffiti writers, predominantly young men, use their activities as a tool to construct the 'self'. For the most part, the 'male' self.

The masculinity of the graffiti exercise brings me to my final reason for conducting this study and writing this book. As I see it, a female gaze on these male forms is long overdue. For a long time now feminist researchers have concentrated their efforts on understanding the experiences of women. There are both political and methodological reasons for this. Firstly, drawing on one's own personal experiences has been seen as the key to feminist research (Bola, 1995). Women studying other women enables this reflection. Secondly, and perhaps most importantly, this focus on women helps to redress the balance that has been traditionally tipped in men's favour. As many feminists see it, men have had too much of a platform for far too long. As a woman interrogating a very 'male' subject, I cross this boundary and break out of this methodological mould. Contrary to those feminists who oppose the steps some women have taken towards studying men and masculinities, I see this as a positive and valuable move. Men may have always enjoyed centre-stage positioning, but we must consider the role that they have been playing in this position – that of the 'norm', the generic human being. As Beloff (1991: 385) maintains: 'Traditional psychology has not been about men, it's been about some sort of mutant person who was certainly referred to as "he" but not "he qua he".'

Men have been talked of and about, but they have rarely been talked on (Hearn & Collinson, 1994). Men have been the focus, but they have rarely been focused on. I believe that if anyone is equipped to problematize men as gendered beings, it is women. Firstly, it is in their interests to do so. Secondly, they see the world through the eyes of the 'other', a vision which sensitizes them to features and concerns which men themselves may overlook or take for granted. Case in point: Angela McRobbie (1980) re-examines two male-authored subcultural accounts from a feminist perspective. Put simply. what they missed, she did not. As she demonstrates, neither one of these male theorists uses their observations to develop a fully sexed notion of working-class culture. They use class or race as the key to unlock subcultural meanings, but their analyses are never pushed further to unravel questions on masculinity, sexuality and the redundancy of women (McRobbie, 1980). Why? One could argue that for male researchers these are not immediate or important issues. However, it is more likely that they are just not as visible. Now I am not saying that men are unable to critically assess the actions and experiences of other men, but I am suggesting that women are perhaps better equipped in this department. As I see it, moving from the vantage point of the 'one' to the 'other' can

gain us much in feminist terms. This book is a very limited contribution to that project.

Chapter outline

I have divided this book into eight chapters. Chapters 2, 3 and 4 contextualize my portrayal of this subculture by introducing broader issues of theory and method. In Chapter 2 I discuss why and how I used ethnographic method by highlighting some of the epistemological problems inherent in both positivist and postmodern approaches to research. Chapter 3 provides a critical review of the subcultural literatures. Centring on Functionalist and Marxist theories, I examine their preoccupation with the issue of class and argue why factors of age and gender must now be woven into the theoretical picture. Chapter 4 opens the door on the field. I outline the research context I worked in and the methods I used and I reflect on some of the benefits and problems I experienced as an outsider and a woman within an illegal, male-dominated environment. Although Chapter 4 can be read by anyone, the two chapters preceding it deal with some fairly abstract theoretical questions which may not be particularly interesting to readers without an academic background. They can be skipped without impeding understanding.

Chapter 5 is the first of my empirical chapters. It is the reader's 'welcome to the world of graffiti'. It sketches out this subculture's form and function by taking readers on a step-by-step journey through the typical stages of a writer's graffiti involvement or 'career'. In Chapter 6 I delve analytically deeper to explore the question of gender. Linking the illegal and dangerous aspects of graffiti with the predominance of men and the 'warrior' style meanings they attach to their activities, I examine this subculture as a site of masculine construction. I go on and develop this reading by looking at how male writers marginalize and exclude female writers and, with this, their emasculating threat. The notion of 'threat' is taken on and discussed in Chapter 7. Here, it is related to the dangers associated with public acceptance of and interest in graffiti. Charting the debate between illegal and 'legal' graffiti writers, I draw attention to the importance of illegality within this subculture and highlight the ways it intersects with issues of power, control, ownership and space. In doing so, I offer up some new ways of defining subcultures. I finish up in Chapter 8 by looking at how this subculture's 'space' or social isolation impacts writers' individual needs and concerns. This chapter explores the graffiti subculture as a 'liminal'

sphere; a place where the features, ties and restraints of 'real life' are dissolved and new identity possibilities are offered up.

As a way of addressing the general lack of analytic exchange between researchers and their researched, I gave my PhD thesis, on which this book is based, back to some of the graffiti writers who had been involved in my research. Their thoughts and evaluations are detailed in an Afterword, giving readers a rare insight into how insiders, as an important part of our audience, react to our portrayals of them.

2
Climbing Down off the Fence: Locating Our Standpoint and Values

Approaches and methods used to generate knowledge are diverse and, on the surface, are often seen to be a pragmatic choice based on timing, accessibility and sample size. What we tend to forget is that our methodological choices are also critically linked to the epistemological and moral value judgements we embrace:

> To be a scientist is to commit oneself to a certain kind of morality (Polanyi, 1962), rather than to adapt to this or that technique. Investigative techniques are determined by metaphysical commitments not by professional affiliations.
>
> (Harré, 1993: 101)

The research standpoint we adopt extends far beyond practical issues because our choices are inspired by our values. These determine how we wish to conduct our research, what we conceive to be its objectives and, ultimately, how we will treat our data. In short, they determine our beliefs concerning knowledge foundations.

Few would deny the influence our values have upon our interactions with other people. Human beings (fortunately) have opinions and, as Berger (1977) recognizes, researchers are no exception: 'The *practitioner of the discipline*, the sociologist, who (after all) is also a living human being, must *not* become value-free' (Berger, 1977: 20, italics in original). Somehow, though, Berger (1977) believes we can suspend our values to ensure our work remains 'value neutral': 'The *discipline of sociology*, I insist as emphatically as I can, must be value-free (Berger, 1977: 20, italics in original).

Berger (1977) is emphatic, but he fails to tell us how this immunity is possible. Unlike robots, we cannot flick a value neutrality switch allow-

ing us to escape our influence on the research process. Our values will always interweave, in some form or another, with our research approach, and our personal qualities, quirks and preconceptions will always leave their imprint upon the interactions and results of our fieldwork. Theory can never simply emerge from data, even if it is grounded in the experiences of others, because our observations are always going to be guided by existing images, concepts and theories (Henwood & Pidgeon, 1993). What we see and what we do not will merely reflect one aspect of our value-laden interests and commitments (Vidich & Lyman, 1994).

This fallibility extends to the scientific paradigm, a model which prides itself on being value immune. Here, interactional effects and unaccounted 'variables' are apparently eradicated by sterile and controlled research environments. Nevertheless, there is a still a human being involved. The scientist still has to communicate with his/her 'subjects', and they with him, and these relations, no matter how brief, will always ensure the pervasive imprint of subjectivity (Harré, 1993; Harré & Secord, 1972; Hollway, 1989). Indeed, the rationale underlying this form of inquiry indicates a value-ridden bias in itself. 'Subjects' are deemed unable to comment or are even deliberately silenced to afford the scientist the ultimate power position (Hollway, 1989). These beliefs and practices do not just shape the scientific approach, but also its findings and the specific form of reality it ultimately presents.

Realizing that there is no absolute foundation for knowledge, some researchers are beginning to examine the interplay between subjectivity and objectivity in the research process (Henwood & Pidgeon, 1993). This had led to an increase in reflexivity, as theorists attempt to explicate the bases of their knowledge and account for the interpretations they make and the consequences that stem from these. Through this, the reader is granted 'backstage access' or a behind the scenes view of the research process. To see a film in the cinema requires little of the audience except enjoyment of the finished product. Occasionally, though, a documentary detailing its creation will accompany it, allowing this audience to appreciate its often hidden construction. Like film directors, ethnographers have a large part to play, albeit behind the scenes. They are responsible for bringing the culture to life. This animation reflects their presence, as well as their subjective vision. It is, as Ellen (1984: 10–11) contends, a 'highly symbolic, intersubjective and personal' encounter.

By acknowledging their personal imprint, ethnographers strengthen their position on this representational platform. They analyse and

illustrate the effects of their presence and the source of their percep-
tions, and their claims and conclusions gain greater validity or, as
some term it, 'subjective objectivity' (Harding, 1991, 1992, as cited by
Henwood & Pidgeon, 1995) because of it. Van Maanen (1988) labels
this mode of reflection 'confessional'. In many ways it is a confession,
in that we admit our values and beliefs and account for how these have
shaped our approach and analyses. However, I do take issue with the
suggested implications of this term. A confession implies we have done
something wrong. If van Maanen intends confession to mean admit-
ting subjectivity, I, for one, do so without regret. I make no apologies
for the subjective nature of my perceptions, for I see this to be an
unavoidable, and indeed valuable, feature of research. Our beliefs and
values should not be viewed as shackles – just as they can hold us back,
so too can they inspire and motivate us. Perhaps, then, we should stop
trying to run from them and use them instead, informing our audience
how by climbing down off the fence and making it clear where we
stand. I present this chapter with this aim in mind.

Shedding the positivist past – the ethogenic theory

The positivists' use of quantification to objectively test presupposed
hypotheses has left many with doubts as to whether this approach is
sensitive enough to understand human behaviour. I recall my own
misgivings in an undergraduate department which privileged quantita-
tive measurement, as opposed to qualitative *Verstehen*. I spent three
years with the nagging feeling that things were not quite right.
However, for the sake of my degree, I limited 'extraneous' variables,
kept my 'subjects' quiet, turned their behaviour into numbers,
identified its 'causes' and presented my 'objective' report within the
rigid confines of its expected structure. Dissatisfaction with this prac-
tice has led many, including myself, to turn to other means of generat-
ing knowledge. The ethogenic theory, outlined below, is one such
alternative.

Quality vs quantity – actor vs subject – action vs causes

The ethogenic theorists were probably the first in psychology to overtly
challenge the philosophy and practice of the positivist tradition. The
1970s saw them abandon, not only its methods of quantitative
inquiry, but, more importantly, the conceptual bases justifying these.
'Conscious awareness, agentive powers and recollection' (Harré, 1993:
6), were re-established as universal human endowments, opposing the

positivistic treatment of human beings as 'subjects', 'automatons' (Harré & Secord, 1972) or 'judgmental dopes' (Garfinkel, 1967). The ethogenists wanted to reverse the belief that people are merely objects responding to the push and pull of environmental forces (Harré & Secord, 1972), and treat them, for scientific purposes, as if they were human beings (Harré & Secord, 1972) – that is, self-directing agents. Behaviourist conceptions of 'behaviour' and 'causes' were replaced with ethogenic conceptions of 'action', 'reasons' and 'intentions' and the task of psychology changed accordingly. Rather than speculate on the 'causes' of behaviour, ethogenists strove to identify 'the meanings that underlie it' (Harré & Secord, 1972: 9). Reynolds (1982: 329) maps out some of these distinctions below:

If we describe what people or animals do without enquiring into their subjective reasons and/or interpretations, we are talking about their behaviour. If we study these subjective aspects of what they do, the reasons and ideas underlying and guiding it, then we are concerned with the world of meaning.

By emphasizing human agency and intent, the ethogenists portray us with society under our belt, as opposed to on our back. As Harré (1993: 98) contends: 'The only causes of action are persons.' This image of freedom is an attractive one, but it is plausible? It is possible that the ethogenists reacted to the unappealing aspects of determinism by somewhat overplaying this notion of free will. In short, they fail to account for the reasons why an individual may be pursuing a certain line of action in the first place. Human beings can act with intent and purpose but, as Dilthey, as cited by Hamilton (1994), maintains, this does not preclude conditions that may have brought about this action: 'The human will is not so much free "from" conditions as free "to" respond to a multiplicity of circumstances' (Hamilton, 1994: 64–5).

Modifying or refining their initial thesis in some respects, Secord (1990: 185) now concedes: 'Persons are neither entirely free, nor is their behaviour determined in any straightforward way by their circumstances. Instead, explaining some acts as done for a reason and explaining some behaviour in terms of causes does not entail any logical contradiction.' Actors are, thus, autonomous in some ways, but not in others. Luckman (1982: 254) clarifies this distinction: 'Personal identities are constructed socially, i.e., historically, in processes in which the individual organisms participate actively – but under natural and social constraints.'

Harré's turn to social constructionism has gone some way towards revising this balance between constraint and freedom. Dualistic notions of society and individuals as self-contained, independent units are dissolved and they are brought together to form a partnership in which they are inescapably linked. Harré now occupies a middle-ground position between the extremes of individualism and collectivism (Harré, 1993). However, he remains true to his original assertions: 'The fact that people are created by other people and that their actions are in essence joint actions does not mean that the actions people perform are socially caused' (Harré, 1993: 3). Individuals may be socially constructed, but they retain their autonomy and agency within this interrelated framework.

Emic vs etic – commentary from within

This emphasis upon agency and awareness has important implications for the ethogenic thesis. Namely, if people are able to act, then they are able to comment on this action. 'Everything we do can be redone by talk' (Marsh et al., 1978: 21), so if we want to know why people do what they do, 'why not ask them?' (Harré & Secord, 1972: 101).

The ethogenists privilege actors' accounts of their behaviour as the only way that 'the meanings of social behaviour and the rules underlying social acts can be discovered' (Harré & Secord, 1972: 7). To impose an external explanation is perceived to be both chauvinistic and scientifically untenable (Marsh, 1982) because no one but the actor can give an authoritative report on the monitoring of his/her behaviour (Harré & Secord, 1972). Insiders' meanings are given priority in analyses (Marsh et al., 1978) as action 'cannot be rendered intelligible using frames of reference current outside of such contexts' (Marsh, 1982: 232).

This 'open souls doctrine', as the ethogenists term it, has much in common with the principles of ethnographic research. Here, too, meanings are privileged over causes and these are derived from insiders' phenomenological life-worlds in their terms rather than those of a detached researcher uninformed by 'emic' motives and intentions (Agar, 1980). Because theory is grounded in the relevant social context or light of 'local knowledge' (Geertz, 1983), it remains sensitive to its constituted meaning. Insiders' terms and categories are not overwritten by pre-imposed theoretical models (Henwood & Pidgeon, 1995), they inspire them and, thus, grant them greater relevance. Like a seed that is grown from its original site of germination, an 'emically' derived theory is inevitably stronger because its roots are firmly embedded within the theoretical soil of context.

Relevance is one reason why these approaches to understanding social behaviour are appealing. Another is the fact that insider representation is made possible, certainly within an ethogenic framework, by accepting individuals as agentic, reflexive and, thus, capable of explaining their world in the way that they see it. Where these strengths lie, though, so do weaknesses. This form of knowledge production is not without its problems.

Windows on the world?

Initial ethogenic work derived theory from insiders' accounts, but, in doing so, it presented its findings as 'truth'. Meanings were not offered as one of many, but as 'the' meaning, and accounts were read, as this quote demonstrates, to disclose evidence of a 'true' and independent reality: 'The things that people say about themselves and other people should be taken seriously as reports of data that *really exist*' (Harré & Secord, 1972: 7, italics in original). Many ethnographers have also tried to reproduce reality, presenting their accounts as 'immaculate perceptions' (van Maanen, 1988) or windows on the world. Implicit in this 'reproduction model' (Hammersley, 1992) is the idea that there is one single 'reality' which exists in some 'out-thereness' waiting for us to discover it.

As the currently dominant force in philosophical thinking, postmodernism has made positions like these very difficult to sustain. As it asserts, meaning is not unitary, but fractured, multiple, relative and subjectively situated. 'Reality' or 'truth' cannot be discovered because its contours constantly shift in line with our cultural and social angles of vision. And if reality or truth is a social construction, then so is the account that describes it. Relativism, as this position is termed, calls into question the very value of our quest for knowledge, and this poses a critical dilemma for ethnography. Under relativist terms, ethnographic work can only offer us entertainment value. To conduct research with the aim of illustrating anything becomes, as Hammersley (1992: 49) recognizes, a futile endeavour:

> We may have to conclude that 'there are as many realities as there are people' (Smith, 1984: 386). If this is so, what is the point in spawning more versions of 'reality' especially given the relative costs of ethnography compared with, say, armchair reflection?

As epistemological positions, realism and relativism position us in no-win, dead-end situations. But need they be? In Hammersley's (1992: 50)

view: 'There is a great danger of backing ourselves into a corner by deploying a dichotomy which obscures the wide range of epistemological positions available.' Our options are not necessarily dichotomous. Indeed, although Harré's position is now constructionist, he still adheres to a modest form of 'policy realism' (Harré, 1990), an epistemological stance I also share. The inductive and rational bases of this position give us a reason to search for existing entities. However, sensitivity to historical and experiential contingencies ensures we reference these without laying claims on truth. By incorporating subjectivity, 'policy realists' claim things as they seem to be rather than as they are, independent of our knowledge of them. As Harré (1990: 313) explains it:

> The policy realist thinks that scientists progress in their projects by achieving a better sample of what there is in the world. The convergent realist thinks that they progress by achieving a better description of the world. The policy realist stocks a museum. The convergent realist stocks a library.

Because this position recognizes uncertainty, we can comment, but not beyond dispute. Theories are revisable and presented in terms of plausibility, not 'verisimilitude' – correlated with truth, but not an absolute foundation for it.

'Policy realism' has much in common with the 'subtle realism' Hammersley (1992) advocates. Here, knowledge is not taken to be 'true', but as 'beliefs about whose validity we are reasonably confident' (Hammersley, 1992: 50). Like 'policy realism', theoretical validity rests on judgements of credibility. This allows us to represent some form of 'independent' reality, albeit in a much weaker form. Phenomena exist, but we cannot gain direct access to them because our assumptions and objectives will always shape the way we perceive them. 'Subtle realism' therefore becomes a particular representation, as opposed to reproduction, of reality.

Harré (1990) and Hammersley (1992) recognize the existence of multiple, partial and competing realities, but, like Henwood & Pidgeon (1994), they do not believe this 'leads to a total scepticism regarding the possibility of arriving at partial warrants for knowledge claims' (Henwood & Pidgeon, 1994: 233). They maintain that, while we can never find an absolute assurance of 'truth', whatever we can find is worth looking for. For many relativists, this represents an easy way out of an impossible situation. In their eyes, relativism and realism are mutually exclusive positions. An amalgamated and diluted version of

these is, thus, a dull and unfeasible compromise, one which enables theorists to have the best of both worlds while ensuring they fail to grasp either sufficiently. I can appreciate the logic of this argument, but when I consider its implications, logic loses. Yes, we can condemn these theorists for wriggling out of a bad situation, but we can also applaud them for making it a better one. Without these negotiations, we lose the point and purpose of research. Surely, it is better to attempt a difficult job, than not to attempt it at all?

Accounts – action through talk or a talk through action?

The epistemological positions we occupy are important in shaping the way we elicit and respond to the data we collect. Within qualitative research, 'subtle' or 'policy' realism still allows us to collect participants' accounts for informational purposes. We no longer retain the naive realist's belief that these contain the key to a unitary or universal 'truth' and 'reality'. Rather, we treat these accounts as insights into insiders' own situated meaning systems, in short their own subjective, partial and variable 'realities'. Harré may have shifted to a constructionist position, but he still distinguishes between two types of respondent accounts:

1. Those which can be discursively analysed to reveal the accomplishment of social acts.
2. Those which comment on and theorize about these social acts.

He defines and treats these accounts differently, for the reason that

> Some of the norms of social action are made explicit in accounts, though for all sorts of reasons. In first order discourse the norms of action are implicit. I shall treat the analysis of first and second order discourses as distinct analytical tasks.
>
> (Harré, 1993: 117)

Like Harré, I see the value of both these informational and constructive discourses. However, I do veer more towards using my informants' accounts for the information they provide. There are two reasons for this. First, I approached this subculture with a limited knowledge of its dynamics and purpose. A full-blown discourse analytic approach, which looks at talk for the actions it performs rather than the information it offers, would have been impractical because it would not have

granted me the wide angle I needed to familiarize with these basic sub-
cultural details. Second, and perhaps more importantly, I rejected a
fully fledged discursive approach on ethical and epistemological
grounds. As a means of clarifying my position, I want to look at the
way Widdicombe & Wooffitt treat their respondents' accounts in their
book *The Language of Youth Subcultures* (1995).

Silent voices – discourse analysis and the distanced informant

In this book Widdicombe & Wooffitt use discourse analysis to explore
issues of personal identity, group affiliation and subcultural member-
ship. Premised on the basis of individuals' reflexivity, they reject the
treatment of people as 'judgmental dopes' (Garfinkel, 1967) and assert
the need for 'an empirical attempt to take heed of members' own
accounts: their own perceptions, reports, stories and anecdotes'
(Widdicombe & Wooffitt, 1995: 28). Recognizing that the insider's
voice has been critically neglected within past subcultural work, the
authors strive to make it heard again. This is commendable. However,
their analytic approach does raise a number of issues concerning the
way this voice is extracted and treated.

In the first section of the text the authors look at the importance of
subcultural membership and categorization to the members them-
selves. Rather than ask them directly, they wanted to see whether
respondents would specify their affiliations voluntarily:

> It was important that the interviewees explicitly declared them-
> selves to be members of a specific subcultural group. Consequently,
> the first question of the interview was designed to be somewhat
> vague, and raise at a very general level the issue of how the respon-
> dents would describe themselves.
>
> (Widdicombe & Wooffitt, 1995: 76–7)

In response to their 'somewhat vague' opening question (for example,
'Tell me something about yourself?') most respondents described their
style of dress. Very few categorized it. Perhaps they presumed the sub-
culture they belonged to was obvious. As the authors themselves state:
'They could infer that our reason for approaching them was related to
the way that their appearance made available the inference that they
were members of a specific subcultural group' (Widdicombe &
Wooffitt, 1995: 85). Despite this, Widdicombe & Wooffitt found
members' failure to identify their subculture significant. Indeed,
requests for clarification, an understandable reaction to the ambiguity

of some of the questions, was judged to be 'a method by which the respondent can avoid giving a subcultural self-identification' (Widdicombe & Wooffitt, 1995: 94). Why? Because dissociating themselves from the group like this enables them to claim and retain an all-important sense of their own individuality.

Widdicombe & Wooffitt go on to use this somewhat shaky finding as a building block for their entire thesis. What I do not understand is why they did not try to strengthen it first by asking respondents to comment on it directly. This way, their reasons for avoiding subcultural identification could be explored and we would not have to rely on an external and, in my view, highly tenuous explanation. As it stands, Widdicombe & Wooffitt (1995) have sacrificed a learning forum for a testing zone; a move which imposes an unnecessary, as well as unhelpful, distance between themselves and their respondents. After all, why test your informants according to your own generated criteria, when you can learn from them by attending to their own?

In the remaining chapters of the book, Widdicombe & Wooffitt (1995) focus on issues of individuality and authenticity. More specifically, they use their respondents' accounts to interrogate the *supposed* rewards of subcultural membership, that is, belonging, identity and affiliation. In response to related questions, they found that members

> provided little sense of subcultures as groups which they joined. Likewise, in their formulations of the significance of being a member, they did not invoke a sense of shared identity, nor the benefits of affiliation with like-minded others.
>
> (Widdicombe & Wooffitt, 1995: 216)

The questions put to respondents were more direct, but, again, interpretational privilege rested with the authors. In their opinion, respondents downplayed any signs of group cohesion and affiliation because this enabled them to salvage their individuality. How can you be your own person if you are just one of the crowd? But before accepting this reading, I think we must acknowledge, as the members themselves did, the nature of the particular groups in question. These appear to be connected on the basis of a shared style. As such, they may not enjoy the cohesion and rewards that other more tightly bound groups do. But, again, why speculate on this? I fail to understand why Widdicombe & Wooffitt (1995) could not be more literal in their enquiries. For example, 'Some people believe subcultures offer individuals security,

identity and a sense of belonging, in your case would you agree?' or 'Does being a member of a subculture affect your individuality?' Respondents could have then clarified the nature of their group and their affiliations and commented on the relevance of this interpretation.

In most cases, interpretation is imposed. Whether this is alternative to members' own is not made clear because they are excluded from this interpretational exercise. Their accounts are accessed, but Widdicombe & Wooffitt (1995) reserve the right to make sense of them. In this light, I see little difference between discourse analysis and the semiotic approach adopted by previous subcultural theorists. The CCCS group dissected members' styles. Widdicombe & Wooffitt dissect their accounts in the same detached manner. The only thing separating them is their approach to this task. Discourse analysts view meaning as personal, particular, subjective and open to dispute. For this reason, their interpretations come with the corresponding discourse that gives us, their audience, a chance to formulate our own conclusions. Through this exchange an 'absolute' reading is avoided and the analysts' interpretational authority is rejected. Maybe so, but by denying participants any input, this authority is still shared exclusively among an academic readership. The academic knows best – we collect accounts and we reserve the right to decree what people are *really* saying or *really* doing through their talk. The danger of this approach lies in the nominal role our respondents now play in the generation of knowledge. Agency may be implicated in their talking 'performance' but this is something of a token provision; one which, perhaps, helps analysts wriggle out of accusations of discursive determinism. I see no reason why this agency cannot be extended to enable informants to contribute as interpreters. I am not saying that we should take their word as 'truth' or that people are always aware of the significance of their actions. The researcher as a 'professional stranger' (Agar, 1980) enables this vision. However, the fact that people may not have reflected on things in certain ways, does not preclude their ability to do so when these views are made explicit. If people are not 'judgmental dopes' (Garfinkel, 1967), as the authors of this book claim, then it makes sense not to treat them as such.

Authority, power and postmodernism: a game of hide and seek

Before sketching out my own research approach, I want to outline the position I have chosen to occupy in my role as an ethnographer. My

standpoint on issues of power, authority and representation will be addressed using *Writing Culture: the Poetics and Politics of Ethnography* (Clifford & Marcus, 1986) as a framing text.

Confronting and challenging the author(ity)

This book presents a collection of essays written by postmodern or literary ethnographers. As I began reading these, I found myself embracing, what I saw to be, an ethically driven postmodern agenda. Its appeal lay in its objectives: acceptance of subjectivity, deconstruction of the researcher's power and authority and an appreciation of the problems of representation. These concerns have been critically neglected by traditional ethnographers. The physical distances they often travelled could be upheld as one reason for this. Remote lands were visited and the ethnographer would then return home to construct a 'true' account which no one could challenge, except, maybe, the insider who had neither access to this finished product nor, perhaps, the literacy to understand it. As ethnographic method grew in popularity, its study targets started to move closer to home. Changes in setting saw a corresponding change in approach. Work within their own society placed insiders on their doorstep and forced ethnographers to recognize their place within the cultural context. The ethnographer who had been previously reluctant to take a good look at his/her limitations (van Maanen, 1988), now emerged from the closet to consider the effects they had upon the people they studied and the portrayals they presented (Clifford, 1986). This reflexive shift uncovered buried issues of authority, power and representation and inspired a whole new climate of ethnographic awareness.

But did it succeed in stripping researchers of their formerly unchallenged positions of power? Apparently not. Postmodernists step in here to question this seeming decline in authority. In their view, power positions are still created and maintained, albeit at a more disguised level, through textual (Crapanzano, 1986) and rhetorical devices: 'All constructed truths are made possible by powerful "lies" of exclusion and rhetoric' (Clifford, 1986: 7). As long as ethnographers construct and write their accounts, their constructed positions of power and authority remain. The postmodern ethnographers' enterprise is, thus, far more radical. They do not just admit their textual control, they relinquish it in an attempt to 'decentre the author' and obliterate their inherited privileges of power (Clifford, 1986). The omnipotent representer exits and the humble translator enters. By leaving insiders' multiple voices unstructured and untainted (Clifford, 1986), postmodern

ethnographers allow them to speak for themselves. They do not have to decree truth from non-truth as a final verdict, and their ability and power to make this judgement are no longer valid. They are now the outsider or the 'other' (Clifford, 1986) and as such, they must speak from within the cultural midst, that is, among these other voices rather than over them. Apparently, this makes their accounts more truthful than those which become 'partial truths' through devices of construction and manipulation (Clifford, 1986).

Pursuing unattainable goals – reinstating unassailable problems

The postmodern ethnographers' goals are commendable, but they are also, in many ways, unattainable. Although I share postmodern convictions that authority can be smuggled in through the use of rhetoric, I cannot accept that we can remove or liberate ourselves from the constraints of representation simply by changing the way that we write. Supporting this, I began to see disparity in their efforts to link principles to practice. Contradictions emerged, in that the very tools they use to fight these problems actually disguise, reinstate and, as we will see, reproduce them in a variety of other ways.

Postmodernists have blown the final whistle on neat and tidy packages of culture. Tyler (1986: 130) explains why: 'The urge to conform to the canons of scientific rhetoric has made the easy realism of natural history the dominant mode of ethnographic prose, but it has been an illusory realism.' Realism is an illusion, so a coherent or ordered account represents a false image of the world. Fragmentation becomes the only step towards 'truth' because 'It describes no objects and makes no break between describing and what is being described. It does not describe, for there is nothing it could describe' (Tyler, 1986: 137). Here I depart from postmodern ideals. What I thought to be an ethically guided project, is one propelled by an epistemological stance I find very difficult to accept. Claims that realism and order are illusory and nothing more than a product of our textual practice are, in my view, problematic. Can it possibly be that simple? Our realities may be constructions based upon our personal and cultural perceptions and assumptions, but does this decree them fictional? 'Construction' implies a process of creation and, with this, a resulting product – in my mind, a subjective reality. This does not define me as a naive realist as there are elements of this postmodern reasoning I share. Namely, the rejection of reality as a unified and singular concept. To assert that one reality fits all is naive because our conceptions of the world vary with our differing experiences. But if we accept reality as multiple, that is,

different to different people, then we must also accept the existence of 'independent' realities; those unrelated to our own and, therefore, existent beyond our recognition and experience of them.

In the progression of the relativist argument, realism is determined to be nothing more than a prop used by researchers to construct a false impression of their authority. This strikes me as a convenience because it suggests that all we have to do is lose realism and, hey presto, problem solved, authority ceases to be a sustainable concept. Even if this were a tenable equation, do we need to renounce realism and order to surrender our power and authority as cultural commentators? During my research, informants consistently provided me with a shared sense of subcultural order and structure. They represented multiple voices and presented multiple realities, but they did apparently share a conception of the subculture as a single, all-encompassing framework. My visions were shaped by their visions. In presenting these, the position of authority became theirs – they deemed it ordered and I translated and analysed it.

Hand in hand with relativism comes an inescapable set of contradictions and inconsistencies. Firstly, if we commit ourselves to insiders' voices, as the postmodern ethnographer does, then to deny them the order or reality they apparently experience, is to deny them the respect we are striving to afford them. We also deceive them by asking for accounts of their realities, only then to depart and attack the basis of everything they have told us. In this sense, relativists become the ultimate authorities in decreeing *what* others experience and *whether* this is real. The supposed power of the insider's voice becomes invalid and illusory because it is ultimately judged.

Postmodernists have responded to naive realists here by occupying an equally extreme and precarious position. While they oppose realists in their appeals to relativism, paradoxically they mimic them in their attempts to justify this as an unequivocal truth. This 'truth' places them in a predicament; they remain committed to their informants' voices, yet if their informants express a shared order or reality and they illustrate it, they are shattering postmodern visions of disorder and presenting themselves as 'authorities'. By virtue of this, postmodernists may find themselves in an uncompromising position of choice – loyalty to insiders, who may invalidate their propositions, or loyalty to their theories, which may mean they have to see things selectively to ensure they conform to their ideals. Thus authority may be absent at a surface level, but a more dominant figure of power, in the shape of theoretical conformity, might be lurking which acts to determine what

is or is not, should or should not be there. Just as scientists may be accused of imposing order where there is none, postmodernists may be equally guilty of ignoring order where there is some.

The power and authority we hold as researchers manifest at all levels and stages of the research process. Yet, postmodern or literary ethnographers concentrate on dismantling its influence at a textual level. This may limit their control, but it does not eradicate it because the responsibility for positioning these 'unstructured' accounts is still theirs. Earlier stages of research are also tainted by this imprint of power. The first step into the field sees ethnographers armed with a particular set of interests and concerns. Ultimately, they are in charge of what is to be asked and, with this, what is to be answered. At an even deeper level, this inquiry requires informants to impose a sense of order or clarity upon their thoughts so these may be intelligible to a listener. True, this is a self-imposed order, but the researcher is still responsible for it. To examine authority at these levels illustrates its pervasive nature. We may attempt to avoid its influence at later stages, but this is, in many ways, a futile exercise because we have been unable to escape the imprint it has left on our earlier activities.

In my view, postmodern ethnographers are visionary but over-idealistic. I say this because many of the sacrifices they have chosen to make in their quest have merely given their power positions an alternative guise. For example, while (seemingly) losing sight of the author(ity), these ethnographers have also lost sight of the culture. A preoccupation with textual concerns has meant that issues of intent now override issues of content (van Maanen, 1988):

> We find philosophers, literary critics, and political economists reading ethnographies of the Balinese and Azande, not out of intrinsic interest in the subject matter, but for their distinctive textual devices and modes of exploring theoretical issues in the process of ethnographic representation itself.
>
> (Marcus, 1986: 167, footnotes)

'What' is said is now less compelling than 'how' it is said. Accordingly, the ethnographer and his/her ability to grapple with problems of representation become the new object of our interest. This removes the spotlight from the culture, which some postmodernists believe enables them to claim value freedom (Gill, 1995). They fail to comment culturally and so are free from the value constraints which act to motivate and influence this commentary (Gill, 1995). Firstly, I would dispute

their ability to nonchalantly shrug off these values. When values are not made explicit, 'it is not because they are not present, but simply that they have gone underground' (Gill, 1995: 17–18). Their lack of cultural focus indicates a bias in itself: 'Epistemological skeptics seem to have reinstated, rather than challenged, the notion of value freedom in research. Disinterested inquiry is their regulative ideal – not dissimilar from that of positivist researchers' (Gill, 1995: 18). Even if value freedom were obtainable – at what a price! Deconstructive postmodern aesthetics are dominated by a sense of detachment, displacement, (Spretnak, 1991, as cited by Vidich & Lyman, 1994) and, at times, brutality: 'Relativists appear to have no aims but to relentlessly interrogate and dissolve every last claim, highlighting its status as construction and deconstructing, with surgical precision, each last shred of meaning' (Gill, 1995: 13). Perhaps this is the problem; they have dug themselves into an epistemological hole which they are not allowed to climb out of. They cannot comment, so they must derive some shred of purpose through dismembering others' portrayals.

Relativists are the only winners in this game, which means that the very concerns that supposedly motivate them are now being flagrantly dismissed. The insider is donated voice and, thus, respect, but the researcher seizes centre-stage positioning, rendering this voice unheard and meaningless. If anything, the chasm between the 'researcher' and the 'researched', claimed to have been breached by the loss of the author, has been widened further by this loss of the culture. In removing debate from its cultural context, the researcher's role has become more removed and the insider's more redundant. What insiders may deem to be important cultural information is, unbeknownst to them, likely to become irrelevant. Irony plays in here because the postmodern ethnographer appears to be following far too neatly in the footsteps of the colonial ethnographer they are trying to walk away from. While the latter concealed their fieldwork practices and stories, the former conceal their true objectives. The insider is told that their world is interesting. What they are not told is that their world is interesting because it can be used to indulge other concerns. A starring role swiftly becomes a hidden credit as the researcher uses his/her power to decree the insider's final significance in this portrayal.

As I see it, the culture is used, abused and sold out as a platform for an academic display of intellectual gymnastics. As postmodernists jump through their epistemological hoops and compete to 'decentre the author', their cultural accounts become more abstruse and their benefits less apparent. Intelligibility is lost, which makes these

accounts true to postmodern ideals, but untrue to cultural members and other interested readers. It has taken a while, but the people we write about are now finally being considered an important audience for our work. This is a relatively new turn in events. As late as 1988, van Maanen examines the various readers of ethnographic work without even mentioning cultural insiders. *When They Read What We Write* (Brettell, 1993) amends this oversight. Focusing on the insider reader, these essays explore some of the representational and interpretational dilemmas they pose, as well as the measures researchers have used to address, solve or deny them. Language is highlighted as an important concern in such matters. Evidently, academic discourse does far more than just educate. It can also confuse insiders, deflect their challenges and preserve our benefits of power (Hau'ofa, 1975, as cited by Brettell, 1993). Illustrating this, Davis's (1993) work was criticized by her informants and she was advised by fellow academics to adopt a more sophisticated style of language. In effect, she was told to use jargon to silence them and avoid their dispute. In this way, language can now afford us the distance and defence that geography previously did. In the past remote cultures could not challenge their portraits because they could not see or read them. Local cultures today cannot challenge theirs because they probably cannot understand them. Academic colonialism replaces cultural colonialism, as jargon becomes an 'exclusionary tool' (Becker, 1986, as cited by van Maanen, 1988) and relativists become relative only to themselves.

Postmodernists seem to be aware of the very limited audience they speak to and the concerns that accompany that: 'Textual, epistemological questions are sometimes thought to be paralyzing, abstract, dangerously solipsistic – in short, a barrier to the task of writing "grounded" or "unified" cultural and historical studies' (Clifford, 1986: 24–5). They respond by using epistemological conviction as an impenetrable defence: 'There has been considered talk about a return to plain speaking and to realism. But to return to realism, one must have first left it!' (Clifford, 1986: 25). We cannot return to what was not or is not there, so in trying to reinstate the culture by making some concrete reference to it, we become 'naive realists'. But do we? I am not sure these positions necessarily correspond. We can reject a unitary conception of culture and accept a multiple version, but does this mean we have to give up the fight? Surely, in line with the goals of ethnographic practice we must try and illustrate even a subjective picture. If not, I fail to see the point of the exercise. Here, then, we enter into a debate about objectives, not realism. If realism becomes the issue, I see no reason why post-

modernists even entertain ethnographic method. If we cannot reference what is not there, as Clifford (1986) implies, then we must ask why they are toying with these cultural illusions in the first place. We no longer read for content, so why are these tokenistic cultures even featured? Ethnographic ideals simply fail to complement relativists' objectives.

Postmodernism has heightened our awareness of some very important issues and I embrace many of its ideals. However, while good in principle, many of them fail when put into ethnographic practice. Essentially, postmodern ethnographers have reproduced all that they have set out to destroy. This is partially the problem. They have tried to destroy that which is indestructible; their power and authority. These ethnographers have not disposed of the author(ity), they have merely provided us with a game of hide and seek. Their power perch has been knocked, but they have not been toppled from it. They never will because, as we have seen here, we cannot ever really escape this position. Perhaps, then, we should take the very valuable directions postmodernism has given us and try to rebuild this perch using a slightly different manual of instructions; one which pushes us to *accept* and *earn* our power positions. If we acknowledge our limitations and work realistically to try and diminish, rather than eradicate them, we might be able to reinstate the respect that has been lost in the pursuit of unobtainable goals.

A culturally oriented approach to research

My research approach was shaped, largely, by the subculture itself. Graffiti writers receive a fair amount of media coverage, much of which is, in their view, uninformed and distorted. While they are not necessarily adverse to the negative coverage, they realize that they lack the power or voice to challenge these stories even if they wanted to. As a result, the issue of representation is a subculturally significant one. In recognizing this, my own position as a narrator became more clear. I was responsible for speaking for a consistently 'spoken for' group. This made me aware of my power, authority and representational control. It also made me aware of how important it was not to abuse their potential.

Qualitative research: a game of two halves

Times have changed in the world of research. As Myerhoff (1978), as cited by Glazier (1993), observes, insiders' questions have now moved on from 'What do you want from us?' to 'What's in it for us?' Do we not owe them something for the time and guidance they give us? I

would say at least an informed and intelligible account which provides them with the opportunity to disagree. To offer this we need to infuse some sort of structure into our accounts by acting as narrators. Ethnographers are well versed in this role as fieldwork is characterized by interplay between proximity and distance and insider and outsider positions. As a 'professional stranger' (Agar, 1980), we use the informed vision of the insider and combine it with the advantages of our perception as an outsider. In terms of insight, no one position is better than the other (Hammersley, 1992). To claim that 'the Outsider, no matter how careful and talented, is excluded in principle from gaining access to the social and cultural truth' (Merton, 1972: 15), assumes there is a truth to obtain, but also neglects the inherent strengths of the outsider's peripheral position: 'It is the stranger, too, who finds what is familiar to the group significantly unfamiliar and so is prompted to raise questions for inquiry less apt to be raised at all by Insiders' (Merton, 1972: 33). If research demands the revelation of all that is tacit (Harré, 1993), then it is the outsider who sees beyond the insider's everyday, taken for granted assumptions. As an outsider in an insider's world they can appreciate the insider's frame of reference, while also detect its significant facets.

Yet, the outsider's vision is not an isolated one. Distance must be complemented by proximity because we rely on insiders to inform our interpretations and ensure these are anchored in the context and culture in question (van Maanen, 1982). As creators of their realities, insiders represent our knowledge bearers. Their views are no more true than others, but if it is their worlds we seek to understand, they become the ultimate authorities. They are afforded direct access to their realities by their experiences of them and the ethnographer gains indirect access through their accounts of them. In a sense, 'The activity of understanding (verstehen) unfolds as one looks over one's respondents' shoulders at what they are doing' (Schwandt, 1994: 123) and, I would stress, at what they are saying. Although we can never be or think like an insider (Geertz, 1983), we can appreciate what it means to be one through involving them in the production of knowledge. They become our socializers. They familiarize us with their particular life-worlds and they afford us the 'local knowledge' (Geertz, 1983) to present our cultural portrayals.

Sharing our perch of power – the fusion of subjectivities

I embrace Harré's assertions of human agency and reflexivity. This is not to say that we have privileged access to the 'truth', but I do believe

we have access to the subjective reasons for our own behaviour. As researchers, we interpret the words and actions of others and, thus, combine their vision with ours. But then why stop here? Given that 'participants are always "doing" research, for they, along with the researchers, construct the meanings that become "data" for later interpretation' (Olesen, 1994: 166), why not include them, as Reason (1994) and Smith (1994) have suggested, in an interpretational role:

> If one's view of a person is as a self-reflexive agent, presumably that holds for the respondent as well as for the researcher. Given that your respondent will therefore be doing this reflexing anyway, why not enlist her/him as a co-researcher in the project?
>
> (Smith, 1994: 254–5)

Using this logic, I tried to share my interpretational privilege with my informants by involving them as interpretational consultants. I did this in two ways. First, I made our interviews forums where we could jointly examine the significance of their actions. In this sense, I avoided imposing hidden meanings to their behaviour in the safety of distance beyond the field. My ideas and interpretations were exposed as I spoke to them, as were theirs, and together we assessed their relevance. Some might question my ability to coerce informants into confirming my views. However, this would define them as lacking in their own, and this was far from the case! The writers were very vocal in our meetings, using this as a chance to redress the voice/power balance that has been lacking in many 'tabloid' style articles about their subculture. The part they played gave them some authority, but it also justified mine. Moulding our subjectivities together through this process of negotiation did not guarantee truth, but it did generate a stronger base for knowledge. Different visions were combined – both were subjective, but mine was grounded upon the insider's, the creator of the reality I sought to understand.

Hollway (1989) reverses this process in her research by using her own knowledge as a base to build on and judge from. As she sees it, treating informants as arbiters of knowledge is naive because we overlook who is producing the account and, thus, the reasons and motives that may shape or distort it. She recommends that we use our own subjective experiences to frame account accuracy. For my purposes, however, this was impractical. I had neither the experience needed to check the validity of my informants' accounts, nor the desire to judge the accuracy of their words. As Hammersley (1992: 53) contends:

'Whether we should be concerned with the truth or falsity of any account depends on how we plan to use it.' I used my informants' accounts to understand this unfamiliar subculture and to gain insight into their perspectives as members of this. Their accounts were not always concordant – to be expected in a subculture cleavaged by different groups with different attitudes and beliefs. However, I had no wish to judge them as right or wrong, as this was not relevant to my task of understanding them (Hammersley, 1992). As I saw it, their accounts were all different, valid and interesting in their own right. In terms of the reasons for the particular commentaries writers gave me, all were motivated to present their 'way' as the 'only way' or the 'best way'. I recognized this, but, again, I did not challenge them because I wanted to understand their rationalizations as reflections of their own specific standpoints.

Giving writers interpretational input during our interviews was not my only gesture towards sharing my power. Following its completion, I also gave many of them copies of my PhD thesis for their thoughts and reactions (see Afterword for their responses). This allowed me to give something back in return for the help and time they had given me during my fieldwork. More importantly though, I felt they had a right to read what I had written about them and comment on it. As researchers, we rarely make room for 'insider' feedback. This strikes me as odd as insiders could be deemed our most important audience. For one, the work is about them, so they are probably more interested than most. However, they also have the power to strengthen our portrayals through their recognition and support. Used as 'logically adequate criteria' (Harré & Secord, 1972), insiders' validations can do little to harm the validity of our research.

Although I worked hard to produce a culturally informed account of this subculture, I did not expect to gain writers' unconditional approval. While I tried to limit biases and inaccuracies, I conducted this research as an academic exercise. This meant I had analyse the subculture and, thus, strip it down to its bare-boned, skeletal framework. This could have made it look flat or boring to an insider, and, thus, unfamiliar and unflattering. Similarly, details that writers might have considered interesting or important were often skimmed over or lost to the academic cutting room floor. I was also left with the difficult task of juggling their multiple and diverse voices. Inevitably, some gained more exposure than others, which, given the value of fame, might have generated some antagonism.

What the above differences in our priorities and perceptions ultimately reveal is my control. No matter what input writers had as interpretational consultants, I occupied the ultimate power position in this exchange. As the researcher, narrator and author, I incorporated the analytic themes that made this story compelling and I decided how it was going to be told. Regardless of what we do to disperse our power and control as researchers, we always come out on top. I have acknowledged that here by outlining my epistemological/research position – at least readers will 'know where I'm coming from'. I have also tried to contain these reflections by dedicating them this chapter. I do not want to follow postmodern ethnographers and drown my cultural subject in reflexive debate. As far as I can, I have positioned this subculture and its members in the spotlight, giving them voice as voice, not as a vehicle to satisfy my own intellectual needs.

To conclude, I would summarize my stance as culturally oriented. This does not mean I am driven by an over-romanticized sensitivity to the plight of the underdog. That would be misplaced. Writers do not view themselves as hard done by or oppressed. If anything, that is how they see people who have never understood or experienced the magic of graffiti. For this reason, I make no attempt to inspire social change or 'improve their lot'. My only political drive lies in my commitment to grant writers the respect and status they deserve as cultural commentators.

3
Are Theories of Subculture Too Class Oriented?

CLASSIFICATION.

Two main academic schools have addressed the 'subculture' as an analytic issue; the Functionalist 'anomie' or 'strain' theorists and, later, Marxist scholars at the Centre for Contemporary Cultural Studies (CCCS) in Birmingham, UK. These theorists assume very distinct analytic positions, as we will see. But they do converge at two main points – both focus on urban, male, working-class adolescents and both share a common concern with the influence of class. They may approach this factor from different directions, but in both cases it is given central consideration.

This chapter will consider the theoretical utility of these theories. Criticisms have been made on a number of grounds. One which deserves special mention is their claim that all members of subcultures are working class. This is an assumption and, as I will argue, a problematic one. The suggestion that subcultures are an inherent 'problem' must also be addressed. There appears to be little space in any of this work for saying something positive about them, aside from the fact that they offer defensive or symbolic solutions to working-class problems. Boiling everything down to class in this way has also pushed other concerns, such as those related to age, firmly into the shadows. This has frustrated many youth theorists who view the subculture in developmental terms; as a social and/or psychological source of support and a way of structuring an adolescent's passage into adulthood (see for example Coleman, 1980; Eisenstadt, 1956; Marsland, 1980, 1993). Unsurprisingly, these theorists are heavy critics of the CCCS group's class leanings. An account which ignores the age-related benefits of subcultural membership is, in their mind, a partial and distorted one. Marxist theorists respond in kind, declaring youth-based theories monolithic, apolitical, ahistorical and analyti-

cally worthless. I review this debate to outline their theoretical positions, but also to draw attention to the neglected association made between subcultures and their predominantly male memberships. This feature is conspicuous, yet both the subcultural and the youth theories grant it little, if any, attention. This oversight comments on masculinity's well-worn use as an androcentric yardstick of normality. That is, the pervasive research orientation by men of men, where men = people and women = the 'other'. In their work, working-class and male culture are assumed to be synonymous. But they are not, and if we are to develop a sufficient understanding of the subculture's masculine make-up and, indeed, its related functions, then we need to start recognizing this.

The Functionalist 'anomie' or 'strain' approach

The Functionalist theories enjoyed prominence in America during the 1950s. From the starting point of Merton (1938), delinquency was perceived as nonconformity to socially accepted goals and values. In this framework, society is seen as a consensual system where middle-class values are universally embraced but denied gratification by the constraints of a working-class background. As a result of this gap between desired goals and means of obtaining them, 'anomie' or 'normlessness' occurs and the frustrated individual is backed into delinquency in compensation.

Albert Cohen develops Merton's propositions in his text, *Delinquent Boys* (1955). Here, the individual, in failing to fulfil 'mainstream' goals, uses 'reaction formation' to invert them, deny their value and pursue a deviant career instead. The delinquent subculture is seen to be '*non-utilitarian, malicious and negativistic*' (Cohen, 1955: 25, italics in original) because it is used by status-frustrated individuals as a hit-back mechanism.

Cloward & Ohlin (1961) adopt a similar approach and outline three types of deviant subcultures; the criminal, conflict and retreatist. The second represents, again, the violent frustration that is felt when a working-class individual is denied access to society's legitimate opportunities.

Miller (1958) takes quite a different stand on these issues. In his mind, middle-class norms and values are subculturally irrelevant. Rather, the member of the subculture merely conforms to the distinctive value system of his/her own working-class culture:

In the case of 'gang' delinquency, the cultural system which exerts the most direct influence on behaviour, is that of the lower class community itself – a long-established, distinctively patterned tradition with an integrity of its own – rather than a so-called 'delinquent subculture' which has arisen through conflict with middle class culture and is oriented to the deliberate violation of middle class norms.

(Miller, 1958: 5–6)

In this case, then, the subculture's 'focal concerns' – toughness, smartness, excitement, fate, autonomy and trouble (Miller, 1958) – are taken to reflect working-class traditions rather than working-class frustration.

Theoretical limitations

Matza & Sykes (1961) step in here to question this apparent disparity between middle- and working-class norms and values. In contrast, they view the 'delinquent' as conforming to 'subterranean' values. These, they argue, are also embraced by the middle classes, but their expression is restricted to the sphere of leisure. The 'delinquent' thus differs only in his/her disregard for middle-class proscriptions of time and place. Bringing the classes and their values closer together like this helps Matza & Sykes (1961) explain why deviance is often occasional. If the subculture's values are oppositional, as Albert Cohen (1955) and Miller (1958) have suggested, then how does an individual embrace them without constantly breaking the law? As Matza (1964: 21) argues: 'Positive criminology accounts for far too much delinquency. Taken at their terms, delinquency theories seem to predict far more delinquency than actually occurs.' Matza (1964) dismisses this image of a committed delinquent and traces, instead, their drifting progress in and out of crime. Parker's (1974) work supports this conceptual shift. As he illustrates, delinquency is rarely a 24-hour phenomenon. Much time is also spent engaged in conventional activity or 'doing nothing' (Corrigan, 1976).

The Functionalists' overprediction of crime can be explained in other ways. Strain theorists present delinquency as a typical or standard reaction to class contradiction (Heidensohn, 1989; Hirschi, 1969). In doing so, they ignore both working-class conformity and the fact that delinquency often decreases after adolescence:

Anywhere from 60 to 85 per cent of delinquents do not apparently become adult violators. Moreover, this reform seems to occur irre-

spective of intervention of correctional agencies and irrespective of the quality of correctional service.

(Matza, 1964: 22)

The fact that many kids 'grow out of trouble' and become law-abiding adults leaves strain theorists with questions that are very hard to answer (Hirschi, 1969). The problem here is that they do not follow through on all the elements of the story. By focusing on outcomes as opposed to processes, that is, entry into and exit from subcultural involvement (Downes & Rock, 1982), they miss shifts in the deviant career and leave us with the impression of a lifelong delinquent – and a socially determined one at that. Self-will and choice do not figure in these accounts. Equating delinquency with working-class traditions or portraying it as a predictable outcome of class membership, squashes out the possibility of choice (Matza, 1964) and puts forward an image of an individual propelled into crime by forces that lie beyond his/her control. — *other outlets = graphin*

Strain theorists seem determined to lock deviance into a working-class vacuum. But closer inspection shows that this seal is not exactly watertight. Inconsistencies, such as middle-class crime, are ignored or carefully explained away (Downes & Rock, 1982; Heidensohn, 1989; Hirschi, 1969). Case in point: Albert Cohen (1955) salvages his class-based theory by attributing middle-class deviance an alternative cause: masculine anxiety. He derives his claims from Parsons' (1942) concept of 'masculine protest', whereby a boy adopts oppositional qualities to the female, namely his mother, in an attempt to establish a masculine identity. Cohen saw this to be more extreme for the middle-class boy who resides within a family unit which isolates him from significant male role models. Apparently, these figures are more accessible to the working-class boy (Cohen, 1955), so his deviant motivations remain status frustration and the problems of his working-class background. The more complex postmodern/psychoanalytic analyses now being developed on gender expose the overly simplistic nature of Cohen's claims. Other writers dismiss this argument in its entirety, perceiving masculine concerns to be just as great, if not greater, among working-class boys (Miller, 1958; Wilensky & Lebeaux, 1958). Cohen (1955: 169) himself acknowledges the limitations of his claims:

We make no attempt here to explore exhaustively, this problem of middle-class delinquency. How pervasive and how intense are these problems of achieving masculinity? In what ways are working-class

and middle-class delinquency alike and in what ways different? What countervailing pressures are there in the middle-class to the adoption of this mode of masculine protest? All these questions require further research.

In admitting that he has no definitive basis for differentiating middle- and working-class delinquency, Cohen's link between class and crime becomes highly tenuous. Indeed, his entire theory appears, at best, speculative because, as he concedes throughout the text, its major tenets all require further research. Cohen's arguments would have undoubtedly benefited from a little less guesswork and a little more fieldwork (Bloch & Niederhoffer, 1958). Following their research on gangs, Bloch & Niederhoffer (1958) found no evidence to support any of Cohen's (1955) claims, that delinquents invert middle-class values, seek immediate gratification or use crime as a hit-back mechanism. Nor did they find boundaries limiting these 'delinquent' activities to working-class American youth alone. Using evidence of similar behaviour patterns in other classes and cultures, Bloch & Niederhoffer (1958) push class factors aside and develop an argument promoting issues of age and masculinity instead. This is not to say these concerns have been totally ignored by the strain theorists. Miller (1958), in particular, highlights the centrality of masculine values within the subculture. However, he diffuses the potential power of his explanation by placing this observation underneath as opposed to alongside his class focus. Similarly, Cohen (1955) touches on gender issues, but he deems these to be significant within the middle classes alone. Both of these theorists came so close to developing a gendered reading of their subcultures, but they seemed to get ahead of themselves and miss the point. As I see it, the problem does not lie in where masculinity is more of an issue, but rather why it is an issue at all. These subcultures/gangs are all male dominated and yet no one picked up on this and scrutinized it.

Unsurprisingly, the anomie/strain theories were eventually rejected for being overly mechanistic and simplistic. As Downes & Rock (1982) have suggested, anomie is presumably more intense for those who fail having once succeeded, than for those who have never achieved. As such, there is no reason why anomie should be restricted to the working classes alone. Functionalist notions of normlessness and universal goals have also been challenged (Downes & Rock, 1982; Heidensohn, 1989; Hirschi, 1969), alongside their depictions of societal consensus. Because their world is perceived ahistorically, in terms of conformity and nonconformity, evidence of class conflict or struggle is

obscured (Cohen, 1987; Downes & Rock, 1982). This reduces the actors to nothing more than the passive recipients of an unquestioned system of rules and values.

The Marxist New Wave approach – work by the CCCS group

In reaction to the Functionalists' stance, the British New Wave Subcultural Theory surfaced in the text *Resistance through Rituals* (Hall & Jefferson, 1976) with a portrayal of 'man' fighting back. This work draws on Marxist understandings of social relations which sees society divided in terms of power and control of forces of production. The relationship between the major social groups is defined as exploitative, oppressive and ultimately conflictual, since the dominant social faction gains at the expense of the subordinate. Accordingly, this theory offers a political interpretation of subcultural activity; its response to a powerful movement in the 1960s which sought to suggest that generational differences were the most significant divisions in society.

As in the strain theory, class occupies a central analytic position here. Consensus, however, makes a hasty exit and conflict takes its place. Functionalist conceptions of 'reaction' are replaced with Marxist depictions of 'action' and their actors transform accordingly. Unlike the Functionalists' 'helpless toy figures' (Heidensohn, 1989: 53), Marxists' subcultural members emerge as working-class rebels. Their mission (albeit unconscious)? – to resist the dominant framework imposed upon them. And their weapons in this struggle? – their subcultural styles. By adopting a distinctive appearance/activity, members oppose 'dominant culture's' norms and values and win, through this, space for their own and their parent culture's meanings and practices. In theory, the subculture is their way of resolving the contradictions of their subordinate class position. In reality, it resolves nothing. This response is a futile, or as Clarke et al. (1976) term it, 'magical' or 'imaginary' one because these contradictions and problems continue to exist at a concrete, material level. This is why members' efforts are deemed to be a 'resistance through ritual' as opposed to reality.

Principles in practice

Jefferson (1976) puts these theoretical principles into practice in his analysis of British working-class teddy boys. Their style he interprets as their 'attempt to buy status (since the clothes chosen were originally worn by upper class dandies)' (Jefferson, 1976: 85). Their territorial

read as their way of maintaining the rapidly declining, ____ditions of their working-class background. Immigrant __ups, perceived to be the reason for change within their communities, become the targets for their frustration.

Clarke (1976) views the territoriality and manual worker style of the skinheads in a similar way – as their attempt to recapture a sense of working-class ethos: 'We would argue that the skinhead style represents an attempt to re-create through the "mob" the traditional working class community, as a substitute for the *real* decline of the latter' (Clarke, 1976: 99, italics in original). The skinheads display their resistance, like the teds, through their exacerbation of an 'us and them' scenario. However, they differ by embracing their parent culture traditions. Unlike the upwardly mobile style of the teds, skinheads adopt a traditionally working-class style of dress and masculine behaviour.

Already, two blind spots emerge. First, there is no explanation given for these different subcultural responses. Why did the skinheads not elect the upwardly mobile stylistic solution adopted by the teds or the mods? Why does the parent working-class culture spawn a multitude of different subcultural styles, some which compete or even war with each other? (Davies 1976, as cited by Smith, 1981). Reasons why different groups in the same structural situation vary in the solutions they adopt, or indeed the problems they choose to resolve, are not provided. Second, Marxist theorists reference the past in order to decode elements of the subcultural present. Subcultural members, we are told, use their styles to lament and in some cases recreate the eroded solidarity of their working-class traditions and communities. The problem here is did these 'communities' ever *really* exist? Many theorists would now challenge these contentions by highlighting this 'community' as imaginary, a romanticized recollection of a past that never really occurred.

Class vs age

Although these 'resistant' styles and behaviours are expressed through the agency of youth, they are said to represent 'class' rather than age-related responses. Within a Marxist framework, 'youth culture' is firmly reconnected to its working-class roots: 'The political analysis of youth culture must focus on the culture's "working classness" rather than on its youthfulness' (Corrigan & Frith, 1976: 236). Subcultures are viewed first and foremost as class configurations. 'Youth culture', as a term used to conceptualize the experiences of this age group, is challenged for obscuring the structural and historical bases of these groups and sustaining 'certain ideological interpretations – e.g. that age and gener-

ation mattered most, or that youth culture was "incipiently classless" –
even that "youth" had itself become a class' (Clarke et al., 1976: 15).

The debate between those promoting 'age' or 'class' in their theoret-
ical analyses has been long running. Eisenstadt (1956), among others,
takes age and age divisions to be 'the most basic and crucial aspects of
human life and determinants of human destiny' (Eisenstadt, 1956: 21).
Theorists, such as Allen (1968), respond by problematizing such argu-
ments. Her main point: yes, youth are powerless, but they are not the
only ones. As she suggests, age alone cannot account for society's gen-
erational conflicts or divisions because many of these are structurally
generated. The CCCS group have built upon the foundations laid by
Allen (1968) and must be commended for reintroducing this complex
political dialect between youth and their class position. However, Allen
(1968: 319) seems to be able call up this relationship without denying
youth certain shared difficulties: 'Young people in industrial societies
share in a common experience of being non-adult and are excluded
from full participation in adult society.'

The CCCS make no such concessions. Responding to the lack of class
analysis within 'youth theories', they try to strike some sort of balance
by tipping the scales the other way. Class alone is examined to the
detriment of any alternative explanation. The significance of age is, as
Marsland (1993) suggests, pushed dogmatically to one side: 'Marxist
analysis tends to derogate other differentiating variables aside from
class to a position so secondary as to approach invisibility' (Marsland,
1993: 215). Their approach cannot be justified here because its
faults are the very ones it attributes to the youth theories – under-
representation. Adolescence is an undeniably prominent feature of
these subcultural groups, yet it is flatly ignored. The CCCS defend
this bias by relegating youth-based accounts to psychological and
biological determinism:

> A focus on the youthfulness of youth culture means a focus on the
> psychological characteristics of young people – their adolescence,
> budding sexuality, individual uncertainties, and so on – at the
> expense of the social characteristics, their situation in the structure
> of the social relations of capitalism.
>
> (Corrigan & Frith, 1976: 236)

But does it? Youth theorists do not just promote psychological and bio-
logical consideration. They ask us in addition to consider the societal

positioning of this group. Although 'youth culture' is seen to be global in scale, at no point do these theorists deny that

> Of course youth culture is part of societal culture as a whole. Of course it is itself internally differentiated into a wide range of distinctive sub-cultures of youth. Of course what it represents above all – in its singularity and in its differentiated forms – is rebellion and resistance.
>
> (Marsland, 1980: 42)

The Marxists occupy a strong position in this debate, but they undermine it by refusing to listen to what others have to say. It is as if they have put their hands to their ears to drown out voices that do not necessarily want to argue with them. As a result, they come across as defensive, as if they cannot afford to entertain such a dialogue. Why might this be?

Theoretical foundations

Marxist theory rests on the centrality of class relations. As such, it maintains a vested interest in perceiving phenomena, such as youth groups or subcultures, in these terms. Class factors must be weaved in to ensure Marxist theory is sustained. This may be so, but surely this theory must legitimate itself through the development and assessment its own and others' ideals? The *Resistance through Rituals* thesis (Hall & Jefferson, 1976) does not do this (Marsland, 1980). An analysis, outline or even nod to other standpoints is notably absent, identifying a bias and indicating the unlikelihood that 'there was even the slightest possibility that their work might have led them – whatever the logic or evidence – to believe that youth culture could be a valid and important concept' (Marsland, 1980: 40). Marxists remain destined to confirm their own propositions. Not just because they foreclose the possibility of others by ignoring them. But because they enter the field already armed with the theories they seek to support (Davis, 1990; Downes & Rock, 1982; Smith, 1981). On all counts, falsification remains improbable. This calls into question the robustness of their entire theory. And it calls us to question their methodology. How tenable are their representations, given their approach and methods?

An obvious place to start when surveying Marxist methodology is semiotics. This is an epistemologically sophisticated method which involves examining relations between signs and symbols for the

meanings they make. It is a natural choice for Marxist subcultural theorists because a great deal of their work looks at the ways members 'steal', 'appropriate' (Hebdige 1979), reassemble and redefine symbols and objects of the 'everyday world'. Semiotics gives these theorists the tools to unpack the meanings assigned to these objects; 'meanings which express, in code, a form of resistance' (Hebdige, 1979: 18). What it does not give them, however, is a handbook on how to do this. There is no absolute reading of these texts, no special combination which helps theorists 'crack their code'. The interpretational options are endless and limited only by the boundaries of the theorist's own imagination. This generates two fundamental problems. One, 'we are left with the perennial sociological question of how to know whether one set of symbolic interpretation is better than another' (Cohen, 1987: xv). Two, the analyst must decide whether 'it is appropriate to invoke the notion of symbolism *at all*' (Cohen, 1987: xv, italics in original).

A simple solution to these uncertainties might be to consult the sign/symbol carriers themselves. Ask subcultural members about the ideas and intentions behind their stylistic creations, thus complementing this external reading with an insider's angle of insight. Apparently the CCCS group see no value in this empirical option (Cohen, 1987; Davis, 1990; Downes & Rock, 1982; Griffin, 1993). The voices, meanings and insights of the members themselves rarely make themselves heard in CCCS accounts. These theorists clearly prefer to develop their analyses in isolation from those they theorize about (Widdicombe & Wooffitt, 1995), reducing them, in the process, to nothing more than a speaking object.

This mute insider may not be an unintended side effect. After all, Marxists occupy a precarious theoretical position here. Coming to the field with their theory already predetermined means only one of two possibilities; insiders' input will either support it or shatter it. It is a gamble. By keeping subcultural members quiet, this gamble is avoided. And by declaring them ignorant, this tactic is justified:

> Unless one is prepared to use some essentialist paradigm of the working class as the inexorable bearers of an absolute transhistorical Truth, then one should not expect the subcultural response to be either unfailingly correct about real relations under capitalism, or even *necessarily* in touch, in any immediate sense, with its material position in the capitalist system.
>
> (Hebdige, 1979: 80–1, italics in original)

Working-class adolescents (the bulk of subcultural members), are said to be 'the least articulate about their relationship to the world' (Brake, 1985: 54). Why? Because 'they are enmeshed in institutions which explicitly devalue and disguise the centrality of class inequalities, and offer an alternative conception which emphasises the importance of age differences' (Murdock & McCron, 1976: 202). Thus, in regard to motive and meaning, these are the last people to ask. Their 'real' circumstances are obscured which will apparently confuse them into explaining their actions in age, as opposed to class terms.

When the going gets tough, Marxists do not waste any time in wheeling out this concept of 'false consciousness' as it is aptly termed. This is a useful tool because, as evidenced above, it can explain theoretical dispute and doubt cleanly away (Hammersley, 1992). Any beliefs that conflict with Marxist thinking are simply put down to a false understanding of one's situation and interests (Hammersley, 1992). This is all well and good but, by the CCCS's own admission, I see no reason to, as yet, assume this ignorance: 'We cannot take it for granted that class constitutes a central category in people's everyday vocabulary. On the contrary, how far this is the case is a matter for empirical investigation' (Murdock & McCron, 1976: 201). If we cannot take it for granted that people do understand class and its associated issues, then we cannot take it for granted that they do not either. Murdoch & McCron (1976) appear to concede this. But, having just stated the need to verify it through research, they backtrack and assert: 'We need in fact to restore the category of "false consciousness" to the centre of analysis' (Murdock & McCron, 1976: 201). False consciousness is prematurely encouraged in an effort to be safe rather than sorry?

However one looks at it, the CCCS group shoot themselves in the foot through their use of this concept. Members of subcultures are not brainless. They are involved, by Marxists' own admission, in a highly complex practice of symbolic meaning making. Surely, their 'symbolic language implies a knowing subject, one at least dimly aware of what the symbols are supposed to mean' (Cohen, 1987: xiv). Similarly, many subcultures involve their members in risky, dangerous or violent activities. With such high stakes in personal safety, I defy anyone to presume insiders lack rational reasons or concrete rewards for their actions. In both cases, the same question applies; if subcultural solutions are 'magical', 'imaginary' and its 'secret meanings' so secret that even their authors are unaware of them, how can the subculture realistically work to resolve class contradictions? The theoretical proposi-

tions that 'false consciousness' is used to strengthen are paradoxiᵢ
weakened, because if problems are real then a symbolic, unconscioᵥ
or unrecognized response does not really constitute an adequate
answer. This has been acknowledged, but it does not account for why
many of these styles are short-lived – the problems persist, yet
members' unconscious, and indeed diverse, subcultural responses to
them do not. As Stan Cohen (1987: xv) declares, expressing my senti-
ments exactly: 'My feeling is that the symbolic baggage the kids are
being asked to carry is just too heavy, that the interrogations are just a
little forced.'

Nowhere is this more clear than below. As we can see, inconsistent
packages come with elaborate explanations included:

- Punks wear swastikas not because they are racist, but because they
 are not (Hebdige, 1979).
- Working-class youth attack other working-class community mem-
 bers because they misrecognize their oppressors (Clarke, 1976).
- And below, class resentment or an adolescent's quest for indepen-
 dence and control?

> They're able to punish us. They're bigger than us, they stand for a
> bigger establishment than we do, like, we're just little and they
> stand for bigger things, and you try to get your own back. It's, uh,
> resenting authority I suppose.
>> (Pupil's comment on teachers, quoted by Willis, 1977: 11)

As Marsland states (1980: 42–3), and I would be inclined to agree with
him:

> They provide no persuasive arguments at all for believing that the
> behaviour of young people expressed through the youth culture is
> usefully or even plausibly interpreted as class action, or that it is
> directed towards liberation from (or mitigation of) class control,
> rather than towards escape from adult control as such.

The CCCS decode all aspects of subcultural style and behaviour in
terms of class resistance and this, in many ways, is their downfall.
Rather than admit instances, like those above, where this reading may
be implausible or irrelevant, they soldier on, making interpretational
sidesteps and asking us to make huge leaps in imagination. The result
is a theory which is far from robust and a reader who is far from

tendency to limit their analyses to those groups that
/confirm their thesis, that is, the non-conformist
nstalls the same sense of theoretical doubt (Cohen,
...ample, in his study *Learning to Labour* (1977), Willis pro-
vides us with a vividly detailed portrait of the working-class 'lads', but
he devotes minimal attention to the conformist 'ear'oles' and offers us
no account of the middle-class student's reactions to the imposed
regime of school life. Similarly, Hebdige (1997) upholds the symbolic
and physical violence of 'working class, disaffected, inner city, unem-
ployed adolescents' as evidence of their ability to pose a threat. They
play 'with the only power at their disposal – the power to discomfit'
(Hebdige, 1997: 402). But what, then, are middle-class, rural/suburban,
or employed adolescents communicating through their use of similar
displays? This is not considered. In Marxist theory, the middle and
working classes are divided into mutually exclusive categories. Middle-
class defiance is said to take place within the 'counter-culture' (Clarke
et al., 1976), while working-class 'resistance' is positioned within the
'subculture'. What this absolute, black and white Marxist division
misses is the possibility of a grey area. Namely, a group or subculture
that incorporates a mix of classes. There is no definition set aside for
this variety of subculture, and the quote following perhaps indicates
why: 'Any political judgement of youth culture must be based on treat-
ing it first as a *working class* culture' (Corrigan & Frith, 1976: 238, italics
in original).

This comment is illuminating. For a political judgement to be made,
indeed to sustain their entire thesis, sub- or youth cultures have to be
working-class configurations. But are they? As my research of the
graffiti subculture will show, this is a misconception; a hardy and per-
vasive stereotype which works to salvage and enhance theoretical
clarity.

Missing links

The CCCS group must be credited for challenging and infusing politi-
cal consideration into a portrait of youth formerly based on age factors
alone. By highlighting the structural influences that differentiate those
within its boundaries, the concept of 'youth culture' has been success-
fully politicized. A commendable achievement indeed. However, this is
still no reason for them to lay sole claims on 'truth'. The CCCS raised
some very important concerns, but they have not yet justified a com-
plete rejection of other mediating factors. The same applies to the

youth theorists. They maintained a firm position in the face of attack and have been equally reluctant to take alternative influences into serious consideration. The fervour of this debate locked each side into their respective theoretical corners, and this prevented both of them from fully exploring the complex dimensions of their subjects. As the battle between age and class raged on, the dynamics of gender, sexuality and 'race' were all but ignored (Griffin, 1993).

Where's the gender?

The following discussion will focus on the issue of gender. While 'race' is an obviously important concern, it is not as glaring as a subcultural feature, and in the case of the graffiti, it is not as relevant (despite the pervasive 'ghetto art'/minority stereotype often attached to this activity).

The masculine heavy membership of most subcultures is not an easy feature to miss. Yet McRobbie & Garber (1976), two female members of the CCCS, were the only theorists to really pick up on and develop it. Adding a sexual dimension to their work, they argue that girls negotiate a different space from boys, one indicating their limited need for the subculture's single sex group solidarity. McRobbie & Garber's male colleagues failed to make this distinction. Presenting their subcultures as 'typical' solutions employed by working-class 'youth', they missed the fact that these groups are more accurately 'male' responses. This oversight firstly weakens the validity of their resistance thesis, as girls presumably experience these class contradictions as well. Secondly, it urgently calls for an address of why boys use the subculture rather than girls. What do boys get out of it that girls do not?

Brake (1985) does not give us fully developed answers to these questions, but he makes a good start by at least recognizing the subculture's 'maleness': If subcultures are solutions to collectively experienced problems, then traditionally these have been the problems experienced by young men (Brake, 1985: 163). Although he places an exclusive spotlight on the working classes, again assumed to be the only individuals involved in subcultures, he does widen the CCCS's theoretical focus by considering issues of masculinity and identity. Granted, he does not cover all the angles: 'Brake consistently makes heroic presumptions about "masculinity". *Why* does it require support? And why subcultural support? . . . As always with subcultures, the "answers" are circular' (Heidensohn, 1989: 55, italics in original). But he does at least address this age/gender gap (Heidensohn, 1989; Hudson, 1988) and start the ball rolling for future research.

Sadly, subsequent theorists never really took it on and ran with it. In many ways masculinity missed the boat, as a well-founded reaction to the white, heterosexual, male 'gang of lads' model of early subcultural theories (Griffin, 1993) shifted theorists' attention away from the boys to the girls; a previously neglected area of youth research. While I am certainly not questioning our need to move on and develop this obviously important line of inquiry, as McRobbie (1980: 37) warns: 'The danger of this course is that the opportunity may be missed of grappling with questions which, examined from a feminist perspective, can increase our understanding of masculinity, male culture and sexuality.' McRobbie suggests we stick with these 'male' subcultural groups and recognize them as such. That is, peel back their androcentric gloss and problematize their masculine component. But, then, why stop here? Yes, these groups are male dominated and patriarchal, but the question why has, again, been bypassed. Why do young men gravitate to these confines? What male demands are met by this subcultural response? Questions like these are hardly ever raised or tackled, and they need to be.

There is one text which begins to take us in this direction – *Masculinities and Crime* (1993) by Messerschmidt. Although this work does not focus on subcultures specifically, it is still analytically relevant as many subcultural activities, including graffiti, are officially illegal. Messerschmidt starts by recognizing that crime is overwhelmingly committed by men. Indeed, his whole theory is born out of this observation. He explains the connection by upholding crime as a resource for making gender, specifically, a strategy for masculinity. Rejecting the simplistic and overgeneralized notions of the sex role theory, Messerschmidt examines masculinity and crime as plural and constructed concepts. That is, as a variety of different masculine expressions which are created through a variety of different crimes. The particular type of crime, or the fact that it is committed at all, is examined with close regard to issues of social constraint and power. As some groups do not have access to the legitimate gender resources available to others, crime is seen to be a valid and attainable means of accomplishing a masculine identity. Messerschmidt recognizes 'youth' as one such group and relates the high percentage of crime committed by adolescents to their lack of power and access to conventional masculine resources. He also differentiates this group, fracturing it and the types of crimes committed on the basis of class and ethnic divisions. Again, however, one critically important mediating influence is overlooked: age. Messerschmidt cites crime as a masculine resource for

'youth', but he does not go on and outline the types of masculinities we see manifested at different stages of 'youth' or explore reasons for these biographical changes. Questions remain: Why do individuals at certain ages select one masculine identity or discourse over another? Why does an individual possibly replace or modify his masculine identity as he gets older? These age-related shifts direct our attention to the functions met by particular discourses at different points of an individual's biographical career.

Messerschmidt (1993) does a good job of showing us how masculinity takes on different pronunciations as it is spoken through different social groups. However, by attributing these distinctions to one's class, ethnicity, generation and the power and opportunities these categories afford, there are points at which his argument begins to sound a little overdeterministic. Men must accomplish their gender identities, so without the power to access conventional resources crime compensates as a valid substitute. Like the strain theory, frustration still apparently figures as blocked opportunities are encountered and compromises are made. In effect, reasons for crime have merely been changed from unattainable middle-class standards of success to unattainable middle-class standards of masculinity. What I think we need to ask before accepting this line of reasoning is first, do all social groups actually strive for these 'middle-class' masculine expressions? Messerschmidt seems to suggest that alternatives serve no purpose but that of compensation, that deviance, for want of a better word, is nothing more than a last-resort resource to accomplish a last-resort masculine identity. We should perhaps conclude by asking whether masculinities really reflect such clear-cut 'race' or class divides in the first place.

There has been a tendency in past subcultural research to push theories in mutually exclusive directions. Functionalist and Marxist analyses isolate class as their main theoretical factor and adolescent or youth theorists isolate age as theirs. Messerschmidt (1993) breaks out of this straitjacket of single variable concern and elucidates, though somewhat deterministically, the complex dialect between class, 'race', generation, gender and 'deviance'. Framing this in processes of masculine identity construction, he offers us an analytically rich starting point for our subcultural interrogations of gender. What he does not offer, however, is a sufficient exploration of the very specific and significant interplay that seems to exist between age, gender and subcultures. Aside from a

lack of social power, what else goes into making adolescence, masculinity and subcultural membership such an abiding relationship? This is one of the questions I will be addressing in my analysis of the graffiti subculture. Indeed, to ignore it, would, I think, prevent us from ever really understanding subcultures and the very 'real' and positive rewards they have to offer.

4

I Woz 'Ere: Tales from the Field

I can be my own worst enemy at times. I am immensely self-critical and have an amazing ability to unravel just about any achievement and represent it in my own head as a failing. Fieldwork is tough, but when you have tendencies like these it can become mildly tortuous. Nothing I did was ever right or good enough. I never tapped deep enough into the heart of this subculture. I never integrated myself enough. I never forged that all important gatekeeper relationship that every other ethnographer seems to treasure and depend on. For a lot of the time I felt like a failure, a sort of badly disguised pseudo-ethnographer. That is, until the day a friend of mine, fed up with my moaning, sat me down and forced me to answer an all-important question, 'Where was I getting all these standards to condemn myself?' 'From other studies and researchers I suppose.' 'And were these researchers all 23-year-old British women studying illegal subcultures comprised of seemingly invisible men who only manifest themselves as scribbled signatures?' 'No.' I had my answer. This was not failure, it was fieldwork – an experience as individual as the person who conducts it and the people who facilitate it. I could not judge myself using someone else's experiences, because that someone could have researched the same subculture, in the same locations, using the same approach, and never have experienced things in the quite the same way I did. By virtue of this, he/she would never have portrayed things in quite the same way I did. Here lies the reason for this chapter. By recounting my research experiences, I quietly account for the subcultural depiction that follows. That is, I accept the possible imprint my fieldwork left upon the look, sound, style and leaning of my analysis and I give my readers the background so they can make this link too. This way, I avoid presenting my work as if it were a window on the world, an 'immaculate perception' (van Maanen,

1988) or the only portrayal possible. It is not. Using this chapter as a backstage pass, I invite readers to go behind the scenes and meet the characters, issues, events and conditions that went into making this work distinctively mine.

The field(s)

I conducted this research in both London and New York. An ethnography usually focuses on a single local culture, so two research contexts did diversify things a little. Nevertheless, I decided that it was important to include New York in this study. It is, after all, the birthplace of the graffiti movement and an important 'scene' in that respect. It also gave me a useful measure of comparison. With two 'scenes', I could observe similarities and differences in subcultural dynamics. I was also able to observe this subculture's worldwide network in operation, that is, the affiliations between writers I had spoken to in both countries and their attitudes towards each other's scenes. Being older, larger and, in many ways, more competitive, New York also provided me with a healthy range of willing informants. There were younger writers, anxious for fame and anxious to talk, and more experienced writers anxious to write off anything or anyone who threatened to overshadow them. There were also the authors of the book *Subway Art* (Cooper & Chalfant, 1984), who being 'experts' gave me a great opportunity to discuss my theoretical ideas. Most importantly, though, New York enabled me to meet some of the writers responsible for the birth of this entire worldwide movement. Many of them have featured in gallery shows, books and films about graffiti and are now making a living from it. They were able to reflect on their career transitions and some of the reasons why they initially got involved – invaluable insights indeed.

The eight weeks of research I conducted in New York were important, but the bulk of my fieldwork took place in London. This gave me a more detailed understanding of this 'scene's' issues and dynamics. For this reason, my American fieldwork complements my focus on the London graffiti 'scene'.

Informants

I conducted a total of 37 informal interviews over a period of two and a half years. Informants consisted of 29 writers, one English youth worker, the two authors of *Subway Art* (Cooper & Chalfant, 1984), three film documentors and two members of the British Transport

Police – one involved in security and the other the former head of the London Graffiti Squad. The writers were a varied group. The majority were male, but I did speak to three women. Thirteen of the writers were London based and the other 16 were from New York. They ranged from 13 to 40 years old, and in respect to graffiti, were either fully legal, illegal or involved in both types of activity. This diversity provided a form of theoretical sampling (Lincoln & Guba, 1985), and allowed me to make comparisons between these writers and their different attitudes, beliefs, goals and realities. I met a large number of other writers over the course of my fieldwork, but most interaction was brief so I did not count them as official informants.

Methods, means and madness

I used a range of data sources and methods in this research. Secondary sources, such as newspaper articles, graffiti magazines and newsletters, books, police reports, the Internet and graffiti itself, provided me with important information. However, my core research methods were in-depth interviewing and participant observation.

When I first started my fieldwork I knew no one. Additionally, there was no place where I could go to meet, talk and get to know writers. In many ways, I was a fieldworker without a field to work in! This meant I had to do a lot of work behind the scenes, unearthing possible contacts and calling people by phone. Clearly, interviews were the most practical place to start. Asking a complete stranger over the phone if I could join them on their next trip to a train yard would not have been a sensible move. When you research an illegal subculture you have to remain very aware of yourself, especially when you first arrive. A wrong tweak in self-presentation can cost you someone's confidence and co-operation. I had to ease my way in gently and slowly build up trust. Contacting writers by phone helped in this respect because it indicated that someone else had trusted me enough to give me their number. As I soon discovered, this subculture is all about recommendations.

Once I had met writers and spent some time with them, opportunities for participant observation began to arise. My experiences as an observer were diverse. They ranged from highly active, adrenalin-fuelled encounters like going to train yards to paint or exploring the graffiti-filled tunnels under New York City, to more casual episodes like hanging out and socializing with writers at their homes or at organized graffiti shows and events. Wandering alone, reading the walls, keeping an eye on new names and relationships, just being out there on the

streets where it was all happening took up a lot of my time as well. It was not all high-tension stuff, but it all, in some way or another, embedded me in the world I strove to understand. This enriched my knowledge and understanding, but it also added dimension and texture to the material I gathered. The information I obtained from interviews and observational situations differed. My interviews were more suited to getting writers to talk in depth and detail about things that were not directly related to the act of painting. In contrast, participant observation allowed me to examine concerns specific to that moment: behaviour, dress, procedure and atmosphere. These details were harder to access in interviews, but they were not the only thing missing. The most important thing I got from participant observation was a different angle on things. For example, hanging out with writers in social situations, I soon realized that the conversation never strayed far from graffiti (if at all!). This led to a very important insight; graffiti was not just a pastime, their lives literally revolved around it. I could never have known this from meeting writers in interviews alone. The problem with a situation set up to talk specifically about graffiti is you lose sight of its naturally occurring relevance in the everyday world.

A process of adaptation

When you position yourself in other people's life-worlds you have to be able to adapt to meet the demands of the situations and personalities you encounter. Sensitivity and flexibility are foremost concerns, which is one of the reasons why ethnographers use participant observation and in-depth interviewing as their main research tools. Both of these methods, as I found out, bend in response to subtle social undercurrents. In my interviews, I could relate to informants as I spoke to them and tackle unforeseen problems as they arose. I could also play down signs of formality, something which could have threatened the free flow of conversation, especially when talking to writers about their illegal activities. As an observer, I was also able to orientate my role or involvement to suit the situation I was in and the people I was with. In some instances, I had to play down my presence and take a back-seat position. In others, I could openly talk to writers about what they were doing and maybe even participate myself.

Digging deeper

As my research progressed, the way I used my methods changed. Initially, I clung to a fairly rigid format of predetermined questions. I ploughed through these in my first couple of interviews like a bull

in a china shop. My lack of confidence abolished any sense of intuition or sensitivity and sent me crashing around over some very delicate dynamics of interaction. This subculture is all about power, of any form. As I calmed down and found my feet, I grew more aware of this and started to give writers greater input and control over our discussions. Effectively, this put them in a position of authority and made our meetings more like 'transactions between cultural teacher and ignorant but eager pupil' (Rabinow, 1977, as cited by Cohen, 1984: 226).

As I let go of some of my own control, I began to learn more. As Cohen, (1984: 225, italics in original) explains:

> We have to navigate the river in order to discover its interesting features. Were we simply to pursue a schedule of our own devising we should then merely be displaying the contrivances of our *own* minds, rather than discovering the minds of those we want to study.

With writers' guidance, new areas that would have stayed concealed started to emerge. Changes also occurred in my understanding. Old concepts were not necessarily replaced by new, but their focus sharpened, their detail enhanced and they started to take on more elaborate dimensions. Basically a clearer picture developed and the subculture became more personalized. I became aware of different writers, their reputations, attitudes, affiliations, frictions, and the various events that had taken place before I arrived. It felt like I was descending into deeper levels of the subculture's make-up.

Unsurprisingly, writers do not expect outsiders to know a great deal about what they do and why. Although I could demonstrate I knew more than most, I was still in their eyes an outsider and therefore ignorant. To get the best out of my interviews, I had to change this perception. I had to deepen the level of discussion and indicate I could manage more 'local' forms of information. Secondary sources came to my rescue here. There are a number of graffiti websites and magazines that target writers as their core audience. As such, they reflect a very advanced frame of reference. I took these to represent 'local discourse' (Cohen, 1984) and tuned in to familiarize myself with 'insider' issues and debates. Armed with these as interview prompts, I was able to demonstrate how much I knew and locate the interview at a suitable level of depth and complexity. This practice also helped to dimensionalize this subculture. While these media portray 'insider' concerns, the

practices, beliefs and attitudes they express are not shared by all. Writers differ in their views and standpoints, and by introducing these interview prompts, I could see how.

Staying in the picture

These 'insider' media served another, perhaps more essential, purpose; they kept me informed. The grapevine does not always reach you when you are an outsider in an illegal subculture. Unsurprising really. A group of people who live in fear of arrest are hardly going to want to share their deepest darkest secrets with someone they barely know. I knew that gaining writers' confidence was going to be tricky, especially given the timing of my first year of fieldwork: 1992 represented a year of paranoia. A clampdown by the Graffiti Squad and British Transport Police had sent the London graffiti scene into a state of panic. Many writers adopted low profiles, communication declined and as this writer recalls: 'Secrecy hit an all time high and shit went underground. This was due to increasing grass rumours and the shock Christmas crackdown mounted by the Graffiti Squad' (*Londonz Burning* Magazine 2).

As a researcher, I felt the effects of their fear. At one point, I may have even been responsible for it. This was one of the most uncomfortable and anxiety-ridden moments in my fieldwork. I had been speaking to a number of older, more legally oriented writers and I decided it was time to talk to someone younger, someone still 100 per cent devoted to illegal graffiti. An obvious name sprang to mind: 'Rate'. This individual was notorious. Despite having served an 18-month custodial sentence for graffiti, he was undeterred. I knew he could impart a fascinating angle on things, but I could not reach him. Every writer I asked seemed unwilling to put us in touch. Like gatekeepers, I assume they were protecting Rate from the possible threat I represented as an outsider. I pushed and pushed, but to no avail.

By incredible coincidence I ended up stumbling across him without their help. Passing the pub next to my house, I noticed a menu stuck to the window. It caught my eye because it was written in a very distinctive graffiti style. I went in and enquired and a man told me, with a certain degree of pride in his voice, that his son had written it, and, 'yes, he is a very well known graffiti writer that goes by the name of Rate'. I was jubilant. I left my number and Rate contacted me and agreed to meet me for an interview. We arranged a time and place, but he never showed up or called to explain why. I saw his father a week or so later and he told me that on the day of my scheduled interview, the Transport Police had raided their flat and arrested Rate for the paint,

photos and other incriminating evidence they had found. This was inconvenient, but it was also very unnerving. I could not be sure of the connection, but after Rate was arrested and subsequently imprisoned, my progress declined. Two writers I had contacted through a friend refused to commit to an interview. Their initial agreement turned, in my eyes, into excuses and avoidance. Another group of writers I met by chance at a graffiti site, also appeared to be unnerved by my presence and interest. They were clear about not wanting to talk to me. I began to wonder whether my arrangement to meet Rate on the day of his arrest had any bearing on this. Perhaps they now had me down as an undercover member of the British Transport Police. After all, Rate's flat was raided on the very day of our interview, a day he could have quite plausibly unearthed all his hidden photos and sketchbooks to show me.

Things did eventually pick up. Maybe this event was forgotten. Maybe I was being overly paranoid about the part I played in it all. Whatever the reason, when times got tough like this and writers went underground, I could always turn to their magazines, websites and even walls to keep me at least partially abreast of what was going on. These secondary sources were an invaluable support.

Juggling voices

Discovering that this subculture was angled by different people with different visions and opinions was refreshing, but it did put me in a dilemma: how was I going to access all these different voices? I was lucky to find anyone willing to talk to me and relied heavily on a process I termed 'successive access'; that is, writers I spoke to would put forward other writers as contacts. This approach was practical but also problematic, because it meant that my leads were typically close friends who shared the former writer's sentiments and perhaps supported their 'stage-managed' commentaries (Berreman, 1962, as cited by Goward, 1984). So while 'successive access' did a good job of highlighting the connections between writers, it did block avenues to other cleavages of the subculture. In turn, this blocked my ability to obtain the 'other side of the story' and examine the degree of fit among writers' divergent accounts and positions (Glaser & Strauss, 1967). It was time to pull out all the stops. I had to find other writers to talk to, which meant I had to call on some pretty desperate last-resort measures. Among these were: hanging out alone at graffiti sites enticing writers to trust me and give me three hours of their time; calling that friend of a friend of a friend who apparently once knew a writer; tracking down writers through graffiti style signs; and even placing an ad in my university magazine.

Not all of these measures worked, but I did somehow manage to scrabble together a pretty good collection of new contacts.

For me, one of the hardest things about fieldwork is negotiating the diversity of people, personalities and perspectives you meet. You have to be all things to all people, which is especially hard in a fractious environment where you are tested and judged by your loyalty and allegiance. It is very difficult to explain to an informant who you have developed a relationship with that, while you appreciate his/her standpoint, you need to speak to his/her arch-enemy and get the other side of the story. Explanations of 'theoretical sampling' and 'multiple voice representation' do not quite cut it! In their world and through their eyes this is an act of disloyalty and a blatant lack of respect for their views.

When I first met writers they would always ask me who else I had spoken to. It was a practice they used to size me up or gauge my subcultural experience and education. In the early days of my fieldwork, I would innocently reel off my list of names, unaware that they were actually saying more about me than them. As my understanding of the respective 'scene', its inhabitants and their relationships increased, I realized how important these names were. While some could elicit trust, others could shatter it and sever any further contact. The simple remedy to this lay in avoiding the mention of certain names. But I did not want to do this, because it meant I would have gained trust but sacrificed a retaliation of opposing views and claims. My other option would have been to adopt an 'ally' persona, openly condemning certain people, views or activities to provide my informant with the confidence to do likewise. For a fieldworker pushed up against the wall, this is often a necessary measure: 'The fieldworker is often forced to take one position, or at least to sympathise with a particular point of view, simply in order to elicit information from anyone' (Goward, 1984: 111).

In my case, the benefits of this practice would never have outweighed its inherent costs. I was researching an illegal subculture where trust is tentative at the best of times. If my 'backbiting' had been exposed, I would have looked two-faced, muddying the neutral, trustworthy persona I was trying to promote. I would have also alienated my former contacts and lost writers' respect generally by my pathetic attempts to ingratiate myself. One thing I learned about this subculture is the importance of being genuine, being yourself, being 'true' to your convictions. Writers are well versed in picking apart faulty or flimsy scripts and anyone found to be 'fronting', as they term it, risks disrespect.

Unable to play the 'ally' or be blatant about my past dealings left me with one other option – my ignorance. By adopting the 'naive cloak' of an outsider, I could play the innocent. That is, interested, enthusiastic,

but totally clueless about the full extent and implications of their group politics and frictions. A slight tweak in my self-presentation and I could be open about who I had previously met and spoken to, without making them seem threatening. There were occasions when I enjoyed this charade. Every so often I would meet a writer who would treat me as if I was stupid, like I was wasting their time. One individual went as far as to charge me ten pounds for an interview, a gesture which indicated I did not deserve or literally had not 'earnt' his time and knowledge. We laugh about it now, and he insisted on repaying me after reading my thesis. But it was at times like these when I would fall back on my 'charade of ignorance' as a paltry source of power. I knew they had me wrong and this made me feel like I had the upper hand, that the joke was actually on them.

Journey's end

During the closing stages of my fieldwork I grew tired. Like Eberhart (1977, as cited by Hammersley & Atkinson, 1983), my discoveries declined and I became less inquisitive. I felt saturated and this started to affect the way I interacted with writers. Previously, they controlled the focus and direction of our interviews. This enhanced my learning, but it also proffered them a tutoring role and some degree of authority. By the end of my research, I knew too much and this reversed our roles. As opposed to listening and learning, I found myself interrupting and informing writers. It was definitely time to pack up!

I only realized how far I had come once I had actually finished. Things I had initially found strange, were now familiar, their significance lost. Before writing up, I knew I had to go through a process of estrangement. Somehow I had to stand back and recapture my initial sense of wonderment as a newcomer to the field. My fieldwork journals were helpful here; however, the greatest help came from interviewing two people with absolutely no apparent knowledge of this subculture. They took me back to where I had started. Like a ladder, their understanding (or lack of it) enabled me to climb back out of the subculture.

Unpacking my personal baggage

> In the field, one's basic humanity is emphasised and such essential traits as age, gender, temperament and ethnicity become, if anything, magnified.
>
> (Wax, 1979: 509)

Fieldwork is a delicate process. We arrive in another life-world with ambitions and goals and yet so many of our victories are dependent not on what we do, but who we are; our personality, appearance, age, sex, background, everything that goes into making us an individual. Looking at it in this way, it seems so hit and miss, so easy to get wrong. It is almost as if we have no control over the outcome. We can manage impressions, fine-tune our techniques and learn from our mistakes, but at the end of the day we are dealing with other people and they have the ultimate say. If they dislike or distrust you, game over, you are out.

Fortunately, my fieldwork did not end in this way. There were some things about me that worked to my benefit, others that did not. There were some things that brought me closer to my informants, others that distanced me. Indeed, some of the things I thought would hamper me, actually helped.

Making an impression

I do not come across as a shy person and for the most part I am not. But when I do not know someone very well I can sometimes appear awkward. Now this is something you cannot afford to be in an illegal subculture where people are suspicious of you to begin with. Worried that it might imply I had a hidden agenda, I hurriedly adopted a form of 'impression management'. Building on my 'naive' outsider persona, I tried to boost my confident, friendly side, and play down any signs of discomfort. Some writers showed an interest in my own background and I would always answer their questions to show I had nothing to hide. This exchange also let me give something back, making our interactions less one-sided and official.

Proximity – united by age

> Young people have certain distinct advantages and they can do certain kinds of research which are out of bounds for older persons.
>
> (Wax, 1979: 517)

Based on my research, I would be inclined to agree with this statement. I was 23 years old when I started my fieldwork and, as the saying goes, age was on my side. First of all, it set me apart from the older journalists, youth workers and other outsiders who have dabbled in this subculture and generated feelings of distrust. More interestingly, though, I think it helped me to overcome some of the negative effects of my role

as a researcher. Informants tend to place researchers in one of two camps; the 'critic' or the 'expert' (Hammersley & Atkinson, 1983). Without wanting to perpetrate any stereotypes, I did not look like your 'classic' expert. I was just out of college and was clearly too young to have developed an area of 'expertise'. In addition to this, I was, in writers' eyes, an 'ignorant' outsider which made my classification as an 'expert' even more unlikely. Since graffiti is illegal, perceptions of me as a 'critic' were much more probable – were it not for my age. I think being young helped me avoid this characterization. Keep in mind, I was around the same age as most of my informants which could have made us seem more like players on the same team. As Hammersley (1991) reports, Honigmann (1970), an older researcher, was not so fortunate. He found it hard to establish contact and trust with his younger, deviant informants who saw him as a disapproving figure of authority. Stereotypes come into play here, and, as Wax (1979: 517) observes, they tend to favour the young:

> In many societies being young and inexperienced can be an advantage because many people regard a young stranger as ignorant, helpless, and as standing in need of guidance. Like a child, the young person is relatively harmless and threatens no one.

Rather than a critic, like Honigmann (1970), I could become an unthreatening contemporary, even an ally perhaps.

Distance – divided by gender

I started my fieldwork fully expecting my gender to have a profound effect upon my dealings with the male members of this subculture. Looking back, there is no denying its significance. Because I could not disguise or modify this aspect of my identity, I stayed acutely aware of the varying dimensions of its influence.

First of all, I found it hard to sustain consistent contact with many writers. For a lot of my time in the field I felt estranged. Now this could have been an inevitable feature of my temporary and specific role as a researcher (Goward, 1984), but I felt our sex differences played a larger part. Informants will always try to 'place the fieldworker within their own framework of social statuses and values' (Goward, 1984: 112). As a woman, I had comparatively little place within this, which was not an insignificant concern: 'The contemporary ethnographer now increasingly experiences the requirement to reveal competence as a member of the society studied, or to suffer the social consequences' (Cohen, 1984: 228). While I could demonstrate competence in certain areas, I

lacked the ingredient which ultimately defines a member of this sub-culture – male status. This inevitably distanced me.

Most feminists conduct and legitimate their research on the basis of proximity, that is, the experiences and similarities they share with their informants. These 'are often used and discussed in research articles as a source of empathy for and a means of building rapport with partici-pants' (Bola, 1995: 293). With this goal in mind, some researchers have tried to match the sex of their research assistants with that of their informants (Diamond, 1970, as cited by Ardener, 1984). This measure seems to suggest that disparity degrades the quality and legitimacy of data. But then, data in themselves cannot be valid or invalid, what is at issue are the inferences we draw from them (Hammersley & Atkinson, 1983). This aside, does difference always work against a researcher? Must the legitimacy of our research depend upon this fit? On the basis of my experiences, I would be inclined to agree with Hammersley (1991: 80) who states: 'Some overemphasise the natural rapport among women and exaggerate the obstacles to rapport between women and men.' My gender created some restrictions, but it also afforded me some peculiar and highly valued advantages.

In the early stages of my research, a writer advised me to take what other writers told me with a pinch of salt. Because I was a woman, he predicted they would try to impress me with exaggerated accounts of their heroism – stuff straight out of a superhero comic book basically. Looking back, his warning was not really necessary. I was rarely fed tales of bloated bravado. If anything, my gender seemed to inspire the opposite effect. Writers earn respect for their artistic skills, as well as their masculine displays of daring and resilience. The need to prove themselves in the eyes of their audience, namely other men, is critical. As a woman, I did not represent an audience for this sort of 'manly' display. This was a blessing because it freed writers from their 'macho' shackles and allowed us to move on and explore other more sensitive areas of concern. My first meeting with Drax, a British writer, illus-trated this most clearly. Because of his notorious reputation as the 'hard man' of graffiti, I expected my interview with him to be dripping in tough man talk. I was wrong. Surprisingly, he was very open, volun-teering sensitive recollections of his father's death, the resulting void this created in his life and the way he used graffiti to fill this. As he told me, most writers use graffiti, in some way or another, to compen-sate for personal problems and insecurities in their lives.

Not all writers were as forward as Drax in offering me these personal details. While valuable, I was aware that bombarding them with a

battery of personal questions could cause alarm. I raised this with Drax, who confirmed I would need to tread carefully:

> Yeah, I think it would be too prying to ask a lot of people because they might not want to talk about it. I mean if somebody said the same to me I probably wouldn't discuss it because my back would go up . . . I think just slowly introduce the conversation and see what they say.

Drax was eager to help and decided that my best way round these difficulties would be to use his name – a gift indeed! By prefixing 'Drax said' before introducing any sensitive areas, I could indicate that these were his claims, rather than the predictable assumptions of a nosy researcher. I could also break down some of writers' barriers. Drax is a prominent and respected subcultural figure and hearing that he had opened up to me like this seemed to give other writers the confidence to do likewise. As a result, I obtained some moving accounts of writers' needs, problems and insecurities and the ways they use graffiti to solve or compensate for them.

In all honesty, I do not think a male researcher could have obtained this sort of material. Not because he is unable to appreciate it, but because writers would have probably reacted to him by upholding their masculine composure and disguising signs of vulnerability. This demonstrated the inherent benefits of my marginality. I could penetrate this private male domain, because as a woman, and, thus, true outsider, I represented a safe audience. Writers could let down their guard because there was no threat of judgement or risk of losing face.

This was not to say I had access to all areas. While I could invite certain admissions, there were others that stayed firmly hidden. For example, when I asked male writers about the potential benefits of a sexually mixed subculture, my question would usually be met by sniggers. They would avoid answering. Only one writer dared to state the obvious, claiming more female writers would give him a better chance of having sex! This view was presented in jest, but it was probably a common attitude – one which could not, it seems, be admitted in my presence. Again, I did not see this as a limitation. While a male researcher could, I admit, create a safer environment for these sexist remarks, I just had to read them differently by attending to the signs of embarrassment or discomfort that stemmed from my presence and questioning. If anything, I felt my distinction as a woman actually gave me a more focused appreciation of the masculine dynamic of this

subculture. What we must not forget as researchers is that 'Outlining the differences one has from the subject matter and participants can be as informative as the similarities that are seen to exist' (Bola, 1995: 293).

In conclusion, I conducted this research as a 'true' outsider. I was not a writer or a man and this kept me, for the large part, on the sub-cultural sidelines. This position had its drawbacks; it kept me from bonding with many writers and it sometimes made me feel out of touch. But it had its merits too, by allowing me to hide behind an apparition of innocence and inviting some unusually sensitive, private and analytically rich admissions. These aside, there is one more benefit I should mention, one which only became clear when this distance was breached. Relatively early on in my research I became quite good friends with one of my informants. We would speak often, go out and mix socially. I was thrilled. I had feared isolation, and here I was developing a key relationship with one of the first writers I had met. Things were working out great. Then we hit complications. To avoid unnecessary elaboration, he met and developed an attraction for a very good friend of mine; an attraction she did not share. His frustration started to affect our relationship as he began to use me a mediator to relay messages and gain information. This put me in a very awkward position – I did not want to give him false hope about my friend's intentions, but then I did not want to jeopardize my research either. I tried to avoid both outcomes for as long as possible, but my patience eventually wore thin, ending this moral dilemma, and our relationship with it. I refused to talk about her any longer and he refused to talk to me any longer. My fieldwork did not seem to be affected by this incident, so I am not relaying it just to warn other researchers about the practical dangers of getting too close. Rather, I include it along with these other merits because I think they teach us an important, but rarely expressed, lesson. Namely, that we should not always fear distance as a sign of ethnographic failure. In some cases, like this one, our research may actually be enhanced if we do not live in the pockets of those we ultimately depend on. Again, whether this is the case depends on the wholly unique and specific situation we find ourselves in.

5

Going Underground: A Journey into the Graffiti Subculture

Those new to graffiti probably know very little about its point and purpose. Graffiti writers are not particularly vocal about what they do, and the tabloid press, who comment more than most, rarely tell the whole story. This chapter will set the subcultural scene and try to fill in some of these knowledge gaps. Readers will take an informational journey through subcultural terrain and gain a basic, but detailed, overview of its nature and function; an understanding of what graffiti writers work to achieve and the different ways they realize these ambitions.

It may surprise readers to learn that a writer's experience of this subculture is a highly structured one. Most follow an established route or career path if you like. I have used the steps and stages of this 'career' to organize this chapter. This will, I hope, achieve two things. First, it should help to ease newcomers into this unfamiliar subculture. Rather than diving into the deep end, readers will immerse gradually, step by step. Second, and perhaps most importantly, it should inspire readers to challenge preconceptions they may have of this subculture as lawless and chaotic. As will become clear from following this career path, it is anything but.

All work and no play – graffiti as a career

As a way of describing deviant involvements, the 'career' concept has enjoyed wide analytic usage. Most notably, Becker (1963) used the notion of career to outline the sequential stages of drug use and highlight, through this, the arbitrary distinctions between deviance and respectability. Similarly, studies of gang members, drug traffickers and football hooligans have also employed this concept to illustrate the

regulated and disciplined nature of deviant behaviour (see for example Marsh et al., 1978; Parker, 1974; Virgil, 1988; Williams, 1989). Perhaps the most direct connection between deviant and legitimate careers is made by Letkemann (1973) in his text *Crime as Work*. While this concept is popular, its value is not seen by all. In her work on LA gangs, Phillips (1999) recognizes similarities between 'mainstream' and gang life, but she rejects 'work/career' analogies for clouding 'real' differences and blocking avenues to 'real' understanding. Best & Luckenbill (1981) go one step further and ask, are such analogies even relevant in the first place? Can deviant careers really be compared to legitimate careers? They identify some important distinctions and conclude:

> Deviant and respectable careers display very different characteristics. Deviant careers are less likely to develop within a well-defined organisational hierarchy and they are less likely to follow standard career paths leading upward. Reward and security are less likely to increase as the deviant career continues and career progression is less often public. Finally, deviant careers are more likely to feature multiple short-term involvements.
>
> (Best & Luckenbill, 1981: 200)

Best & Luckenbill are right to remind us of these potential differences, but deviant activities differ and their analogous features will vary accordingly. Obviously, the careers of a graffiti writer and a stockbroker are not identical, but there do appear to be enough parallels to warrant the use of this concept. In fact, many of the distinctions Best & Luckenbill identify are, in this case, dissolved. Standardized stages of activity define graffiti writers' developments and position them within a form of group hierarchy. Just like an employee in a large company, writers start their careers at the bottom rung of this ladder and, through hard work, try to move up. The higher they rise, the greater the apparent rewards. Similarities aside, some important differences do indeed separate them:

1. Writers are younger than most wage earners and their careers are considerably less enduring. As these British Transport Police figures confirm, the majority of 'active' writers fall within an adolescent age bracket:

 It can be seen quite conclusively that the ages 15 to 19 years are the ages that appear to be most at risk from the temptation of commit-

AGE OF THE WRITER, DROP OFF IN ADOLESCENTS

ting graffiti based offences. After the age of 19 years, the instances of persons being detected committing graffiti offences decreases dramatically.

(*British Transport Police Annual Report*, 1991)

2. Probably explaining this drop-off, writers' careers do not usually offer material gain:

You're not being financially rewarded, it's your own reward (Claw).

It's a non paying career, it's just something you dedicate yourself to (Sae 6).

There's no financial gain, I suppose getting the respect of total strangers is payment enough really (Mear).

This subculture translates financial reward into symbolic capital, namely fame, recognition or, as Mear puts it, 'the respect of total strangers'. Symbolic or not, this is a highly valued wage. These writers are just a few of the many who cited it as their primary incentive:

Jel I did it for the fame, that was basically it.
Sae 6 Same, yeah, that's the number one answer. It's the fact that just because of your name you get respect, you know.

Fame and respect, there's the two driving forces.

(Acrid)

The name pictured in Figure 5.1 says it all.

As writers earn fame and respect, their self-concepts begin to change. At the beginning, 'when you start off doing graffiti you're more or less like a nobody and you just work your way up to be someone' (Col). In this light, a writer's career might be better described as a 'moral career' (Goffman, 1968). Goffman describes this as 'the regular sequence of changes [. . .] in the person's self and in his framework of imagery for judging himself and others' (Goffman, 1968: 119). Drawing on Goffman's work, Harré (1993) presents the moral career as a life trajectory defined in terms of public esteem. As he asserts: 'The pursuit of reputation, in the eyes of others, is the overriding preoccupation of human life' (Harré, 1993: 32). Many people undertake a secondary career within confines specially designed and

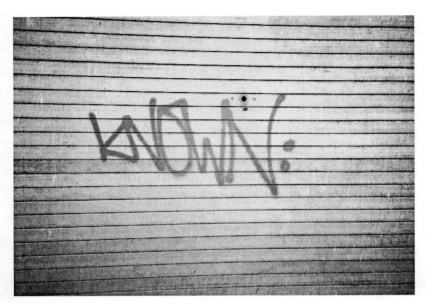

Figure 5.1 I am 'Known'

sustained to facilitate this goal (Harré, 1993). Marsh et al. (1978) present football hooliganism as a prime example of this. A 'hooligan' develops a career by proving himself in often 'organized' confrontations, earning the respect of his peers and elevating himself upon the group's status hierarchy. He becomes known across the country as the 'baddest', the 'hardest', the most dangerous to 'mess with', and his sense of self changes accordingly. If moral careers can be defined as 'available structures in a youth culture for the establishment of self' (Marsh et al., 1978: 64), then graffiti represents a moral career in its purest form. Gaining respect, fame and a strong self-concept is openly expressed as a writer's primary objective and the subculture is fully set up to support this goal.

The work metaphor writers use to describe their 'claim to fame' also corresponds with the analytic work model Harré (1993) uses to portray social behaviour as 'deliberate action directed towards certain ends' (Harré, 1993: 181). By this he means that just as individuals work to produce concrete and material things, so too do they work within the social realm to produce abstract or expressive products, such as respect and reputation (Harré, 1993). For Harré (1993), this work model is a convenient analogy. For writers, it is a meaningful way of life:

Graffiti takes a lot of work, you can't be half hearted about it . . . It's the work ethic.

(Claw)

If you get sucked into graffiti, it's like a job, it has to be successive for it to be successful. Like, if you really want a career in a business, you have to sort of get your head down and get into it and I think with graffiti, with the element of extremism and wanting to be the best and the most famous and all the rest of it, you get into it and it just takes on the same role as what a job would.

(Drax)

Writers face the same arduous climb up the career ladder as any individual who wants success. The only difference is they probably put in a lot more overtime. A graffiti career is no nine to five vocation:

You can do it 24 hours. Basically, your life can revolve around graffiti.

(Acrid)

It becomes like your lifestyle, you know what I mean, it's a full time thing.

(Sae 6)

Listening to these writers explain how they live out this demanding lifestyle is exhausting in itself:

When I was doing six or seven hours' work in an office, there'd be times when I'd do all three nights in a row. During my lunch hour I'd plan the pieces [large graffiti productions], finish work at six, go to the shops straight after work to steal my paint. . . . I'd have some dinner, leave my house at half ten, get to the train depot at 12am, go in at two, finish at four, won't get home 'til six or seven, then go to work. I did that for about three days in a row and, like, come Friday, I was asleep at work on my desk.

(Acrid)

When we were painting trains . . . you stay until the sun comes out, then you've got to climb back in the train, you're all dirty, it's early in the morning, you didn't get no sleep, all you do is go right back to the bench and wait for the trains to come by. See what I mean,

you're living this whole thing. You know, you go home, you finally get your pictures, What do you do? Go straight to a discount store, you go steal more paint and you go through the same thing the next night, you know.

(Sae 6)

A graffiti career offers no reprieve. When writers are not exerting themselves physically, they are probably exercising themselves mentally:

I do graffiti 24 hours a day. I go to school, I sit at my desk and I draw. I don't pay attention in class because I just can't. I write tags [signatures] in my books, like do throwups [larger signatures] on my school bag, I just do that and then fail everything, but you know!

(Col)

Graffiti pervades all their waking and, in Akit's case, also sleeping hours:

I just enjoy it, I love it, I dream about it. I wake up and I've got these letters in my head and colour schemes and I freak out when I see graffiti, it's just wicked. I'm totally obsessed with it, 24 hours a day, seven days a week, I swear it's on my mind all the time, all the time!

An interest in graffiti can dominate writers' lives and other concerns or activities may suffer as a result. Regardless, they remain committed. Graffiti offers them fame, respect and status – real and immediate rewards that play a centrally important social role (Harré, 1993), especially within the lives of young people (Eisenstadt, 1956; Coleman, 1961). Reflecting this, youth groups will 'usually evolve a status system of their own, which allocates prestige according to their own specific goals and value emphasis' (Eisenstadt, 1956: 98). This is exactly what we see here. The graffiti subculture has its own status structure, its own criteria for placing individuals on this and its own symbolic, but highly valued, rewards. What differentiates it from many other youth groups or subcultures is its explicitness, its open recognition of its own point and purpose. Fame, respect and status are not naturally evolving by-products of this subculture, they are its sole reason for being, and a writer's sole reason for being here.

A career path

Let us now look at how these rewards are claimed by examining this career in greater detail. This section will take readers down the path most writers follow in their quest for success.

Seeing the ad

Graffiti involves the public inscription of one's name or 'tag' (see Figure 5.1): 'Each person had their own tag, kind of like a logo in advertising, and it was the logos of those names I was initially inspired by' (Futura 2000). If you grow up in a big city, chances are you will see these names like advertising written on the walls of your road/block or perhaps lining the street or tube/subway route you take to get to school everyday. It is this repeated exposure which seems to inspire a new writer's interest. Rather than blend into the background, names pop out and become familiar:

> It was seeing the names and saying, 'I saw that on the last train', you know, I started identifying those names.
>
> (Iz)

> At the beginning you don't really know nothing, what you see is the writing on the wall and that sort of turns you on, because they're like famous.
>
> (Sae 6)

In recognizing these names, new writers begin to recognize the point of the subculture – fame. They are also presented with an element of challenge. It was other people's skills and abilities that inspired Col and Jel to assess their own:

> I remember the first time I saw it and, like, I was always amazed how everybody could do this and get away with it, so I was like, 'I want to try this.'
>
> (Col)

> It starts by you looking at the walls. I'd seen everybody doing it, so I was like, 'Oh, I wonder how long it would take me to do that?' . . . I said, 'I want to be better than those guys, I want to get up more than them.'
>
> (Jel)

The graffiti-covered walls and surfaces of the city act as a form of sub-cultural advertisement. They tell a new writer what can be achieved with a little time, effort and commitment and they provide a guideline for these goals. They also indicate what can be bettered, and it is this which feeds the competitive spirit of the subculture. At the end of the day, 'that's what keeps it going, competition breeds us' (Acrid).

Choosing a name

Having developed an interest, writers must now decide upon the name or 'tag' they plan to use. The name is the basis, or as Norman Mailer (1974) put it, 'The Faith of Graffiti'. It is the most important aspect of a writer's work and the source of their fame and respect. Graffiti is illegal so writers do not usually use their 'real-life' names. A new name also provides them with a new start and another identity (see Chapter 8). Writers choose their names on the basis of a whole range of reasons. Most will appropriate a word, often from pop culture or some other social reference, because it communicates something about them as a person. Others may opt for a nonsensical word because the letters work well together. This is important because letters can affect what writers can do with their written names. For example, a prominent writer, 'Prime', now regrets choosing his name because the P and the R are both top heavy and difficult to mesh together in larger artistic productions.

Every writer will try to find and keep an original name and claims of ownership are not uncommon: 'Drax, that's my name as far as I'm concerned. In London, that name and any spelling of it is mine' (Drax). 'Biting' or copying anything that another writer does is discour-aged, unless, as in the case of a name, it can be differentiated in some way. For example, a writer may adopt another usually 'inactive' or 'retired' writer's name as a sign of respect, but he/she will be expected to affix a number to the end of it to indicate they are not the 'original', for example, Steam 2. Another exception to this rule comes when a writer is out of commission for some reason. Acrid illustrates: 'When I was inside, doing time for graffiti, other people were putting up [writing] Acrid. Like people respected me so much, they were doing pieces and putting Acrid beside them.' In this case, a writer can write another writer's name because

> that's just your friends, I don't know if the police know, making sure everyone else knows you're still around, even though you're not. It's like if a writer dies, gets chased out of a train yard and elec-

trocuted, other writers will still put him up as a mark of respect because he's gone. Or like a friend of mine's inside and his brother and friends will put him up till he comes out so he keeps his fame.

(Mear)

A better alternative is not to be caught and put inside in the first place. Here another name practice comes into play. While most writers have one main name, highly 'active' illegal writers with a high police profile might 'have another name, so if one name was hot [wanted by the authorities], you could write under another name' (Futura 2000). They may use this 'ghost' name at all times and in all places, or employ it more selectively like the following writer: 'If you notice to my house, there's no tags on my street because I don't want to leave a trail, so I'll like write Y***a [disguised for confidentiality] instead of Claw . . . because now that I'm well known, I'm kind of wanted' (Claw).

Writers use their names or tags to gain fame and recognition, so using another one may jeopardize their profile. Drax is philosophical about the pay-off: 'Yeah, you don't get so much fame out of it, but it's like with the fame, comes the police grief . . . so you have to be prepared to, sort of like, get some silent fame.' If the writer is very well known he/she may not have to forfeit any fame anyway. 'Ghost' names are generally used by very active or prominent writers, and as Kilo maintains: 'Once you get so far along the line, people recognize your stuff anyway.' A high-profile writer's 'style' speaks just as loudly as his/her written name.

Occupational hazards

Illegal graffiti involves a celebration of the self. An individual writes his/her name and effectively says 'I am', 'I exist'. In this subculture, however, it is not enough simply to 'be', to 'exist'. One must be and exist stylishly. Style is a centrally important part of graffiti. The way you write your name, the letters you use, their shape, flow and form, the colours you choose, all these things go into making a writer's 'style'. And other writers will judge you, often harshly, on this basis. Realizing this, newer writers, like the one below, often feel a little apprehensive about their debut:

I've just been doing it really gradually. I haven't done a lot because it's only recently that I thought I'd got any good . . . I didn't want to start busting my styles and everyone would go, 'What's she bothering for, she's making a fool out of herself', rather I'll wait before I'm

remotely good before I started doing anything proper like piecing [more complex name designs].

<div align="right">(Akit)</div>

By developing her skills slowly, Akit avoids the risk of peer criticism. In effect, she negotiates one of the 'hazards' that make up a 'moral career' (Goffman, 1968). These are basically occasions 'on which an individual can gain the respect or risk the contempt of his fellows' (Marsh et al., 1978: 19). An ego is at stake here and new writers are not taking any chances. Most will start by practising their skills on paper at home:

> You start alone, it's like practice and that, and you do that for ages and ages because you don't want to do any old crap when you go out, you have to think about it.

<div align="right">(Ego)</div>

> There was, like, six months to a year that I had the name Futura 2000, but I didn't have a signature that was like worthy of going public, so I worked on my technique for a little bit until I went public.

<div align="right">(Futura 2000)</div>

When risk has been reduced and the writer feels ready, the name is debuted. At this point they switch from a private to a public orientation.

Making an entrance

Although some older writers work legally doing gallery or paid commission work, the majority start and sustain illegal careers. Illegality is a natural starting point for a new writer. First of all their interest in graffiti is usually inspired by seeing other illegal writers' work. Second, the adventure, excitement and release of the illegal exercise play a large part in initially captivating their attention. These writers all recount the pull of these illegal elements:

> Unless your goals are illegal when you start, you would never do graffiti. If your goals were legal, you would go to art school and be a brilliant illustrator or a brilliant artist . . . It all started in our adolescence, we were all pursuing the same sort of goal, be it on walls or trains, to destroy.

<div align="right">(Proud 2)</div>

> I made a fair amount of money doing legal art for TV commercials and other film endeavours. In actuality, all of this paled to the thrill of being chased through back streets and narrowingly escaping the beam of police headlights. Living precariously against the grain took precedence in my daily routine.
>
> (Teck – *Urb* Magazine 37, 1994)

Proud 2 puts the attraction of illegality down to destructive impulses, a desire to cause disruption perhaps. Teck, above, puts more emphasis on its adrenalin-fuelled thrills and risks. Whatever the motivation, these rewards cannot be found in a legal working environment.

Neither can a young writer's subcultural education. Graffiti is a craft and like any other it comes with its own range of techniques, skills and procedures. Writers need to familiarize themselves with the tools of their trade; what marker pens to use, which are the best sprays and pens for making stains with, which spray brands are suitable for which jobs, how to apply different spray nozzles to alter line widths and create different effects, how to paint without making drips or spotty paint marks. Suffice it to say graffiti has a steep learning curve which writers follow and complete through practical illegal experience:

> When I first started out on my own, I was doing a lot of illegal stuff and that's where I learnt the ropes.
>
> (Zaki)

> See, when you start you don't know nothing, but as you get more into it you start learning more and more about it, like how you go about doing things.
>
> (Jel)

> *Nancy* Does the illegal side become a sort of apprenticeship period then?
>
> *Rate* Yeah, yeah, sort it out on the illegal side, get your style. . . . If you notice, it's always older writers, like about 25, always doing exhibitions and the younger ones are just doing trains, bombing and that.

As Rate remarks above, older writers with developed skills and abilities are more likely to be doing legal work. This is not to say that all writers go on to do this. An illegal education merely enables them to make this move if they so desire. As Ego declares, referencing one such

writer: 'Yeah, Inky's making a living out of it now, you know, he's made his name, got his preparatory skills as such.'

Before moving to paid work, Inky above 'got his preparatory skills' but he also 'made his name'. This is probably the most important reason why writers to start their careers within an illegal sphere. It is here that they find their audience and it is here that they earn their profile or 'make their name'. Fame, respect and recognition, the point and purpose of graffiti, are usually earnt illegally.

Making a name

Claiming fame is referred to as 'making a name' and there are three main graffiti forms that writers can use to do this; the tag, the throwup and the piece. These are all variations of the name and, at a basic level, involve one of two activities – a stylistic or a prolific inscription of this word. Writers can adopt these different graffiti forms, and with this, different paths to prominence, but their careers tend to follow a fairly standard pattern: 'Usually every writer starts off on paper, works their way to paint and bombing and then works their way to doing pieces and they get better as they go on' (Col).

Following the practice of their skills on paper, writers generally start by 'tagging' or 'bombing', that is signing their name like a signature. Most use spray paint to do this, but other tools include marker pens, shoe polish, paint sticks, stickers, stencils or sharp metals that allow writers to scratch their names into windows and hard surfaces. The writers below expand on the role tagging plays at this stage of a writer's career:

> It's a very natural process. I mean you start and I don't know if you've ever used spray paint, but it's not an easy medium, so you start by tagging because it's the easiest thing to do.
>
> (Freedom)

> Because you've got to learn the basics of painting, you spend more time getting up [tagging] than you do dropping [painting] pieces, because you can't make pieces until, you know, you've got the skills to do it.
>
> (Stylo)

Tagging is the easiest place to start. But practicalities are not the only governing factor. Tagging is also the 'proper' and expected place to start. Most activities in this subculture are regulated by unwritten, but

recognized, rules, expectations and ethics, and the progression of a writer's career is no exception:

> You can't just pick up a spray can and start doing pieces and that. It isn't really the right thing to do. You've got to do your fair whack of putting your tag up everywhere.
>
> (Steam)

> As a writer you've got to bomb up, you've got to go through your tagging years.
>
> (Kilo)

Tagging represents the first step of a writer's career, his/her 'roots', the credentials that make him/her a writer. As Steam implies, it is a suitably lowly point of entry:

> If you haven't done your roots, tagging and stuff like that, you can't really call yourself a graffiti writer. You've got to go through the whole process, it's like anything, you have to go up the ladder. You can't just walk into McDonald's and go from floor sweeping to being manager or whatever, you've got to learn to do everything, go up the ladder.

What may look like evidence of scrawling chaos in its final form on the wall actually belies a deep-rooted sense of order and discipline.

'Getting up'

New writers need to 'get up' or establish themselves in the eyes of others. As the easiest and quickest graffiti form, tagging gives them the exposure they need to do this:

> More importantly than doing pieces is tagging, if you want to get your name up, you want to get it all over and you want people to know you, recognize your name.
>
> (Claw)

> When you're younger, you've got to get credit, you've got to tag up, put your name everywhere to get known and that. Until you've done that, you're nobody really.
>
> (Steam)

Essentially, tagging 'lets everyone know that you've arrived' (Acrid). As this represents a writer's first attempt at making him/herself known, the pace of activity is generally frenetic. Steam conveys the mood below:

> A big part of it is getting known and once you're known that's it, but it takes a good long while to get known. You have to put tags up every single day . . . like, going out at night, putting your name up on walls, buses, trains, everywhere you can think of, until you get so well known, people wonder who you are.

The quote above gives us a small taste of an all but sacred subcultural activity. All writers have done it and many older or more experienced writers go back to it when they feel the need for its curiously soothing influence. Tagging or bombing is an organic part of the graffiti experience. It is typically a solitary activity carried out in the dead of night when the risk of being seen and arrested is lessened. Armed with a spray can and a mission, writers will walk, often miles and miles, writing their names and marking their spots. The more visible, the better. There is an aggressive quality to it, a release, as writers rattle the can and 'hit' the wall, but a calming rhythm also emerges – walk, spray, walk, spray, walk, spray. The uniform sound of the spray adds to this as the writer rewrites and rewrites his/her name in the same size and style. An older writer with things on their mind may use this activity to relieve stress or block out worries. Younger writers, however, have only one thing on their minds – fame. They do not need bombing for its relief, they need it for its ability to make them known. Walking all night, every night for weeks on end earns them profile, but, it also earns them respect. Productivity is the whole point of this exercise, the principle governing this activity. A tagger is highly active because

> the underlying rule is just get up, put your name everywhere, do as much as possible in as many places as possible.
>
> (Dondi)

> You need to earn the respect of other writers by just getting up everywhere . . . People start seeing that name and you start getting, sort of like, respect. If you're a writer and you don't get up, there's no point, you know what I mean?
>
> (Rate)

Taggers are judged on the basis of 'quantity'. The more names they have 'up', the more respect they get. Their coverage is taken into

account as well: 'Some writers stay in the same depot [train yard] all their graffiti careers, but they don't get as much respect for it as someone who does all the depots or all lines' (Acrid). Writers may start 'getting up' locally, but to really taste rewards, their target area should be expanded and their name should be seen in many different regions of the city or underground/subway system. Writers who manage this are labelled 'up' or 'all city'. This confirms the prominence of their names, but it also comments on the progression of their 'moral careers'. After all, 'if other writers know us, we're making something of ourselves' (Col).

As a writer progresses, he/she will probably start to experiment and 'get up' using other forms of graffiti. As Dondi explains: 'It starts off with the tag and it just gets bigger and bigger, you develop a tag and then you start to master spray painting.' Many writers complement their tags with the use of 'throwups'; simple, but larger outlines of their names. As illustrated in Figure 5.2, these are created using 'bubble' letters and an optional white or black 'fill-in' (interior letter shade). Like a throwup, a 'dub' is differentiated by its distinctive black 'outline' and silver or gold 'fill-in'. As writers become more well known, they may transform these designs into 'three-strokes': 'A three-stroke is basic-ally a throwup with one letter of your tag, probably the first letter. Like, if you write "Cherish", you just do a big bubbly C and everyone knows it's Cherish' (Mear). If they are famous enough, their authorship is recognized. This may also enable them to inscribe their names using a mingling of letters, resulting in a distinctive shape as opposed to a legible word.

These graffiti forms reflect a writer's development, but, like the tag, they are relatively simple and demand little evidence of artistic ability. A design of this kind generally represents the tool of a 'bomber', a writer who competes through productivity and coverage as opposed to artistic competence. His/her aim lies in securing the title of 'king'. This is a prestigious award given to the writer that is considered to be 'all city' or, as detailed below, the most 'up' on a certain train line:

> King of the line, that's when you've got tags, ups and everything on trains and walls, electrical boxes, all along one line. Someone might say, 'Oh Drax is king of the Northern line', and that, because he's got tags on every station or whatever.
>
> (Steam)

The award is not usually officially declared, as to writers 'it's obvious who's up the most, there's no real need for it to be said' (Mear). But

Figure 5.2 A throwup

this 'obviousness' does not rule out disagreement or challenge. Many writers will in fact make their own claims on this title either verbally, or visually by putting the symbol of a crown on top of their name (see Figure 5.3) or by writing king next to it. They will have to be prepared to support this claim though:

Nancy So not everyone will agree with that claim?
Acrid Yeah, but that's the good thing about it, because you keep having to prove yourself. Like so and so may think he's done more insides than you, or he's got more Northern lines running or more Pics [Piccadilly line] or whatever and you think, 'No he's not, I'll have to do some more'.

This position is highly revered so competition for it is fierce. A king has to work consistently to ensure his/her name is 'up' in greater quantities than others. If you ease up for even a day, 'you will get stopped by all those other people who want to be in your position' (Acrid). This is the case for any bomber, king or not. To be successful, you have to be successive. This separates a 'true' bomber from a 'fly by night':

SKIP

Figure 5.3 Using a crown to claim the title 'king'

You just keep going, you know. It's no use starting out, make a name for yourself over say a year, reach a certain peak and then give up, you know, because then people just look at you as a no one who came and done something for a year and that's it.

(Mear)

Bombing is all about quantity, productivity and staying power so time is a critically important commodity. This might explain why this career stage generally lies outside an older writer's domain. As Steam explains: 'It's really difficult to stay up because you're getting older, you haven't got time to keep putting your tag up every single night and that, so it is difficult.' Ideally, tagging or bombing suits younger writers, those with

SKIP

more need to make a name, less responsibility and more time to main-
tain the frenetic pace of this activity. Older writers tend to move on to
develop other skills, although there are exceptions. Because this option
lays no stress on artistic capability, 'if you don't have any real artistic
talent, which a lot of graffiti artists don't have, then you're going to
keep tagging' (Futura 2000). Writers without the ability or inclination to
push forward can always use bombing as an accessible route to success.

Piece promotion

A writer with the experience, skill and desire to meet greater challenges
will probably graduate his/her career to more sedate levels as a piecer.
Sae 6 recounts this change in his career direction:

> You just started writing your name around the neighbourhood, you
> know, and as time went on you wanted to be more productive,
> because you saw that people were doing more than just writing their
> name . . . So I started getting into piecing trains and all that.

As illustrated in Figure 5.4 a 'piece', short for 'masterpiece', is a larger,
more elaborate, colourful and stylistically demanding depiction of the
writer's name.

Figure 5.4 The piecing of one's name (*Photograph*: Kirs. *Artist*: Sed)

Because piecing takes more time and effort, writers cannot be as far-reaching in their coverage. Here, one's tagging activities serve another purpose:

> See writers that piece and don't tag, they don't get respect, because people say, 'Who the fuck are they?' Tagging supports your name, because people say, 'Claw, oh yeah I've seen that before', and they don't know where, exactly why, but they've seen it.
>
> (Claw)

Writers will probably continue to bomb or tag, but for many, like Claw, this pursuit takes on a more sideline role:

> I try to do two pieces a week on walls or on trains and I try to go bombing at least one night. I used to really like to go bomb. I used to really like seeing my name everywhere, but now it's sort of maintenance, it's sort of making sure, it's boring now.

As writers move on and search for new ways to push and extend themselves, tagging fades into the background a little. It may still be used to preserve the writer's profile, but it loses its place as a vocation. This is not to say that writers now slacken off. While piecers cannot be as prolific as taggers, they still need to maintain their fame: 'You can only do no pieces for so long before people start going, "Wait a minute, he's not doing anything." So you have to still do something to keep the fame thing going' (Zaki). The amount of work that is required of them, however, lessens. Drax outlines the differences between earning respect as a tagger and a piecer:

> If you had a piece in every borough, okay, as opposed to 50 or 60 tags in every borough, you would be considered more up really than the person with all the tags, although you haven't got as many pieces of art work . . . But if you were just a really good artist with a few pieces you wouldn't necessarily be compared to someone who was everywhere tagging. There has to be a lot of coverage and the more you do the better and the ability and the quality of the work you put up is all taken into consideration as well. I mean the ideal thing would be to be absolutely everywhere, nice pieces everywhere plus your tags as well, but that's hard to achieve. I suppose the aim is to be the most up and the best.

Quantity and quality is a hard mix to sustain, so writers will usually focus on one option or the other. The two are not usually compared. Tagging and piecing are different activities, so judgement involves different criteria: 'There's two trains of thought, it's like how much you're up and then how good you are at actually painting. If you can get up a lot and paint well then you're going to zoom up there' (Zaki).

Piecers are dealing with more complex and time-consuming designs, so their work is assessed for its quality rather than quantity. At this point 'style' comes into play as a central component of a writer's work. Achieving fame through piecing requires proficiency in technique, skill and design and writers are judged on varying aspects of this. Detailing accessories such as shadowing, highlights, overlapping letters, three-dimensional effects, fading, arrows, sparkles, stars, characters, backgrounding and colour schemes are all taken into account in the overall assessment of the piece (Figure 5.4 evidences many of these design details). The most important demonstration of a piecer's skill, however, lies in his/her letter forms. These are a writer's principal concern: 'Letters should stand on their own with no help of colours or elaborate techniques. [. . .] Colours and designs are secondary, focus in on the primary concept in graffiti and master your letter forms' (Professor P-Kay – *On The Go* Magazine, Dec. 1993).

To 'carry good style' and produce work that 'burns', a writer's letters must be neatly finished with a sharp, straight and dripless outline. Proficient and sophisticated methods of letter connection, filling in and backgrounding should also be evident. An innovative lettering style, if the writer can manage it, is an added bonus. In the early days of the subculture writers would push themselves to invent new letter forms, claiming these as their own through the use of a copyright symbol. Playing in, as yet, uncharted territory, this creativity was expected of them. Today, after 30 years, the scope for innovation has declined and, while originality is valued, it is not demanded. Writers are perfectly justified in sourcing from the subculture's established collection of lettering styles: blockbuster, bubble, wildstyle, computer rock, mechanical, supreme script, platform, machine, bar, marshmallow, to name but a few. Indeed, their personal imprint will usually lend these designs a unique flavour of their own:

> Everyone steals ideas from other places, little dots and stars and designs and stuff and a lot of people just rip off complete styles, but the combination will usually be, like, unique to somebody. The style

of the lettering they use, the use of colours and specific little things, it's authentic, to them it's original.

(Drax)

Once established, a writer's style becomes his/her hallmark:

> A writer usually has his own style. Some people's style you can basically tell straight away . . . I can tell a 'Drax' piece a mile off or a 'Cherish' piece or an 'Acrid' piece, just by some of the colours they use or just by the shapes of their letters.

(Mear)

Journeys into space

To earn fame writers need an audience. Accordingly, the places where they paint are usually highly visible. Spots like highways, overpasses, bridges, street and traintrack walls do a good job of putting writers' work in the public eye. However, the best canvas for their work is one that moves, extending their audience and the reach of their name. Buses and trucks are a popular target for graffiti. American and British writers are also painting overground freight or passenger trains, sending their work to different regions and areas of their respective countries. I have even seen writers tagging on money bills – a sure guarantee their names are going to get around! The ultimate vehicle, though, will always be the subway/underground trains:

> The trains moved, they went from one borough to the next and back. . . . We pieced on buses for a while, but it didn't work that well. They clean it really quickly and buses are kind of local, they'll only remain in one borough. The trains were the perfect medium, they went underground, they went everywhere.

(Dondi)

These trains travel good distances, but unlike overground trains they can always be tracked. This means writers can follow their work, keep an eye on its progress, and most importantly, determine where it is going to go in the first place.

Because public graffiti is illegal, its location and the difficulties involved in painting there will always be taken into account. For example, painting in a train yard is a highly pressurized, dangerous endeavour, so a train piece is generally seen as a greater achievement and granted more respect than one upon a wall. For the same reason, a

piece in a highly risky location will not be held to such high stylistic standards: 'You might do a piece and it might not be all that good, but because you've done it in a certain depot or certain night or because the yard is considered hot [risky] and you've still gone in there, you still get respect' (Acrid). A tagger or throwup artist can enhance respect in a similar way by 'tagging in difficult places or places that are hard to get to and that, say on the top of bridges or like high up places' (Steam). The greater the danger, the greater the respect. Unusual locations or those which beg questions of possibility will also increase a writer's fame and profile. Mear recounts the reaction that followed his use of space in this way:

> The whole side of this building was scaffolded, so we climbed up the scaffolding and did these gold little dubs and you couldn't see them. And then a couple of months later they'd taken down the scaffolding and so there was these two pieces of graffiti right in the middle of the building. It was like, 'How the hell did they get up there?' That was one thing I got a lot of respect for or a lot of fame. A lot of people talk about it.

The scale of a writer's work is used as another indicator of their skill and stamina. A typology of the different sizes and positions of a piece upon the carriage surface of a train allows writers to classify these works accordingly: 'There's top to bottoms, there's end to ends, top to bottom end to ends, whole cars and there's window downs, which is below the window and there's panel pieces, which are just pieces between doors' (Zaki).

A larger piece will earn a writer more respect because its size indicates that he/she spent more time in danger and physically extended him/herself to cover this space. For most illegal writers, the greatest achievement is 'a whole car top to bottom, those are the best, that's a big thing for writers to accomplish' (Cavs). A whole car top to bottom, or T to B, covers the entire surface of one side of an underground/ subway car, from the top to the bottom and including the windows (see detailed in Figure 5.5). This is a great feat of physical strength and endurance. A train carriage is an imposingly large canvas, and writers will need tools or specialized techniques to help them cover it. Some elevate themselves by clinging on to the small grooves that run along the roof of the train. Others straddle the sides of two trains, using one to shimmy up and paint the other. A few opt for an easy life and actually bring their own ladders or crates to the train yard to give them

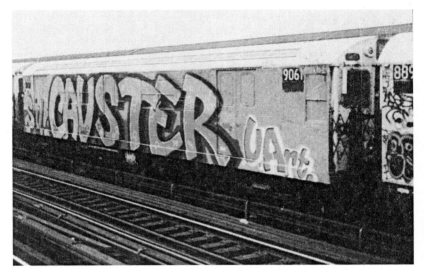

Figure 5.5 A whole car top to bottom (*Photograph and Artist*: Cavs)

added height! No matter how it is accomplished, any writer with a whole car top to bottom under their belt is guaranteed a rousing applause. The respect earnt for this is unparalleled, making it any illegal writer's ultimate ambition: 'Every graffiti artist wants to do a whole car top to bottom or whole carriage by himself, which not many people in London have actually done' (Mear).

Shifting career gears

Having outlined a writer's transition from bombing to piecing, readers should now be seeing hints of the pattern characterizing writers' sub-cultural careers. As other theorists have observed in their own subcultural studies, new members tend to start at a more frenetic pace. Unlike older members, they still need to establish their unknown reputations (Marsh et al., 1978; Parker, 1974; Werthman, 1982; Williams, 1989). Writers at this stage have little reason or incentive to slow down or curtail their careers. The promise and taste of fame and respect ensure their unwavering devotion:

> *Nancy* What would make you give it up?
> *Acrid* The loss of my arms and legs! I dunno. Even if I started abseiling, rock climbing, travelling the world and that,

Nancy You'd still take your spray cans!
Acrid Opportunity arises!

> I consider it as like a career now, because I plan to bomb and piece until I die. I don't plan on stopping.
>
> (Col)

But most do eventually stop, or at least slow down. As writers move on in their careers, their energy declines, their activity decreases and their attitudes change. The older writer below notes this shift: 'Your most important years are your younger years because when you're younger you write on anything, you're just on a quest, it's, like, write, write, write, get up more and more. Now as you get older, you start slacking off' (Jel).

When a writer reaches higher levels of the subculture's status hierarchy, the pace of his/her career starts to settle. Mear explains why: 'By the time you're somebody you don't have to do as much, you can quieten down a bit, you know.' For a 'somebody', a writer who has claimed fame and made a name, the need and, indeed, appeal of this effort seems to lessen. As Proud 2 confirms: 'I think you need that enthusiasm, you know. I don't want to go out on a wet Saturday night, spending my time in a train yard, running the risk of getting my hair fried or whatever. I haven't got that passion anymore.'

We could stop here and conclude that older writers do not need graffiti or its rewards as much, that their careers have reached a peak and they have the fame and status they need. But to really understand this transition, we need to go one step further and consider the age-related changes that may be occurring in other areas of these writers' lives. As outlined below, age carries with it a fairly heavy bag of increased responsibilities and legal liabilities:

> It's a younger thing because it is actually something, unless you become a legal artist, that takes a lot of work and doesn't actually have any financial gain at the end of it and a lot of older people don't have the time or the dedication to want to do that kind of thing, you know, because they might have families or responsibilities. They are also going to be viewed more harshly by the courts and stuff if they're caught.
>
> (Drax)

It's no coincidence that most people in graffiti are about 12, 13, when they start and most people when they get to 20, sort of, slow

down. I think there may be several reasons for that, i.e., you've got to go out and earn a living and it's against the law and it takes a lot of time and effort . . . You calm down a little bit, you don't take so many risks, but it's usually financial, like, you've got to pay a mortgage or you've got kids or something like that.

(Zaki)

As a writer gets older, the main difference between this career and any other becomes vividly clear. This career does not pay the bills:

I mean they buff [clean] the trains and that's your career, your subway writing career, it's been cleaned in one swoop. Now you have nothing. Now all you have is a rep to live on, but that doesn't pay the bills. I mean, all these things come into play when you're graduating high school.

(Dondi)

At this point in an individual's life, financial concerns start to over-shadow subcultural ones, and a 'mainstream' career will probably start to overshadow its subcultural counterpart:

Once you have a nine to five job you start to grow up. You don't have the energy you had as a teenager and only your weekends are for graffiti and the rest of the week you have to do some stupid job for someone else and that takes away your spirit.

(Pink)

The career, formerly pursued as a full-time occupation, is either cur-tailed or, as Claw illustrates, adjusted to part-time status:

I mean I still tag, I try to do it once a week, you know, when I go out, I bring a pen. But, you know, I have a life other than graffiti now. I have my friends and my art, I'm starting my fashion again . . . I'm a writer first and foremost, but I'm also a graffiti writer last in my whole life, so I just incorporate it into my life by making small changes.

Kicking the can

To become 'real', the identities or reputations we develop need to be exposed to an audience. Other people's recognition grants 'who we are' or claim to be, substance and validity. But, while breathing life into

our identity displays, they can also inject them with a degree of inertia (Emler & Reicher, 1995). As Emler & Reicher (1995) contend, one cannot be a Catholic today and a Protestant tomorrow because one's peers will not accept such shifting claims. The graffiti subculture breaks down such constraints. By moving through the subculture's recognized stages of activity, writers can make justified changes to their identities. This flexibility allows them to negotiate the difficulties of their illegal position and, indeed, avoid them when they become too much. To illustrate, an established or 'veteran' writer with increased responsibilities can discard his/her 'illegal' identity and adopt a 'conformist' one by announcing his/her subcultural 'retirement'. Jel and Sae 6 elaborate:

> *Nancy* So it gets slower as you get higher?
> *Sae 6* Yeah, you just sort of semi retire, you know.
> *Jel* You've been accepted.
> *Sae 6* You made your mark on society, that's what it is, and now you've been accepted by the top writers, you've already proved yourself.

When writers 'retire' they have generally proved themselves, made their names or 'paid their dues', as this is termed. As we can see in the two quotes below, this absolves them of the need to keep building their names or developing their careers:

> You know, 'Iz' did his share. When he made a name for himself, he did it for so many years, he has nothing more to prove . . . He's just doing it, just to let people know he's still around.
>
> (Cavs)

> 'Prime' doesn't do a lot, but what he does is quality. He doesn't need to do a lot, he's got such a name.
>
> (Kilo)

As in other cultures or societies, graffiti 'veterans' earn their right to certain concessions. Unlike younger writers, they can decline or relinquish their illegal careers without losing their identity or credibility. As Zaki demonstrates below, they are also freed from the need to meet the subculture's standards of stylistic excellence:

> The pressure is a lot less on me now. If I went and did something now, it wouldn't matter if it was really shit. People would probably

go, 'Oh, wicked', because I'm thought of as the granddad now, so I'm not meant to be running new styles or being the best.

These allowances come with their position. 'Veteran' writers occupy a very secure place at the pinnacle of the subculture's hierarchy. Here, their former achievements speak for them. As Col illustrates below, there is little that can now jeopardize their status. When you get to the top, you'll be remembered for ever:

Col See, you can go to the top of the line, stop completely or just catch a tag here and there.
Nancy And that's okay, you're still top?
Col It's fine, you're still there, you're at the top.

At this point a writer's illegal career reaches its closing stages. Although this signifies the end of their 'active' career development, many 'retired' or 'veteran' writers will continue to do the odd piece of illegal work to let other writers know they are still around and to reinforce their status. Alternatively, some choose to extend their graffiti careers down other avenues.

Going legal

At a certain age or life stage, writers may find themselves at a crossroads. On one side they have 'real life' responsibilities which start to demand more of their time, money and attention. On the other, they have an illegal pursuit which they cherish, but cannot harmonize with their present lifestyle. Ego illustrates the kind of tension that typically emerges:

I'm painting in the beginning, doing all the illegal stuff . . . How old am I now? 25. You know, if you're arrested again and again eventually, because of your age, you're going to get put inside. It's like fuck that, you can't be a phantom all your life.

What it often boils down to is a very difficult 'one or the other' choice. Unless, like Mear, writers can find 'another door': 'I could have stayed doing illegal stuff and never looked at the legal side of it, but the legal side just opens up another door.'

So what does this legal door open up on? First and foremost, options. Legal work consists of a mix of different activities. What unites them is the fact that they are all 'licit'. A writer does not have to break the law

and risk arrest. Consequently, legality enables writers to nurture both a legitimate, law-abiding lifestyle and an interest in graffiti. Jel reflects on this below:

Nancy So how old were you when you started thinking, 'Maybe I'll start doing a bit of legal work'?

Sae 6 When I started turning like 21, 22.

Jel I guess that comes when you get old and you start maturing and you start knowing that you want to be serious in life. You want to be responsible, you know keeping up with yourself and doing the right things in life.

In some cases, legal work actually helps them create this 'responsible' lifestyle. With the skills and inclination, a writer can make an income, or certainly supplement one, from doing commercial graffiti work like mural commissions, selling canvas/gallery pieces or perhaps designing tee shirt and clothing prints. For writers like Sae 6, 'moving over' and making money out of graffiti is a logical step forward: 'Your parents aren't supporting you anymore, so you've got to take the only thing you know how to do best and say, "Maybe I can make a living out of this."' Faced with the financial demands of 'real life', 'you just find ways of turning your hobby into something which will pay the rent' (Proud 2).

Commercial legal work moves writers out of the boundaries of the subculture. They no longer paint for their peers or themselves, they have a new audience now; the person or business buying their work. Writers can, however, claim the best of both worlds. That is, 'go legal' while keeping, and possibly even enhancing, their place and audience within the subculture. Most graffiti scenes have their own 'halls of fame'. These are 'legal' painting sites, like basketball courts or playgrounds, where established writers can paint without police interference or other illegal distractions. Like art galleries, these sites are heavily trafficked by other writers who come from far and wide to take photos of the pieces being showcased and to exchange news and views with each other. Anyone who paints in a hall of fame is guaranteed a widespread audience, a source of fame and maybe even a chance to establish an international reputation. Drax explains why this step up in profile is important:

For bigger writers and more accomplished ones, once you've proven to everyone in London you do it and earnt your respect in London,

you have to move on from that. You know, you've got to crave for something more, world wide respect . . . because you can only achieve so much here. Once you get that big as well in the illegal scene, you're going to be so much in the eye of the police and stuff, it's going to be impossible to do anything, so you need to, kind of like, expand beyond that.

This subculture is made up of a number of different scenes around the world. Almost every major American city has a graffiti presence. Europe is saturated. And scenes in Australia are also starting to proliferate. Together, they form an international hierarchy, or worldwide competitive arena. Writers literally have a global stage to perform and shine on. So how do they go about doing this?

It would happen automatically to you if you were good enough and doing enough stuff. People start mentioning you in magazines or letters or you would just go into the world and meet writers who'd heard of you because your fame has travelled.

(Drax)

When the authorities started their war against graffiti, writers adapted by finding a new way of exposing and circulating their work; photographs in graffiti magazines. Initially local, these publications have developed and many now enjoy an international readership. This has done much to bring this worldwide subculture together: 'We're becoming more and more united because of all these graffiti magazines' (Lady Pink). Connections between writers in different countries have been built and, as noted below, an international level of dialogue and competition has opened up: 'It's heavily competitive too, more so on a world wide level because of all these magazines' (Futura 2000). Thanks to this exchange, a writer can take that one last step in his/her career and earn fame and a following in corners of the world he/she may have never even heard of.

Before concluding this chapter, I should make two things clear. First, what I have provided here is only a skim reading of a writer's progression through this subculture. There is more to be said about this career and a deeper analysis will be made in Chapter 8. Second, the career sequence I have outlined should be taken as general, rather than

uniform. There is no absolute blueprint of this process. Writers may differ in the paths they choose, the time they spend at each stage of activity, and, indeed, the points at which they start and end their careers. What I have presented is typical or conventional. Most writers make these outlined transitions and most do appear to decrease their illegal activities in their late teens or early twenties and, at this point, either retire, give up or 'move over' to continue their careers as legal or commercial artists.

What all writers share, regardless of their differences, is a common motive. All of them enter this subculture with an ambition to be the best, the most famous, the most respected, and it is this that makes a graffiti career a 'moral career' in its purest form. All its paths, progressions and purposes lead to one openly recognized end goal; a strong self-concept. If achieving this is, indeed, one of the most fundamental of human concerns (Harré, 1993), then a graffiti career merely represents a raw alternative of the progressions we all strive to make in life.

Highlighting this parallel is important. Without it, one may be tempted, as many are, to put graffiti down to some deficit like lack of intelligence, morality or social skills. When it comes to 'youth', narratives like these are no new thing. 'Folk devils and moral panics' (Cohen, 1987) have existed for as long as we have been able to define 'teenagers'. Teddy boys, mods, rockers, ravers and varying other youth groups have all received a societal vote of no confidence. And this subculture is no exception. But, while graffiti may bear its label as 'vandalism', it cannot carry the connotations usually associated with it. Graffiti is neither mindless nor senseless. Far from it. The time, energy and effort that are put in reflect an underlying rationale and serve a clear and coherent purpose. In the past, theorists have linked subcultural activities to issues of class resentment. This bond is unravelled here. Graffiti is not an act of spite or malice, a 'for the hell of it' crime which angry working-class kids use to attack the middle classes at their most vulnerable, that is, through their property (Cohen, 1955). This subculture has its own audience and its own agenda, one which clearly questions 'hit back' motives or feelings of 'status frustration'. Writers strive to reach their own goals, not other people's. Indeed, the very fact they have goals lays waste to Albert Cohen's (1955) portrayal of impetuous, impatient and unambitious subcultural members. There are long-term aims and objectives at play here and the incredible industry writers display in their quest to reach them must also be acknowledged. To use Willis's (1990: 2) words: 'There is work, even desperate work, in their play.'

It is here that Cohen's (1955) thesis is probably at its weakest. When one looks beneath the surface of this subculture, the so-called 'middle-class' values honoured within 'wider' society are not rejected, they are fully embraced. Graffiti writers demonstrate the same dedication and diligence to achieve the same status and standing as an individual does in any other profession. Yet, such legitimacy generally eludes them. The picture painted of graffiti is one of chaos and anarchy; writers as a seething mass of testosteroned adolescents hell-bent on destruction. But, then, surface impressions are clearly misleading. The members of this subculture are not a breed apart. They are a group of young individuals working hard to conform to their own meaningful guidelines and structures.

6
Constructive Destruction: Graffiti as a Tool for Making Masculinity

This chapter will move beyond the rewards of fame, respect and status to explore other, perhaps less immediate, reasons for writers' involvements. What else do they gain from participating in this subculture? A member of the CCCS group would probably say a chance to resist hegemony and solve, 'albeit magically' (Cohen, 1972: 23, as quoted by Clarke et al., 1976: 32), class-related problems or contradictions. But does this theory still hold good? Recent theorists have said not (Griffin, 1993; McRobbie, 1994). During the mid 1980s, postmodern critics stepped in and sent Marxism, in its various guises, into a state of crisis, attacking 'its teleological propositions, meta-narrative status, essentialism, economism, Eurocentrism and its place within the whole Enlightenment project' (McRobbie, 1994: 44). In dismantling their vision of a unified and fixed society, Marxist notions of resistance started to crumble (Griffin, 1993) and moves beyond this theoretical vocabulary started to be made (McRobbie, 1994).

I share these departing moves, but my reasons differ slightly from those above. It was not Marxists' appeal to a rigidly defined class system that worried me so much. Rather, it was the offhanded way in which they put groups into its categories. Illustrating this, Clarke et al. (1976) situate

> respectable, 'rough', delinquent, and the criminal sub-cultures *within* working class culture [. . .] though they differ amongst themselves, they *all* derive in the first instance from a 'working class parent culture' (Clarke et al., 1976: 13, italics in original).

But do they? CCCS theorists were almost obsessive in the way they attempted to squeeze subcultures into a working-class mould; a mould

which the graffiti subculture does not seem to fit. Although I had no definitive means of checking its class make-up, my own observations and the writers I spoke to declared this 'poor kid' stereotype exactly that:

> You'd be surprised how a lot of kids come from really good families, upper class, upper middle class.
>
> (Pink)

> Graffiti permeates throughout the educational spectrum. Expensive fee paying schools can produce the worst offenders.
>
> (M. K. Scanes, Graffiti Management Ltd – *Developing Metros*, 1991)

This subculture cannot be defined by its class make-up, or its ethnic make-up for that matter:

> Graffiti writers come in all shapes and sizes . . . I know tons of Jewish writers that come from these wealthy families and I know these black kids from the projects and I know these white kids, so I think graffiti really spans everything.
>
> (Claw)

Apparently, 'graffiti has infiltrated all walks of life' (Iz) which makes a Marxist model for it far too limited. The CCCS group may have differentiated working-class subcultures and middle-class countercultures, but they made little concession for groups which incorporate a mix of classes or races, like this one. My reasons for rejecting a Marxist framework were, therefore, practical. With this class base shattered, it did not offer me any analytic use.

Where, then, does this leave me as a subcultural theorist? In McRobbie's (1994: 156) view, with a lot more theoretical leeway:

> Now that the search for the fundamental class meaning underpinning these formations no longer constitutes the rationale for their cultural analysis, we can also afford to be more speculative, more open to reflecting on meanings other than those of class.

I intend to use this freedom to explore the one feature this subculture does display – a predominantly male membership. According to *British Transport Police Records* (Jan. 1992 – Jan. 1994): 'The sex of graffiti offenders appears to be almost entirely male, only 0.67% of

people arrested are female.' This presents us with an essential question – why does this subculture, like many, seem to attract men and not women? In explaining this, gender becomes a critical issue (Heidensohn, 1989). Until recently, though, it has been largely ignored: 'Gender relations [. . .] have generally been obscured from practice and academic debates with the implication, for example, that class relations are of greater significance' (Hudson, 1988: 41). Alternatively: 'If gender is discussed at all, it is always with women as the focus' (Stanko & Newburn, 1994: i).

Rather than ask why men are present in subcultures, theorists have tended to ask why women are absent. Posing the question in this way has directed attention away from the potent significance of this male skew. To really understand this, we need to shift our emphasis, and as Zaki suggests: 'Instead of questioning why more women don't do it, maybe we should question why men do. Maybe that's more of a question, why are men always constantly striving to do?' In this chapter I will argue that male graffiti writers 'do' because 'doing' allows them to construct and confirm their masculine identities. The 'doing', or the actual nature of writers' activities, holds a central place in my analysis. I, therefore, depart from the CCCS group who focused primarily on the subculture's 'style': 'Roughly, this is what the actors wear and how they wear it' (Brake, 1985: 12). These ensembles are read as commentaries of resistance; depictions of class-related problems and an actor's attempt to resolve these. But style as a signifier perhaps facilitates this reading. If we consider the illegal, aggressive or dangerous activities that often accompany these 'styles', I think we arrive at a different understanding of resistance and a less ambiguous representation of the subculture's purpose. We also gain, in the case of graffiti, a firmer grasp of the role and meaning of 'respect'. In their study of football hooliganism, Marsh et al. (1978) consider the dangerous situations in which 'hooligans' earn respect. They also appreciate, as do Emler & Reicher (1995) in their study of deviant reputations, the daring and bravado that must be displayed to obtain this recognition. However, in both studies, the masculine connotations are only touched on, they are not fully explored. I also read a 'hooligan's' actions as his way of building an esteemed persona or reputation, but, more specifically, an esteemed masculine persona or reputation.

In keeping with this angle, this chapter will move beyond an ethogenic analysis to examine the subculture as a space for the construction of masculinity. It will also move beyond the main tenets of the labelling theory. If writers use their illegal activities to construct a

masculine identity, then deviance becomes deliberate, functional and more than just the consequence of an applied label (Becker, 1963).

I have divided this chapter into three main sections. The first two will focus on male writers. The type of masculine identity they build and the features of the subculture which lend themselves to this construction will be explored, alongside the important part respect plays in confirming this persona. The female writer will be addressed in the final part of this chapter. Women are a marked minority within this subculture. This section will consider reasons why and examine how those involved experience and carve space within this male-dominated and often misogynistic environment. Theorists have studied women within female subculture before (see for example Blackman, 1998; Kearney, 1998), but this will be one of the first studies to look at the gender dynamics that emerge when women infiltrate subcultures that are predominantly male.

Masculinity: it can be a crime

'What are you, a man or a mouse'? This question is irrational, the answer is obvious. However, in asking it, we are asking someone to prove their manhood by demonstrating the skills and qualities which are taken to define this status. In this sense, masculinity is not an essence that one naturally exudes, it is something that gains its meaning through a process of construction and display. To put it another way: 'Nobody was born a man; you earned manhood' (Mailer, 1968: 25, in Gilmore, 1990: 19). And you can do this in a number of different ways. Moving away from the overly simplistic, reductionistic, apolitical and ahistorical notions of the sex role theory, masculinity is now recognized within a multiple light, as a relational construct among a range of competing and changing identity expressions (Edley & Wetherell, 1993, 1995; Hearn & Collinson, 1994; Kimmel, 1987, 1990; Messerschmidt, 1993; Pleck, 1981; Rutherford, 1988; Stanko & Newburn, 1994; Westwood, 1990). Gender construction is no longer a matter of adhering to one set of prescribed rules. It is a negotiation or articulation of identity through the use of many different resources and discourses.

Realizing the work that is involved in producing gender (West & Zimmerman, 1987), crime is now starting to be recognized as one such resource or '*one* means for developing an identity as a man' (Hudson, 1988: 37, italics in original). As opposed to a passive enactment of the

already defined male sex role, crime has come to be seen as the negotiation of an identity which gains a different pronunciation as it is spoken through different classes and races (Liddle, 1993; McCaughey, 1993; Messerschmidt, 1993; Stanko & Newburn, 1994). Just as there are varieties in types of crime and the individuals who commit them, so too are there varieties in the types of masculinities constructed through these different activities.

These reconceived accounts fill in some of the gaps left by those who either ignored or oversimplified the links between masculine construction and crime. However, they are not without their problems. Masculinity is scrutinized here, but it is rarely problematized. What is masculinity? Can we, as analysts, be sure that the behaviours and qualities we so readily describe as 'masculine' are, indeed, unproblematically so? Put another way: 'How is the theorist to identify instances of "masculinity"? [. . .] by what *criteria* are these instances identified?' (Coleman, 1990: 189, italics in original). We need a way of justifying the actions we choose to count as 'masculine'. Referencing the meanings of those who perform and intend them can begin to offer us this (Coleman, 1990). If, 'competent persons-in-the-society can be assumed to be skilled in the attribution of, avowal of, use of, and engagement in gendered activities' (Coleman, 1990: 195), then what is often missing, and what I intend to provide below, is evidence of how the graffiti writers themselves 'define' their actions in 'masculine' terms. A combination of both 'insider' and 'outsider' definitions will allow me to talk meaningfully about these 'masculine' behaviours without risk of lapsing into imposed stereotypes.

'Men's work'

By positioning graffiti's risks and dangers as 'men's work', Drax and Steam convey the 'maleness' of their actions:

> I think it's attractive to boys because of the so called machoism with regard to risk and adventure.
>
> (Drax)

> Not many girls do it . . . it's more of a guy's thing because of the risks you take and that.
>
> (Steam)

Steam expands on this point below and explains why he believes boys relate to these risky illegal features rather than girls:

Nancy So what is it about graffiti that appeals to boys alone? Why do you think more girls don't get into it?

Steam Because there's too many risks and I couldn't see a girl going into a train yard.

Nancy Yeah, but before that, what was it that made you think, 'Oh I'd be into doing graffiti?'

Steam I dunno, it's just rebellion isn't it, it all depends what attitude you've got.

Nancy But girls can be rebellious can't they?

Steam Yeah, but I can hardly see them going to a train yard and stuff like that.

A writer's involvement in this subculture is seen to depend upon a rebellious attitude; an attitude which girls may share, but fail to express. Steam implies cowardice to be the reason for this. Others that chose to comment implied the same:

Nancy Why do you think more girls aren't involved?

Sae 6 Because it's a rough job, it's going in the tunnels, it's fighting, it's carrying the axe, it's dangerous,

Jel There's a lot of dangers and risks.

Sae 6 It's a hard-core thing and plus it's even more hard-core to a female when she hears our stories, you know.

Jel Imagine a girl going into a train yard where they know there's a rat, a live rail, it's dirty.

Sae 6 You hear the stories right, so you've got maybe 80 per cent of the girls that hear these stories are really scared to begin with. Here they are hearing us talking about, 'Yeah, we was at that tunnel, these guys rocked up with bats and the cops came and they chased us and the third rail.' You know that's a turn off to girls.

These accounts all highlight intrinsic differences between men and women. This is 'men's work' because girls do not come equipped with the stamina that enables them to face the pressures of this environment. How, then, does a female writer explain the paucity of women within graffiti? Pink illustrates:

Nancy So why is it more women aren't into graffiti?

Pink Because it's a dirty job, a dirty hard job. You have to carry paint in the dark, crawl through God knows what and hide

behind disgusting things and scale big fences. Basically it's men's work. It's that, you know, most girls are raised to be little feminine things. . . . It just takes some qualities and girls are just way too feminine and they don't have nearly as much guts to do such daring things like that.

Like these other accounts, Pink defines graffiti as 'men's work'. Her focus upon its dirtiness as one reason for this is interesting, as Griffin (1985) also found that girls preferred office jobs for their cleanliness. Pink activates gender stereotypes, but she denies these an innate character by referencing socialization processes. As she suggests, girls lack stamina because, unlike boys, they have not been raised to display this. Lack is still the operative word here though. Although Pink privileges nurture over nature, she still explains female absence in terms of female incapacity. In her account, girls are still missing the qualities which enable boys to do graffiti. Accordingly, 'masculinity' is still the all-important factor of distinction.

Interestingly, not one of these writers has considered the possibility that girls may have no interest in graffiti. In Brake's (1985: 182) view: 'The "absence" of girls from subcultures is not very surprising. These subcultures, in some form or another, explore and celebrate masculinity.' Boys may therefore get something out of graffiti that girls do not; namely, a relevant and meaningful identity. In which case, girls may be brave enough, but not sufficiently interested. Kilo and Lee mirror the tone of explanation provided earlier, but they deviate by considering this possibility:

Nancy What is it that makes it such a male activity? Why do you think girls aren't into it?

Lee It's dangerous to go in yards and that.

Kilo I suppose, I dunno it's a bit macho, you can't say it, but would a girl sort of really want to be out in the freezing cold or whatever, like painting at night?

Lee Girls have more sense.

Kilo Yeah, maybe that's what it is, it probably is, well they say girls are more mature and that.

Nancy Would you say it's the risks as well?

Kilo Yeah, the risks involved as well, you know. I mean if a girl really wanted to do it, no problem, but you just don't find that many girls interested.

Nancy What is it that attracts boys rather than girls?

Kilo The excitement, the risks, the challenge. It's those sort of things that attracted me to it. You know, the buzz you get out of the challenge involved . . . pushing yourself to the limit.

In this account, graffiti is defined in terms of relevance rather than capability. As Kilo suggests, its illegal risks and perils are more attractive to boys who use this challenge to push and test themselves. In this version, danger is not just a female deterrent, but rather a less emphatic deterrent to men who depend on it to construct, what Flannigan-Saint-Aubin (1994) would call, 'hard-(w)on' masculinity. As Prime illustrates below, this is an identity that puts 'itself constantly on the line to prove itself and to merit its status' (Flannigan-Saint-Aubin, 1994: 254):

Nancy Why do you think blokes are so into it?
Prime It's part of the image. There's the macho thing to it, the Superman, superhero thing is very much prominent, 'No one can do what I can do, no one can go through what I've gone through.'

Writers define the 'masculine' nature of graffiti using two types of accounts. In one, we are told that, unlike boys, girls lack the ability to cope with the demands of this activity. Here, the 'masculinity' of the exercise is clearly emphasized. In the other, boys and girls are differentiated on the basis of motivation alone. Again, however, we see the male writer as more motivated than the female. Using either account, we gain a vivid depiction of, first, the 'masculine' meanings writers give to their illegal activities and, second, the way they use danger and risk to construct and comment on these.

Proving the point

As a site for constructing masculinity, the graffiti subculture embraces a doctrine of confrontation and achievement (Gilmore, 1990). Writers confront risk and danger and achieve, through this, the defining elements of their masculine identities; resilience, bravery and fortitude. Looking at it in this way, graffiti could be viewed as a form of 'initiation rite' or 'rite of passage' (Eliade, 1958; Raphael, 1988; Young, 1965). While there are many different articulations of these in both primitive and modern societies, their structure and purpose remain the same (Raphael, 1988). All function to dramatize an individual's movement from one status or identity to another. In most cases, the passage is

that of child to adult or, more often, boy to man. And in most cases, it is facilitated by some form of trial, test or ordeal (Phillips, 1993; Raphael, 1988). After all, what this rite or ritual really symbolizes is 'the negation of the weakness endemic to childhood, the affirmation of the strength required of manhood' (Raphael, 1988: 6). And how else is a young man going to affirm this strength or, to put it in more practical terms, 'gain a reputation for being "tough" unless the skills involved are occasionally put to a test' (Werthman, 1982: 293)?

As a working environment, illegal graffiti presents writers with more than enough hazards to test these skills. These include the threat of arrest, the dangers of oncoming trains, and perhaps most importantly, the electrified third rail which powers these. Mear gives us a clearer appreciation of these dangers below:

> We used to cross tracks at stations, which is a real risk. You'll be standing on the platform, jump down onto the tracks and tag the opposite wall. There's three rails and you've got to cross each one to keep your balance to reach the other side. If you're on the third one for long enough and the train's coming, you're definitely going to get fried. I was on it once and I did a tag and I could feel a tingling in my foot and I ran back and the bottom of my shoe had melted!

Faced with difficulties like these, a writer's artistic quest rapidly transforms into a self-evaluating exercise, a test to see just how far they can push themselves:

> It's challenging yourself because nowadays you've got to have the guts to go.
>
> (Col)

> You'll go and do it any time of the day, sometimes not even at night, just to see if you can get away with doing it in broad daylight.
>
> (Ego)

Writers approach this trial with questions of capability so its ultimate seduction generally lies in its point of completion – the time when these questions get answered:

> When I go on the train to do a piece . . . my heart is racing and I just feel that I'm going to vomit. I get out there and I'm like, 'Huh,

huh, huh' and I start painting and then when we actually get out of there I feel great, I'm happy, I'm on the train going home, I feel happy, it's a wonderful feeling of, 'Oh wow, I just did this.'

(Claw)

It's a different buzz altogether doing illegal stuff . . . It's the fact that it's dangerous and you've done it.

(Ego)

I think it's being able to go in, do it, pull it off, come away with photos and know you've done it.

(Kilo)

You get through it and afterwards there's a certain elation because you've done it, you've overcome this fear.

(Freedom)

If masculinity is something that is directed towards certain goals (Flannigan-Saint-Aubin, 1994), then this is the point when these are realized. A writer has confronted danger, dominated fear and, as Freedom conveys, can now walk away with a more defined sense of his own masculinity:

It was a kick when you came out of a train tunnel after you did a piece and I think part of it comes down to keeping grace under pressure. You know, you have trains burrowing down on you, cops chasing you, you have different gangs in there, you don't know what's going to happen and when you finish and you come up . . . you're walking through some ghetto, which makes you feel kind of manly anyway, and you're thinking, 'Yeah I did it.' So there's a certain sense to the illegality.

A writer's masculinity may be self-satisfied through this test but 'to be a man it is not simply enough *to be*: a man must *do, display, prove*' (Miles, 1991: 205, italics in original). The claim to this identity, like any, 'depends upon public acceptance of that claim and social support for expressing that claim' (Emler & Reicher, 1995: 229). Accordingly, evidence of one's masculinity is also presented for others to recognize. By writing his name on a train or in an illegal area, the writer effectively says, 'I was there and it was my courage and resilience which got me there.' The nature of this challenge and the masculine qualities

which enabled its completion are, as Freedom recognizes, authorized by this signature:

> If your name rode by on a train . . . that implies that you ran up a train tunnel, probably late at night, left your parents, faced the gangs and everything else and wrote your name on it. So that's what it was about and the better you did it then the more it implied, like, you stayed there longer, you did it better, you know.

Respect is the key here. Writers do not risk their life and liberty for the sole sake of a written name. They take these risks because they know this will gain them other writers' respect. Acrid illustrates what a writer needs to do to earn this: 'I respect someone, like, new security fences, guards, cameras, they went in there by themselves and didn't have anyone looking out for them, they pieced and bombed the trains and then they got out.'

The meaning of this symbolic capital now becomes clear. Writers do not earn recognition and respect for any old endeavour but, more specifically, for their 'masculine' endeavours – those that incorporate a display of daring and courage. As Prime indicates, no pain, no gain:

> To me the essence of graffiti is working hard, developing style and being able to pull it off under extreme pressure. Only then do you earn the real rewards of respect from people who know the difficulties, seeing your piece run where you managed to retain the style in near complete darkness, hanging off a rusty pipe or standing on a rickety crate inches from a live rail. And of course while you're doing all this, you're shit scared that you're gonna be raided by mad cops and thrown in jail.
>
> (Prime – *Graphotism* Magazine 3)

If respect approves writers' 'masculine' performances, then it also serves to confirm their status as men. Observing respect to be an important currency among sportsmen, Messner (1991) draws a similar conclusion, explaining it as 'a crystallisation of the masculine quest for recognition through public achievement' (Messner, 1991: 69). We can now see why the name plays such a central role within writers' activities. Without it, masculinity loses its accountability and the recognition it needs to confirm itself (Messerschmidt, 1994; Westwood, 1990). As Kimmel (1994) contends: 'Masculinity is a *homosocial* enactment. We test ourselves, perform heroic feats, take enormous risks, all

because we want other men to grant us our manhood' (Kimmel, 1994: 129, italics in original).

The approval men gain from others for 'proving themselves' completes the final and, perhaps, most vital part of this constructive process. Indeed, writers uphold this respect, status or 'approval' as their main reason for doing graffiti. Its importance is also reflected in the subculture's hierarchy which ranks writers in these terms; the greater the danger and risk and thus necessary daring and machismo, the greater the respect, the greater the status, the greater the man. Personal validation of one's manhood is worth nothing without this public reinforcement or recognition (Raphael, 1988). Masculinity is a dramatic affair and when an attentive or physical audience is absent, then some other element of social drama will be incorporated (Raphael, 1988). In most cases, and certainly in this one, this element is competition. Acrid's use of the word 'most' below illustrates how important others are when it comes to assessing oneself: 'Basically, you're proving yourself to be the most artistic, the most innovative, the most daring, the most suicidal, sort of thing.' Writers must be more daring, more suicidal, more artistic and more innovative than their peers because

> Contest/opposition appears to be the masculine modality par excellence and the obvious route to self-identity: I come to know myself only by knowing that something else is not me and is to some extent opposed to or set against me.
>
> (Flannigan-Saint-Aubin, 1994: 244)

Masculinity is not a free-standing asset. It depends upon comparison and, thus, competition and challenge for its significance and profile. This helps to explain why graffiti is such a compulsive activity. If others' achievements can reflect upon, and potentially threaten, one's own masculine status, then masculinity cannot be solidified through one single demonstration. It 'must be proved, and no sooner is it proved that it is again questioned and must be proved again' (Kimmel, 1994: 122). To maintain their subcultural standing, writers must produce, and in response to others' activities, keep producing evidence of their masculine status.

Muscular creativity?

This subculture could not function as a site of masculine construction if its activities were legal. Used as a masculine resource, illegality allows

writers to test themselves, and develop through this, some sense of identity or character. In this way,

> It's like sports or anything else, kids prove themselves under immense pressure. They prove themselves to be leaders, followers, cowards, you know maybe a streak of courage that you didn't know you had and under all that pressure character develops (Pink).

Pink draws a parallel between graffiti and the 'rite of passage' an individual undertakes within a sporting environment. As Whannel (1992) argues: 'There is a close fit between sport and masculinity; each is part of the other, so that prowess in sport seems to be and is seen as the completion of a young boy's masculinity' (Whannel, 1992: 126, as cited by Williams & Taylor, 1994: 215–16). In sport, masculinity is formulated through similar tests of endurance (Messner, 1987, 1991; Raphael, 1988; Westwood, 1990; Willis, 1990) and within similar competitive structures: 'The sports world is extremely hierarchical' (Messner, 1991: 64). The tools that are used to confirm it are also comparable. Like graffiti, one's audience becomes an important source of validation (Messner, 1987), a means 'through which the athlete attempts to solidify his identity' (Messner, 1987: 61).

So these affinities position graffiti, sport and their masculine definitions within similar constructive confines. However, an important difference does remain; graffiti places comparatively little emphasis upon physical skill, force or stamina. While it is demanding, eliminating the effeminate connotations that are often attached to anything artistic, 'it's not as if it's boxing, which is just stupid men hurting each other' (Zaki). Boxers or athletes prove their worth in overtly physical terms. Writers, however, use courage and cunning as their primary credentials. They break into train yards to paint their names and earn recognition and respect for their bravery and dexterity; mental representations of masculinity as opposed to physical ones. The two are very different, but writers see their masculine connotations as synonymous. In the extracts below, Freedom and Proud 2 equate graffiti with the masculine meanings given to football and fighting:

> You know what differentiates graffiti from, let's say, the football player on the high school football team that takes the hardest hit and gets seven stitches in his jaw, that everyone goes, 'Oh look',

and, 'Ah', the next day, 'Did you see that hit he took?', and every-
thing else. That's the exact same parallel with a graffiti writer at the
age of 14, 15 years old.

(Freedom)

The guy that puts the hammer over someone's head is the one
they're going to look at in the pub and go, 'Oh yeah, he's well hard',
and he gets the same sort of respect that someone like Drax will get
for being everywhere. It's just a different way of interpreting that
energy.

(Proud 2)

The writer is granted the same recognition as the footballer who is
esteemed for his physical resilience and the fighter who is respected for
his 'tough' persona. Yet, he enjoys this without having to call upon
physical abilities which he may not have. In sport, 'athletic ability is
like any other form of class privilege; it effectively prohibits, for those
who do not possess it, equal access to competitive success' (Raphael,
1988: 113). On this pitch, however, there are no losers: 'Vandalism
may be attractive not only because it provides a "game" in which a boy
can prove his manhood but also because this "game" is one at which
every boy can succeed' (Gladstone, 1978: 26, as quoted by Coffield,
1991: 49).

Crimes like graffiti introduce risk and danger into the masculine
equation. In doing so, they lessen an emphasis on physicality.
Offenders must be brave rather than strong and cunning rather than
fast. Theorists rarely go this far in explaining crime's masculine affor-
dances. While it is acknowledged for overriding material or finan-
cial restraints (Campbell, 1993a, b; Coote, 1993; McCaughey, 1993;
Messerschmidt, 1993, 1994; Jefferson, 1993), it is seldom seen as a
means of avoiding physical ones as well.

Urban warfare: blowing up masculinity

War makes strange giant creatures out of us little routine men
who inhabit the earth.

(Ernie Pyle – 'Here Is Your War')

The main setting for graffiti has always been the train yards/depots
of the underground or subway system. For a writer with a sense of

adventure and a taste for danger, these forbidden territories are a compelling challenge; a site where they can confront risk, dominate fear and validate themselves as men. But this is not all they represent. Skore, among others, also perceives his working environment as 'a battlefield where we can get out all our pent up frustrations' (Skore – *Londonz Burning* Magazine 2).

This is just one of the many militaristic metaphors writers use to characterize aspects of their subculture. As in many other all-male groups or gangs (see for example Bloch & Niederhoffer, 1958; Katz, 1988; Miller, 1958; Yablonsky, 1962), warfare and combat themes feature heavily in writers' verbal and physical activities. In my mind, these narratives are more than just convenient analogies. In this section, I present them as evidence of the extra work writers put into creating, sustaining and, indeed, amplifying the masculine impact of their actions.

'The theatre of war' – making masculinity a fighting matter

I have chosen to introduce this 'militaristic' theme and the factors inspiring it using Harré's (1993) dramaturgical model or metaphor. Writers present their actions in military terms and I re-present them in theatrical terms, as a form of performance or production. While this helps to highlight the constructive processes at play, it can also be used to show the 'style' of the display – that is, how one does things and the character one acquires from this (Harré, 1993).

Script writing

Their are two main performers on this illegal stage:

1. The graffiti writers.
2. The authorities or, more specifically, the graffiti squads who have been assigned to control graffiti in New York and London.

Their conflicting goals, and the antagonistic relationship they share as a result of this, have given writers all they need to reconstruct this illegal stage into a theatre of war. As Pink proclaims: 'It's a lot like a war, everyone sneaking around in dark clothing at night, that kind of thing.' A new script is written and roles are changed accordingly. Writers now play the outlaws and the authorities their enemy: 'To go bombing, it's like the cops on the outside are your enemy. You don't know what's going to happen, you get chased, get arrested' (Col). The old plot is also revised. The enemy's moves are no longer

deterrent measures, but rather battle tactics which writers oppose in the hope of claiming victory. Their mission: 'To take over London and to fuck LRT [London Rail Transport]' (*Londonz Burning* Magazine 1).

The battle centres around a fight for power and control of the subway/underground system. Although writers do not and will never literally control this, they use their graffiti as a symbol of domination. As Prime asserts during a period of time when London writers were particularly active: 'Early '87, the underground system nearly got completely taken over.' The authorities' failure to keep their trains free of graffiti is taken to signify the subculture's supremacy. 'We're running this system', declared one piece of graffiti I saw.

Prop changes

In keeping with this new script, old props are also replaced. By using military terminology to describe their actions, writers transform their spray can into a symbolic weapon of war. As Proud 2 observes: 'It's almost exchanging a gun for a spray can.' Through this, the writer fires *'hits'* (tags) like bullets. Unlike the 'tag', which declares 'I'm here', *'hits'* proclaim, 'I'm here and I have the power to wreak havoc and destroy.' Although *'bombing'* involves the same action as 'tagging', the emphasis on the name is overshadowed by destructive intentions. Drax conveys the kind of tone in this quote: 'Bombing rampages. [. . .] Think about the sheer power of it, the power to shock, to disgust, to excite, to destroy, all in the same instance' (Drax – *Graphotism* Magazine 3).

In the same way, pieces are *'dropped'*, like missiles, to *'burn'*, *'kill'* and *'destroy'* the trains and walls they land upon. Even writers' tag names (see Figure 6.1) and styles orientate towards this warfare: 'His pieces are well armoured with style for combat' (Prime – *Graphotism* Magazine 6). The resulting damage may be 'buffed' (chemically removed), but the enemy's trains must still carry the *'scars'* of this battle. These are faint and jaded outlines of destruction which stand as a testament to the subculture's victory.

Costume design

By using their graffiti as a weapon, writers fight rather than paint. Accordingly, a costume change is also called for. Writers exit as a band of artists and enter as an army of soldiers. The language and imagery they use to portray themselves suggest this is an identity they want and enjoy. The excerpt below describes, from a writer's view, a scene

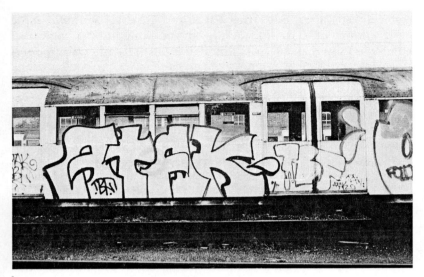

Figure 6.1 'Atak' on the London Underground (*Photograph*: Inspector Chris Connell)

during a 'train jam'; an organized attack upon the underground system by a large group of writers:

> Slowly hits are beginning to appear, everybody is fighting for the best panels, the carriage stinks and is thick with mist. With the carriage totally killed, we move down to the next one, fucking that too. [. . .] We're clambering down across the tracks and battering the outside panels. A tube pulls in next to us, the doors open – Rads!, fucking loads of 'em! We run down the train, force into the driver's cab and kick open the backdoor. Everyone is pushing to get out. We jump from the train and run off down the tracks [. . .] the rads are everywhere. The escapes that night are stories in themselves.
>
> (Kers – *Londonz Burning* Magazine 1)

This account is drenched in militaristic imagery, tone and meaning. In his description, the writer presents the event as if it were an army manoeuvre; an operation which is disrupted and abandoned as the enemy launches an unexpected attack and the writers disperse. The press appear to be equally charmed by this militaristic rhetoric (Katz, 1988). In reference to the above event:

The invaders 'bombed' six trains in the space of about two and a half hours. [. . .] They say the operation was well organised. [. . .] Most of them managed to escape through the system's maze of tunnels.

(Newspaper excerpt printed in *Londonz Burning* Magazine 1 – source unknown)

This reporter thus joins the subculture's script writing team; the 'invaders' (writers) 'bombed' (vandalized) several trains during a seemingly organized 'operation' (event). . . . But most of them 'escaped' (got away). The military identity that writers embrace is clearly reinforced by this reporter's selective choice of words. This probably explains why I found it proudly displayed in one of their graffiti magazines.

Graffiti magazines are an important part of this production because they provide writers with the collective voice they need to sustain their identity as an army. Using this vehicle, Prime alludes to the writers as a unified group bound by a common goal:

One chief of BTP [British Transport Police], asked who he thought would win the fight for the lines, said the writers would because there's too many writers and too many yards that can't be covered at the same time. Damn, look what's happening now in the '90s, we're giving it to them! So be careful, develop styles, be professional and, most important, keep your house clean. Without hard evidence, their hands are tied.

(Prime – *Graphotism* Magazine 3)

Like a high-ranking military figure, Prime feeds his army tactical advice and tries to rouse their spirit and resolve. The writer below adopts a similar tone and urges others to share combat intelligence with the uninitiated – the lower regiments of the army who urgently require this expertise:

The writers are very inventive. Pens are made to make fat marks and new inks are mixed to repel buffing. All these are highly secret tactics in the war and new writers have to really struggle to find out methods. [. . .] New writers must be schooled by those for whom it is too late, so that the culture learns by its mistakes.

(*Londonz Burning* Magazine 1)

This display of unity is more than just an identity prop. Writers depend on a certain degree of connection and contact with each other to keep them one step ahead of their enemy. As Drax explains:

> It keeps the networking going. People do trains in certain spots and it's a done thing to discuss what they did, where they did it, when they did it, how easy it was, did the security come and also show off their photographs.

Writers' crews are important in this respect. A crew is a group of like-minded writers who band together under a single name to form a union. Crews can be small or large, illegal or legal, local or even international. But they all share a common purpose – support: 'It's like you start moving in a firm. You get information about where to get your paint from. If they go to a yard and it's safe, they phone you up and go, "Yeah, that yard's safe". We're like a gang sort of thing' (Rate). Crew members also tend to paint together. When you find yourself in enemy territory, trustworthy accomplices are all-important:

> *Nancy* So what's the point of a crew?
> *Kilo* Security. You know if you're going to a yard, you want to be with someone you know, someone who's not going to grass you up if they get caught, someone who's going to look out for you, like you'd look out for them, sort of thing.

In this light, a crew could be seen as a subunit of this subcultural army, a writer's squadron, as it were. Popz makes this implication explicit: 'The crew or platoon I currently paint for is KIA, Killed In Action, a crew consisting of various artists and vandalz from the city who come together to form an understanding. We shall overcome' (Popz – *Londonz Burning* Magazine 1).

Writers use their illegal status to transform their subculture into a world of warfare. Analysing this theme within a dramatic frame of reference helped me highlight its constructive significance. This is not really a war, the subway system is not really a battleground, the writers do not really fight, the spray can is not really a gun and the subculture is not really an army. They become these things through the work writers put in both on stage and behind the scenes. They write the script, they act the part and they design the costumes and props which sustain the authenticity and quality of this production. While the media also help out, one more name must be added to this list of final

credits – the authorities. Ultimately, they play the most important, albeit inadvertent, part in this production – the leading role. Without their opposition, there would be no enemy and without an enemy, there would be no war. As a way of illustrating this, the spotlight will now be placed on the battlefield; that is, the train yards/depots where these two enemies actually fight it out. This scene change will allow us to see how combat themes gain their significance through action, as well as talk.

Breaking and entering enemy territory

It's about 10.30 p.m. It's dark, drizzly and I'm in the Bronx in New York waiting outside a subway station for a group of writers who have agreed to take me with them to paint freight trains. I don't know the area, I don't know all the writers that are coming and I don't exactly know what I'm letting myself in for. On all counts I'm feeling nervous.

The three writers I'm meeting arrive (late) and after brief introductions we start to make our way to the train track. It's a 20-minute walk or so, and I use this opportunity to try and get to know the two writers I have never met before. It's hard. At times like these writers are not really in the mood for 'meet and greet' niceties. They have other things on their minds. Like athletes before a big competition, they tend to go into themselves and mentally prepare for the challenges that lie ahead. I let them get on with it. But their sombre moods do unnerve me a little. I am wondering whether this is about to turn into one of those 'I wish I could rewind my life and make another decision' situations! My instincts don't give me a clear answer, so I ignore my concerns and keep going.

We continue along this road and after a while it dawns on me that we are actually climbing uphill instead of winding down to the train track below. I ask what may seem like a stupid question, but we arrive at a highway bridge and I get my answer. From here we get a good aerial view of the train track we are going to follow. This precautionary measure allows writers to check for signs of trouble or activity on the train line; one of the afforded luxuries of painting overground trains! Everything looks clear so we make our way down to the hole in the fence entrance below. There's a hitch: the hole in the fence entrance no longer exists. There is no sign of it. Anywhere. An argument starts and blame begins to get thrown around, as it always does when things do not go according to plan in a pressurized situation. 'So and so should have come down earlier and done a recce to make sure everything was in order.' 'So and so should have done it himself if he was so worried.'

'So and so should have double checked with another so and so who came and did this yard a couple of weeks ago.' 'That so and so would never have told us because he doesn't want loads of people doing this yard and making it hot.' . . . The writers thrash out their frustration for a bit and then get back to the task at hand. These difficulties delay us, but they do not deter. We search for and eventually find a new gap in the fence further up. After a 15-minute wait to double-check for signs of life on the other side, we climb through and our mission resumes.

We proceed down the train track to the lay-up where the freights are housed. It's stop/start progress, as any sight or sound of an approaching train on our track or any other sends us scrambling into the trackside undergrowth to make sure we are not seen and reported. The mood is different now we are inside this fencing. There is a sense of urgency. The writers have stopped talking and are now communicating using sign language, just in case there are track workers around. Ten minutes down the line we get to the lay-up, a small section of track set back against the rail banks. Moods lighten a little. There is no one there, writers or otherwise, which means they have two very large trains at their disposal. The writers pick their spots, unpack their paint, take out their sketches and get started on their outlines. While they do this, I keep watch, using this opportunity to soak up the atmosphere and reflect on what makes this such a captivating part of the graffiti experience. Here we are on a quiet, dark overgrown stretch of railway line, removed from the hustle bustle of the city and its familiar references. It's a weird sensation of calm and exhilaration. Because while the world feels almost tranquil out here, I know we are actually in all sorts of danger. It's a situation which could go either way. We could be lucky and get in and out of here without being seen. Then again, we could round a corner on our way back and BAM, suddenly find ourselves neck deep in trouble. You can react out here, but you can't plan and predict. In a funny way, it's a nice reprieve from the 'real' world where you are expected to plan and predict everything from what you're going to wear in the morning, to how you are going to run your life.

This gut-level, raw, almost primal experience of fear and uncertainty is an invigorating one and, as many theorists have recognized, a key ingredient in the whole venture (Campbell, 1993b; Katz, 1988; Willis, 1977). Without risk, the adrenalin-fuelled excitement or 'buzz' factor is lost (Csikszentmihalyi, 1975). And without this, a writer's adventure becomes nothing more than a routine exploit: 'We do trains because it's a buzz. To do a wall ain't the same, it's just dead, no excitement' (Rate). Fences, laser beams, cameras, security guards, patrol dogs and a

multitude of other imposed dangers and obstructions make this a gru-elling task. But they also make it an exhilarating one:

It's like one big adventure every time we go to a depot.

(Acrid)

It's a buzz as people say. It's exciting, it's funny, it's adventure. It's an adventure which is criminal, but not madly criminal, get into a bit of danger, you know.

(Stylo)

It's a lot more exciting . . . for the sake of playing the old cops and robbers kind of thing. You get to run and hide and the rush of getting away with it, so it's more like a game.

(Pink)

Pink classifies this as a 'cops and robbers' type scenario, highlighting the all-important presence of an enemy or opponent. Proud 2 goes even further and draws this comparison: 'I mean if you go into a tube train yard, if you did that in World War II, you'd be going into a city and trying to blow someone up.' Like a soldier entering enemy confines, the writer must work around security measures and complete his/her mission undetected. It is a war and, as we can see in Acrid's account of this procedure, nothing stands in the way of victory:

I went out the front of the station pretending I was waiting for a night bus, just killing time. . . . The security guard drove past me . . . and it goes down to the car park, parks in the corner with all the lights off and, basically, what they do is watch everyone jump over the fence, let them do their pieces, then call the police straight away. By the time they arrive everyone gets caught. So I have to think. I have to do this yard, there's no two ways about it, like this guy's not going to stop me. . . . So what I did is come from the other side. There was these bushes and I crawled underneath, . . . and it was raining, so I was really filthy. . . . There's offices above, like LT [London Transport] offices, and there were people in there, so I get myself in a position so, as I get the moment, I'll run across. So it takes me about two hours to get into this depot and I was crawling and being really careful so they can't see me. So I see it's all clear, I run under the platform, over the lines and climb in between the trains, so I can't be seen. So I start my piece and the paint is, like,

clogging up because of the weather, because it's so cold and my fingers are going numb, so I'm having to use really thick nozzles so paint spurts out and there's less control of it. So it takes me two hours to piece this piece that normally take 40 minutes. . . . Then I went and bombed all the other trains, including the one right in front of the security guard . . . I ran out of the yard as fast as I could, up the embankment and stashed my paint.

There is a paradox at play here and my own train yard experience in New York allowed me to see it in action. Ironically, the difficulties we faced did not inhibit my chaperones, they only increased their determination. For a writer, there is no such word as 'can't': 'Their obstructions just make the thrill more exciting, trying to get in. There's always a way, there's always a way in, always a way' (Mear). The authorities present writers with an irresistible challenge and strategies will be used to ensure this is always met:

The average graffiti offender appears to keep a potential target under observation for a considerable amount of time before the actual attack and, to be quite frank, they appear to be better at seeing police in sidings than we are at seeing them.
(Inspector Connell – *British Transport Police Annual Report*, 1990)

Mear confirms Inspector Connell's suspicions:

Almost every yard is barbed wired now and has got security guards walking round every ten minutes or every half an hour. We've been to yards and sat somewhere and watched the whole depot for like three or four hours, just timing the security guards, what time they came out the shed, walked round and went back in. . . . We'll let them get on with it and then they go back in the shed for half an hour and we jump down, do what we got to do in half an hour and get back out. So by the time they walk round again, it's already there. . . . I've done something, come out and just watched them come back in the morning and they see it, 'Those bastards have done it again!'

The scenario evolves into a chess game, as writers pit themselves against and attempt to surpass the authorities' deterrent measures. Challenging the view that young offenders are impulsive, unintelligent and unrestrained (Willetts, 1993), the writers' moves are strategically planned and ceaselessly enterprising:

What they do now, they just, at random, pick a yard and go and raid it. . . . We was just monitoring their program at the time. We'd, like, work brains with them because, like, we'd do it for a couple of months in a row at, like, twelve o'clock and they'll be in there at one o'clock thinking we're still in there and the piece will already be done. Then we'll go in there at three o'clock in the morning. . . . We were just running circles around them. Keep a little pattern going for a while and when we think they're onto it, change it.

(Mear)

Running the lap of honour

The last step to victory involves the 'running' of the writers' work on the underground/subway/train system. This circulation indicates that the authorities have been unable to stop writers entering the yard, have not detected them at work and, finally, have been unable to prevent the train from running. As Zaki declares: 'It's a real show of defeat if they send it out.' While this exposure is an important symbol of triumph, writers also depend upon it for fame, inspiration and, as Prime specifies, the survival of their subculture: 'Graffiti survives because it feeds off itself. The more that's seen, the more is done' (Prime – *Graphotism* Magazine 3).

Recognizing this, the authorities employ their own tactics: 'Graffiti breeds, therefore the adoption of a quick clean policy is of paramount importance' (Inspector Connell – *British Transport Police Annual Report*, 1991). Writers are well aware of this policy and its apparently selective application. In Kilo's view, the Transport Police are not lacking in their own astuteness:

If a train's been bombed, like throwups, tags, whatever, they'll run that for about six months. . . . But a piece, if someone did a window down, whole car top to bottom, whatever, full colour, they'd never run that unless they had to. They're worried people might see it and like it . . . they're worried the public might think, 'Why are they spending all this money, it's not that bad', as long as they run the bombing.

As always, writers rise to a challenge. Mear outlines some of the tactics they use to impede this particular practice:

What we'd do is go to a depot like Gloucester Road. There'd be five trains in there, we'd do a nice whole car on one and totally abolish the other four, just battering it, so they'd have to pull out the other

four and let the half decent one run with the pieces on it. . . . Or you go to a depot and if there's five trains in there, you take ten writers and you piece all five trains, so there's no way they're going to pull out five trains in a day.

Alternatively, writers may force the authorities into running their work by playing with their knowledge of transport schedules and procedures:

They don't like cleaning trains on Sunday, so we'd do Sunday, 80 to 90 per cent of it will run. The worst day is Friday because they just keep the trains in and do them over the weekend. Also if you know the train positions in a depot and you know the ones they can't take out of service, like the early morning ones, once they're running, they have to run all day. . . . Basically, the trains on the outside of the depots are less likely to run. The ones in the shed tend to run more often.

(Acrid)

Writers delight in outwitting their enemy. For some, this game of cat and mouse is an even greater source of enjoyment than the act of painting itself: 'It's a big game. That's why I do a lot of graffiti, you play games with them' (Acrid). This comment reminds us that 'It is not so much what people do, but how they perceive and interpret what they are doing that makes the activity enjoyable' (Csikszentmihalyi, 1975: x). Perceiving this confrontation as warfare changes a writer's priorities and pleasures. Outsmarting and humiliating the authorities is no longer just a means to an end. It becomes, as we can see below, the whole point of the exercise:

Drax and Skip did a piece right opposite the police headquarters and it's still there . . . I mean if that's not a blast in the face to the police! It really makes them look stupid. It's like doing a whole piece on the side of Scotland Yard and getting away with it.

(Mear)

In this 'strange dance of criminality and enforcement' (Ferrell, 1996: 159), the enemy ceases to be a sideline concern and becomes the focus of writers' activities:

Lee A lot of people just bomb because of the BTP [British Transport Police].

> *Kilo* Yeah, I think it's like a revenge thing more than anything.

Kilo references revenge as the reason for their directed fight. However, as I go on to illustrate, this is not the only factor inspiring the ferocity of this war.

The subculture and the squad as two of a kind

The writers' relationship with the graffiti squad or British Transport Police (BTP) is distinctive, differing from their relations with other 'outsiders'. As often exemplified in 'cops and robbers' style dramas,

> *Kilo* There's probably even a certain amount of respect between us and them to a degree, that weird sort of respect, I don't know what they call it. But it's like when I was getting dealt with in my court case, the BTP guy who was dealing with me, we was like on first name terms, like he was dropping in for tea and stuff and trying to get me to grass myself up.
>
> *Lee* Yeah, but he's sly.
>
> *Kilo* Yeah, he was sly, but like in a certain way.
>
> *Nancy* Was it like a game?
>
> *Kilo* Yeah, yeah, yeah, it was. He knew, when he was trying to do me, he knew exactly, he knew it was me, but he just couldn't prove it. Like I said, he was just trying to, like he came into my work, like twice, trying to interview me at work. It was funny.
>
> *Lee* They're pretty crafty.
>
> *Kilo* Oh, but they've got to be though.

Kilo suggests almost a bond between them. This connection has been noted by others and related to the similar values that cop and criminal cultures embrace (Campbell, 1993a, b; Fielding, 1994; Reiner, 1992). Mirroring the writers' stance: 'Undoubtedly, many policemen see their combat with "villains" as a ritualised game, a fun challenge' (Reiner, 1992: 113). We see this affinity expressed and, indeed, recognized in the account above. By referencing their mutual respect, Kilo implies a mutual understanding, an appreciation that they are players in the same game. Bringing this relationship even closer, they also play for the same prize. Like the writers, the graffiti squads are struggling for control of the underground/subway system. What is more, their attitude towards this bears striking similarities: 'Don't ease up. The risk of relaxing in the fight against graffiti can be sadly demonstrated by a look at Brussels' (M. K. Scanes, Graffiti

Management Ltd – *Developing Metros*, 1991). Like the writers, the squad view their task as a fight. The rousing tone of this address is also comparable.

The writers maximize these apparent similarities by viewing the squad within their own frame of reference. In this next quote, Mear refers to the squad's attempts to raise their profile in subcultural terms, as a desire to 'make a name for themselves': 'They had new people join the graffiti squad and they wanted to make a name for themselves, so they started raiding quite a few people just for the hell of it.' Further affinities are playfully illustrated in the quote below:

> The Vandal Squad love graffiti. Their job requires them to forage for graffiti as much as you do. When you wreck enough walls, they'll want to meet you. Just like jock swingers [adoring fans], they'll recite every spot you hit.
>
> (Mark Surface – *On The Go* Magazine, Dec. 1993)

In New York, these similarities are intensified by the squad itself. As Cavs explained to me:

Cavs See this piece here, it got crossed out. See the 'V', the cops crossed it out. They do 'VS' for the vandal squad. They do that 'V' and then they circle it. By crossing my piece out, that's like a warning, you know.
Nancy Does that say toy [incompetent writer] there?
Cavs Yeah, the cops did that. Yeah, they know all about it, they know everything, that's their job, you know. . . . See all the V's, they ragged [messed up] our whole car. Look at this beautiful whole car and the cops crossed it out. You know why? Because that's disrespecting us.

By writing their own distinctive 'tag', using the subculture's terminology and crossing out writers' work to disrespect them in their own terms, the squad remove their 'official' mask and effectively present themselves as a rivalling graffiti gang. This might explain why the writers' battle against them is so personal and directed. Their fight for control of the lines becomes less a subculture opposing an authoritative body and more a confrontation between two rivals of equal and similar status. Reasons for this culture clash become even clearer when we consider what this control actually signifies.

May the best men win

Masculinity may be constructed through crime, but, as Messerschmidt (1993) observes, it is also constructed through police work. Through controlling crime, police officers formulate a collective form of hetero-sexual, hegemonic masculinity (Fielding, 1994; Messerschmidt, 1993). Through evading this control, criminals construct a similar form of identity. As masculine expressions, both celebrate mastery and control (Campbell, 1993b), and virtues of stoicism and fortitude (Fielding, 1994). Like the subculture, 'The police world is one of "old-fashioned" machismo' (Reiner, 1992: 124).

While these identities are linked by their similarities, they are also joined in their differences. Where one succeeds, the other fails. Where one wins, the other loses. The police must control deviance to claim their identity, the deviants must evade this control to claim theirs. It is a 'zero-sum contest', as Raphael (1988) terms it, one is always con-structed at the expense of the other.

In this light, the conflict we see here might be better viewed as a battle of masculinities. Not so much rival masculinities competing for hegemony (Connell, 1989), but more similar masculinities fighting for potency. Warfare represents combat for control of the train system, but underlying this is a struggle for masculine supremacy. Given the effort writers put into scoring this off each other, it is hardly surprising that its group equivalent is so fiercely defended. The stakes are high. Losing this battle means that the defeated party was not cunning enough, daring enough, tough enough and, therefore, 'masculine' enough to stand the pace. Victory is understandably important and writers will put everything they've got into achieving it: 'They don't understand, the more they try to stop it, the more it will keep up. . . . I'm telling you, the more they put pressure on, the worse the destruction will become' (Claw).

In presenting their obstructions, the authorities effectively ask writers to 'come and have a go if you think you're hard enough'. Basically, they lay down a challenge and ask their opponents to defend their masculine honour and dignity through acceptance (Polk, 1994). Writers take this challenge very seriously. Dignity is an important concern, especially for an adolescent group like this one:

> Some recent studies of adolescence have shown many young people to have an almost obsessive interest and preoccupation with the maintenance of dignity and the careful scanning of the social envir-onment for occasions and acts of possible humiliation. When such

acts have been identified some adolescents may undertake violent retaliation, which in their view has the aim of restoring the dignity that they have lost.

(Harré, 1993: 30)

Supporting Harré's (1993) observations, Drax rallies the defeated troops:

We have just recently come through a huge onslaught of action by the British Transport Police graffiti squad, one, it must be said, we didn't even see coming. Admit it, we lost that battle, [. . .] So wake up Britain, the war is on again after the recent heavy defeat at the hands of the graffiti squad in our last battle. Don't deny it, face the facts, learn the relevant lessons, re-arm, re-group and analyse strategy, for this war is far from over.

(Drax – *Londonz Burning* Magazine 2)

Defeat does little to dampen down writers' spirits. Ironically, it just makes them more determined to win: 'Whatever they do, there's always a way. . . . They're doing all that, it just makes you more determined to beat them' (Kilo).

When a battle is won, it is celebrated. By dedicating their pieces to their defeated enemy, writers revel in their glory:

You can leave a message to the BTP like, 'Ha, ha, caught you sleeping', or, 'Phone crime line', something like that, that's going to get to them.

(Steam)

The graffiti squad have really taken some stick in the past. . . . You do a whole car and you put, 'PC Knight is a fat git', on the end and that bit will run for months and everyone will see it and he'll probably see it everyday running past Baker Street [Squad headquarters].

(Mear)

Even face to face, provocation prevails. When the British graffiti squad failed to secure Drax's long-awaited prison sentence, he used this as another opportunity to mock their incompetence:

The whole graffiti squad, every single one of them, was at my court case on the Monday. They had a whole section of the seating. . . .

There'd been all this big hype and big roll with graffiti and stuff, okay, and I think I was just going to be the icing on their cake. . . . And then, of course, when I got my fine and community service, it just totally backfired on them. It was hilarious. Steve Cattel, who was in charge of my case, had always been alright, always been totally fair, always been friendly, like jovial . . . but then when I came out afterwards and was like, 'Nice one Steve', he just looked at me and his face was, like, so gutted, really, really, like badly, just so gutted, ha, ha!

What we see here is a celebration of masculine supremacy. On these occasions, the writers were more cunning, astute and skilful and the authorities lost their fight for this status. Any attempt to do this quietly or gracefully was also denied. Using these antagonistic gestures, the writers uphold their enemy's failings and force them to confront and remember them.

Single combat: the personal spoils of war

Like brothers in arms, writers join as one in this fight. Masculinity becomes a group attribute and a matter of subcultural pride and dignity. However, it is still the individual writer who defends and bolsters this. So how does this 'war' influence individual constructions of masculinity?

From writers to warriors

Warfare has always carried masculine connotations (Arkin & Dobrofsky, 1978; Raphael, 1988). One only has to look at how new recruits used to be lured into service to see the association: 'Join the army, be a man', 'The army will make a man out of you.' Such promises are, in many ways, understatements. The army fosters and celebrates extreme masculine virtues (Coote, 1993). In doing so, it does not merely offer soldiers a chance to be or become 'men' (Arkin & Dobrofsky, 1978; Rutherford, 1988; Coote, 1993; Raphael, 1988; Segal, 1990). Rather, it pledges to make 'supermen', men of all men:

Of all the sites where masculinities are constructed, reproduced, and deployed, those associated with war and the military are some of the most direct. [. . .] the warrior still seems to be a key symbol of masculinity.

(Morgan, 1994: 165)

In changing the script, writers have transformed their subculture into a militaristic world of mass machismo, an environment 'within which the cult of masculinity, *per se*, is celebrated' (Campbell, 1993a: 45, italics in original). Here, young men do not just become tough and daring writers. They become brave and honourable soldiers, warriors or, as Morgan (1994) maintains, 'key symbols of masculinity'. Put simply, warfare pumps a massive measure of machismo into writers' already 'masculine' actions.

'Wanted'

Writers use the respect and recognition of their peers to validate their masculine identities. The introduction of an enemy ensures this process no longer rests among writers alone. As Acrid illustrates, the graffiti squad provide writers with another audience for their displays and, with this, another source of respect: 'Fame and respect, there's the two driving forces . . . not just from the scene, even the graffiti squad give you a certain amount of respect.' Coming from an outside source, attention from the authorities carries extreme prestige: 'We were the most wanted graffiti crew for two consecutive years. I was the most wanted graffiti writer, with "The Fabulous Five", in '77 and '78 by the TA [Transport Authority], and those guys are priority number one!' (Lee). Lee recounts his wanted status with a sense of pride and it is not hard to understand why. If being a famous outlaw is the whole point of the exercise, then what better way to have this confirmed or, indeed, enhanced than having one's name etched on the enemy's hit list. If the enemy knows you, then you must be bad!

> Nobody wants to get caught, but after they've been caught, which they nearly always do at first, they think they're there now, known to the police and, 'I've got a name', you know, 'I'm a big boy now, the police know who I am, they'll be watching out for me.'
>
> (Mear)

More opportunities for glorifying this status are presented in the theatre of the courtroom (McCaughey, 1993). Acrid provides us a dramatic rendition of his court case:

> A lot of officers were involved in my court case and the amount of witnesses! If you had come to my court case there was boxes and boxes of paperwork like no one's business and there were eight defendants and seven barristers between them, like seven clerks. The

big day of the sentence, the court room was absolutely packed, like, relations in the gallery, reporters, the old graffiti squad, the new graffiti squad. Like, when I was going up there, I'd be getting photographed and all that.

Here the writer takes centre stage. A small bit part swiftly becomes a leading role and the show sells out as the public cram in to watch the celebrity in action. After-show reviews follow, but their negative write-ups are unimportant. A folk devil, as Acrid illustrates, can easily be subverted into a folk hero (McCaughey, 1993):

I made front page, like I made every national newspaper, radio and TV. I was treated like a celebrity in the pub and all that. Like my cousins, when they went to school, they were like, 'Oh my cousin's Acrid', or whatever, 'He's been on TV', superstar sort of thing!

Contact with the authorities may, therefore, have its drawbacks, but it also has its perks. Their attention does not just validate a writer's identity as an outlaw (McCaughey, 1993; Yablonsky, 1962), it also bolsters it. Acrid is well aware of the irony:

Getting caught is an occupational hazard, it's accepted. But the way it was done with me was over the top and people see that. The police made me look bigger than I was by refusing me bail and having me kept on remand so long and all that. And the way they treated the court case as well. They asked the reporters to come down because they were expecting me to get another year or two in jail. They wanted to make an example of me, but it backfired on them.

It backfired on them because they ended up giving Acrid more of what he was being prosecuted for trying to obtain in first place – fame and notoriety. With one's name in lights, prosecution begins to lose its negative overtones: 'If I get caught, as long as I'm on the nine o'clock news, I don't really mind!' (Akit).

In the last two sections of this chapter I have presented illegality as a resource which writers can use to build, confirm and even amplify their masculine identities. In doing so, I have made an important but, as yet, unstated point: this crime has a purpose. Graffiti is not a mindless destruction of public property. It is a means to an end – specifically a masculine end. This introduces an agentic angle into the picture of crime, one which is very much lacking in the analytic portrait painted

by the labelling theory (Emler & Reicher, 1995): '*Social groups create deviance by making the rules whose infraction constitutes deviance* and by applying those rules to particular people and labelling them as outsiders' (Becker, 1963: 8–9, italics in original). Making a link between deviance and society is useful, but focusing on the reaction alone obscures the reasons why an individual may be committing the crime in the first place (Downes & Rock, 1982; Heidensohn, 1989). We see the actor as acted upon rather than acting, labelled through no fault of his/her own. The underdog comes out on top, but they are stripped of intent and motive and portrayed as nothing more than the 'passive playthings of labelling processes' (Gouldner, 1970, as cited by Heidensohn, 1989: 76).

What Becker's theory neglects is the *role* of illegality. Here, we see it function as the subculture's backbone. Without it, the threat, danger, challenge or test and the fame, respect and masculinity that writers earn from completing this, would be lost. Fun must also be added to this list. The enjoyable aspects of crime are often overlooked (Jefferson, 1993; Katz, 1988), but, for writers, they are all important:

> *Nancy* So what if it was legal?
> *Claw* I would never do it. If it's legal anyone can do it, who cares! If they said, 'Hey come bring your little card, you can get spray paint, you get a designated wall', it would be utterly boring.
>
> It defeats the point if, all of a sudden, you're allowed to do it . . . it's not the same as blatantly running around and just going on a mission.
>
> (Akit)

> *Nancy* If it was legal would it lose its appeal?
> *Col* Yeah, because then there'd be no threat, graffiti would be a waste of time. I go bombing for the excitement, it's like I get a great adrenalin rush out there, I really do.

Becker (1963) fails to acknowledge that deviance often has a purpose. That, in cases like this one, breaking the law is not accidental, it is deliberate – a gesture of action, rather than mere reaction (Emler & Reicher, 1995).

In accounting for the ways social control increases deviance, Wilkins (1964) makes the same mistake. Again, the deviants are victims rather than perpetrators. Deviance is seen to escalate, not because individuals gain from this process, but because they lose:

The definition of society leads to the development of the self-per-
ception as 'deviant' on the part of the 'outliers' (outlaws), and it is
hardly to be expected that people who are excluded by a system will
continue to regard themselves as part of it.

<div align="right">(Wilkins, 1964: 92)</div>

While it is important to recognize the power and inertia of institutional
forces, in the words of Emler & Reicher (1995: 7): 'It is equally important
to recognise that people may also adapt, shape and seek to use for their
own ends the definitions thrust upon them.' Emler & Reicher (1995)
rewrite Wilkins's (1964) chain of events by making the reputation one
gains from crime its cause, as well as consequence. Graffiti follows this
modified script. Writers keep up their illegal activities because they want
to sustain the image or definition that has been imposed on them.
Graffiti is not a gesture of frustration or alienation (Wilkins, 1964)
because being an 'outlaw' is the whole point of the exercise:

> It's against the law, you know at that time when you're growing up
> it's like you're just an outlaw, you know. You don't have a horse,
> but you can be like an outlaw, you're out in the wild west. . . . The
> whole thing about graffiti is being an outlaw.

<div align="right">(Sae 6)</div>

In short, the part the defining agencies play in encouraging deviance
has been badly miscast. Yes, making graffiti illegal and reacting to it as
such sustains its existence (Wilkins, 1964): 'I think that the actual
essential thing is the fact that it is illegal. If you took that away from it
then it would never exist or it wouldn't carry on to exist' (Proud 2). But
for different reasons. Its forbidden status provides writers with their
thrills and spills, while also granting them the tools they need to
fashion their masculine identities. Just as masculinity is carved out of
conflict with school authorities (see for example Connell, 1989;
Messerschmidt 1993, 1994; Willis 1977), so is it defined in similar ways
through opposition against this body of law.

In among the boys – involvement as the female 'other'

Very few girls seem to write graffiti. I conducted my fieldwork for over
two years and during that time I heard of few more involved than the
three I interviewed, namely Pink, Claw and Akit. The lack of women
within subcultures has been recognized and related to a number of

different factors: their experience of greater parental control, their domestic apprenticeship within the home (Frith, 1978, as cited by Brake, 1985) and their differing interests and concerns (McRobbie, 1980; McRobbie & Garber, 1976, 1991). Using the arguments of this chapter, I would endorse one more reason for their absence. Namely, that girls 'organise their social life as an alternative to the kinds of risks and qualifications involved in entering into the mainstream of male subcultural life' (McRobbie & Garber, 1991: 7) because these risks and qualifications offer themselves as tools for a typically masculine, as opposed to feminine, identity.

Researchers have been slow in acknowledging the subculture as a site of masculine construction. As a result, they have been slow to observe the related implications of the female member's absence or indeed the inferior role she usually occupies when she is present. In the past, this role has been understood as a reproduction of the subordinate status women occupy in wider society (Brake, 1985; McRobbie & Garber, 1991). However, located within a setting where masculinity is made, it is perhaps better understood as a position that has been enforced upon her by boys who are trying to protect their masculine credibility. A girl who can do the same thing as a boy has the power to silence his masculine commentary. Unless, that is, she is relegated to a place where her actions have no volume; a girl on the subcultural sidelines is going to have very much less to say than a girl on the pitch.

In this section I look at the difficulties Akit, Claw and Pink experience as female writers and use these to illustrate two things. First, the apparent threat they represent as women. And second, the different ways male writers deal with and try to deflect this. In examining their struggles, I fill in some of the gaps left by other theorists. Many have told us that girls are excluded and relegated in subcultures, but they have not told us how. Likewise, the female member's response to this subordination is also neglected, leaving us with a static picture of unquestioned gender relations. I bring this picture to life in this section by referencing the, often silent, female 'other'. The story she tells will provide us with a rich understanding of the ways she is marginalized by her male peers and the tactics she uses to oppose and override these measures.

I should note that, while I am sure there are other writers who have attitudes and experiences that differ from those presented here, the similarity of the accounts I obtained in both New York and London suggests this is a fairly standard depiction of gender relations within this subculture.

Hurdles of acceptance – overcoming female distinction

Let us start by looking at some of the obstacles girls face. This section will examine womanhood as a hurdle of acceptance, a blemished distinction that female writers must try to suppress to earn a place among her male peers.

Holding back the tears and the flowers

As we heard male writers explain earlier, girls do not really do graffiti because they are not brave enough. How then do male writers explain a girl who shows an interest, and, thus, the guts to participate? They find another way of differentiating her. In the quote below, Steam talks about going with a girl to a train yard. Again, he references her as behaving differently from boys. She may be courageous, but she is not capable of coping with the pressures:

> *Steam* I couldn't handle going to a train yard with a girl hanging by, then all of a sudden we get raided and, like, this girl would be panicking, she wouldn't know where to run, what to do, she wouldn't be able to run that fast and she would get us all caught. I wouldn't take a girl to the yards.
> *Nancy* What makes you think a girl couldn't handle it?
> *Steam* I don't reckon they could. Like, say, for instance, we go to a train yard and all of a sudden we get raided, what would you do?
> *Nancy* I'd run wherever I came in.
> *Steam* What would you do if you got caught? Would you inform the police of where they live or whatever? Say, for instance, they said to you, 'You can either go to prison or you can tell us about these other people?'
> *Nancy* I don't think I'd react any differently to a bloke.
> *Steam* I dunno, I reckon you would, you'd crack under pressure.

The masculinity of the exercise is re-emphasized. She may have the daring to go, but, unlike boys, her resolve would rapidly diminish within the situation itself. Pink and Akit recall this as a common response to their requests to go with male writers to the train yards:

> They didn't take me seriously, some little girl like, 'Take me to the train yard, take me to the train yard', and they wouldn't have anything to do with it . . . I got the things, 'Oh you'll scream, we'll have to protect you.' Some people don't want that added responsibility, you're worried for your own ass as it is.
>
> (Pink)

Nancy So writers are not keen to take you to a yard?

Akit Oh no, they think I'd cry and go, 'Boo hoo', you know if someone came along I'd just go, 'Alright then take me.' But I'll be running faster than the rest of them man! I'll leave 'em for dust, I don't care, I'll just run.

Girls enter this subculture and gain an automatic and tainted set of traditional feminine qualities. These construct her as a timid, delicate little thing with absolutely no fear threshold and a tendency to burst into tears at the slightest hint of danger. She faces a hurdle, then, that boys do not. While they start equipped with the male gender that guarantees their acceptance, girls start with one that must be disguised or rejected. As Pink recognizes:

Guys can't lose face by wimping out in front of a girl, I couldn't do that either. I couldn't go off and cry and scream and carry on like a girl because that's what they expected, so I can't do that. I had to prove myself too, that I wasn't a wimp and I could carry my own paint thank you.

The female writer's task is a difficult one. Male writers work to prove they are 'men', but female writers must work to prove they are not 'women'. As Pink illustrates above and below, they must replace all signs of femininity (incapability) with signs of masculinity (capability):

Nancy So would you say a lot of the qualities you need are traditionally masculine, macho?

Pink Yes, I had to adopt all of that. I had to be an aggressive little thing and dress like a boy.

She also had to paint like a boy which she did not do. This male writer comments on her distinctive style:

Freedom It's unfortunate that her earlier work was as feminine as it was because I think that turned off guys. Guys wanted to paint guy stuff.

Nancy Right, and if she was going to be part of this then she would have to paint like a guy?

Freedom Yeah, and she wanted to paint flowers.

By painting in a floral/feminine style, Pink fell short of her male peers' stylistic standards and sacrificed the respect that was given to those of equivalent ability.

Finding the 'balls' to be one of the boys

In this subculture there is little room for a woman to represent herself as a woman. As Fine (1987) found in other male-dominated groups, men set the standards that women must live up to and masculinity remains the yardstick against which women are judged. The phrasing used in the two quotes below is revealing. As it implies, it takes inherently *male* qualities to excel in graffiti:

> It takes a lot of *balls* and skill to go out and paint a good piece.
>
> (Eez – *Freestyle* 5)

> *Nancy* What qualities would a girl need to get involved?
> *Col* We'd, like, put her on a mission to, like, see if she gets up enough, see if she's got the *balls* to go.

To be accepted, a girl must behave like a boy. She must act as if she has 'balls', that is, demonstrate the same attributes that boys are thought to possess. Masculinity is upheld as her goal, so when she achieves this male writers tend to signal her worth in 'male' terms: 'Pink was like just another one of the boys. She was down, she used to go hard, she'd do like handball courts and stuff, she was really good' (Col). Pink is credited because she acted like 'one of the boys'. Similarly, once Claw demonstrated that she was committed to graffiti, her female distinction was removed in reward:

> What happened with 'The Violators', they were like, 'Ooo, check her out', and then they saw that I could do this and I am serious and now it's like, 'Yo, this is Claw.' The first time I was like the little princess, now I'm just one of the boys.

To be treated like 'one of the boys' is a clear sign of achievement. It indicates that the girl has behaved in a 'male' way and has, thus, diminished her distinction as a female. This is just one step, though, on a long road. The female writer still has a lot more to prove. She may dress, behave and paint like one of the boys, but she remains 'just a girl' until she shows that she is 100 per cent 'down for' or dedicated to graffiti.

Mission impossible: unobtainable authenticity

Dedication is a centrally important value within this subculture. Although it serves a practical purpose – you can only obtain fame through dedicated effort – it is also upheld as a measuring rod by which writers judge each other:

Nancy What qualities do you need to be a good writer?
Kilo You've got to go through it all really. you've got to bomb up, you've got to go through all your tagging years. If you get busted you've got to continue sort of thing.
Lee It's dedication, isn't it.
Kilo Yeah, that's it really, like you said, that's the one word that sums it up.

Writers who have met the criteria listed above are said to have 'paid their dues'. This means that they have completed a full service of illegal work and have demonstrated a sufficient degree of dedication. Hard work legitimizes them. Measures which offer a short cut or alternative route to fame are frowned upon, unless the writer has already 'paid his/her dues'. Smith illustrates this below in his comments about 'Revs' and 'Cost', two American writers who enjoyed enormous fame from their use of sticker-based messages (see Figure 6.2):

Smith Revs used to get up on the trains and he did some nice pieces. Cost never really did trains, the little bit he did he was considered a toy [incompetent artist] by the older generations.
Nancy But they've made a massive name for themselves.
Smith It's hard to say, because there are other graffiti writers, like myself, who are concerned with what they do with graffiti, so it's kind of hard to respect them for those things . . . I guess I give Revs more respect because I know who he was.

While disapproving of their nonconformist activities, Smith legitimizes Revs, the writer with a longer history of illegal work. Revs's partner, Cost, had not, in Smith's view, 'paid his dues' and, thus, earnt his right to this 'cheap fame' as is termed.

In this subculture individuality is complemented by conformity – to stand out, one must fit in and to fit in one must work diligently through established stages of illegal activity. This productivity declares that a writer has staying power, but it also comments on how devoted he/she is to the subculture/artform: 'See the more you get up, the more

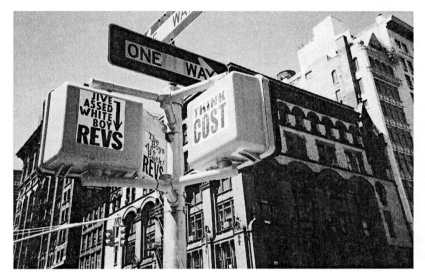

Figure 6.2 Revs and Cost's sticker messages

respect you get. Other people will say, "Oh he's done a lot give him respect." If you do just one thing, then they will say, "Hey, you're not really dedicated to the art form"' (Smith). A faithful or dedicated writer is one who is undeterred, one who stays committed to graffiti through passing trends and difficult times when giving up might seem tempting:

> I remember in the mid 80s writers were like, 'Oh graffiti's played out', see it was like a trend to certain people, like fashion and all that, graffiti was like that for them. But the real dedicated would ignore that, they would keep doing it.
>
> (Cavs)

> *Kilo* If you're not dedicated, the first time you get arrested you're going to give up.
> *Lee* Then you're not a writer in the first place, because if you were you wouldn't give up just because you got caught.
> *Kilo* Yeah, it wouldn't stop you.

A dedicated writer is, as Lee confirms, a 'writer'. At the end of the day, writers work to be 'real', 'true', 'proper' and credible. The hallowed

prize for sticking with graffiti through its many ups and downs is authenticity. But this is not something which everyone can claim. Here, like the dance club scene that Thornton (1995) studied, authenticity is presented 'in masculine terms and remains the prerogative of boys' (Thornton, 1995: 105). While the female writer can try and demonstrate her commitment and, thus, eligibility, she does not get the same chance as men to do this.

Before a girl even starts, her expression of fidelity and dedication is tainted by the factor that often inspires her interest in graffiti – her male writer boyfriend. All three female writers reference a boy as their initial incentive:

> I met some girl at my school and I got mates with her and she had an older brother and he was into it and I kind of went out with him for a little bit. . . . He would do outlines for me and all that and I thought, 'That looks alright', you know, and I started writing on a bit of paper.
>
> (Akit)

> It was over a boy, he was like my first boyfriend. . . . They sent him away and I was heartbroken, my very first boyfriend, so I hooked up with his friend and learned how to write his name and continued writing his name on the streets and in school.
>
> (Pink)

> I had met Sharp and Sharp and I instantly fell in love. . . . He put me up, whenever he wrote a tag it was Sharp Claw. . . . He went away for three months and his friend, Sane, kind of felt like a lost puppy, so he stuck really closely to me and he was the one that took me writing.
>
> (Claw)

Male writers I spoke to would always highlight this connection, attributing the female writer's involvement to another man:

> *Kilo* You do get the odd one, like there was some girl that was recently writing Lady.
> *Lee* You usually find that it's just the writer's girlfriend.

In the quote above, 'the writer' claims a male definition. The female writer is denied this and receives instead her label as 'the writer's' girlfriend. She is recognized and defined by her male affiliations because

ultimately men claim responsibility for her presence: 'A lot of them have been involved in it because of their boyfriends. . . . My sister painted trains in '74 because her boyfriend was a painter, so he got her into it' (Lee).

The female writer must always suffer the stigma that is set against her in these terms. Namely, that she is not doing graffiti because she has an authentic interest in it, but has rather flopped into it in an effort to subscribe to her boyfriend's preoccupations. Mear hints at this: 'A lot of girls get into it in a little way, you know, because they happen to meet a guy and he's into graffiti and all. That's the only way they really take notice of it most times.' Male writers use the female writer's associations with other men to reverse her loyalties. Her boyfriend is seen as her focal concern, rather than the subculture, and her interest and dedication are deemed superficial and ephemeral because of this. As Mear decrees: 'It was just another pastime for them at the time and now they're no one. . . . I don't think there's any girl out there who's dedicated enough. I mean it's a matter of putting in years now to make a name.'

Claw demonstrates how attitudes can change when girls find a way of proving that they are committed to graffiti:

It was interesting the last time I went painting with Pink and Smith, we went to do freight trains in Queens. We met there and there were two other writers that came that I didn't know and they were, like, acting to me, like, 'Oh who's fucking girlfriend is this? What the fuck is this chick doing here? What the fuck!', you know, they were, like, kind of rude to me. . . . When we got to the yards and I pulled out my paint, they were like, 'Well, what do you write?', and I said, 'Well, why don't you watch.' So I wrote Claw and they were like, 'Oh, Baby Claw, Claw lover, that's you?' and I was like, 'That's me', and then they were like, 'Hey, I think that's great.'

Illustrating what girls are up against here, these male writers were initially dismissive of Claw, writing her off as someone's 'girlfriend'. They changed their tune, though, when they realized they had actually heard of her name. This indicated that she had put time and effort into 'getting up', which, in turn, endorsed her dedication and earnt her their respect.

When a female writer manages to win this recognition, she does not get to keep it very long. Male writers do not expect her commitment to last, so any legitimacy they grant her will always be provisional:

A lot of people are pessimistic about it, 'Oh yeah, she's a girl, yeah sure.' They, kind of, respect that she's getting up, but know she'll give up in six months. . . . because most women just start writing because some guy they like is a writer or something like that. I mean I know it sounds terrible, but it's true. Most guys just see them as here today, gone tomorrow.

<div align="right">(Drax)</div>

The female writer's sell-by date is clearly marked. She is not predicted to last beyond her supposed source of inspiration: her writer boyfriend:

It tends to work out like if there's a girl writing, she's going out with a graffiti artist. . . . Like, as soon as Nicola stopped going out with her boyfriend, she stopped doing graffiti and Sue soon stopped after that, when we split up.

<div align="right">(Acrid)</div>

The female writer cannot really win. She must behave like a male writer, yet, when she does, she is still judged harshly for being a woman. Her gender remains highlighted, subjecting her to different treatment and presenting her with different objectives. While the male writer works to earn respect, she works to shatter stereotypes and gain a sense of acceptance. Akit recognizes this, but she is adamant about pursuing her career with the same intent and pace as any other writer:

If they're wanting me to sort of prove myself or something, I'm not going to go out of my way. I don't do it just so they can say, 'Oh at least she's doing it.' I just do it for myself . . . I'm not constantly out to go and, like, prove something and say, 'Look I'm here and I'm staying', you know.

Even if the female writer did want to prove she can work as hard as the rest of them, she is still, through no fault of her own, at a serious disadvantage. She is an unusual member of this subculture and this makes her route to fame quicker:

I was already famous as soon as I started, just because I was a girl,

<div align="right">(Pink)</div>

If you're a girl, you've bigged yourself up already, sort of thing,

<div align="right">(Acrid)</div>

greater:

> You get a lot more famous as a girl,
>
> > (Smith)

and easier:

> A girl could get away with doing less than a geezer because she's a girl. I know it's sexist and that, but that's the way it is.
>
> > (Acrid)

Although this short cut may look like a bonus, it is actually a hindrance. Writers are legitimized by the hard work and effort they put into graffiti and the female writer's quick rise to stardom strips her of her ability to demonstrate this. She does not gain from her profile, she suffers. She gets fame without effort and this prevents her from proving she is dedicated and deserving of the authenticity or legitimacy that comes with that. For the female writer, as Akit illustrates, legitimacy is a very slippery achievement:

> *Nancy* So you get the feeling they're not taking you seriously yet?
> *Akit* I don't know about yet. I don't know, they'll always be ones who think, 'Oh she shouldn't do it, she's a girl, what's her problem? She's mad', or whatever. I don't know what I've got to do to prove myself really. You know there was all this rubbish about, you're not a proper writer until you've painted a train. So I thought right I've painted a train, what more have I got to do? And someone else says, 'you're not a proper writer until you do a top to bottom whole car', you know what I mean?

When Akit tries to become a 'proper' writer, the rules governing this change. The authenticity that male writers enjoy is elusive and appears to lie just beyond the female writer's reach. She gains a different sort of acknowledgement, one, as Pink recalls, based upon her activities as a woman:

> *Nancy* Were you judged by the same sort of standards as the boys?
> *Pink* Um, it's kind of weird, guys are still, they're like, 'Yeah that's really good for a girl', and stuff like that.
> *Nancy* Double standards?
> *Pink* Yeah.

Perhaps, as Freedom testifies, female writers like Pink will never obtain the recognition that other boys are granted:

> *Nancy* Was Pink judged by the same standards as the guys?
> *Freedom* No, not at all, no, anything she did was going to be jaded. People would look at it and they would either (a) patronize it and say, 'Ah well, that's a good piece', whether it was good or bad or (b) they would just dismiss it because it was Pink. It was one of the two and she would never get the credit she deserved for being a fine painter, which I think she is.

This subculture's values, beliefs and standards make it almost impossible for a woman to be recognized. Boundaries of acceptance are narrowed or closed and testimonies of achievement remain intangible. Unable to escape her female distinction, the credit she supposedly earns from being 'one of the boys' stands unrealized. What these barriers, obstacles and hardships begin to tell us is that the female writer may not be particularly welcome here.

The unwelcome one

As Akit's experiences affirm, girls can encounter a hostile reaction from other writers:

> I haven't been anywhere with all them top bods and all that, like half of them don't even talk to me. I don't know what their problem is . . . like I saw 'Teach' at Fulham and either he was bloody stoned or I don't know what, but I nodded and goes, 'Alright' and he just looks straight through me and a few of them are like that as well.

Clear-cut gestures of disrespect carry the same sting. While painting at a hall of fame,

> I went off for, like, half an hour and when I was gone Diet turned up with Hash, Skore, Mear, Mess and, like, Elk was there painting at the same time. And, like, Skore comes along, 'Oh that's that Akit bird', they were all standing there talking about me and Max was painting away listening to them and Skore was going, 'Yeah, I wanted to paint that wall, I might just go over it', even though I'd just finished it. I was just thinking, 'Fuck off, oh what's the point', you know I've never even chatted to the bloke.
>
> (Akit)

What Skore intended to do here was insult Akit. Writers do not paint over other writers' newly painted pieces unless they wish to signify their insignificance. Why Skore wanted to insult Akit is another question. Writers usually have a reason for belittling each other like this. Just as they usually have a reason for ignoring each other. With none apparent, it would seem that writers are using these gestures to tell Akit to admire what they do, not do what they do. This message is received and understood:

> *Akit* It's a totally male dominated thing, like totally. It's a bloke's thing, graffiti, you don't associate it with girls at all, it doesn't come into it really.
> *Nancy* Do you feel they're sort of possessive about it?
> *Akit* Yeah, totally, like I shouldn't be involved.

This is masculine territory and like women who invade other male-dominated confines such as the police force (Fielding, 1994), the factory shop floor (Messerschmidt, 1993), the military (Morgan, 1994) and football (Williams & Taylor, 1994), the female writer is an unpopular visitor. Why is this?

No place for a woman

Although this subculture represents a blatant rejection of the conventional, its attitudes towards gender are paradoxically traditional. Conventional sex roles and the pressures of heterosexuality are not escaped, as McRobbie (1980) has suggested, they are reproduced and reinforced. Illustrating this, Iz locates the role he expects a woman to occupy within a conventionally passive domain: 'Girlfriends of writers, let me tell you something, the shit they have to go through because they're loving and caring and know the risks and dangers involved.' The man performs his role as the brave and valiant warrior and 'his' woman stands at the sidelines anxiously awaiting her hero's return. In deviating from this script, Pink overstepped boundaries of female respectability. While her male peers extended their gender roles through graffiti, as Freedom recounts, she offended against hers:

> A lot of them were old school Latin guys and a woman's place is not in a train tunnel competing with them. That's the main thing I give her a lot of credit for, not even so much for what she did or didn't do, but for sticking it out because it's a hell of a ride.

The message is clear; a hazardous environment designed to facilitate masculine competition and display is no place for a woman. Men work hard to ensure this is fully understood. Claw recalls her boyfriend's reactions to her involvement: '"Sharp" didn't want me to write and he has a problem with me writing now. We're broken up, but he told me that he doesn't like it. He asked me if I was doing it to bother him and no I'm not.' Although involved himself, Sharp found Claw's activities very difficult to accept. Lee, a writer, adopted a similar attitude to his girlfriend Pink's involvement:

> He wouldn't allow me to paint trains and all that because he knew how dangerous it was. I mean that's just a boyfriend's kind of pro-tectiveness, it's just like, 'Forget it, my girl is not going into danger at all.' . . . He wouldn't let me hang out with graffiti writers or paint trains, so I rebelled against that and after a few years that was that.
>
> (Pink)

While sympathizing with his motives, Pink could not take Lee dictat-ing her behaviour. Akit offers a similar commentary, viewing this control as a violation of her freedom:

> A lot of blokes don't like it. I've had a couple of boyfriends and they're just, 'Right give it up', and all this stuff. And I've said to geezers, 'Look if you don't like it, if you can't accept it, fuck it, because I'm not giving up for no one except myself, if I want to.'

Female writers stand upon harsh, and often hostile, terrain, yet many tough it out and persevere. Apart from enjoying graffiti, an added incentive perhaps lies in their ability to make a statement: 'People have tried to repress me. This is my total statement to all of them that I'm going for it, love it and lick it . . . I'm doing it as my feminist statement to the world' (Claw). By renouncing traditional codes of feminine behaviour, the female writer disrupts the subcul-ture's and society's sexual status quo and rejects her subordinate place within it. She has come a long way since the days of her subcultural sisters a decade or so, and as illustrated below, her subcultural profile needs updating to reflect that:

> Girls are present within male subcultures, but are contained within them rather than using them to explore actively forms of female identity. The subculture may be a social focus, something to dress

up for and an escape from the restraints of home, school and work, but as yet no distinct forms of femininity, which have broken from tradition, have evolved.

(Brake, 1985: 167)

The girl who passively embraces her assigned and traditional feminine role takes her final bow. Her part is now played by a woman who rejects conventional femininity and masculine dominance. In short, a woman who does her own thing. Liberated and independent is not the only thing she becomes through this display, however.

'It's a man's world but it would mean nothing with a woman or a girl'

What the female writer demonstrates through graffiti is her ability to be 'masculine'. What the female writer becomes through this, is a threat:

> I find that men are very, very threatened by me writing because it's very masculine to them. They don't understand at all. It's like, 'Oh I don't want my girlfriend running around on the street writing graffiti.' I went out with this guy last year. He had written when he was young, but he had a big problem with it and he would call me up and say, 'What are you doing?', 'Oh darling, I'm just home knitting and I'm baking a pie and I think I'm going to stay in tonight and wash my hair!' He had such a problem with me writing . . . so many men are threatened by it.

(Claw)

So why is this female display of 'masculinity' threatening? Why is the fact that women can do what men do 'as men' unnerving? To answer this, we need to look at the relational way in which gender identities are formulated (Gutterman, 1994; Herek, 1987; Kimmel, 1987, 1994; Messner, 1987). As Herek (1987), citing McGuire (1984), explains: 'Personal identity (self concept) involves what we are not, at least as much as what we are' (Herek, 1987: 76). Masculinity and femininity are not boundaried and isolated constructs, as the sex role theory implies, they are critically interlinked. One cannot exist or be defined without the other (Kimmel, 1987): 'Identity requires difference in order to be, and converts difference into otherness in order to secure its own self-certainty' (Connolly, 1991: 64, as quoted by Gutterman, 1994: 221). To retain its clarity, masculinity must be other than or different from femininity (Flannigan-Saint-Aubin, 1994; Messner, 1987; Pleck &

Thompson, 1987; Segal, 1990). As Segal (1990: 132) explains: 'It is insufficient for the "men" to be distinguished from the "boys"; the men must be distinguished from the "women".' Being a man, as Kimmel (1994) asserts, means not being like a woman. Women must remain 'women' to allow men to remain 'men'.

Through declaring graffiti 'men's work' and, hence, beyond female capability, male writers activate this gender distinction. Through declaring graffiti 'women's work' as well, female writers threaten to dissolve it. This would appear to be one of Claw's objectives:

> Basically, writing for me was to tell these guys for all these years that I've had, 'Girls can't do this, oh, you can't come blah, blah, blah, no, oh no, you have to stay home, oh no, you're fucking bullshit', this is my way to say, 'Look, I'm a woman and I can write too.'

Claw is emphatic about shattering beliefs that women are out of their league in this subculture. To prove it, she pushes herself extra hard and paints in places which ensure this is fully understood:

> I want to do the riskiest, the most outrageous stuff because I'm a woman. So people would say, 'How the fuck did she do that? A nice Jewish girl, nice Jewish girls don't write.' I write and I write for women. I'm doing this to say, 'You and your closed little mind, we can do this, anybody can do it, as long as they have the will and desire to do it.'

The female writer has little to lose through asserting her equality. She merely reinforces the fact that she, as Zaki recognizes, claims as much right to this 'masculine' ability as her male peers:

> Whether it's right or wrong, it's seen as a masculine thing to go out and risk your life and everything like that. But when you strip it down, everyone is equal to do that, you don't need anything . . . there's no reason why a girl can't go out and do that.

The male writer, however, has everything to lose because 'If women can do what "real men" do, the value of the practice for accommodating masculinity is effectively challenged' (Messerschmidt, 1993: 132). Female capability muffles the sound of his masculine commentary. Female superiority, however, fully silences it. The threat of femininity

reaches full force when a woman, like Pink below, does what 'real men' do better than them:

> *Pink* Boys, because of their machoness they can't back out of these things, but females can say, 'No I'm scared, forget it.' Boys have to prove that they're manly and that's all there is to it, especially when there's a girl watching them. The boys have to do the stupidest things when I'm watching them.
>
> *Nancy* So your boys had a harder time?
>
> *Pink* Yeah, they couldn't wimp out, they couldn't lose it. Last week some kids walked up on us in the yard, two of the boys that went with us, and one of them is older, they took off running like rabbits. Ah man, they didn't come back for an hour! I felt so bad for him, I know this guy was embarrassed.

To wimp out in front of another man constitutes loss of face. But to do this in front of a woman who does not show this fear, makes this failure doubly significant and lessens their status as men considerably.

Reasons why the female writer is not particularly welcome in this subculture can now be understood. Through inhabiting this 'masculine' discourse and dissolving her role as the 'other', she shatters beliefs that graffiti awards men uncontested 'masculine' status. Knocking their manhood like this appears to be one of her objectives. This female member is far more political than previous theorists have given her credit for: 'Girls may rebel against male supremacy, but even in the aggressive subcultures toughness is not aimed against their men, but is a move to be accepted by machismo men' (Brake, 1985: 176). Male acceptance and approval are important, but the female writer is also 'doing this to rebel against men. It's a fucking repression against women, it's like, "Go fuck yourself, I can do this shit better than you, so what have you got to say about it?"' (Claw). Not much perhaps. But there is a lot they try to do about it.

Deflecting threat – making her presence unfelt

Eliade (1958) and Remy (1990) define a 'mannebunde' as a 'men's hut' or all-male fraternity/paternity grouping. Reflecting its function, women are usually rigidly excluded: 'This is the place where those males who have earned the right to call themselves *men*, or are in the process of attaining this emblem of privilege, gather' (Remy, 1990: 46, italics in original). Because of the female writer, this subculture fails to fully satisfy this definition – though not through want of trying.

Although male writers cannot physically stop girls from getting involved, they can, through excluding their competitive force, deny them a place within an all-male subcultural core. Strategies operate to exclude women or secure their 'absent presence'. Female writers recognize these and act in ways to undercut them.

Questioning her authority

Claw understands the threatening nature of female achievement and outlines one strategy male writers use to try and deflect it:

> This guy, 'Deal', he disses [disrespects] me all the time, 'Oh who did your piece?', I'm like, 'I did my piece', 'Oh yeah right, that kid did your piece.' It's because he's real up and he's a dick and he's jealous. And I've said, 'You want to piece? I'll burn you off the wall, let's go paint', and he never comes through. He knows, and I know, he's afraid of me.

By denying that Claw is responsible for her own work, or giving her a chance to prove this, 'Deal' extinguishes her competitive force – she is not a challenge, because she is not really a painter. Like Claw, Pink's authority was also revoked. She explains how she worked to reclaim it:

> At first I didn't get respect because everybody just thought I was somebody's girlfriend and so and so was putting up my name. But, you know, after a while I went piecing deliberately with different groups in different parts of New York so that everyone could see that I could actually paint this stuff and I'm not having some guy do it for me.

By painting with a wide variety of writers, Pink made it clear that she was responsible for her own work and deserved her own credit. Claw makes similar claims by rejecting help from other writers: 'When people try to help me do my piece, I get really, "No, no, no, I have to do it, don't, I'm doing it", because I don't want anybody to, you know, say, "Oh, I saw Divo do her piece." I want to do my piece.' Male writers' attempts to assist female writers are common. Pink recounts the kind of help she would get when she went to the train yards with other writers:

> Whenever I did go with other guys and older guys it always brought out this paternalness in them . . . They'd get so silly and stuff, like not letting me climb a big fence or anything like that, they would

just reach for me and pass me like a little doll. They'd also put me in the spot most likely so I could get away faster and everyone else in the higher risk spot or something and just do all kinds of chivalrous things that normally they wouldn't do for a little toy [inexperienced writer], kind of weird.

It is interesting that this help was not given to the 'male 'toys', who, being novices, probably needed it more than Pink did. This suggests that as boys, 'toys' or not, they had to prove themselves by their own merits and learn to stand on their own two feet as 'men'. Pink was not subjected to this masculine test. She could accompany them, but, as a girl, she was not expected or, indeed, allowed to prove her worth in these terms. In this way, any 'masculine' actions she performed could quite easily be accredited to the boys who helped her. They are no longer signs of her bravery, skill and stamina, but rather theirs. Claw refuses help and refuses male writers this reassurance:

Nancy Do some guys get paternal with you? Do they try and take you under their wing?
Claw Sometimes, yeah sure, but I don't let it get to that level because I'm Claw, I'm not under anybody's wing. I'm wingless, I'm flying on my own two feet here. You know I'm sure some people would like to say I'm under their wing, but I'm not.

By removing the female writer's authority and, thus, competitive force, the male writer preserves his masculine potency. He performs unaided, his actions thus retain their masculine impact. He performs against other men, his actions thus retain their masculine credibility. He performs, she does not. Without a competitive input, the female writer loses her presence. The boys remain the competitors and, thus, only members of this reconstructed fraternity grouping.

'Nice style, shame about the legs'

The female writer is allocated an alternative position in this subculture, one where her status as a woman is elevated above her status as a writer. While male writers are acknowledged for their artistic skills and accomplishments, her worth appears to be based on her physical appearance:

Nancy Would you have a girl in your crew?
Seam All depends how nice looking she was.

> *Nancy* What about Pink? She's good, Would you have her in your
> crew?
> *Seam* No, she hasn't got good enough legs! If I was going to have a
> girl in my crew, she would have to be nice looking!

> *Nancy* So if a girl was to be involved, would she be accepted into
> a crew?
> *Lee* Depends how nice looking she is!
> *Kilo* That would probably come into it, ha, ha!

On a graffiti-related level, girls are often irrelevant. Their interest value
hinges on what they offer as sexual objects alone:

> *Nancy* What would be the reaction if suddenly there was a girl
> tagging all over London, more than anybody else? Would there
> be quite a lot of talk about it?
> *Steam* Oh yes, there would. She would be respected, but they'd
> all be thinking, 'I wonder if she's nice looking, I wonder if she's
> a good?!*!', that's the attitude.
> *Nancy* Wouldn't she also be respected for doing what the rest
> of you are good at?
> *Steam* A little bit, yeah.
> *Nancy* So if she got up more than anyone else.
> *Steam* I don't know, she might be respected, but people would
> just see it as, 'I wonder what she's like', it's, like, sexist.
> *Nancy* So a girl hasn't anything else to offer?
> *Steam* In a way, yeah. That's how I see it anyway, I don't know
> about other people.

Other people appear to share Steam's view. Jel declares a girl's interest
in graffiti as irrelevant to his reasons for wanting to interact with her:

> *Nancy* What about the girls involved?
> *Jel* Female writers, I don't really care much for them . . . That
> art show we went to, I was talking to girl writers, but I didn't
> care about the graffiti part of it, I was just like, 'How about
> you and me get together, go round the block and have a beer?',
> you know.

In keeping with this physical focus, male writers tend to pay more
attention to what the female writer does with her body than her spray

can, that is, her sexual activities, rather than her subcultural ones. Freedom illustrates with reference to Pink:

> You know on the surface everyone was, 'Hey Pink, How are you doing Pink? Good to see you Pink', and then the next second it was like, 'Yo, you know who Pink is doing? I know she's sleeping with this guy and that guy and blah blah', none of which is really true, but it was just guys being guys.

In the majority of cases these sexual allegations are unfounded. They are merely exaggerated stories or spurious rumours. Akit and Pink elaborate on their content as well as the hurt and upset they cause:

> Graffiti writers would just bad mouth me and say I'm just some little slut, I'm probably just doing everybody when I go to the train yard. These rumours have stuck until now, people are still saying stuff, guys are still saying that they did so and so with me, guys I wouldn't touch with a ten foot pole are saying horrible things about me. . . . It's that you're a dyke or a slut, that's it, so I had a lot of problems with that.
>
> (Pink)

> There have been times when I've been really, really fucked off with writers, just because all of them, because it's such a little community . . . and because I'm the only girl I get talked about enough and I've heard the maddest stories I'm supposed to have done. I'm supposed to have fucked this writer and that writer I don't even know. I'm supposed to give any writer a blow job, give me a can of hammerite and I'll do anything and all this kind of stuff, just the maddest things. And it's just been like this constant battle where I've got to try and prove myself that I'm not a slag, I'm not out to fuck writers, you know what I mean?
>
> (Akit)

Characterizations of the 'slutty' female writer are so commonplace that when I raised this matter with Zaki he predicted what I was going to say before I had said it:

> *Nancy* Every single girl I've spoken to has said exactly the same thing, in that the rumours that go around are all the same.

> *Zaki* 'Oh what artist is she fucking?' I'm afraid that's men down
> to a tee . . . no one would say that about a bloke, would they?

Men, as Zaki distinguishes, would not be considered in these terms.
This is clearly illustrated in the extract below where Claw is discussed
by a group of male writers:

> *Nancy* How do people see Claw as a writer?
> *Sein 5* She has a bad rep.
> *Nancy* Why?
> *Sein 5* Because she's a slut or something. I dunno, I dunno because
> I don't know her. She does have a bad rep though, but that's a
> rep, that's bullshit.
> *Nancy* But as a writer is she respected?
> *Key* She's a jack [novice]. If you weren't hitting trains, you missed
> out.

In asking for their views of Claw 'the writer', rather than comment,
or not, on what they knew about her ability or achievements, these
writers chose to evaluate her in terms of her sexual behaviour. Had I
asked the same question about a male writer, I am sure his sexuality
would not have featured in their response. Unlike female writers, a
male writer's reputation or identity rests upon his subcultural, not his
sexual activities, his demonstrations of masculinity, not his passive
physicality. At the end of the day, his status 'rests on his behaviour
in spheres other than sexuality' (Hudson, 1988: 37); spheres which
grant him a presence, a competitive force and an opportunity to be
recognized.

Male writers work hard to secure the female writer's 'absent presence'
and it is not hard to understand why. By 'suppressing them, men can
stake a claim for their own manhood' (Kimmel, 1994: 134). In trans-
forming the female writer into a sexual object, male writers shift atten-
tion away from her achievements and the challenge she may represent.
She becomes nothing more than a body and her emasculating force is
diminished as a result. Removing her authority and competitive input
achieves the same end. Her actions are stripped of their masculine
meaning and power, and, with this, their threat. Using these strategies,
male writers force the female writer back into her role as a 'woman';
that is, someone different from them, 'other' than them. Through this
they regain the male-only retreat they need to reassure and preserve
their masculine potency (Rutherford, 1988). I finish this section with a

quote by Iz which clarifies how important the 'maleness' of the subculture actually is to writers:

> Look at how masculinity and the male species is under attack. We always have to make the change, in the workplace, home life. How many years were men raised as the breadwinner? What you say goes now. Alright, we're sensible, so we're more open minded nowadays. . . . But possibly because of the constant attack against masculinity, that is where this comes from.

Iz alludes to the subculture as a masculine safe house, that is, a forum where men can escape the influence of feminism, its pressures for equality and the emasculating potential he sees coming with that. In this sense, we could also understand graffiti in historical terms – as a masculine backlash against the changes pioneered by the second wave of the women's movement.

This subculture must be acknowledged for what it is. Not a site for 'youth', but a site for 'male' youth – an illegal confine where danger, opposition and the exclusion of women is used to nourish, amplify and salvage notions of masculinity. This a fairly new take on subcultural meaning. Past theories generally overlooked masculinity as an analytic angle. Miller (1958) alluded to it in his examination of the subculture's 'focal concerns', as did Albert Cohen (1955) when he distinguished between male and female crime. But in both cases masculine issues were overshadowed by class issues. The Functionalists' failure to deal with gender is perhaps understandable. As Heidensohn (1989: 55) concedes: 'They lacked a sociology which could supply them with the conceptual tools.'

The later generation of theorists cannot claim such allowances (Heidensohn, 1989). The CCCS group may have given their subcultural members goals and intentions, differentiating them from the puppets featured in Functionalist accounts. But, by prioritizing a political reading of their activities, I would say they gave many of them the wrong ones. There is more to graffiti than politics. Writers do not put themselves in grave physical and judicial danger just to oppose bourgeois impositions/institutions and parade their differences (Corrigan & Frith, 1976). A more immediate and personal reward is gained – a clearcut masculine identity. The CCCS theorists ignored the subculture's

gender constructive role. In doing so, they left the female member's marginal position unproblematized too. Here, we see the female writer dismissed to the outer edges of the subculture, not because she accepts this position, but because she is forced to these corners by the male majority. Her subordination is not quietly endured, as implied by accounts which leave her voice silent, it is actively resisted. It is also actively imposed. Previous theorists have read the peripheral place girls occupy in subcultures as a reproduction of societal sexism. I have found it useful to go one step further and look at it as a male expression of the female member's emasculating threat. It is in his interests to nudge her out because, as a girl, she has the power to dilute his masculinity. It is either her or his male credibility – one of them has to go.

These arguments invite us to re-evaluate Marxist subcultural theory, but I do not think they demand we abandon it. Not yet, anyway. What I have found may be relevant to this subculture alone. Masculine construction, as an analytic angle, works for graffiti, but could the same be said for 'club' or dance cultures? These place little emphasis on danger, challenge and competition and reflect a largely equal membership of men and women, although girls still occupy a secondary role (McRobbie, 1994; Thornton, 1995). In this sense, a grand meta-theory, like that developed by the CCCS, may be too broad a project. Subcultures differ – some may be class based, male based, style based, others may be 'race' based, female based or activity based. What holds for one theoretically, may not hold for another. What we need, then, are theories that are sensitive to subcultures in all their rich and varied forms. Subcultural definitions which reflect and cater for these variations are also required. If one theory cannot fit all, then can one definition?

7
Keeping Its Distance: The Subculture's Separation from the 'Outside World'

We hear talk of 'subcultures' all the time. The term can be found in the popular press, in 'underground' style magazines, in debates and discussions among the young and the old. One can even hear it bandied about in Madison Avenue marketing meetings – the all-hallowed 'subculture', the source of future trends! Yet, despite its prevalence there seems to be very little consensus on what the term actually means. As it stands, it incorporates a wide range of groups from punks to Hell's Angels, graffiti to Riot Grrrls. These are not all illegal. They are not all male. They are not all young. And they are not all centred around a certain 'style' or activity. So what binds them together under this one umbrella label? What is their defining characteristic? As the CCCS saw it, their distinction. They told us that subcultures 'must be focused around certain activities, values, certain uses of material artefacts, territorial spaces etc. which significantly differentiate them from wider culture' (Clarke et al., 1976: 14). Yet, they also told us that this definition holds for the working classes alone: 'They are all subordinate sub-cultures, in relation to the dominant middle-class or bourgeois culture' (Clarke et al., 1976: 13).

This label is, thus, extensive while also selective. Groups which are not working class are not included because they represent the 'dominant' culture against which this definition is based. What I, alongside many other theorists (Evans, 1995; McRobbie, 1994; Thornton, 1995), have had trouble with is this notion of a dominant majority or cultural norm. The social landscape does not appear to boast a group which fits this description. What it yields instead is a series of disparate groups which, like 'subcultures', each express their own values, styles and ways of life. Realizing this, Mear sums up the limitations of this class-based model beautifully: 'I mean there's so many different

meanings to subculture. I mean I look at, I don't know how you say it, "yuppyism" as a big upper class subculture, but no one wants to talk about them.'

Well, now, perhaps they do. When the CCCS's model crumbled, any restrictions in defining subcultures appeared to go with it. With no class boundaries to worry about, the subcultural floodgates opened up and a whole new wave of contenders washed in. I attended a conference which saw punks to the company Benetton defined as a subculture ('Theory, Populism and Subcultural Dress', 1995), a conference which left a group of academics very confused. The problem with no boundaries, is no limits. The term 'subculture' becomes infinite and overly vague. Two and a half hours were spent discussing the use of this, now, measureless concept: Do subcultures, as we know them, exist or are they merely the subparts that make up cultures in totality? Is a meaningful use of this concept still possible or even valid? Perhaps not. But in declaring the subculture dead and buried, where does this leave its apparent members?

As I see it, they are the ones we should be consulting on these matters as the key to this dilemma lies, potentially, in their hands. Perhaps subcultures are only subcultures if their own members recognize them as such, if they themselves draw boundaries and define themselves as members of a group which is seen as standing 'apart' from others. Hence, if individuals, like those interviewed by Widdicombe & Wooffitt (1995), provide 'little sense of groups they joined', do 'not invoke a sense of shared identity, nor the benefits of affiliation with like-minded others' or 'do not provide a sense of attributes shared by virtue of common category membership' (Widdicombe & Wooffitt, 1995: 216), then rather than use this to question the social reality of 'all' subcultures, we may simply conclude that these particular individuals are not subcultural members. A shared 'style' may not, as they imply, be enough to form a subculture in any tangible or constructed sense. In this way we avoid having to abandon the term 'subculture', and just set ourselves the task of reworking it slightly. Despite their different guises, memberships and activities, perhaps subcultures should be literally that: 'sub-cultures'. 'Sub' not in the sense of different from or beneath other groups and cultures, as this would involve outsiders' own value judgements. But 'sub' as in separate from. A subculture may be defined as that which constructs, perceives and portrays itself as standing apart from others as an isolated, defined and boundaried group. Definition is thus made possible, but it must come from the members themselves.

This chapter will elicit this definition by focusing on the graffiti subculture as 'part of' but also 'apart from' the rest of society. Many accounts examine subcultures making little or no reference to the relationship they share with the 'outside world'. Either that, or the theorist imposes his/her own value judgements about the meaning, nature and form this takes. But then viewing this relationship through the eyes of the members themselves can help us see processes of group construction and definition in play. Accordingly, the first section of this chapter will look at the different ways illegal graffiti writers position themselves as 'outsiders'; that is, members of a socially detached and isolated group. How they use this 'world apart' construction to enhance their power, solidarity, and with this, the solidity of their subculture, will also be explored.

In the second section of this chapter I explore what their public image or status actually means to them – whether this has negative or positive connotations. Again, the member's viewpoint on this has hardly been considered. Theorists like Stan Cohen (1987) and Clarke (1976) may have recognized that 'Aspects of dress, style and appearance [. . .] play a crucial role in group stigmatisation, and thus in the operation and escalation of social reaction' (Clarke, 1976: 184). But they did not go on and examine what these social reactions meant to these members or, indeed, the part they may have played in actually encouraging them. This section will amend this oversight. Using the debate that rages between illegal writers and those who seek legal, paid graffiti work, I will show how illegal writers promote their 'controversial' illegal activities to invite public stigma and rejection and win, through this, space and the feeling that they alone understand, control and own this subculture.

Worlds apart – the subculture's publicly private parade

I want to start with a snapshot look at how the graffiti subculture sits in its social context. Writers are not immune to the 'outside world'. They reflect on how the public view them, if at all. In most cases, outsiders are seen to be oblivious: 'The basic general public haven't got a clue about it, don't really know anything. Some people don't even know it exists' (Mear). Conversely, those who do notice graffiti are generally assumed to be opposed to it:

> I have found that the politics and rationalization of graffiti are indiscernible to the outside world. It is viewed, all too many times,

solely as vandalism. Those who blanket graffiti with condemnation, block off the light of reason as well.

(Teck – *Urb* Magazine 37, 1994)

As 'kids', 'criminals' and 'folk devils', writers do not get much chance to expose the 'light of reason' or correct what they see to be unfounded criticism. Well-meaning outsiders may lament their lack of voice, but, interestingly, such sentiments are not expressed by the writers themselves. As Zaki explained to me:

> It's quite a wonderful feeling to be part of something that is misunderstood by the rest of society. . . . I'm glad they don't know, it's something that they'll never understand and if they did understand, would you really want them to in the first place? I think the fact that people who resent it, people who don't understand it or are against it, that is an added impetus with a lot of people to say, 'Well, this is our thing, no one else understands it, so, you know, who cares.' It's the fact that the more people slag it off, the more people will do it.

Writers delight in and, as we will see, further encourage outsiders' ignorance. This subculture is all about standing apart and, as Reimer (1994a: 68) contends, building a knowledge gap is one way of doing this: 'The establishment of fixed groupings is based on access to specific knowledge – knowledge not shared by those outside the group in question.' Knowledge is power, but it also creates a distance which makes writers feel segregated, superior and bonded. Let us now look at the different ways they reinforce this gap and its rewards.

The superior society: separating mentalities

Extending the distance between them, writers use outsiders' criticism in productive ways. Rather than perceive it as a difference in opinion and, thus, a valid view, it is taken to reflect an inferior mentality. Like the stereotypes that are used to characterize writers, outsiders are also homogenized in this manner. Blind and programmed conformity is upheld as evidence of their inadequacy:

> I don't expect the well programmed to understand that there are other things in life to want to know or understand. This would upset too many of their cosy conceptions of life and may force them to question their own meagre existences. [. . .] You probably go to

work, go home, watch TV, go to the pub, go to bed every day and think you're really living. Well let me tell you, you're probably so tuned into this 'normal' existence, so full of spoon-fed bull from all forms of media of the perfect image, that your sight of reality is limited to what you're allowed to think.

(*Londonz Burning* Magazine 2)

In this extract, outsiders/'conformists' are not portrayed as different from writers, but rather lesser – tragically ineffectual people unable to recognize and confront the social limitations imposed upon them. Having found the strength to reject these, writers celebrate themselves as the 'superior' ones, those 'in the know', those who live their lives to the full, immune to the pressures that encourage the half-hearted existence of others (see Figure 7.1). They revel in this image:

At least in your lifetime you can say you've done something. There's all these people just floating in and out of tubes, going home, going to work and you've actually left your mark and that's a good feeling, knowing you're not just one of the lemmings, sort of thing, that you stand out from the crowd.

(Zaki)

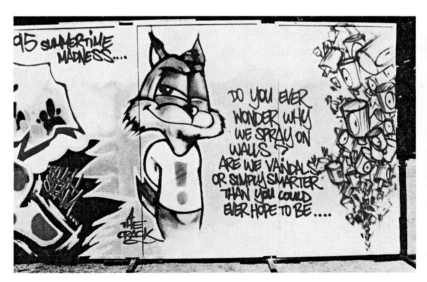

Figure 7.1 The superior society (*Photograph*: Frank Malt, collection of Steam, London. *Artist*: Rough)

It would be all too easy to stop here, accept these narratives and over-romanticize this subculture as a seedbed of hegemonic rebellion and resistance. But we must remember that, in many ways, writers are as conservative as any. They seize upon outsiders 'conformity' here, but they underplay their own. The rules they follow, the ethics they embrace and the values they share with the outside world are unref-erenced in these accounts. The respectability of 'mainstream' society, often upheld by writers as a comparison or measure of their own worth is, in this case, twisted into a sign of inferiority. This strategy, which Snow & Anderson (1987), as cited by Spencer (1994), aptly term 'distancing', allows writers to isolate themselves from the roles and associations which clash with the way they want to see and portray themselves. Here, they stand apart as free spirits who have broken through the boundaries of regulation and restriction. Affiliating themselves with 'conformist' outsiders would, in this instance, work against them. Their self-depictions would dissolve and, not only that, outsiders' criticism would also gain some impact. By writing their critics off, writers silence what they have to say:

> See I'm not really bothered at the end of the day whether people like it or not because I know 99 per cent of people don't like it, don't understand it and never will. I'm not going to go out of my way to try and prove myself to them and say, 'Look this is what it is, this is why I do it', do you know what I mean? They're just narrow, blinkered and it's just beyond them really.
>
> (Akit)

Outsiders' condemnation reveals nothing now but the limitations of their own minds.

The secret society: drawing boundaries

Writers use differences between those who do not share their experiences and views to evoke a feeling of 'us and them'. Grossberg (1997) recognizes this as a common subcultural boundary, one which members use to con-struct the outside world as the 'other'. They are not the 'enemy' per se, but rather the mass group against which the subculture defines and dif-ferentiates itself. In this section we will see writers take this 'us and them' distinction a little further. Outsiders and insiders are not just positioned as different 'types' of people. By drawing a physical boundary between them, they are also positioned in different worlds. Illustrating this, the writers below present the subculture as their own private 'system':

Sae 6 It's a system,

Jel But it's only among us, not with the outside world. They will look at us and be like, 'Bunch of idiots.'

Sae 6 But we wouldn't even care, see they have no say so. It doesn't bother me any response they have towards us and they do, you read about it in the press. You see, all their campaigns have nothing to do with us because they're not from our world.

The subculture turns inwards and positions itself as a 'world apart', a society distinct from the one which houses it. While this turns external criticism into a distant and irrelevant mumble, it makes the critics themselves distant and irrelevant too. Writers band and bond together as a private and elite society. Anyone outside of this is faded into the background:

It's a clique, it's so underground, it's not for normal everyday people, it's for that certain sect of people. . . . You're not doing it for other people on the street. You're doing it for yourself and you're doing it for others, because unless you're a writer, at the end of the day, you can't even begin to appreciate or understand it.

(Akit)

Writers, as Akit maintains, write solely for other writers. But outsiders seldom realize this, often presuming that writers are trying to present them with some form of message. As the resident graffiti 'expert', I am often having to explain to the curious, but perplexed outsider, that, 'No, Teach Diet', for example, 'is not some comment about obesity or an ironic dig at our perceptions of the ultimate body image, it is just two writers' names.' As these are only really of interest to other insiders, the walls tend to speak to them alone. This does not mean outsiders are forgotten though. Writers are aware that the public are an excluded audience, which, in turn, reinforces their experience of living in a different world:

I mean for the basic public, you're walking down the road and you see a bit of spray paint on the wall and you don't take a second glimpse, you know, you don't bother to read it, you just walk straight past. For a graffiti artist, it's like living in another world, you know what I mean? Every bit of writing on the wall means something to someone and you take notice of it all.

(Mear)

Writers walk the streets and read a private billboard of subcultural information. Outsiders do the same and see only a vandalized wall of unreadable and obscure scribble. The writers enjoy this distinction:

> Like the biggest moans people go on about, 'Oh I like the pieces, the colourful stuff, but I just don't understand that scribbling business.' That's exactly it, you don't understand it. You know, I don't see it as scribble, I see it as names and I know quite a few of them.
>
> (Stylo)

The greatest satisfaction comes when graffiti does not just confound, it frightens. To many, graffiti is sinister and threatening and this gives writers something of an upper hand:

> People say, 'Oh it's threatening sitting on a train full of graffiti.' Well, it makes me feel comfortable. I know that sounds selfish, it's just that, you know, we like it, we don't want everyone to feel comfortable with graffiti, we'd rather they didn't.
>
> (Stylo)

Writers use the city as their canvas aware that outsiders know nothing or little of the markings they see. This public yet very private parade of their subculture appears to give them a sense of power. The subculture is flaunted in the face of the public, but it remains out of their reach. This observation ties in with Hebdige's (1997) more recent work. Drawing on Foucault's analysis of the microrelations of power, Hebdige now sees the subculture's alternative styles and poses as a form of empowerment. Rather than resisting, members play with 'the only power at their disposal – the power to discomfit, the power, that is, to pose . . . to pose a threat' (Hebdige, 1997: 402). The same thing can be seen here. Being perceived as the unknown, alien, or even dangerous, 'other' makes writers feel potent. In recognizing this, they do not just rely on the public's ignorance, they make sure of it using measures which further distance them.

Privatizing graffiti's communication networks

Writers paint differently according to their audience. As Jel explains:

> We have our different styles; simple style, wildstyle, canvas style. Like if you don't want others to read your stuff, it's only for us to read, then you'll go wildstyle and hide it with arrows and colours

and all that other stuff. If you don't care, you want everyone to read it, you'll do simple style.

Styles and their levels of readability vary, but, as Proud 2 observes, an emphasis does seem to be placed on illegibility: 'The traditions from what I've grown up with, the more unreadable, the better.'

A writer seeking fame is generally expected to demonstrate skill through the use of 'wildstyle' (pictured in Figure 7.2). This is the sub-culture's most complex letter form, characterized by its angular inter-locking letters, distorted letter boundaries, accompanying arrows and extensive use of colour. An experienced audience may be able to deci-pher its obscured letters, but these are not usually apparent to the untrained eye. Accordingly, a great deal of writers' work

> only really speaks to graffiti artists. It is by and for us. It doesn't really talk to the public because some of the names are so compli-cated to read, the styles are so intense that your average everyday man can't decipher it anyway.
>
> (Futura 2000)

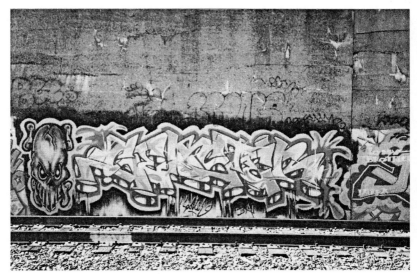

Figure 7.2 'Wildstyle' (*Photograph*: Kirs. *Artist*: Sed)

Outsiders are ostracized and, in many cases, deliberately. Yet, when you look at it in real terms, they lose little through their exclusion. For the most part, graffiti relays a writer's name, an insignificance to someone who is not involved. Writers, however, gain a lot. In their mind, graffiti becomes 'a subversive act, a conscious artistic expression with a revolutionary purpose: using guerrilla tactics to control your own networks of communication' (*Vibe* Magazine, Oct. 1994). In this sense, it becomes an important, if illusory, source of power and control.

The specific terminology writers use also provides similar rewards. Alternative vocabularies are a common feature of adolescent, male, deviant or secret groups (see for example Argyle, 1986; Bloch & Niederhoffer, 1958; Eliade, 1958; Remy, 1990; Williams, 1989). Williams (1989) sees them as 'a form of social criticism, with an emphasis on shocking or confusing people from the outside' (Williams, 1989: 10–11). Although I disagree that they are created and used for this purpose alone, there is a story in American graffiti folklore which does a good job of demonstrating this. A young writer, apparently frustrated by the Transit Authority's victory over graffiti, sent a letter to the FBI threatening to 'bomb' all the clean trains. To an insider, his intentions are clear – he was planning a graffiti blitz. The FBI, however, interpreted this message using their own frame of reference. They panicked, went to see New York's most prominent writers and begged them to talk 'the bomber' out of blowing up the system. New York writers love this story because, again, it depicts outsiders as 'out of the know' and out of their depth. In the early stages of my own research, I felt exactly that. Unfamiliar with their terminology, I spent most of my time feeling confused and left out – a true outsider. This feeling eased as I learnt more and grew more adept at relating to writers in their own terms. But these initial struggles gave me great first-hand experience of how private and inaccessible this subculture can be, and how writers work to keep it that way by obscuring their verbal and visual languages.

The silent society: unspoken solidarity

Distanced and disguised from those outside of it, this subculture operates like a hidden 'other' world. Its members also gain a sense of this removal. Writers' graffiti identities are often secret and distinct, and their lifestyles are juggled to make sure they stay that way: 'It was always something that you did on the side, that you hid from your parents. It was mysterious and it was supposed to be that way' (Freedom). Nowhere are writers more mysterious than outside on the streets where they work. The general public may see their graffiti, but

few actually see them doing it. As Henry Chalfant, a photographer of the art form, recalls: 'I took pictures for years, several years without ever meeting anybody. That was fascinating too because it was mysterious.'

I experienced the same thing. Desperate for informants in the early days of my fieldwork, I would walk the streets in the hope of seeing a writer in action. I never did. To this day, I have never stumbled upon anyone writing illegal graffiti. It is as if writers are ghosts, weaving among us without our knowledge. Mear evokes a similar image: 'It's like a silent society of people. I mean you're just getting into it now, but you could walk down the road and pass four or five graffiti artists and you wouldn't even know.' Again, the fact that outsiders are oblivious makes writers feel dominant. This writer puts the feeling into words:

> I will admit I live my life feeling rather smug, rather superior, knowing that I know of them and they know nothing of me, gloating in front of a piece at the passers by or passengers who have no clue of my double life. It's kind of like, I know who did that, whilst you're still wondering. The feeling you get when you know a secret others would die to know.
>
> (*Londonz Burning* Magazine 2)

Although writers are invisible to people in the 'real world', they see each other. Using cues that would mean nothing to an outsider, they can pick out others who share their secret bond. Acrid and Mear reveal some of the give-away signs:

Nancy　How can you tell if someone's a writer?
Acrid　The way they watch the trains. They could be seven foot tall, three foot tall, black, white, green, male, female. You see writers, they don't want to look at trains in the yard because they know it's a give away sign. Sometimes you can tell from the hip hop way they dress or they might have a pen in their hands or a camera on the tubes.

> You could be out on the buses at night and you'd see, like, two or three other guys get on the bus and they'd come and sit at the back and you'd know they must be graffiti artists as well.
>
> (Mear)

Even the way someone walks gives away potent clues. I was walking down a street with a writer in New York recently, and we passed

someone who he claimed was also a writer. I saw nothing, but he saw a fixed stare, a head-down stay-inconspicuous stance and a barely concealed effort not to look at the walls. To prove his point, we approached and asked him. Writers will always pose the question 'You write?' to establish their connection. In this case, he did and the two of them exchanged names, gossiped for a bit and then departed like old friends. Once introductions like this are made, an unquestioned bond is forged:

> It's like the guy could be white, black, young, old, it could be a girl, you might not have known who it was and it's like they're instantly a friend of yours, from the second they kind of say who they are. In this world, it's like a password to, sort of, friendship or respect or whatever.

> (Drax)

Akit puts the immediate affinity writers share with each other down to graffiti's unusual and perhaps covert nature:

> All of a sudden you meet a writer and it's bang, you have something so much in common. Graffiti's not just an everyday thing, like train or bird spotting, you know. It's not a normal hobby and you meet that person and you're both totally on that tip, it's just weird.

Writers share a symbolic consciousness that outsiders do not and this appears to invite a unique type of bonding. Yet, while this may look like a naturally occurring feature of writers' interactions, we need to remember that it is also, in many ways, a necessity. Without feelings of solidarity and notions of community, the substance this subculture needs to be a separate 'world' dissolves. With no bond connecting its members, it becomes less a 'world apart' and more a scattering of isolated individuals.

To sum up then, I would call this group a subculture, but not for the usual reasons. Cloudy, vague class criteria or modes of appearance and behaviour are, in this case, overshadowed by a much clearer distinction – distance. In all senses, writers express a feeling of exclusion, a being and a belonging to something which sits apart. They promote their subculture as literally that – a boundaried group which stands detached from the world surrounding it. And, yet, this, ironically, is exactly what it is not. Look a little closer and one can see that this subculture is actually firmly tied to this 'outside world'. It needs these ties to position and define itself. For only by hiding, and being misunderstood and criti-

cized, can it find the 'distance' that enables it to be a 'world apart'. And only by being a 'world apart' can writers participate in an 'expression of personal and subcultural power' (Brewer & Miller, 1990: 361) and solidarity. This subculture may look like a disembodied group floating in its own space, but it is in fact intrinsically linked to the world outside of it. This must be near for the subculture to be far.

Distance makes the art grow stronger – the legal vs illegal debate

The grand divide between high and low or 'dominant' culture and its various subcultures has been an active point of interest over the years. Yet, as Thornton (1994, 1995) rightly points out, very little attention has been paid to the divides that operate *within* these subcultures. The graffiti subculture is not, as we will see here, one big happy family united in its views and attitudes. It is a fractured group which offers its members a diversity of standpoints and realities. Its main division centres around how the subculture should present itself to the outside world. Proud 2 elaborates:

Nancy Is it like a secret society?
Proud 2 Yeah, it is and a lot of people want to keep it that way, they don't think it's good talking about it so much . . . They're very narrow minded, I think, because they want to keep it private. But you're not going to educate people by saying I'm not going to talk to you.

While the majority of writers want to keep the subculture secret and secluded, some, like Proud 2 above, feel it should take off its shroud and explain itself to the outside world. But, then, what happens when the subculture makes itself accessible like this? To many, it loses the benefits that come from being hidden and distant. This threat has generated raging debate between those who promote an internal focus, illegal writers, and those who seek legal work, thus taking the subculture out of its hiding place and positioning it in the glare of 'wider' society. This illegal vs legal debate is an active subcultural dispute and its main arguments are outlined here to illustrate three things:

1. Subcultural cleavage.
2. The role illegality plays in hiding this subculture from the outside world.

3. Reasons why illegal writers want their subculture to stay distant and hidden.

Setting the scene

Before getting into this debate I should clarify a few definitions. As indicated below, legal and illegal writers do not live in neat self-contained categories:

> It's not very often that you're put in one category or the other. If you do a substantial amount of illegal stuff, you're considered an illegal writer, no matter if you were the biggest gallery person going, doing the most exhibitions or whatever, you'd still be considered illegal.
>
> (Drax)

Categories overlap, but illegality remains the deciding factor. A writer who does any illegal work is generally labelled 'illegal'. Writers who 'move over' to legal work, following an illegal past, also remain known as illegal. In fact,

> a lot of people would consider it alright for them to do as much legal stuff as they could and still be considered illegal. Whereas, the other way round, the ones who are considered legal writers don't tend to do hardly any illegal work.
>
> (Drax)

Legal writers are those who have not really dabbled in the illegal arena. Writers who have been illegal and then turn to legal work, decrying their past and others' illegal activities, would also be classified as 'legal'.

As far as the work itself goes, again it varies. At its most basic level, legal work differs from illegal because it is not against the law; there is no threat of arrest. Wall writers who paint solely within legal areas like halls of fame, would, therefore, be considered 'legal'. Although illegal writers also paint here, they have or continue to do illegal work as well. Legal work may also involve a wage. Many legals earn money by selling their canvassed paintings within galleries or doing commission work for shopfronts or advertising campaigns. This is the most observed difference between the two groups.

The debate

Essentially, this debate centres around how, where and why graffiti should be practised.

Context

The first division lies in where these writers paint. Legal writers reject an illegal context for their work because, as they see it,

> The potential for big arse, full colour pieces has never been as great as on a legal wall. Though many might argue that a full colour, top to bottom train is the ultimate achievement, trains are not where new styles tend to develop.
>
> (Stylo – *Graphotism* Magazine 2)

To legal writers, graffiti is all about developing an art form. In their quest to do this, they can often be found trying to steer illegal writers away from their seemingly 'futile' illegal activities. Below is a typical argument:

> If you continue to concentrate on this aspect you're going to end up with *NOTHING*. Eventually things will follow on from what's happened in New York – virtually no pieces running. [. . .] They didn't/couldn't take it any further because they tried to beat the system – and *YOU CAN'T BEAT THE SYSTEM*. So you've got to work with it, get inside and change it for the better.
>
> (Eez – *Freestyle* Newsletter 5)

The same writer urges 'illegals' to rethink their position:

> One of the reasons I've been doing this newsletter is to try and show you what is possible if you choose a certain direction to go in – one of positive attitude and of legal painting as a base to build on. [. . .] I've got my act together and I truly believe I've chosen the right direction to go in. Can you say the same?
>
> (Eez – *Freestyle* Newsletter 5)

This comment, which implies the writer has 'seen the light' and is somehow more 'clued up', should indicate why the relationship between these groups often gets strained. Illegal writers do not take well to this kind of lecturing:

They should never try and impress their ideas on someone, it's not down to them. Like who do they think they are? Like, I've never told them to stop what they're doing. I'd never say, 'Oh you should do trains to make up the numbers' or whatever.

(Acrid)

However, it is not just the imposition of these legal views that creates this tension. More importantly, it is what they represent. In direct opposition to the legal stance, illegals assert: 'Graffiti is most comfortable and appropriate slapped where it shouldn't be' (Prime – *Graphotism* Magazine 3). Illegals reverse the argument that art does not belong on walls or trains by saying this is exactly where it does belong:

I don't really believe in like putting graffiti on canvas or stuff like that . . . it just gives it a different perspective, people start looking at it differently and, I dunno, it just becomes something totally different. It is art blatantly, but it's not meant to be there. I reckon it's meant to be on a train, wall or some surface or another, but not canvas.

(Akit)

As most writers see it, graffiti is meant to be where it was originally born and developed, not on a canvas, but out on the streets: 'As style developed on the street, for the street, by the street, graffiti, in my opinion, loses its essence and whole point in an enclosed space' (Skore – *The Real State* Magazine 6).

In response to the legal position, and severely weakening it, illegal writers draw upon tradition as a very strong tool of defence. Illegal graffiti claims its title as the grass roots of the art form. It represents 'the original way to do graffiti' (Zaki) and remains because of this, 'the pinnacle of it, everything else after that is a step down' (Zaki). Legal work comes a very poor second on this ladder of credibility. As in high culture, tradition and history are revered influences that play an important part in legitimizing a writer's work. Zaki uses a wonderfully descriptive analogy to illustrate this:

The graffiti canvases were never really the real thing. They were just like a watered down version. It's like getting a famous painting by Degas and converting it onto a little postcard or Y-fronts or something, it just doesn't work. I mean it will probably sell quite a lot, but that's not the way it was meant to be.

Wrapped up in issues of tradition come the all-important values of commitment, dedication and fidelity. A writer who is true to the subculture's traditions is seen to be loyal and supportive of its roots. The subculture's roots are deemed important, and in straying from them, legals are often accused of disloyalty. Prime hints at this below:

> I'm not saying that I don't think legal pieces, gallery work, canvases and all that are graffiti, but you can't lose the spirit of what graffiti started from, how you started, from seeing bombed trains, lil' Joe Bloggs going all city, pieced trains etc.
>
> (Prime – *Graphotism* Magazine 3)

In the quote above, Prime holds illegal work responsible for inspiring a writer's interest in graffiti. This claim strengthens the illegal argument even further. More than just a revered tradition, illegality can be upheld as the subculture's life-force, its whole reason for being. Drax presents this argument below:

> The illegal scene built graffiti in this country, got it noticed to people. Let's face it, people are going to start graffiti by seeing it on the street or on trains. They're not going to do it by seeing it in galleries because you don't get to see it in galleries unless the scene's already developed anyway.

No matter which way they argue it, illegal writers all stand by the same conviction. Put simply: 'The real life and spirit of the subculture is public graffiti . . . because that's from the raw, that's how it started and that's what gives it the life' (Prime).

Content

The subculture's conventions do not stop at graffiti's context alone. Style and content also enter into this debate. Traditionally, 'Lettering is the key to graffiti. I mean characters are like a side issue' (Zaki). Lettering is the basis of this art form and a central feature of an illegal writer's work. The legal writer is not as stylistically conformist in this respect:

> *Nancy* Is there more use of characters on the legal side?
> *Proud 2* Yeah, because you can demonstrate more sort of virtuosity, you know . . . With letters you can get away with a lot.

You know these letters look good, but, in a real sense, they're not really that well thought out.

Legal writers adopt a more expansive approach to their work and suffer because of it. As Drax explained to me:

A lot of these legal writers haven't developed, what I would call, lettering styles and skills and, therefore, their style, although it's very good, it's considered arty farty or whatever, so a lot of people won't give them credit for it. Whereas, if they were good at letters and they chose to do these other things as well, people would respect what they're doing.

Pictorial, abstract or 'arty farty' legal work (see Figure 7.3) is discredited for sacrificing the traditional essence of graffiti. As before, it loses its right to be classified as 'real' graffiti:

I mean graffiti was always based around the idea of writing your name . . . the characters and all the rest of it, it's artistic, but it loses

Figure 7.3 Pictorial aerosol art (*Photograph*: Frank Malt, collection of Steam, London. *Artist*: Part 2)

the point of what, exactly, I think graffiti is. A lot of people have tended to say, 'Oh it's not graffiti.'

(Drax)

The 'real' deal

In many ways, this entire debate boils down to a simple contest of authenticity. Illegal work, in all its guises, is promoted as the 'real', 'true' and, thus, ultimate form of graffiti:

Illegal stuff, that's really always where the real scene is.

(Prime)

To me, the only true graffiti is illegal graffiti.

(Zaki)

These definitions extend to its practitioners too: 'Any true graffiti artist gets the biggest buzz from doing illegal stuff' (Zaki). Writers who deviate from the 'illegal' path are stripped of this legitimacy:

We got a lot of flak from a lot of guys that we weren't interested in the illegal aspects of it . . . they were saying that we were fakes.

(Proud 2)

When 'The Chrome Angels' were around we had a few exhibitions and things like that and there was a lot of people saying we weren't really graffiti artists, you know, this wasn't what it was meant to be.

(Zaki)

The legal artist must deal with the illegal writers' power to impose definition. As they remain committed to the traditions of the art form, they claim the right to decree or define what is and is not graffiti, who is or is not a writer and what these individuals can and cannot, should or should not do. In response to these narrowly defined illegal standards, legal writers' only real option is to stand apart and agree to differ:

For every person, like Drax, who says, 'It's all about your traditions and the act of doing graffiti', there's someone like me who will say, 'No, to me it's not about that, it's about if you and me were to go to a wall and produce an image, who would do the better image and that's what, at the end of the day, matters.'

(Proud 2)

Legals strive to develop their artistic skills and they see these illegal conventions as a barrier to this:

> I mean, for me it's now at the stage where I want to develop the artform so we can become distinct from other people. But then there's all these rules and regulations in terms of what is permissible to paint, like letters or characters or there's this whole silly abstract thing, you know, 'Oh, that's not graffiti, that's not graffiti', and, like basically, no it's not, but it's still using a spray can . . . I've got no problems with anyone who does graffiti on that level, it's when people start to say what you can and cannot do.
>
> (Stylo)

Illegal purists provide their legal counterparts little room for manoeuvre. They regulate these concerns diligently, becoming, in many ways, a contradiction in their own terms. Stylo unravels the inherent paradox of their position:

> The most hardcore supposedly illegal writers have got, like, a whole book of rules about how to be illegal or how to be a graffiti writer and it just kills me because, to me, it's all about doing what people are telling you not to do or it's just doing what you want to do really.
>
> (Stylo)

On the one hand illegal writers symbolize the 'rebels', trampling down the rules and restrictions that society imposes upon them. On the other, they stand as staunch conformists, openly setting and policing rules and restrictions themselves. Given this disparity, we are forced to ask why their conventions are so important to them. Why is legal work denied credibility and, thus, discouraged? Can tradition really be that important? If so, why?

Illegality: the defence of distance, distance as defence

The notion that subcultures lie, or struggle to lie, outside the corporate world is a resilient (Thornton, 1994, 1995) and, for many theorists, outmoded one: 'This romanticism of authenticity was a false and idealised view' (McRobbie, 1994: 161). Supporting her contention, McRobbie (1994) uncovers some of the commercial motives that operated and operate within the punk and rave scenes respec-

tively. Such enterprises draw these 'subcultures' into a close and symbiotic relationship with the world they are supposed to resist and repel. But does McRobbie's finding mean all subcultures commit themselves to this commercial relationship? While punks and ravers may not be the pure, uncontaminated groups that reigned within the work of the CCCS, the graffiti subculture, or the illegal side of it at least, tries to be. Let us review here the role of illegal authenticity. This emerged in the previous section as a form of 'subcultural capital' (Thornton 1994, 1995). By conforming to certain illegal conventions, writers are promised a powerful degree of legitimacy. In effect, they are encouraged not to attract or 'talk' to the outside world. A similar dynamic can be seen in club cultures (Thornton, 1994, 1995). Here, 'underground' activities are celebrated. They refuse to occupy categories defined as 'mass' or 'mainstream', and acquire from this a rewarding sense of credibility or 'hipness'. Thornton (1994, 1995) sees these rewards as ends in themselves. The clubber's ultimate concern is being 'hip', credible and 'in the know'. While image certainly comes into it, I see their impact within the graffiti subculture as a little more far-reaching. Clubbing is a money venture, a business which already sits within the commercial world. Graffiti does not. It is a 'criminal' activity and, as such, it still has the scope to stay 'pure'. By encouraging illegality, the prize of authenticity helps it in this struggle.

What they don't like, they don't touch . . .

Drax sees illegal graffiti as a little like an armour and shield. By shocking, confusing and alienating outsiders, it hides the subculture from the commercial world or 'the powers that be': 'Bombing, tags or even racking [stealing paint] [. . .] all these things and others have no financial potential and are, in fact, an obstacle between us and the powers that be' (Drax – *Graphotism* Magazine 3).

Taken to its logical conclusion, this narrative positions illegal writers as the brave defenders of an 'underground world'. Now one could overlook the rationale underlying this, and focus instead on the way it serves illegal writers' identity needs, but this would be to miss the point. Let us look again at some of the ways illegal graffiti does actually rebuff the interest and intervention of the 'outside world'. First off: 'A lot of it's indecipherable, you know. I think that has always been why people don't like it, they can't read it' (Martha Cooper). Illegal graffiti does not speak to outsiders and many reject it on this basis. For writers

like Sae 6 below, this is the whole point. Keeping graffiti obscure, keeps outsiders out:

> By somebody like that being able to come into my area and read what I'm doing or even know about it, then it's selling out. Now you're breaking up the whole thing, you know what I'm trying to say? It's like organized crime, once you have all these other people involved, it's no longer organized crime.

Illegal graffiti's location also helps it in this quest. As Zaki recognizes, art outside cannot be packaged or bought: 'I'd rather have a graffiti canvas than a painting because that's what I like, but it's not the same as having it on a train go by. You can't buy things like that and you can't buy walls either.' Unlike legal work, illegal graffiti is inaccessible. It stands out of outsiders' reach, resisting their manipulation and precluding their interest. Illegal graffiti's strongest tool of defence, though, will always be the fact that it is illegal:

> There's nothing more controversial than illegal graffiti . . . Whereas people see legal stuff and you get a far better reaction. It's when you take graffiti to the tube trains, that's when you start getting all your bad press, like the public won't tolerate it.
>
> (Proud 2)

It may not be harming anyone, it may even look pretty at times, but at the end of the day, illegal graffiti is against the law. This, for many outsiders, makes it unacceptable. And this, for many insiders, is exactly what they want it to be:

> *Jel* Illegal shit, it's a turn off to them.
> *Nancy* And that's good?
> *Sae 6* Yeah, because they can't get in on it, they can't get in on it.

What outsiders don't like, they don't touch and what they don't touch remains isolated or, as Sae 6 terms it, 'underground':

> I don't want nobody in no three piece suit to like my stuff. You see, I'm an underground person. That's the thing about graffiti, it's a whole underground culture, you're writing for the writers . . . We don't cater for these people, you see I just don't give a fuck.

Writers communicate with those beyond their boundaries to make sure they stay beyond their boundaries. And they do so through the voice of illegality. From this angle, the 'deviant as innocent victim of negative label' theory is, once again, completely reversed. Outrage and moral panic is their *goal* or, as Thornton (1994, 1995) puts it, the vehicle of their resistance, not the verdict. In this case, crime is driven by an awareness, agency and purpose – isolation from the outside world.

Not for sale

This drive to keep graffiti illegal and out of commercial clutches does not come from the lure of authenticity alone. Subcultural fidelity lends a powerful hand in this endeavour. This is an influential value which pushes writers to 'stay true' to the subculture's illegal traditions. Illustrating its power, Sae 6 explains how he has struggled to develop his style without losing sight of his illegal beginnings – lettering:

> I'm trying to expand, trying to bring it out, but I'm still not going to be selling out. . . . I still maintain the rules, you know the lettering form. I change it around and play with the arrows, but I'm still using the letter form, so I'm still showing respect for graffiti because that's how I started out. I'm not going to sell out.

By keeping letters central to his work, Sae 6 resists 'selling out'. This term describes the process by which the subculture's traditions, those which speak to insiders alone, are abandoned to attract or accommodate an outsider audience. The interview excerpt below does a great job of putting this concept into context. In this, Sae 6 reprimands his friend, Jel, for adapting his language to suit my 'outsider' needs:

> *Sae 6* It gives you more props.
> *Jel* Meaning popularity.
> *Sae 6* No props. Jel, you got to use the correct form. You can't, you're not selling out Jel, you know.
> *Nancy* No, you use it, it's alright I can keep up, you'll just have to translate some of them.
> *Sae 6* Yeah I'll translate, but I don't want to give you it.

This phrase, 'give you it', sums it up. A 'sell out' is a writer who gives away the subculture; one who compromises it and themselves to cater

to an audience with a more delicate palate. Drax comments passionately on such individuals, their work and their underlying incentives:

> The neatly packaged, we're from the street, we don't do trains, we're nice legal guys, look we're so full of expression spelt S-H-I-T gang. That's where the hard work of thousands is going – into the back pockets of bullshitters who sell ours and even their own artistic souls for as much as a sniff of what they perceive to be fame. [. . .] They deprive the public of seeing real street level graffiti, producing watered down crap with no soul, no style, no feeling, light weight rubbish which they think will catch the eyes of the public and ascend them to the status of 'the artists from the street'.
>
> (Drax – *Londonz Burning* Magazine 2)

Here, legal writers are portrayed as 'packaged' goods; fakes who have exchanged their true persona for one that attracts, rather than repels, outsider interest. Their motives, as the term 'selling out' suggests, are seen to be financial, and, as Zaki reminds us, these go against all the principles of the subculture: 'One of the most amazing distinctions is there's no pay involved . . . With graffiti, it's just for the love of it.' Writers who dedicate themselves to unpaid illegal work do so 'for the love of it'. Their incentives are deemed 'pure', 'true' and legitimate because they stem from love not money, loyalty not greed. The legal writer is contaminated by his/her earnings and, as Jel and Sae 6 illustrate, rejected on this basis:

> *Sae 6* He's not a name, he never painted a train, he's excluded. . . . He's like a person who used graffiti to sell. He made a profit off it, he's a sell out.
>
> *Jel* To us, he's like the arm that we never had.

From an illegal perspective, the legal gesture is one of betrayal. The illegal sphere and its traditions represent subcultural roots and purists believe these should be nurtured: 'Peace and respect to all those writers who know their roots. Peace, no sell out' (Keen One – *Londonz Burning* Magazine 2). Nurturing these means looking inward, deterring outsiders' access and interest, in short, sustaining the subculture as a segregated 'world apart'. In detaching themselves from these illegal roots to market themselves for public consumption, legals disarm the subculture of this distance and, as Iz puts it, 'destroy the cause': 'Writers that

make money off this artform, no matter how you look at it, they destroy the cause.'

. . . And what they don't touch remains ours

So what exactly is this cause? What are illegal writers fighting so hard to avoid? What threat accompanies outsiders' acceptance, interest and commercial involvement in this subculture? Drax gives us his view on such matters:

> What if we do gain acceptance from these 'powers', from the 'man in the street', then what will happen? They will turn it, like everything else good, into a sick charade of Sun Newspaper like headlines: 'Graffiti is in', 'This week we talk to the artists from the street who have made good', 'Win a trip to New York' and of course the art will have no depth, soul or meaning. Then as Mr Byrite or Marks & Spencer's sell off their last stocks of Wildstyle slippers or aerosol art knickers and decide not to restock, the powers that be will be back with: 'Graffiti is out', 'Boy died after inhaling paint', 'Stop this craze now', 'Graffiti promotes drugs and violence', etc. And then it will be good-bye to this whole scene, good-bye to any respect from anyone anywhere, good-bye to our discredited history and good-bye to all those that encouraged the sell out as they'll be living it up on a yacht somewhere laughing and then what will we have left? Nothing. [. . .] Now I'm not saying there isn't a place for commercial success within our scene, of course there is, for those who deserve it. But it can only really be (to me anyway) a part of it, not where the scene is heading. This isn't the stock market and the time will never be right to 'sell out' because without roots this tree will die.
>
> (Drax – *Graphotism* Magazine 3)

Drax talks of graffiti's commercialization or 'incorporation' (Hebdige, 1979), but his concerns seem to go beyond the fact that someone will make money out of it. Implicit in this account is the idea that the outside world will take control – not of the subculture per se, but of its meanings. Once graffiti enters commercial confines, the 'powers that be' are given the reins to its definition. They can make it cool, 'edgy' and popular, filling the shelves of department stores with products covered in its imprint. Then when the 'craze' fades and demand dies down, they can make it old, tired or menacing and wave it goodbye in a flurry of negative press. The threat is not so much what they define or do with graffiti, it is the very fact they can. Illegal writers are

possessive of their subculture and they enjoy the power that comes from knowing only they understand and direct it: 'This is our community, this is our nation, our contribution to the world, it's our job to preserve it, insure it and nurture it – not someone else's (Phase 2 – *Vibe* Magazine, Oct. 1994).

The reasoning behind their argument is, therefore, simple; do not move graffiti away from its illegal traditions because this will tame the subculture, open it up to outsiders and position it in a world where writers will have to struggle for its ownership and control. Keep it hidden, because 'if they can't understand it, claim it or market it, they don't give a fuck about it' (*Vibe* Magazine, Oct. 1994). In rejecting their world, the subculture stays their world.

This chapter has contextualized this subculture by looking at the relationship it shares with the outside world. This has been valuable because it has allowed us to see how the writers themselves construct and struggle to defend their chosen position within society. For illegal writers, this is a secluded niche. This group assert themselves as a subculture (in the literal sense of the word) and they work hard to stay that way. So far, these observations mesh with those of the CCCS group. As in their thesis, 'space' surfaces as an important prize and 'resistance' features in the way writers work to win it. Subtle, but important, differences emerge, however, when one considers the purpose of their 'resistance', the nature of this 'space' and, indeed, the reasons why it is won.

In the CCCS's work, subcultures take on a political guise. Using their 'resistant' styles and activities, members oppose the hegemonic meanings and values of the 'dominant' culture and crusade to 'win space' for their own. But are these 'resistant' gestures their own values and meanings? Do they seek accommodation? Or do they serve another purpose? From what we have seen in this chapter, I would say there is a little more to it. Illegal graffiti is more than just a flagrant refusal to 'fit', or a half-hearted rebellion against the impositions of the powerful. It is a way of inviting public rejection and creating some sense of distance between the subculture and the world it sits in. In this sense, writers are winning space, but a different type of space from that of the CCCS group. This is not a place where they stand out of hegemony's shadow. It is one where they stand *apart* – not as cultural innovators and political crusaders, but as social outcasts and folk devils. What the CCCS overlooked is the possibility that subcultures

may actually strive for and celebrate their stigmatization. All too often this is seen as the consequence of their 'resistance', rather than its goal (Thornton, 1994, 1995), as illustrated below, a negative, as opposed to positive, outcome:

> Exploitation of subcultural style, by the dominant culture, has itself two opposed aspects; on the positive side a heavy commercial investment in the youth world of fashion and trends, and on the negative side a persistent use of style-characterisations as convenient stereotypes to identify and, hopefully, isolate groups dominantly regarded as 'antisocial'.
>
> (Clarke, 1976: 185)

The CCCS's research is marred by the absence of the subcultural voice, and this quote re-emphasizes the desperate need for its presence. A commercial investment is, for graffiti, anything but positive and its isolation is anything but negative. In this instance, a Marxist reading just does not translate. Rather than countering hegemony or challenging 'dominant' culture's meanings, the graffiti subculture supports them. It hides itself from the public, revealing only its 'negative' side – that which continues to confine and subordinate it. While hegemony may be used to explain away writers' celebration of this, it does not do a very convincing job. The problem with hegemony is

> it seems too general and malleable a concept to be of much use in the analysis of concrete living social practices. [. . .] Hegemonic perspectives seem to be deeply uninterested in these actual practices and recoup 'popular cultural' contents too quickly into the politics of people/power block relations.
>
> (Willis, 1990: 156–7)

Hegemonic analyses view the world through political lenses. But they need to take these off occasionally to see how the 'suppressed' are creating their own cultural practices and products, and with these, their own notions of power and ownership:

> Psychologically at least, the informal symbolic workers of common cultures feel they really 'own' and can therefore manipulate their resources as materials and tools – unlike the books at school which are 'owned' by the teachers, unlike fine art paintings which are 'owned' by the curator.
>
> (Willis, 1990: 136–7)

Possession is the prize here, which helps us understand why subcultures tend to be dominated by the young – those who do not own or control anything else. It also explains why many of these groups, like this one, 'exercise their uses and economies in precisely eluding and evading formal recognition, publicity and the possible control by others of their own visceral meanings' (Willis, 1990: 3). What is hidden from and then rejected by the outside world becomes their loss and an insider's gain. The subculture remains their world – accessible and meaningful to them alone.

8
Making a World of Difference: The Personal Benefits of Subcultural Membership

In this final chapter I want to give a little space and attention to this kind of comment: 'The wonderful thing about graffiti, you get people from all walks of life and all ages that are involved, because you get out of graffiti what you want. You know there's so many different things you can get out of it' (Zaki).

It is touching to hear writers talk about graffiti and the immensely powerful role it has played in their lives. At times, it almost sounds as if they are talking about an old friend, someone who stepped in and stuck with them through good times and bad. I want to give this impact that the subculture has clearly made on their lives some relevance. For a long time it has been denied that. In the work of the CCCS group, the subculture was not a place for personal gain, but rather somewhere for members to work out or through, at an imaginary level, class-related problems and contradictions (Clarke et al., 1976). Structural rewards were emphasized at the expense of personal ones, relegating members' youthfulness and the age-related issues they might have addressed through the group to secondary concern. Today this focus is shifting. Promoting the personal above the 'political', theorists are now leaning more towards looking at subcultures in terms of 'the modes of empowerment they offer' (McRobbie, 1994: 174). This chapter will do likewise. It will also consider their source. The graffiti subculture stands, as we have seen, as a detached 'world apart'. Aside from granting writers a sense of subcultural control, this distance also gives them the tools to create a 'liminal' sphere; that is a confine symbolically removed from the 'real world' and all the ties, relevances and restrictions that may be found there. This is a powerful construction and I explore its dimensions in the course of this chapter.

179

The first section touches on themes of adolescence and autonomy. Building on foundations laid by Brake (1985), I look at this subculture as a free space which young people can use to explore who they are and forge a sense of their own independence (Brake, 1985). Willis (1990) sees the youth or subculture as an important source of guidance. With no cohesive or 'whole' culture to adhere to and, thus no 'ready values' or 'models of duty' to follow, these groups can help structure an individual's passage into adulthood (Willis, 1990). I join Willis in this reading, and look at how the rules, order and layout of this subculture act as an aid during a young writer's quest for independence.

The remaining sections of this chapter focus on issues of identity. Academic work of the past never quite made the link between subcultural practice and the construction of identity. Theorists now understand its importance:

> Identity could be seen as dragging cultural studies into the 1990s by acting as a kind of guide to how people see themselves, not as class subjects, not as psychoanalytical subjects, not as subjects of ideology, not as textual subjects, but as active agents whose sense of self is projected on to and expressed in an expansive range of cultural practices.
>
> (McRobbie, 1994: 58)

We have seen how writers use their graffiti to build their masculine identities. This chapter will look at the way they use graffiti to create an 'alternative' identity; that is, an identity free from the ties and constructive restraints that attach to and limit the personas they occupy in the 'real world'.

New world, new life: passage to independence

Theories of adolescence are diverse. Classical psychological and sociological accounts portray adolescence as a developmental 'stage' which occurs in response to the 'unsettling' physical and emotional changes or social role confusions that arise during one's teenage years (see for example Blos, 1962; Erikson, 1968; Josselson, 1980; Marsland, 1980, 1993). In contrast, Functionalist theorists, most notably Eisenstadt (1956), Coleman (1961) and Parsons (1942), present adolescence as a stage of progression not upheaval, a form of continued socialization, rather than inner turmoil and 'storm and stress'. Others move away from the concept of adolescence as a stage altogether. Davis (1990) sees

this period of life as a manufactured social phenomenon, a concept created by the disjuncture between childhood and adulthood. This latter perspective is valuable because it shifts us away from universal notions of youth and injects much needed diversity into the tasks and pressures young people face as different sexes, in different cultures and at varying points in history (Allen, 1968; Griffin, 1993; Silbereisen & Eyferth, 1986). And it can do this, as McRobbie (1994: 178) demonstrates, without suffocating itself under the weight of relativism: 'Without presenting youth as an essentialist category, there are none the less a sufficient number of shared age-specific experiences among young people which still allow us to talk meaningfully about youth.'

The most significant of these has to be a desire for independence. Youth stand at the brink of adulthood and at this point issues of autonomy start to gain full impact. Whether one sees this as a result of internal drives and impulses, changing roles and responsibilities, restricted rights and opportunities, 'teen' narratives, or a combination of all of these, depends upon one's theoretical standpoint. However, it is an issue which is tackled within almost any account concerning youth or adolescence. This section will also touch on it, but not with the aim of supporting or developing a specific adolescent perspective. This would resemble, like these theories themselves, more a statement of faith than a proven 'truth' (Davis, 1990). Rather, my interests lie in writers' own interpretations of their needs and desires and the way in which they use the subculture to satisfy these. In short, I want to look at these age-related changes from the point of view of those involved.

Claiming space

To be young, as Ganetz (1994: 87) sees it,

> is to be powerless, to see one's own life controlled by other forces than one's own. It is not only one's parents who have power, but also institutions such as school and leisure organisations. The market and the state also intervene in young peoples' lives.

Power and self-control are live issues for young people. They lack it, and, as the writers below confirm, they want it. All three convey the frustration they felt at this age, linking this with the time they started writing graffiti:

> I suppose I was pissed off with just being told what to do all the time, you know, it was nice to do something a little bit different.
>
> (Stylo)

I felt the desire basically to do something and achieve something for myself. I was feeling stifled.

(Drax)

You're at the age where you don't really want to have to be told what to do. Like once you get into the high school level, you begin to feel a little grown up and everything. . . . That's why graffiti begins here, at that 13 to 15 age group.

(Futura 2000)

These writers were all searching for some sort of 'space', somewhere where they could flex their own muscles and be their own boss. This adolescent pursuit is a well-recognized one: 'One of the distinguishing features of youth culture is just this search for places where one can be in control; a place to be alone and with friends; a place free from parental and other adult interferences' (Ganetz, 1994: 87). The graffiti subculture fits the bill nicely. As this writer told me: 'It's a clear cut means of breaking away, doing your own thing' (Series). In this subculture, writers escape 'real life', that is school, family and home, and find themselves with the space and freedom to 'come into their own'. Henry Chalfant elaborates:

There's no bureaucracy to deal with here, which might make any transitional event for you meaningless. If you do it through the institution, it becomes meaningless, they are so little to do with you. . . . No one intervenes, you get on with it for yourself.

With no teachers, parents or supervisors present, writers are left with complete control of their own development:

You can control your own destiny here, it's totally self propelled.

(Claw)

The one thing about graffiti is the fact that you couldn't go and buy a book about it, see what I mean, there was no guidance to it.

(Sae 6)

When you're really into something madly, you learn every facet of it, don't you? Because a lot of it's self taught, you can work out things for yourself or experiment by making mistakes.

(Zaki)

Here, writers advance their skills and learn their trade in their own time, in their own way and for their own reasons. Given this, is it hardly surprising that they put such a massive amount of effort into the progression of their graffiti careers? For perhaps the first time, they gain full responsibility of their own achievements, an awareness of their own abilities and a clear sense of 'the powers of the self and how they might be applied to the cultural world' (Willis, 1990: 12). By standing apart, out of the reach of adult control, this subculture is able to provide its members with all the tools they need to discover themselves and make the transition into adulthood. To reiterate, that is autonomy:

> You're giving yourself your own guidance, you're not being tutored, you're not being told, 'This is what you have to do, you must go to college, you must be a lawyer, you must be a doctor.' . . . You've found something that is your own.
>
> (Ego)

Freedom:

> I still think to this day it's about freedom, that's the assessment I would make.
>
> (Iz)

And control:

> Here's an outlet that you feel you can have control of because society sort of makes you feel like you're controlled.
>
> (Pink)

The physical risks and dangers writers face only enhances these rewards:

> It follows an adolescent pattern, you know, you start to feel your own independence. Now you're responsible for your own life completely. Like, if you make one false move, your life is in your hands and you could get killed, so you're showing that sort of independence.
>
> (Pink)

In this subculture, members gain more than just a metaphoric control over their lives!

Structured freedom

Graffiti offers writers an escape from the shadow of adult control, but it does not, as we will see here, leave them floundering in their own freedom. Like many youth groups, this subculture eases its young members' moves towards autonomy by providing them with alternative sources of structure and support.

'The rules of disorder'

While writers challenge the rules and regulations set by 'wider' society, they do not divorce themselves from the discipline these represent. Although it may not look like it on the surface, this subculture is actually tightly regulated. It operates its own governing system and its own set of rules and guidelines. These may be unwritten, but 'they are clear. There are these aspects, rules and marks that you live by as a graffiti writer and you learn as you go' (Claw).

So what makes these rules different from those flaunted within home, school or society? First of all, they are more relevant: 'They identify much better with the rules of the community because they're self made rules and they fluctuate and they're sort of appropriate for the field you're in' (Lee). Secondly, they are self-generated: 'Our society has its own rules that are not inflicted upon us by appointed figures, but a voluntary set of rules lived by through belief, rather like the customs of a religion' (*Londonz Burning* Magazine 2).

Without an appointed body of 'authority', writers keep their self-control, and the subculture keeps its discipline. It is this duality of constraint and freedom that makes it such an ideal place for the young to reside while they feel their way towards independence. Here they gain free space and a clear set of guidelines to help them navigate it. These provide them with a repertoire of accepted moves, a clear set of steps towards goals and, as Futura 2000 endorses below, a valued source of confidence (Argyle, 1986):

> I remember so vividly being like a toy [novice] and not knowing anything about the rules and just pretty much keeping my mouth shut and listening and wanting to learn, you know, having some education before I just jumped into the thing blindly.

'The youth of today'

Although age is insignificant in this subculture, distinctions in status and experience are key. Writers recognize these by dividing themselves into two basic categories: 'Basically you've got old school and new

school. Like your new school will be all the people that are out bombing at the moment, like new names, like I don't even know half of them' (Kilo).

The subculture adopts generational divides and, it seems, the attitudes that come with them. As in wider society, older generations of writers can often be found moaning about the 'subcultural youth of today'. Jel steps on to his soapbox here: 'Back in our day writers had more morals and the kids of today have grown at a much faster pace, so the kids of today are more wild than when I was younger, they're just really crazy.' As Ego complains: 'It's what kids are like now though, it's getting worse and worse.'

Young writers join this subculture and find themselves rapidly inserted into the same 'youth of today' category they occupy in the world outside. Life in this lowly position is far from easy, as this excerpt from a magazine article directed specifically at them demonstrates:

1. You suck until further notice.
2. It's going to take a long time before we even acknowledge your existence, even longer before we can bear to look at that foul scribble you call your name.

<div align="right">(Mark Surface – On The Go Magazine, Dec. 1993)</div>

Older writers are 'elder and better' and the young novice is 'seen and not heard'. Adding insult to injury, they must also carry the label 'toy'. As this word infers, they represent playthings, figures who are merely there to amuse and entertain others. Indeed, to call an older or accomplished writer a 'toy' or make childlike insinuations, as below, is a common form of insult: 'He's down with the crayola posse' (Az).

So how could these status distinctions possibly help a young writer in his/her quest for independence? Firstly, by offering them the security of a clear-cut structure (Argyle, 1986). Like new army recruits, young writers enter the subculture and are quickly shown where they stand and what is expected of them. Although their position is menial and unrewarding, unlike the 'real' world, it is not fixed or enduring. With a bit of hard work and dedication, they can soon climb to the heady heights of their heroes. Like Drax, they may even get a new generation of writers asking for their autograph! 'Drax says he gets kids coming up to him and asking for his autograph, you know, 13 year olds. Because to have a tag by Drax in your book, it's like getting someone's autograph or something' (Proud 2).

I witnessed something similar to this while I was conducting research in New York. I was talking to an older writer outside the graffiti shop I used to go to, when a small crowd of young boys started to gather around us. We continued to talk and they moved in a little closer. They were like star-struck fans hanging off every word he uttered. Eventually, one of them came forward and asked him to tag in his 'black book'. That was it, he was there for the next 20 minutes signing his name and answering questions. Being part of this enabled me to appreciate the second, and perhaps most important, benefit of their status differences. This individual ceased to be merely an 'American writer', he became an icon, a celebrity, and, thus, a figure who could be worshipped and emulated. At this point in life, as Proud 2 explains: 'You change your role models. I mean I adopted people, prominent people in the scene. . . . I suppose it's like a popstar, they're your role models. For the last part of my teens, it was a few prominent guys in graffiti.'

In the early days of the subculture more formal mentor–apprentice partnerships were also common. In exchange for paint or help in the train yards, older writers would train up younger protégés. As Henry Chalfant recalls: 'You could watch people develop . . . take over the style that their teachers had taught them and improve on it and actually become more famous than them.' This mentor–apprentice relationship is a developmentally important one (Levinson, 1978). Moving towards independence, the mentor provides the adolescent with a supportive transitional figure (Levinson, 1978); an unrelated role model who initiates and smoothes their journey into the social world outside of the family unit (Hamilton & Darling, 1989; Levinson 1978). Even without this personal contact, the benefits are there. It is enough just to look up to someone as a role model, watch their behaviour, imitate and learn from them (Hendry et al., 1993; Kandel, 1986). The graffiti subculture enables this by ranking and categorizing its members.

This section did not present a 'typical' portrait of adolescence. There was no sign of storm and stress, angst, internal confusion, trauma or rebellion. Just a practical process of adaptation and a search for some sort of space. These writers all talked of their desire for independence, the need to stand on their own two feet and be recognized as their own person. With nowhere else to do this, they turned to the subculture. The problem here, then, is not an individual one but a contextual one (Fiener & Klein, 1982). Similarly, the response is not a confused one, but a goal-oriented, agentic one. Writers have adopted this subculture as a task environment, a place where they can actively shape

their own development (Silbereisen & Eyferth, 1986). And they have built it carefully to perform this role. While it offers freedom and autonomy, it also provides structure, stability and support. Rules and roles maintain order, discipline and guide behaviour. And generational divides provide opportunities for role taking and learning. This supposedly lawless subculture may have retreated to a secluded corner to be a 'world apart', but it has clearly carried aspects of the 'real world' with it. . . . Not all of them though.

New world, new life, new persona: passport to potential

When writers start writing graffiti, they start a parallel life. I say parallel because this is not the only life they lead. Straddling both the 'real' world and the subculture sets in play a sort of double existence. Mear describes this 'Superman syndrome', as I term it, as lived experience:

> It's like you have two totally different lifestyles. Probably people at work don't know what the hell he's doing in his spare time. You know, it's something totally different. It's like having a split personality. It's like me, at one stage my parents, my mum, didn't know where I was going at night. I'd be back before morning, you know, I'd just have a normal day.

In distinguishing between these different identities and lifestyles, Mear fills a theoretical gap that many theorists leave vacant. All too often the subcultural member is presented as that alone (Davis, 1990; McRobbie, 1980; Widdicombe & Wooffitt, 1995). Little attention is paid to the other areas of his/her life, the different identities he/she juggles and how. Members of this subculture are very in tune with these issues. A writer may be a writer but, as Mear appreciates, he or she is also someone's son, brother, daughter, father or employee. Mear describes this as akin to having a split personality. In doing so, he recognizes himself as a postmodern subject, one whose 'self is conceptualised as more fragmented and incomplete, composed of multiple "selves" or identities in relation to the different social worlds we inhabit' (Hall, 1989: 120, as quoted by Reimer, 1994b: 129).

Some theorists see this rupturing of self as stressful, as producing 'anxiety states resulting from distress at such contradiction, and the consequent desire for wholeness, unitariness – a coherent identity' (Henriques et al., 1984: 225). But distress need not be inevitable. Writers seem to avoid any anxiety or confusion by avoiding any sense

of contradiction. A distinction between 'real' and 'subcultural' life is drawn and the self is neatly fractured to accommodate this: 'You develop this whole other identity that doesn't really apply to the real world' (Dondi). Rather than one person housing two identities, writers become, like Superman, two different people. Both these identities remain distinct and, as we will see here, for good reason.

'The Superman syndrome'

Splitting the self like this serves an important function. Aside from avoiding confusion, writers are also 'kind of escaping real life' (Dondi). Like rebirth, they join the subculture, choose a new name and establish a new persona. For a new writer, especially an adolescent one, this is not just 'a matter of acquiring a new label, but rather of being a different person involved in different things (Kohl, 1972: 111). Name changes have always symbolized changes in status and role (Bloch & Niederhoffer, 1958; Eliade, 1958; Fiener & Klein, 1982; Harré, 1993; Young, 1965). As an important feature of initiation rites, they 'indicate that the novice has attained to another mode of existence' (Eliade, 1958: xiii) and, thus, stand as a marker in his/her quest for autonomy (Bloch & Niederhoffer, 1958). With their new name, writers stand as their own person, free from the other ties and associations that define them. For perhaps the first time, as Henry Chalfant explains, they define themselves:

> You're kind of transforming, you're no longer a child, you hold your own destiny and identity in your hands. And graffiti is like that, it's the first step of having your identity in your hands, you're responsible for it, for the persona you're going to present to the world as an adult.

For some writers, this control over their identity represents freedom. For others, it is a source of stability. Futura 2000 explains how he used his new identity not so much to escape definition, but rather construct it:

> At around 15 I was told by my parents that I was adopted and I guess the shock of hearing that put me in a situation where I didn't know who I was, kind of thing. And there was this happening outside on the streets where I could suddenly become an anonymous person and create a new identity for myself, which is pretty much what I used graffiti for, to create an identity which I was

certain of. Nobody would be able to come and say, 'Well you're not that person' or whatever, there was really no question. I could hide behind the anonymity or I could be quite public about it. However, I wanted to deal with it, so that's what really got me into it, that I needed to, I was looking for my self identity.

Whether writers use their identity to avoid, escape, seek or stabilize, at the end of the day its most important feature is its potential. Its beauty lies in what you can do and who you can be with it. As these writers recognize:

In the graffiti world, you can be the same as bloody Calvin Klein or whoever else.

(Mear)

You can be an underground celebrity within your own community, your own setting.

(Sae 6)

This identity is the person writers yearn to be – the successful, famous, respected person that they may not be able to be elsewhere. Essentially, this identity is their own route to self-actualization or the American Dream:

You know, it's because you can never be famous in the higher life, you know, you're nobody, you're being looked down at, you know. So we had to find a way to become movie stars in our own way.

(Jel)

I just think a lot of people see it as a way they're going to get some sort of recognition within their own group. . . . A lot of people see that they're not going to get noticed, they'll just be another statistic, but the guys that do graffiti are there.

(Proud 2)

I mean, as an adolescent you've got to just wait until you grow up for people to take notice of what you're doing. So with graffiti, you can start at any age and people will look up to you. However small you are, people will look up to you with some respect.

(Mear)

With this identity, you can put on your cape and become 'your own sort of superhero, I dunno, it's a kind of sense of being someone' (Ego).

Keeping worlds apart

This subculture is an escape, but only if writers keep their lives and identities separate. If the two worlds mix, its rewards dilute. Boundaries operate to stop this from happening.

'Foolish fidelity' – keeping graffiti out of 'life'

The first can be found in writers' definitions of what it means to be a writer. As we saw earlier, 'proper' or 'real' writers must prove themselves and pay their illegal dues. But what point must they work to? When are these dues said to be paid? Answers to these questions can be found in the category writers use for those 'guys who've got to keep carrying on and on and on and really pushing it, they're obsessive' (Ego). This type of writer is generally called 'fanatic' or 'hardcore'. The fact that there is a specific label for them indicates they are somewhat unusual. Drax outlines how they differ using Rate as a classic example:

> You've got to talk to Rate. Rate is like, 'I've been in prison and I'm a total psychopath, I don't stop.' He's out there to destroy trains and you just think, 'What the fuck is this guy on?', or 'Yeah, yeah, I've heard it all before.' But when you realize his age and the fact that he's been to prison and that, you just think, 'Shit, he really means it.'

Fanatics are illegal writers who continue to write at the same scale and pace following arrest or even a spell in prison. Despite the commendable dedication they display, writers' opinions of them are mixed:

> *Nancy* People that carry on in the face of massive charges, people like Rate, is he highly respected?
> *Kilo* People either respect him or think he's stupid. I respect him.
> *Lee* Yeah, he's just dedicated.
> *Kilo* I mean to be knocked back, as he's been, and still come out, you know.

Fanatics might be admired for their efforts, but many view the lengths they go to as reckless, irresponsible and stupid. There are, it seems, limits to the dedication expected and fanatics go beyond these:

Nancy Did Acrid get a certain amount of respect for doing what he did?

Drax Yeah, definitely. Even now, to an extent, people say he did a lot of stuff. But I think if you're just a total idiot who doesn't care or think about getting arrested, then anyone can go out and do that amount of stuff easily. It's like to do it and get away with it earns you more respect than to do it continually and just fuck yourself up over it, you know. I mean 'Kast', for example, is probably the most respected London train writer ever, just for style. He served time for graffiti and then he had a court case coming up, where he was looking at getting something close on two years for graffiti and he went on the run from the police and he's been on the run ever since. . . . It's like graffiti has completely and utterly screwed up his life and people, I'd say quite unanimously, respect him as one of the best London train writers ever, but, at the same time, I don't think people respect what he has allowed graffiti to do to his life. Although people will say it's unfortunate, a lot of other people, even reckless writers, would say, you know, he should have been more sensible. Like Acrid is someone who falls into that bracket, he got arrested and he didn't learn, he just carried on being stupid.

A writer should be dedicated, then, but not 'too' dedicated. When graffiti starts to interfere with 'real' life, life beyond the subculture's boundaries, writers have gone foolishly beyond the call of duty. These life-worlds should be parallel, not merged. An ideal writer is one who recognizes this, acts 'sensibly' and, to cite Drax, 'does it and gets away with it'. This subculture is no escape if one is sitting in prison because of it.

'The liminal world' – keeping 'life' out of graffiti

Having two separate identities might help writers escape the associations and insecurities of their background, but what about the features of 'real life' which cannot be so easily disguised or avoided? Harré (1993: 208) describes these as 'stigmata':

> Stigmata are fateful attributes of individuals, which they can do nothing to remove and which they cannot help but acquire. [. . .] someone born into a despised ethnic group cannot by their own actions slough off that ethnicity.

Putting gender aside for the moment, this subculture manages stigmata like class, 'race' and physical appearance by paralysing their influence. And it does this by bringing its second boundary into operation. A very clear line is drawn between graffiti life and 'real life' and writers are expected not to cross it. Drax illustrates this below when he talks to me about the dynamics of friction and dispute:

> With graffiti, you've got an alterego, which is your tag. And, you know, it can be 'Rough' is crossing out 'Skip', 'Rough' is saying this about 'Skip', it's all graffiti chit chat which blows between people, you know. But once you overstep the boundaries of personal behaviour, graffiti behaviour and people actually start knocking on your door and punching you in the mouth and stuff with no interest in regard to, like, graffiti or tags or anything okay, then you've overstepped the boundaries of what you can afford to get away with. I mean, I can sit here and go like, 'So and so', using their tag name, 'isn't any good, so and so is this, so and so is that.' But I wouldn't add to it, 'Yeah and, like, his sister's ugly too', or something. Do you see what I'm saying? You can't overstep that kind of like boundary.

When you step into this subculture, you are expected to leave all traces of 'real life' on its doorstep. This includes your background, your identities and the baggage that may come with that. Male writers cross this threshold carrying nothing but their graffiti name and persona. On this side of the line, 'you're only based on that, you're based on what your actions are under that name' (Stylo).

By soundproofing itself against the influences of the outside world, the subculture functions as a 'liminal' sphere. This is 'a transitional place in which normal expectations of behaviour are suspended, allowing participants to take on new roles' (Murray, 1989: 186). Here, real life and the issues that may divide and influence it, are put on pause. Prime, a black writer, provides a powerful illustration of this below:

> I mean, I've met people that I would have never met, people like skinheads who are blatantly racist or whatever. I can see it in them and they know we know, but when you're dealing on a graffiti level, everything's cool, everything's real cool and I go yard with them, they'd come round my house, I'd give them dinner or something.

On this liminal terrain, you are not black, white, rich or poor. Unless you are female, 'you are what you write' (Sash). And what you write

determines exactly who you are and where you stand. This is clearly conveyed in the quote below. Here, Jel tells his friend Sae 6 to show me his book of graffiti sketches and designs. Jel wanted to me to see how writers perceive and define each other:

> You know what backs him up, show her the book Sae. You know, when you meet a writer and they talk to you, all you have to do is whip something like this out. That's your credentials right there, that speaks for you, that says what you are and what you've done.

You can become 'more' than yourself in this subculture because you escape the need to represent yourself. Your graffiti, as Jel confirms, 'speaks for you', freeing you from the features or factors that might normally hold you back. In this liminal world, an 'idiot' can be 'alright': 'Once you get good at it, and it's not as if it's hard to get good at, people will think you're alright, when actually, at the end of the day, you could be a complete idiot' (Akit). A 'weirdo' can be respected: 'He's a bit of a weirdo, but he's alright, he gets up and that. That's why I respect him, because I see him up all around' (Rate). And a 'freak' can be a king: 'You could be four foot tall with four eyes, buck teeth and a lump, but if you rocked lines and produced fresh cars, you were a king' (Prime – *Graphotism* Magazine 3).

But a woman, as we saw in Chapter 6, cannot easily be any of these things. She is the exception here. Unlike male writers, she comes into this subculture laden down with the baggage of her gender. She cannot penetrate this liminal world and she cannot share in its rewards. This might lead some to dismiss it as an illusion; an idealistic fantasy which helps keep the subculture alive. But this would be to ignore the very real benefits that male writers enjoy here. This subculture is not a fantasy world, it is a man's world. And as such, it can still be used as real evidence of the real rewards women miss out on.

The name is the fame of the game – missing bodies

What we begin to gain at this point is a sense of removal. If 'writers judge each other through their artwork' (Lee), then, effectively, they dissolve the relevance of their personal and physical selves. This further emphasizes the female writer's exclusion from this subculture, since her physicality and sexuality are generally commented upon. However, it also says something interesting about youthful vulnerabilities and the insecurities surrounding who one is and how one looks.

This section will explore this theme by looking at how writers use their written 'tag' names to build a non-physical or, as I term it, 'virtual' identity.

The 'virtual' self

In Proud 2's opinion: 'You can sum graffiti up in two words, "I am." That's basically what it is, "Look at me", it doesn't matter if you look at me in a negative or a positive way, but, "Look at me."' When you strip it down, graffiti writers are literally honoured for nothing more than being – for existing and demonstrating this to others, a process they call 'making a name for yourself' (Cavs). This saying is fitting because it conveys a sense of absence. People can make a name for themselves in any area of life – for example, she has a name as a troublemaker; he is very tough on new students, he has a name for that. When you have name, it is not a direct confirmation of you, it is your reputation. Similarly, the writer is also 'making a name' in the sense that he/she is becoming known for something. It is not the writer that stands on the street corner declaring 'I am, I exist', it is their name. When writers 'make a name' for themselves, they literally, as this quote illustrates, make a written name 'for the self': 'I mean, look at graffiti, it's a celebration of self. It's, like, this is me, Claw, this is my name, this is my art, this is me, me, me. It's a me thing and it's my identity, this is who I am and it's a total representation of me' (Claw). Claw sums it up beautifully: 'this is my name, this my art, this is me.' And Stylo and Prime depict it beautifully in their quotes below:

> Like if you paint somewhere and you go back there, you feel like you belong . . . there's a bit of you there.
>
> (Stylo)

> You like seeing your name, you like knowing that, yeah, you've left your mark. It's like you being there and other people seeing it.
>
> (Prime)

When writers spray their names on a wall, they appear to leave a part of themselves there too. Almost like a stand-in or a double, the name embodies and represents the individual who wrote it – 'there's a bit of you there', 'It's like you being there.' Zaki recognizes this relationship between a writer's written name and physical self and puts it down to the sensory experience of using a spray can:

> With a spray can it's a different way of applying things, it's, sort of like, intimate with yourself. . . . A pencil and all those tools are extensions of yourself. But, for some reason, you've got this thing coming out with air and colour at the same time, it sounds kind of corny, but it is coming from you, sort of thing. As opposed to dip in the paint brush and apply colour, with spray it's so immediate, it seems to be coming from you sometimes.

The intimacy of this medium appears to infuse an essence of the writer into his/her work. The two merge and boundaries dissolve: 'Whenever I paint, it's just a physical extension of myself' (Iz).

When writers talk about their work, the self is always prominent. Their written names offer them a substitute for the self, a representation of the self, an embodiment of the self and an extension of the self. Basically, their written names appear to offer them another form of identity. Alongside a 'different' identity, removed from 'real life', writers also take on a 'virtual' identity, removed from 'physical life'. They seem to be aware of this. In the extracts below, Akit, Stylo and Zaki talk about the way writers 'know' each other on the basis of nothing more than their written names:

> There's hundreds of people all over the city who don't even know what you look like, where you come from or nothing, but they know you. It's weird.
>
> (Akit)

> When you're first known, someone knows who you are and they don't, they don't know you, you know, who you are, but they're talking about you.
>
> (Stylo)

> It's a great thrill to do something then come back the next day and know that people are seeing that, but, at the same time, they don't know who you are. You never get, like, personal fame, you know, your name's famous, but you're never really famous.
>
> (Zaki)

A theme that runs through all of these accounts is the writer's known/unknown status – 'people don't know you, but they know you, you are famous, yet unknown'. Writers appear to use this contradiction

to distinguish between the two identities they possess; one physical, the other virtual, the name we see written on the wall.

Virtual construction and the reinvention of 'self'

Having a virtual identity leaves one's 'real life' or physical persona very much in the shadows. As Claw sees it: 'It's like you're a mystery. You know, the last time I did a piece I wrote, "Twinkle twinkle little Claw how I wonder who you are", because people don't know.' Even one's sex, the most prominent feature of one's self, is obscured: 'It's just a name, whatever, but I'd meet people and they'd heard of Akit, but they didn't know that Akit was a girl and stuff like that and they'd be like, "Oh, you're a girl" ' (Akit). Writers clearly enjoy this disguise and the phantom-like status they gain from it:

> I kind of like the fact that people don't know who I am, they know Claw. My friends were telling me that they heard this rumour that Claw is like a big black kid with one arm and then somebody also told me that Claw is this Puerto Rican 15 year old and then Claw is this other person. I always hear these rumours about who is Claw and I kind of like it.
>
> (Claw)

Notice the way Jel refers to a picture of his name as 'his picture': 'You know what's good, when you're hanging out with all these kids and they open up a book and your picture's in there and they don't know it's you though.'

The enjoyment writers experience probably stems from the fact that this virtual identity is 'a secret one and you can become more than yourself because people don't know you' (Stylo). As a virtual being, a writer can transcend their sex, appearance and other physical features and effectively reinvent themselves. This is somewhat similar to Internet users and identity formation in cyberspace (Bassett, 1997). The difference between them lies in the fact that writers can enjoy these rewards without the help of technology. Older than we originally thought, this concept of 'virtual identity' can be traced back to the sub-culture's first ever tag, throwup, piece or message:

> What youths thought about themselves, their environment and, maybe most importantly, what they wanted to be, was reflected in their tags, throwups, pieces, messages etc. They created identities for themselves.
>
> (Prime – *Graphotism* Magazine 3)

Let us now look at some of the tools they use to make these creations.

What's in a name?

The tag name a writer chooses is important as this can help them stand out in a crowd: 'There's a lot of names like Sim, Sem, Cap, Kip, Cop, Ken, Cess, which are just quite irrelevant really, you have to work really hard to get those names noticed' (Drax). The names that Drax labels 'irrelevant' appear to lack a solid sense of meaning. Conversely, a 'good name' carries connotations and, as Dondi indicates, a great deal more impact: 'You just had to have a good name, good names usually made it. A lot of guys had bad names, it just didn't click. Like, Butch is a good name, wow Butch!' The name seems to work when it conjures up some form of image – not any old image though. The writer below makes this distinction:

> An example of a good name is 'ARGUE'. It looks fly [good] when written, sounds cool when spoken and conveys a combative attitude. On the other hand, 'ENEMA' (actual name) looks, sounds and conveys a shitty attitude.
>
> (Mark Surface – *On The Go* Magazine, Dec. 1993)

If a name conveys an attitude, then it plays a very important role in the process of constructing an identity. Effectively, it stands 'as a communication to the world about how one is feeling about oneself and what it is about oneself one would like to advertise' (Fiener & Klein, 1982: 49). First impressions count, especially in this world where they are often only impressions. Consequently, writers need to think carefully about what they want to say about themselves. Acrid talks me through his intentions:

Nancy So why did you choose your name?
Acrid Do you know what Acrid means?
Nancy Acrid, it's bitter.
Acrid Yeah, that's me.
Nancy How did you get that name?
Acrid I liked the letters and I liked the meaning . . . I just thought what word would suit me.

Acrid chose his name because it said something about him; something he wanted to say. Drax makes this link between a writer's name and search for identity below and explains the image he strove to create through his own choice:

Nancy So the tag name's important, you choose that with care?

Drax Yeah it is important, but there's some people who change their name every week because of problems with the police or they don't like the letters or they can't seem to find the right identity with it or whatever. . . . With mine, I was thinking, 'Yeah, yeah, this graffiti, I like it, I must get a tag', and I wanted something that sounded quite dynamic, you know, not one of those smooth names, Romeo or something, right. I suppose an X has got an element of that in it, one of those harsh sounding names. And then there's this Bond film, *Moonraker*, and there's a guy in it whose name's 'Drax', 'Drax Industries'. It just had this taking over the world kind of feel about it, this mad guy that was trying to take over everything.

Writers use their names to build up their identities, and the images they choose to project are revealing. Most communicate notions of strength, power and control – 'Butch' is macho, strong and forceful. 'Acrid' denotes this strength through its associations with a bitter taste, the opposite to sweet – a shocking or disturbing experience. Likewise, 'Argue', as the writer explained, conveys this feeling through its combative undertones. Although 'Drax' as a word has little meaning, its letters, the X specifically, the actual sound of the word and its original reference, again, imparts a sense of power and dominance, as he states, a 'taking over the world kind of feel'. Not all writers use their names to inspire these typically masculine connotations. Another image may be more relevant; Claw – incisive, sharp and piercing: 'It really fits my personality . . . it was just a natural tag.' Futura 2000 – a visionary pioneer: 'Futura 2000, it just had that kind of ring to it that seemed to apply and it was always done at an angle, going up to the right, so it was kind of like kicking off, going to the future.' Alternatively, writers may choose not to define themselves at all and adopt a meaningless word that has private significance or is beneficial for its letters alone.

'It's not just what you say, it's how you say it' – style as a statement

Given that the physical body is not a prominent feature in this subculture, what one wears and how one looks is not of great concern. Style, however, is. Rather than clothe themselves, writers use their lettering styles to clothe their names, their virtual selves. As Prime explains: 'You build up a style, it's like your signature, a part of you, it's you saying something about yourself and putting it somewhere and other people see it and recognize it and click.' So what does a writer's style

psychopath. [. . .] The generally 'tooled up' nature of my work reflects this I guess.

(Skore – *The Real State* Magazine 6)

Skore is aware of the way his work says something about him. Indeed, he tries to correct its misleading impressions. Other writers will use their work to actually create such impressions. As Zaki reveals: 'Maybe you like things that aren't like yourself because I've always wanted to do big, bold, blockbuster letters, maybe that's why' (see Figure 8.2).

Like clothing, graffiti gives writers the freedom to project an alternative image of themselves (Carter, 1967, as cited by Brake, 1985; Ganetz, 1994). Unlike clothing, it also enables them to carry off this 'new look'. A small and shy writer can use graffiti to become a big and bold writer. But a small and shy skinhead might have a few more problems:

If they sport heavy, macho clothing (for example Hell's Angels or Skinheads), they are a walking challenge and have to be hard enough to live up to their image. They have to indicate that they 'deserve' the uniform.

(Brake, 1985: 178)

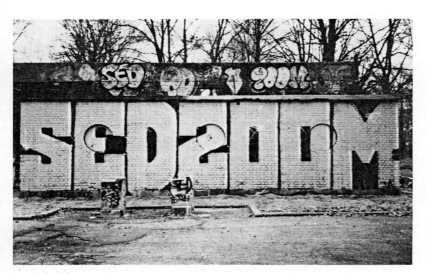

Figure 8.2 Blockbuster letters (*Photograph*: Kirs. *Artist*: Sed)

The skinhead has to physically support or match his/her 'look'. The graffiti writer escapes these restrictions. Until, of course, they meet another writer in person. At this point, as Prime relays, a bubble often bursts: 'There's pictures you've built up of people. Every time you meet someone it's, "Oh, I thought you were a big guy", ha, ha, ha!'

A question of location

In looking at the ways writers build up their virtual identities, the location of the name should also be considered. At a time in life when issues of power, autonomy and control are key, this feature has a lot to offer.

These writers, among many, express the satisfaction they gain from seeing their names around their environment:

> I see my name about, I feel, sort of like, cool, good about it.
>
> (Rate)

> It was a good feeling to wake up the next day, walk along the street and see your name there.
>
> (Steam)

This enjoyment perhaps comes from seeing one's name as a representation of oneself; a self that is out there in the world, exposed, alone and, as Zaki implies, irrepressibly independent:

> *Nancy* So what is it about that, seeing it again, just that it's there, it's permanent?
>
> *Zaki* Well, no, because you know that it might not last. Hmm, it's like if you do a drawing, you go away and you come back and it's there on a bit of paper, your drawing. But if you do graffiti, it's on a wall or a train or something, it's in a different element, it's on a medium that you've never seen before and it's out there in the world, sort of thing. I know it might sound stupid, but if you've done something inside, you've got on the light, it's inside in a familiar surrounding so it helps, but if it's outside, it's not natural . . . it just stands out.

A name on a piece of paper sits inside, safe in its sheltered environment. A name on a wall or train, however, enjoys none of this protection: 'It can be destroyed within hours and you're doing something that moves as well . . . it moves around and then it gets killed' (Zaki).

The imagery Zaki uses here is interesting. In this 'animated' narrative, the name or virtual self resembles a hunted animal, out there alone braving the rigours and hazards that it may encounter. It earns a boldness from this, but it also acquires a guise of supremacy:

> Like you usually see letters on little things and to see a word that big moving along or even stationary on a wall, it's not what you'd normally see, it's out of its normal surroundings, it's blown up. . . . You see the colour or the outpouring of graffiti, it stands out amongst all that.
>
> (Zaki)

The huge names in Figure 8.3 impose themselves upon the unsuspecting environment, standing out, proud and dominant upon their conquered context. In this case, the hunted becomes the hunter. Feiner & Klein (1982: 49) elaborate on this theme:

> Names help tame the powerful. Giving something a name or label offers the illusion of controlling or limiting it. The subway's powerful machines are tamed by placing one's name on them; the name celebrates victory and possession, like one's brand on a wild steer.

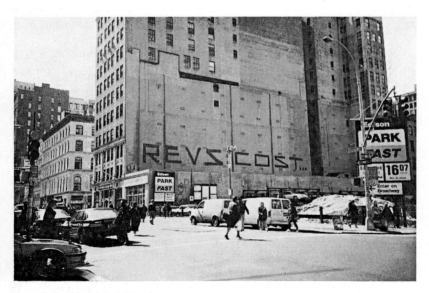

Figure 8.3 'Revs' and 'Cost'

The speed and motion of the train only magnify this dominance. As Lee observes: 'That was the beautiful thing about it, that these pieces moved out of your sight and you couldn't arrest it, it arrested you for the few seconds that it was in the train station, for when it went by you, then it was gone.'

The name enjoys the same power as the machine it rides upon. It cannot be stopped. It lies beyond the control of those who see it passing. Against the force of the train, they remain impotent. They can only watch as it thunders past to its next destination. 'It's a good feeling to see your name run' (Cavs) – like the train, the name or virtual self is going places.

'Shouting on the wall' – animating the virtual self

To most people, graffiti is just background scenery, urban wallpaper if you like. To those who write it, however, it is a secret sign language – literally: 'There's conversations between people who haven't met, through writing' (Prime). As writers' names hit the wall a form of interaction begins to develop, one which mirrors, on the wall, the activities that might occur in front of it. In line with their virtual identities, writers have created a form of virtual communication. This means that 'even without the physical contact of networking with people, interaction is constantly being made between writers that don't even know each other' (Drax).

Drax presents this exchange as a substitute for face-to-face or physical interaction – a process which has been termed 'metonymy' (Marsh et al., 1978). Zaki and Series provide further evidence of graffiti's metonymic role below by describing its purpose in purely 'physical' terms:

I see tagging as *talking* to other graffiti artists.

(Zaki)

Basically it's just *shouting* all over a wall. It doesn't mean anything, it's just *shouting* all over a wall.

(Series)

I would disagree with Series here. Shouting all over a wall like this is far from meaningless. It plays a very important role. Namely, it allows writers to animate or put the virtual persona they have chosen to evoke into play. In this way, it offers them another resource with which to construct their virtual identities.

Sign language

As true as it was when Kohl (1972: 87) wrote it: 'A simple reading of wall graffiti gives one a sense of the range of irony, cynicism, ambiguity, praise and insult that is at the command of individuals.' If you watch the walls, the first thing you may notice is the way 'Graffiti attracts graffiti' (Acrid). What is happening here is 'that you're communicating with others. You'll find that you do a tag and someone else will tag next to it' (Ego). A name appears and slowly it will morph into a small congregation, as others see it and add their own. In one sense, it is a simple way of saying hello. Just like friends who meet in the street and stop for a quick chat, 'You're letting them know you've seen them there, like instead of walking past the wall, "I know you've been here"' (Acrid) (see Figure 8.4).

But this gesture carries more than just a polite acknowledgement. In a subculture fuelled by competition and divided by status, this greeting is also an important mark of respect. Drax explains:

> If someone I've never met before happens to have placed a tag everywhere that I've done, depending on the way in which it is done, I could take that as a sign of respect. Like he's saying, 'I've seen your name, I'm, kind of like, following your spots as well.'

Figure 8.4 Saying hello

Positioning yourself up close to another writer's name indicates that they are worthy of your attention. In effect, it grants them some importance. But here it gets more complicated. While this homage may be suitable behaviour for a younger/unknown writer, for a more established name it is seen as unfitting. Drax explains how writers use wall space to assert their status (see Figure 8.5):

> Say I place a tag on a huge big wall, nothing on it, generally speaking another accomplished or known writer will come along and place his tag somewhere indiscriminately on the wall away from mine. Even though he's obviously seen your tag, he'd be more of the attitude, 'I saw the wall, I wrote my name there, I don't even remember seeing your name there', that kind of mentality. Whereas a younger writer might give you the acknowledgement and not really worry about that kind of thing, actually deliberately putting it near your name just to, sort of like, say, 'Yeah respect, I've written here too.'

An unknown writer on a mission to be noticed has a lot more names to meet and greet before he/she can afford to be stand-offish. Knowing that 'writers will always look at their own tags when they go past

Figure 8.5 I'm as good as you

again' (Drax), it pays to get as close to them as possible. He/she will need to be careful though, because mixing one's signals is, as Drax demonstrates, an easy mistake:

> If I'm doing tags, whether there's a few on the wall or whatever, if I come back and there's a tag deliberately placed above mine, some-times it could be taken as like a friendly little challenge, but a lot of the time it is a deliberate attempt to make you look irrelevant, you know, especially if there's loads of other space on the wall.

Like any social situation, there are rules of etiquette that need to be learnt. Place your name above, rather than beside, another's and you will receive a less than warm reception (see Figure 8.6). This is a plain and simple way of saying I'm above or better than you. When Prime found such a message he responded in kind:

> I did my crew tag, 'Famous 5', and one of them put 'London Giants' on top, not touching it, just above it. So then I came and put mine on top again. . . . When they put their tag above, I knew that was saying the London Giants are better than us, and he knew that I was saying, 'No you're not', by doing a tag on top, 'No you're not.'

Figure 8.6 I'm better than you

Similarly, one should only introduce oneself to another writer once. Write your name more than this and you'll be seen as 'a cheeky git who's showing off' (Drax). Unless, that is, you are an older or more established writer in which case your actions would probably stand as a more serious challenge. Steam explains:

> *Nancy* Say Drax is king, how would someone try and challenge him?
> *Steam* They'd just do their tags maybe next to him, like four tags next to the side of his one, something like that. They'd put it everywhere as well, just so people would see it.

Crowding another writer's name with more than one of your own literally declares, 'I'm more than you' (see Figure 8.7). The surrounded writer's status is questioned because the space that supports it has been reclaimed by the other writer.

A larger name, as Drax implies, can relay a similar message (see Figure 8.8):

> If you had a huge can of paint, you'd just hit the wall. You wouldn't need to sort of try and put it next to anyone, because there's no way

Figure 8.7 I'm so much more than you

Figure 8.8 I'm bigger than you

they're going to go past and miss it. That big name could even be taken as offensive, you know. And, of course, there's the possibility that you might accidentally clip over the edge of their name.

The greatest danger of using a larger name lies in the possible contact it might make with another's. When you touch a writer's name, you break one of graffiti's most cardinal rules: 'Everyone knows from day one that if you go over the top of someone that is a serious crime, sort of thing' (Zaki). A writer's tag is sacred and most writers, as illustrated below, will go out of their way to respect this:

> I don't go over people unless I have a reason to. I'm very respectful. If there's no room on a door for me to write my tag, I don't write on that door. I will not go over people.
>
> (Claw)

> I never had guys going, 'Futura, I'm going to fucking kill you, you wrote over me', because I'm from the old school of respecting each other's tags. If there's no space available, I'll just find some other area.
>
> (Futura 2000)

If cramping a writer's space signals their insignificance, then encroaching on it to the point of touching or covering their name (see Figure 8.9) is an even greater insult. A writer should not make this contact 'unless you want to show a deliberate lack of respect for them. It's like you're showing, "Well I don't care about you, I'm just going to write the name on you"' (Drax). A metonymic translation of this might see the individual pushed aside or ignored.

In this case, though, there is some room for poetic licence. Acrid explains how size steps in as an influencing factor:

> As long as it's bigger and better, it's not so offensive. . . . I've done plenty of pieces over people's tags. It wasn't a sign of disrespect and it wasn't taken as that. Say I put a tag over someone's piece, that's a sign of disrespect. But if it was the other way around, it would be no big deal.

Figure 8.10 provides us with a good illustration of this. Here 'Elk' insults 'Dreph' by painting a 'dub', a relatively simplistic graffiti form, over the top of his piece. The message Dreph has left on Elk's work asking him to explain himself gives us some idea of the impact of this action. Essentially, this exchange follows the same dynamics as a

Figure 8.9 You mean nothing

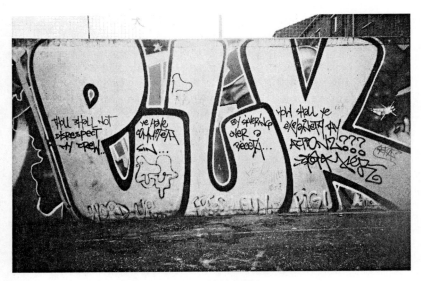

Figure 8.10 A dub placed over a piece (*Artist*: Elk)

face-to-face confrontation. In this, an insult would be somehow greater if it came from someone smaller than oneself. This is a more overt threat to honour because one's size has been dismissed as unimportant. When the scenario is reversed, the insult loses some of its sting. A smaller individual may merely present a safe target. If anything, the insult lies at the feet of the bully or coward who does not have the courage to pick on someone his/her own size.

While a name over a name can be read in different ways, a line through this offers no such ambiguity (see Figure 8.11). It ignores all the rules which work to protect the name and represents the most extreme mark of disrespect. For Akit, who found her name lined out,

> *Akit* I was just like, 'Oh my God, fuck, oh no!' It's like the end of the world, you know.
> *Nancy* By lining you out what are they saying?
> *Akit* 'You're shit, you're nothing.'

A line is taken to be a more striking attack because it is a deliberate and violent slash through one's name. If a tag over a tag is a subtle shove, then a line is a punch in the face. Supporting this translation, Drax presents a slap and a line as optional, and thus comparable, forms of

Figure 8.11 A weapon of assault

punishment: 'He'd find out by getting his name crossed out or a slap in the head from someone that he'd done the wrong thing.' Additionally, the offended writer will usually use this symbol to fight back with. Retaliation is the normal response to finding one's name crossed out:

> If people go over me, diss [disrespect] my pieces, any of that, when someone disses me, I'll diss them back.
>
> (Col)

> If someone dogs [lines] me out, I just dog them out myself, see their tag, dog them out as well.
>
> (Rate)

The exact same stages of a physical fight are metonymically enacted here. A writer is insulted, assaulted or challenged and he/she retaliates to defend his/her threatened honour (Matza, 1964; Polk, 1994). In most cases, the 'beef' or friction will be 'squashed' by this response. In some, though, the dispute drags on.

A fight that continues or escalates is generally recognized as a 'war'. Writers use their city walls as a billboard of information, so a large 'cross out war' usually becomes a focus of interest. In the early days of

my research, such a war erupted in London. Cred, a relatively young and unknown writer in the crew RCS, began to line out Drax, a figure of considerable standing within the London scene (see Figure 8.12). It started, predictably, with a throwaway insult: 'Something about Drax cussing [insulting] RCS, saying they were all toys and that' (Rate). Acrid, the leader of 'RCS', gives his take on this: 'I think a lot of it was because RCS, the people that started it, were from Drax's area and were, like, younger, toy writers. In time we overtook him and he got a bit upset. . . . He couldn't outdo us.' Naturally Drax offered me a very different version of events:

> In my opinion, it started because a lot of the RCS people came from my area, and I've always done a lot of stuff here, got more exposure. . . . To use a phrase, I suppose a couple of them got out of their prams really. It's like they got jealous and rather than sort of have respect they started to just show total disrespect really, just going over my stuff, sort of like saying, 'Well we're from round here as well', sort of thing. And then I suppose I crossed out their stuff and it developed from there. . . . It just got more and more malicious really.

Figure 8.12 'Drax' lined out

Whatever the initial cause or reason, it sparked a conflict that made its mark on the entire London scene. As the scale and fervour of this war intensified, others began to take sides and get involved: 'Writers that don't even know either of us in person were actually going round crossing Cred out, just because he was discrediting an accomplished writer for no reason' (Drax). Likewise, others stepped in on Cred's behalf and extended the boundaries of the war by attacking those with no direct involvement. Kilo found himself caught in the middle of this crossfire:

> 'Cred' and 'Serch' and all that lot, they all had a go, but then 'Fest' just tried to carry it a bit further by crossing out me and a load of people that were innocent, people that weren't even involved in it the RCS, PFB business.

The war raged on for a year and a half before a ceasefire was declared and calm was restored. As Kilo remembers it:

> That Cred guy must have obviously had enough because I saw a piece that he did in Hoxton, like Drax's area, and on the dedications it had PFB and all the crews that he'd messed with. So, I dunno, maybe he just thought is it worth it.

Writers will often dedicate their pieces to other writers and crews as a sign of respect (see the bottom-right corner of Figure 8.13). Like a handshake, then, Cred used this gesture to call a truce. Unbeknown to the rest of London, the war that had stormed within their city and fractured an entire subculture had just been brought to an end.

The virtual self: reaching the parts other selves can't reach

In the previous section we saw how writers use their graffiti to 'make a name' and literally make themselves. They adopt a virtual identity, and using a number of different tools, sculpt, shape and bring this to life. So what sort of persona are they creating here? What do they use this new identity to say about themselves? For the most part, something masculine it would seem. Many writers choose a hard or 'macho' sounding name and then write this in a visually bold or aggressive style. This style can make them look like a 'raving psychopath', a 'violent person' or perhaps just bigger and bolder than they really are. This name is then situated outside, in locations

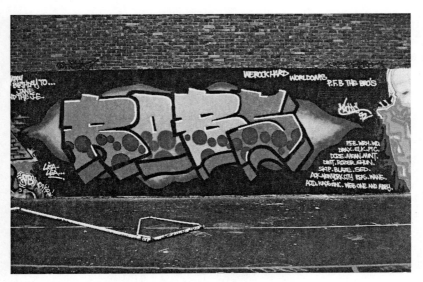

Figure 8.13 A writer's dedications (*Artist*: Robbo)

which give it a sense of fortitude, dominance and, depending on where it is placed, life. Positioned on a wall with other names, writers have the power to animate their virtual personas and communicate – greeting, challenging, insulting, assaulting, attacking and fighting with other writers. Although they have a choice over what they can say about themselves with this identity, masculine narratives of strength, power and control appear to prevail. The virtual self is clearly used as a masculine resource and an immensely powerful one at that.

The pen is mightier than the sword

Drax and Cred never actually met each other. They assaulted, insulted, attacked, fought and despised each other for a year and a half, but they never ever met in person. When a fight like this starts on the wall, it usually stays there. Using words and symbols, rather than fists and weapons, enemies 'will battle it out on the wall in paint' (Col). There are no injuries, no broken bones, no scars, no casualties. Here, you 'get a photo to show for it instead of bruises' (Prime). This is the beauty of the whole process. But it is also the point. As Willis (1990) and Marsh et al. (1978) also observed in their studies, the goal is not to fight as often as possible, but as little as possible:

Nancy How do you diss [disrespect] someone?
Col Well, usually, you just go over what they did. It's very odd
that a writer will go up to a writer they don't like and say it to his
face because then there'll be a regular fight.

Physical provocation invites a physical response. Virtual provocation
invites a virtual response. Or, in some cases, maybe even a creative
response. Rather than replicate this conflict metonymically on the
wall, writers may also depict it in their pieces. The scene in Figure 8.14
shows a large and aggressive-looking fish character bearing down on a
smaller, weaker one in a menacing parade of physical dominance. The
smaller fish looks anxious, and says as much in the speech bubble that
has been painted in 'Oh shit, out of my depth.' Proud 2, the artist
explains his intentions: 'I put up this great big bull shark and kept this
one to make the other artist look a bit silly.'

The point of this exercise was to intimidate the other writer. And
the point is, again, he could. Proud 2 may not really be stronger, more
aggressive and more commanding than this other writer, but he looks
it in this piece. By picking up their spray cans and sticking with
the wall, writers override the constraints which might otherwise
tarnish their masculine displays. As Willis (1990: 104) recognizes: 'The

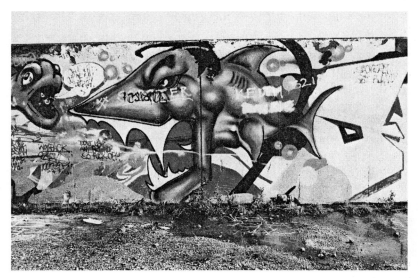

Figure 8.14 A creative display of strength and dominance (*Photograph*: Frank
Malt, collection of Steam, London. *Artist*: Proud 2)

worst [. . .] is to be somebody who acts hard but is really not hard "inside". Such a person creates an external persona that is unmatched by bodily force and skill.'

With graffiti you can create this image, but you do not need to live up to it. This makes it a much more powerful masculine resource, than say, sport (Messner, 1987, 1991; Westwood, 1990; Willis 1990), fighting (Polk, 1994), bodybuilding (Mishkind et al., 1987) or posturing (Brake, 1985). True, these physical activities can serve as constructive options when men have no others (Brake, 1985; Messner, 1987, 1991; Mishkind et al., 1987; Polk, 1994; Westwood, 1990; Willis 1990). After all, a man always has his body: 'One of the only remaining ways men can express and preserve traditional masculine male characteristics may be by liter- ally embodying them' (Mishkind et al., 1987: 47). But not all men are created equal and not every man will have a body he can benefit from, no matter how hard he works at it! In graffiti, none of this matters. 'You are what you write' (Sash) in this world, which means 'Your name has to mean power' (Jel), your physical and personal self does not.

The freedom writers gain from this is enormous, and they well know it:

> It's no coincidence that graffiti is just a piece of art and that's what you get your respect for. . . . I've never been someone who wants to draw attention to myself, I've never been that confident. But, at the same time, I was doing something that put myself in the spotlight, sort of thing. But with graffiti, it's your artwork that's on show, not yourself.
>
> (Zaki)

Zaki talks about his graffiti or 'virtual identity' as if it were an actor, one that reaches the parts his other identities cannot reach. For many, graffiti is exactly that, their one and only opportunity to put their 'real' selves aside and play the role they have always wanted to play, the character that have always wanted to be:

> Well, some people do graffiti to, like, show their other side. They could be really, really, quiet, you don't know who they are and, like, here's a way for us to express how we feel on a wall, on a train, doing a piece.
>
> (Col)

> There's a prominent group of young guys who are very unsure of themselves, insecure about themselves . . . and graffiti is very much

like their alterego, like, how they would really like to express them-
selves. It's a very outgoing expression, how they would really like to
be.

(Prime)

Individuals who are shy and unconfident find a voice through graffiti
because they do not have to speak. Their name or 'virtual self' speaks
for them which means they can recreate themselves and then sit in the
wings and direct the performance:

Even though what you're doing is yourself, it's being able to open
up yourself without actually changing yourself. . . . The thing that
sums up graffiti, it was a way for me, and probably a lot of other
people, to express themselves and feel confident and feel they are
part of the world, but, yet, still be me.

(Zaki)

The rise and fall of the subcultural identity

I want to finish this chapter by looking again at the pattern of a
writer's graffiti career. This has already been outlined in Chapter 5,
but the insights we have gained since then flesh it out considerably.
In most accounts, the points at which members join and leave sub-
cultures are ignored. We are given a static picture of their present
involvement alone. But, then, these junctures can enrich our appre-
ciation of the subculture's rewards, and why, at the time members
leave, these lose their importance. They can also give us insight into
other aspects of a writer's non-subcultural life by allowing us to see
shifts in the identities members occupy. Graffiti writers accommo-
date, as we have seen, two self-contained personas; one 'real life' and
the other 'subcultural'. Questions emerge: How do they negotiate
this duality? Do the positions that these identities occupy always
carry equal weight and significance? Apparently not. Supporting
Hearn & Collinson's (1994) observations, these identities are priori-
tized at different times: 'In a divided society it is very difficult, and
probably impossible, to hold onto numerous composite identities
equally at all times; some will be prioritized over others and their
meanings may change over time' (Hearn & Collinson, 1994: 111–12).

Changes in the meaning and prominence of writers' multiple
identities would seem to relate to the relevance of their particular

rewards. A closer look at their career paths and the corresponding rise and fall of their graffiti identities will help us see this more clearly.

The rise – holding on

Graffiti provides writers with a potent source of personal confirmation, often compensating, as Drax intimates, for its lack elsewhere:

> Some people have problems or confusion within their lives and something like graffiti may give them a direction, which can make them forget their problems, okay, and actually make them feel better about their lives and what they're achieving in life. . . . When I was younger, graffiti made me forget my worries and it was something that gave me confidence and a bit of identity within the male world.

Understandably then, many writers are reluctant to let go of graffiti's influence. It bathes them in success and remains a centrally important part of their lives:

> When I think to myself at night, 'What have I achieved?', I always feel that graffiti has been one of the most positive things and that's probably why I cling to graffiti so much, that's why I don't want to leave it because I don't want to get rid of that.
>
> (Zaki)

For some, graffiti becomes the most or only important part of their life. Drax now uses his graffiti identity or tag above his 'real' name and identity. As he explains: 'It's, kind of, so strong that people know me as Drax that don't even know about graffiti, do you see what I mean? It's like the name has completely taken over to an extent.' Drax no longer makes a distinction. He is Drax wherever he goes and whoever he is with. His graffiti identity has crossed over into 'real life' and is used in all settings as his core or primary persona. 'Sham 59' embraced his graffiti identity in a similar way. Prime recounts what happened when he went into prison and found himself without it for a while:

> Sham 59 went into prison and I saw him soon after he came out and it was like he was off key, he was in a daze, he didn't really know what he was doing. The number of times he'd say, 'I've lost my identity, I don't really know what I am doing, I don't really know where to go' or whatever. After a while he started bombing

and now he's like hardcore. You can see it's settled him out. It may just be that's where he left off when he went inside, so he's going back to that, but it's a bit more than that I think. It's more that's the identity he built up for himself.

Sham 59's graffiti persona was much more than just a sideline or complementary identity – it was his 'master status' (Davis, 1990), it was who he was. In losing it, he effectively lost himself. For writers like Sham, graffiti goes a whole lot deeper than mere recreation. It represents a life-force. It is their way of finding, building and, as Drax intimates, keeping their strongest persona alive: 'It's hard for people to let go of graf because they've got a whole new persona and they don't want to let that die.'

The fall – letting go

Delinquency appears to run in phases. Following a peak in adolescence, involvement characteristically declines (Emler & Reicher, 1995; Jessor, 1986; Silbereisen & Eyferth, 1986; Werthman, 1982). Writers' graffiti careers follow this apparent pattern. Initial stages may be frenetic, but most writers do eventually 'let go', as Drax puts it, cutting down on their illegal activities and diluting the significance of their graffiti identities. A typical expression of this 'dilution' is outlined below. At a certain point these writers all found themselves shifting away from the use of their tag names:

For a very long time my name has not been so prominent . . . I've stopped really, you know, 'My name is Prime, it's Prime, it's Prime.' It's been more about other things, things that are going on in your life rather than just your name.

(Prime)

In 1980, I did a train where I didn't even put my name. It was no longer about names or letters or any of the stereotypical work, it was about just colour and form. It had nothing to do with, 'Yo, here I am, this is who I am', it was more to do with, 'What's that!?'

(Futura 2000)

You start to say, 'Well, I'm a grown up, my subject matter's changed, it's not about my tag anymore.' It's about painting and interacting with a whole broad audience through your art.

(Lee)

Incentives change and other concerns come into play. The written name becomes less compelling and one's graffiti identity begins to slip away a little. As Drax reminds us, it is very hard to sustain an identity if you do not use your name:

Nancy Why is it that the illegal lot do more lettering?
Drax Because your name's more important, the identity is much more important. You can't create an identity by doing por-traits . . . it's all to do with lettering and writing your name.

In addition, no name means no fame, suggesting that writers start to lose interest in the respect and recognition that gives this identity its point and purpose. Stylo confirms this apparent shift in concern: 'It's only when you get older I think that you start to develop style for its own sake, as opposed to just, like, 'Oh, I must give you respect.' I think people if they're older, they paint more for themselves, you know.'

Priorities change. Personal gain becomes more important than audience appreciation, which means 'the risks are no longer incurred exclusively for what can be demonstrated about the self for taking them' (Werthman, 1982: 295). In time, these illegal risks may not be incurred at all. As their careers progress, many writers, like Drax below, find themselves developing a greater interest in the art form:

When I first started, I had less interest in art work, I wasn't really interested in art at all, I was just interested in putting my name out . . . and then, I suppose with the interest in art, the illegal-ity gets less because you can be happy to do a legal wall.

The emphasis changes and graffiti becomes a form of expression, rather than a source of respect; a demonstration of talent, rather than a display of courage. At this point, a writer's illegal career tails off, the identity that was nourished by it fades and a change in self-definition appears to take place:

The changes came as I grew. With years, I became less interested in fame and more tuned to my art, more embarrassed at being caught and less likely to rack [steal] paint. In other words, I was assimilating into the same society I pillaged in previous years.

(Teck – *Urb* Magazine 37, 1994)

What eventually happens, whether you realize it or not, you become the establishment. After a time, unless you're totally an outlaw, you know, if you want to change, if you want to become part of society and be someone positive, then you have to become part of it.

(Futura 2000)

As Teck and Futura 2000 'grew', their 'outlaw' identity lost its allure and a more conformist one stepped up to take its place. Some theorists explain these identity shifts in terms of the duties and responsibilities that start to increase around this age (Clarke, 1976; Levinson, 1978). These naturally play a part, however, alone, they leave little room for the choices and desires we see evidenced in the accounts above. Teck and Futura 2000's step out of the subculture into the 'real world' appears to be chosen rather than obliged, suggesting that graffiti's identity and rewards became less important to them.

Lessened incentives and the opportunities of age

Focusing here on the subculture's male majority, illegal graffiti provides writers with a masculine resource. Whether breaking into a train yard, outwitting the cops, fighting with other writers through the wall or walking the streets alone on a secret mission, writers are creating a traditional and unambiguous masculine identity. Younger writers tend to be more involved in these activities than older ones, suggesting that the value and relevance of this particular masculinity bear some relation to the age or phase of the actor. According to Hart (1992), a male adolescent's 'ideal self' centres around physical action and activity. The media have undoubtedly played a part here:

Media celebrations of 'diehard' masculinity confer widespread acceptance on the perceived need for masculine 'hardness'. Young men are bombarded with images which attest to the glamour and potential rewards of conforming to 'traditional' masculine virtues.

(McCaughey, 1993: 37)

But, then, gloss and glamour alone do not explain why this 'diehard' masculinity is often embraced by younger rather than older men. To understand this, we need to look at adolescence as a juncture in the masculine career structure.

Toys to men: an age-related masculine career

As teenagers, young men are probably testing out their masculinity for the first time. We have all seen it, the adolescent boy posturing to comical effect to make up for the doubts and insecurities that sit firmly lodged in the back of his mind. He is not yet convinced his manhood works properly, so he is giving it extra throttle to compensate (Levinson, 1978; Thomas, 1990):

> Youth stand at the threshold of manhood, and consequently they are more obsessed by the postures and poses that symbolise and confirm it. [. . .] He wishes to demonstrate that he is a man. He is not, and thus he is driven to extravagant and incredible bravado.
>
> (Matza, 1964: 156–7)

We can see this logic manifested here in writers' career changes. Younger writers start by adopting a very traditional 'diehard' masculinity. Using their illegal graffiti, they get to play the warrior or the superhero. No one is going to question Superman or Actionman's masculinity, and no one is going to miss it either. This masculine discourse is not exactly a subtle blend. It screams testosterone, making sure it gets the attention and recognition it needs to be validated. With fame, respect and status under their belt, or proof that their masculinity is valid, worthy and 'real', older writers can afford to slow down a bit:

> *Nancy* So for the older lot the illegality isn't so important?
> *Claw* Well, yeah, because they've reached a certain level where they don't need to prove themselves anymore.

As Marsh et al. (1978), Parker (1974) and Werthman (1982) explain it, a solid reputation has been developed and the individual can now calm down and live off it.

This is not to say that masculinity is a completed project, however. A writer at the end of his illegal career does not stop making himself into a man. He just stops using illegal graffiti as a resource. As one gets older, other options might start to make themselves available. Teck outlines this switch below:

> We were assed out of the game as young people first, long before we became graffiti artists. An aggressive rampage through the city was my skid mark on society's smooth tarmac. I was an artist so fuk the rules. I eventually made more stringent guidelines for myself

(steering me away from getting up), but only after starting a business, buying a car and sharing in the adult experience. [. . .] As people around me began hearing me, I needed to yell less. I suppose it's the natural progression of things, we grow up and fit in.

(Teck – *Urb* Magazine 37, 1994)

For Teck, being young meant being impotent and alienated. The rules and regulations of society gave him no reward and, thus, no reason to follow them. Graffiti clearly offered him a whole lot more; fame, respect, independence, recognition and masculinity. Until he began to need it less. As Matza (1964) notes:

Boys are less driven to prove manhood unconventionally through deeds or misdeeds when with the passing of time they may effortlessly exhibit the conventional posts of manhood – physical appearance, the completion of school, a job, marriage, and perhaps even children. Adulthood may not in all social circles definitely prove manhood, but it is always good *prima facie* evidence.

(Matza, 1964: 55, italics in original)

Although Matza (1964) offers us a problematic definition of manhood by ignoring men who are single, gay, unemployed or childless, Teck's experiences support the general gist of his argument. Given a degree of presence and a share in 'the adult experience', his graffiti career and identity began to dissolve. Like the young drug dealers, athletes and gang members that Williams (1989), Messner (1987, 1991) and Yablonsky (1962) studied respectively, Teck found more relevant and lawful ways to confirm his masculinity and claim standing and respect. He found, what Prime might call, direction in life:

Nancy Would you say the illegality gets less important as you get older?
Prime Yeah, yeah, I'd agree with that, yeah. Because you get to be more settled in your thoughts about life in general. When you're adolescent, you're looking around, you're hanging round with kids and you haven't got so much direction. But slowly you start to get more direction in other things in your life.

What we see through this career process then is a change in masculine expression. Writers shift from a 'retributive' (Rutherford, 1988) or 'traditional' (Pleck & Thompson, 1987) discourse, with its emphasis on

toughness, respect and status, to a more modern or conventional mas-
culine style. Connell (1989) saw similar changes when he studied mas-
culine construction within a school environment. Over time, most of
the boys replaced a posturing and aggressive style of masculinity with
one which exemplified rationality and responsibility. These shifts in
what could be called a masculine career, highlight one of the most crit-
ical problems with the 'sex role theory': 'Gender socialisation theories
conveyed the strong message that while gender may be "achieved", by
about age five it was certainly fixed, unvarying and static – much like
sex' (West & Zimmerman, 1987: 126). Far from it. Here, the sex role
theory's tunnel of gender looks more like a maze as writers twist and
turn into different masculine orientations. The different directions
they take reveal masculinity's dynamic nature, but they also uncover a
critical, yet hugely neglected, link between masculine style and age
(Bjerrum Nielsen & Rudberg, 1993).

 Theorists have barely touched on the role age plays in shaping mas-
culine presentation, focusing instead on the mediating influence of
one's 'race' and class (see for example Edley & Wetherell, 1995). Yet
this factor would seem to be important. Bjerrum Nielsen & Rudberg
(1993) recognize the gender style shifts that occur around adolescence
and use Erikson's (1968) concept of the adolescent 'moratorium' to
explain them. They present adolescence as a time of freedom and adap-
tation, a phase where parental influence is dissolved and different cul-
tural possibilities can be played out (Bjerrum Nielsen & Rudberg, 1993).
As they see it, adolescents can relate to their gender identities in an
experimental and reflexive way. They have both the space and the
freedom to ask, 'Is this me?' and change if it is not (Bjerrum Nielsen &
Rudberg, 1993). Bjerrrum Nielsen & Rudberg (1993) must be applauded
for highlighting these age-related gender shifts. However, their work
does paint us a somewhat over-idealistic picture – adolescents as happy
shoppers scurrying around buying into any old discourse which might
just 'tickle their fancy'.

 To picture this as a marketplace, a free choice of gender-styles, would
be misleading. These 'choices' are strongly structured by relations of
power. [. . .] masculinity is organised – on the macro scale – around
social power.

 (Connell, 1989: 295)

Bjerrum Nielsen & Rudberg (1993) uphold adolescence as a time of lib-
eration, but they totally ignore its additional constraints. Adolescents

are, like many social groups, limited in their access to certain sources of social power (Messerschmidt, 1993, 1994). Until, or unless, this increases, their range of gender options remains restricted. In most cases, this results in a 'claim to other sources of power, even other definitions of masculinity. Sporting prowess, physical aggression, sexual conquest' (Connell, 1989: 295), or even crime may do: 'Crime is a resource that may be summoned when men lack access to other resources to accomplish gender' (Messerschmidt, 1993: 85).

But is this all these other resources are? Last resorts? Makeshift masculine options? Our gender choices may be 'structured', that is, shaped by social forces that lie beyond our control, but surely they are shaped by our own desires and interests as well? To see gender construction in power terms alone is misleading because it infuses a sense of frustration into this endeavour which may not be felt. Those unable to buy into middle-class gender definitions are depicted as discontented window shoppers, discursive paupers who have been forced into fashioning a 'last ditch' identity out of whatever resources they might have left. Can we be sure all men even want and strive for this middle-class or power-based masculine ideal in the first place? A young writer may not have the resources to embrace the 'cool masculine style of the computer executive' (Liddle, 1993), but his 'diehard' (McCaughey, 1993) masculinity looks like far more than just a dull compromise. If we are to understand what is appealing about these 'other' discourses and the reasons why they may be chosen, rather than claimed in compensation, we need to scratch a little deeper and try and uncover their unique rewards. Making this her priority, Hollway (1984: 238) argues: 'Any analysis which focuses on subjective positioning in discourses requires an account of the investment that a person has in taking up one position rather than another in a different discourse.'

The younger writer's investment in this 'traditional' (Pleck & Thompson, 1987), 'retributive' (Rutherford, 1988) or 'diehard' (McCaughey, 1993) discourse is clear. It is overt – a teen boy cannot afford to be subtle yet. In addition, it celebrates notions of power, control, independence and freedom, meanings which interface with cultural definitions of youthful masculinity and maturity. In this sense, writers are commenting on more than just limited resources through their use of this discourse. They are indulging their needs, interests and concerns and, thus, taking up their constituted positions as young men. I use the words 'use' and 'indulge' here because I want to emphasize the active nature of this process. Our identities may be constituted by our positions in certain social frameworks and these placements

may provide us with a guideline or an outline of 'being'. But working with a pre-written script does not, as some theorists have suggested, have to rule out the presence of agency (see for example Henriques et al., 1984). Far from it: 'The constituted character of the subject is the very precondition of its agency' (Butler, 1992: 12, as quoted by Gutterman, 1994: 224).

To say that the subject is constituted, is not to say that the subject is determined. It is to watch the subject bring their discourse and identity to life and then carve and tailor it so it sidesteps constraints (Shotter & Gergen, 1989) and meets their needs. This is exactly what we did in this chapter. We watched writers take their graffiti persona, their tag, their written name and we watched them build an identity out of it. We watched them strip this identity of all the ties and restraints of 'real life', including their own physical bodies, and then we watched them reinvent themselves. Granted, writers might not have written a brand new script, but they have certainly tweaked it enough to tell a very different story. In this, Joe Bloggs becomes a 'king', a legend, a warrior, an enemy, respected, or at least recognized, by writers all over the world. Basically, Joe Bloggs becomes 'another person' until it is rewarding enough just to be Joe Bloggs again. This is the time 'real life' starts opening more doors, offering Joe alternative, and perhaps more relevant, ways of claiming the respect, status, masculinity, autonomy, power and control he/she found within graffiti.

What I find so touching about all of this is that none of it is taken for granted. Writers are well aware of what this subculture gives them and the lack it often makes up for in other areas of their lives. They recognize, can articulate and are thankful for its rich array of personal rewards. This might explain why these were missing from the CCCS's subcultural accounts (1976) and Widdicombe & Wooffitt's (1995) more recent text. In both, the members were effectively silenced. The CCCS did not even ask them for their views. After all, they had a class-based agenda to fulfil which would not have benefited from these personal insights. And although Widdicombe & Wooffitt (1995) inquired, this was little more than a token gesture. Their questions were predetermined and ambiguous and the responses unsurprisingly scanty. I think that if we are to take anything from this chapter, it should be the importance of really listening to and involving the people we seek to understand. We need to challenge the belief that our informants lack

insight and awareness. We need to stop building these ideas into our research methods. And we need to stop overwriting their voices with our own. If we are to produce accounts that we can actually learn from, accounts fleshed out and informed by insiders' lived meanings and values, then we need to start granting them the ability and opportunity to tell us their story.

Conclusion

This book was about graffiti, but it was really a story about the (male) young and the nameless and their search for voice, masculinity and status at a time in life when this is often hard to find. With a spray can and a little dedication, we saw them find all this and more. By writing their name, they earn fame and respect. By doing it illegally, they build a masculine identity. By excluding girls, they protect this identity. And by excluding the 'outside' world, they add power, ownership, autonomy and escape into the mix. In this subculture, young men gain the freedom of possibility, the chance to go beyond the limits of 'real life' and be who they want to be.

Graffiti's rewards are manifold, but there is a thread connecting them. Put together, they articulate a process of change and development, transition and progression. Like the army (Arkin & Dobrofsky, 1978; Coote, 1993; Morgan, 1994; Rutherford, 1988; Segal, 1990), the Boy Scouts (Hantover, 1978) or the sportsworld (Messner, 1987, 1991), this subculture could be viewed as a modern-day 'rite of passage', a transitional vehicle which helps its mainly male members journey from one status to another (Eliade, 1958; Glaser & Strauss, 1971; Raphael, 1988). They enter as a boy and a nobody, and having completed its illegal tasks of endurance and fed off its rewards, they emerge as a man and a somebody. The contribution this subculture makes cannot be underestimated. Finding a meaningful route to adult/manhood is not an easy task for young people today. Material resources like money or a career are not yet accessible or relevant. And traditional avenues via public displays of physical prowess or bravery are all but obsolete (Raphael, 1988). In this day and age, the young have to be a little more creative and find ways of building

their own props and operating their own rites and rituals. This sub-culture provides us a wonderful example of this creativity.

Approaching graffiti from this personal angle helped me paint a human face back into the subcultural picture. Graffiti writers are not just dots on a class landscape, as the CCCS's work would sometimes imagine them. They are people, more specifically, male adolescent people with their own concerns, hopes and desires, and their own particular way of tackling and satisfying these. Although the CCCS made similar claims about the agency of their subcultural members, the hegemonic theory they used to do this paradoxically revoked them. The concept of 'false consciousness' lies at its heart, portraying their members as somehow blind, working to remedy a situation that they do not even realize exists. Similarly, the working-class contradictions these members suffer depict their response as inevitable, activating structuralist notions of overdetermination. Their social agents, as Willis (1990: 157) remarks, 'may not be seen as passive bearers, but they have still not become much more than brightly coloured cardboard cut-outs pushed around the hegemonic boardgame'.

While hegemony is a theoretically important notion, alone, it leaves little room for the conscious and creative processes we have seen in play here. Using these, I join Willis (1990) in his move towards a more dynamic model of cultural practice:

> Rather than see humans as lumps of 'labour power', meaningful only in work or altogether 'redundant', we will then need to see them as full creative *citizens*, full of their own sensuous symbolic capacities and activities and taking a hand in the construction of their own identities.
>
> (Willis, 1990: 145, italics in original)

This shift in vision would take us beyond the faceless landscape of the Marxist world. It might also help to dimensionalize the flat and sometimes 'meaningless' landscape of the postmodern world. In its full-blown form, postmodernism would have us believe that we are inscribed positions in provided texts and artefacts. I have argued against this. We are people, not robots, and, as such, we come endowed with the creative powers to construct, adapt and reformulate our discursive positions to our own gain. Being human, as Willis (1990: 11) contends, 'means to be creative in the sense of remaking the world for ourselves as we make and find our own place and identity'.

By stripping us of this agency, postmodernism consigns us to an existence which, while plausible on paper, does not *always* fit with the one we live out in the 'real world'. Yes, it has pushed us in some positive and enlightening theoretical and epistemological directions, but at times, it pushes a little too hard and asks us to accept its own metaphors for reality (Willis, 1990).

I used ethnography in an attempt to 'stay in touch' and avoid these pitfalls. Its strength lies in its ability to balance theory, analysis and grounded experience (Wulff, 1995; McRobbie, 1994; Redhead, 1997). And its beauty lies in the way it provides 'rich' empirical material and reflection woven together with the lived meanings and values of those it studies. It was the backbone of my study. Without it, I would have been unable to access and present the writers' voices, and without these, I would have been unable to understand their world as they live, see and experience it. The CCCS group offered us some very sophisticated arguments concerning subcultures and their functions. But we rarely heard the members themselves contribute to this thesis. Their silence will always bewilder me. How can one document or interpret a cultural slice of life without referencing the people who create, sustain and live in it? Reading *Resistance through Rituals* (Hall & Jefferson, 1976) is, in many ways, like going to see a play with no actors. The scene is set, but it is not animated or brought to life. I tried to remedy this in my work by casting these often unemployed subcultural actors in a central role. The part they played made all the difference. With their input, we gain a vivid and radically different interpretation of the CCCS's script, one which makes themes of masculinity and adolescence, rather than class, central to its plot. As an ethnographer, I played a directorial, as opposed to a leading, role. I made these analytic lines prominent and I knitted them together to narrate a compelling story. However, it was the actors who initially delivered them. By making the actor/insider's voice and habitat its first port of call, ethnography fleshes out the fine-grained complexities of social life that other methods can sometimes miss.

But while ethnography may reach the parts other methods cannot, it cannot always reach all of them. I conducted a fairly thorough study of the graffiti subculture in London and New York, but there were areas which remained beyond the scope of my research. I did not, for instance, explore any of the subculture's rural or suburban scenes or, indeed, those in other countries and cities around the world. I met a writer recently who learnt his trade in Johannesburg, South Africa. The story he has to tell is the subject of a whole other book.

Nor did I look at how this subculture is changing in line with tech-nological developments. Difficulties in painting trains and ensuring these 'run' has prompted many writers to find other ways of exposing their work, for example through the use of magazines, videos and the Internet. These communications media have extended their potential audience, but they have also enhanced writers' abilities to network and interact with other writers in other 'scenes' and countries elsewhere. It might be interesting to look at how these advances are affecting this subculture's sense of 'worldwide' unity, and, indeed, its traditions. Already there is debate over whether graffiti belongs on the Web. From what I have heard, there are also cross-out wars now raging in cyber-space! These new developments are rich and weighty and open up a whole new chapter in this subculture's evolution.

Lastly, I did not delve very deeply into life as it exists beyond subcul-tural boundaries. Like most studies, I spotlighted the public sphere, life on the subcultural streets as it were. Taking a closer look at a writer's life at home, school or work could be immensely valuable and enhance four areas of our understanding:

1. It could show us, 'up close', some of the 'real life' restraints that graffiti supposedly counterbalances, thereby clarifying the sig-nificance of its claimed rewards.
2. It could help us appreciate the complex interplay between writers' multiple identities. A graffiti identity is not all-embracing. In some contexts, such as home or work, it is played down or even con-cealed. A look at these 'private' spheres would show us how this identity exchange is negotiated and why.
3. It could also, as McRobbie (1980) proposes, reveal some of the ways in which these different worlds cross and merge:

 The family is the obverse face of hard, working-class culture, the softer sphere in which the fathers, sons and boyfriends expect to be, and are, emotionally serviced. It is this link between the lads' hard outer image and their private experiences – relations with parents, siblings and girlfriends – that still needs to be explored.

 (McRobbie, 1980: 41)

 McRobbie (1980) asks us to look at how working-class masculine culture manifests itself in the 'softer sphere' of home and family. Extend these class boundaries, and this would be an important goal for future studies on graffiti.

4. Finally, a dip into life outside of this subculture might help future theorists tackle some of the questions I left untouched. Namely, if all young men are striving for masculinity and some sense of autonomy, why is it that only some of them get involved in graffiti? Apart from opportunity and inclination, what, if anything, is present or absent in their lives that is/is not in the lives of other young men? A look at their experiences at home, school or work might give us these answers.

It was not possible for me to take my readers on this trek across non-subcultural terrain. Although this represents a valuable project for the future, it might have to remain a 'nice thought'. There are boundaries and thresholds that we cannot always cross as researchers and relative strangers, and expecting to gain access to a writer's life at home could be deemed an over-ambitious project. One's home is a relatively private confine, as McRobbie (1980) recognizes. But, in this case, it might also house people who are unaware that their sons, daughters or husbands are even involved in graffiti. Issues like these will ensure that certain doors are closed on us, and closed doors will continue to emphasize the importance of the insider's voice. If we cannot see or experience these things for ourselves, then we must take our visions from the words of those who can.

It has been about nine years now since I first opened my eyes to the world of graffiti. In this time I've learnt a lot. Not just obvious lessons about its ways and practices, but also some pretty revealing things about myself. This world took me by surprise. The people I met, the sights I saw and the stories I heard, each one reached into the back of my mind and cracked apart a distorted preconception. While I consider myself an open-minded person, like anyone I can be lazy. I was happy to entertain the images of testosteroned mayhem I was fed. I saw graffiti as a random destructive act; enjoyable, yes, but not one with any far-reaching implications. My perceptions of the people who wrote it were just as skewed. Simple-minded tearaways and menacing ones at that. Before my first meeting with a writer, I left the house and a scribbled note to my flatmates telling them what I was doing, when I should be back, and where to come and look for me if I did not return! I was ignorant, but I was also lucky, because, unlike most people, I got a closer and more informed look at this world. What I saw crushed my initial assumptions and left me with a really valuable lesson – something I hold with me now and something I hope this book has also relayed. That is never to take things at face value. Constantly challenge

stereotypes and always interrogate the surface view of things. Because while the writing may be on the wall, its words do not always speak for themselves. Sometimes we have to work a little harder if we want to hear the story they have to tell.

Afterword: Writers Talk Back

Once it was finished, I gave copies of my original thesis back to many of the British writers who had been involved in my research. It is not easy giving your work back to the people it is about. Yes, it concerns them, they have a right to read and comment on it, it is an important way of thanking them for their time and effort. In reality, though, it is a really daunting task. Insiders are a highly critical audience. Naturally. Having someone decipher and then represent you is fairly threatening, especially for a group that does not have a lot of voice to begin with. With less power, they have more reason to search for it by highlighting all your mistakes and failures. This was exacerbated, in my case, by the attitude below:

> *Nancy* So there's a strong belief that if something's going to be said, it should be said by those involved, rather than an outsider?
>
> *Stylo* Yeah, it's like anything, if you're not controlling it there's always a chance that you're going to get subverted. The only way to represent is represent yourself. It's like anything, you're always going to get someone saying how it is when it's not you.

Knowing I was up against this attitude and add to that the fact that my material on masculinity could be seen as threatening, I was ready to have my work ripped to shreds. To my surprise, though, it was not. Just the opposite, really. Writers' reactions were very positive. Those who got back to me were complimentary about my work, and interestingly, about the way I approached my research. Their comments are detailed below.

Drax

I have seen many an article and thesis written with regard to our movement. Initially, I read these with enthusiasm, wondering how the outside world viewed us. Unfortunately, it seemed that most just didn't understand the essence of our artform. The authors just dived into a crescendo of clichés and stereotypes, which, when backed up with inaccurate facts and misrepresentation, resulted in the piece being somewhere between a joke and an insult. Consequently, my enthusiasm for reading such works died. I did, however, continue to help people who wished to write on the subject, as it is something I love and am more than glad to talk about. Thus, when I was approached by Nancy I was happy to let her interview/question me, though I cynically thought, like most people, she would hear only what she wanted to hear and write accordingly, depicting the stereotyped funky-pseudo-graffiti writer-cum-breakdancing-broken

home-rebel without a cause that is usually featured in articles on graffiti. Alas, I was wrong!

On reading Nancy's work, I was shocked/delighted to be reading something I could relate to and, indeed, enjoy. The writing was devoid of the usual 'they're so coolisms' and didn't take us on a journey through the dark, dingy and still vaguely romantic world that is the London graffiti underworld. It allowed the writers (through quotes) to speak for themselves and consequently the factual information and opinions stated were more relevant. Reading this thesis, I found myself engrossed in the subject matter – reading it from start to finish in one sitting! Admittedly, some of the academic jargon had me lost, but with a graffiti drenched brain like mine it is almost impossible for me to read something on the subject and find it interesting, let alone enthralling. This work *was* enthralling and for once I was glad I had assisted somebody. The inclination to go off on tangents, whilst debating our scene, is one we graffiti writers are all guilty of, and it was rewarding to see that Nancy had indulged us that luxury and not pushed for the stereotypical 'We're just misunderstood' or 'We're out to destroy the system' quote. All this has been heard a thousand times and merely serves to cloud any possible introspective look into a subculture which is deeper, more intricate and deserving of better. It was refreshing to read about our scene from a more analytical or documentary angle. The cardinal sin of most authors is to allow self opinion and personal viewpoint to dominate. The work then becomes inaccurate and eventually boring. By allowing the artists to speak for themselves, Nancy creates a piece which relays an open minded outlook of a scene which is all too often written about from a self promoting or demeaning viewpoint.

I would be glad for this thesis to be read by somebody who wished to understand the essence and depth of our movement, encountering it on more than a superficial or judgmental basis. It was an excellent read and, though I am more than familiar with the subject matter, I enjoyed the way it gave an account of what is a much deeper and involved subculture than most people would give it credit for. This thesis wasn't the usual misinformed rubbish. It was unbiased and, unlike most fraudulent accounts I encounter, truly and uncompromisingly real.

(Drax – written communication, 1997)

Dane

Nancy details (through the words of writers) truths and insights into this culture and links them to her own perspective as a searcher of knowledge and diver into unfathomable depths. She goes deep, illuminating behaviour patterns in their breeding ground. Nancy took time to check out our lifeform first hand in its own environment. In this she has gone further than those before her, and she still had enough oxygen to reach the surface again and tell the tale.

(Dane – written communication, 2000)

Stylo

This is the first time I have read something on the subject from an outsider which actually hits the nail on the head. I was expecting the old social deprivation argument, but this work goes beyond that. It is the most detailed study of the subculture ever done. My only criticism would be that I don't think writers discriminate as much on gender as portrayed. Some of them are a bit like Bernard Manning – any excuse to single people out will do.

(Stylo – written communication, 1997)

Prime

In this writing I'm going to give my comment, analysis and criticisms of Nancy Macdonald's thesis. On meeting Nancy, through Stylo, my first thoughts were 'Oh shit not another one.' Someone trying to be 'alternative' by doing their academic work about graf. I wasn't new to the idea and found it unoriginal. Most observers don't come across as having the inclination to get the deeper facts or tell the story as it is. But I love talking about what I do. When I finally saw the finished product, I knew I'd have to eat my words, even if only on effort. From my point of view, the subject warranted a substantial piece to be written about it and Nancy definitely came through on that.

Reading through the chapters that form her theoretical foundation (2–4) it soon became clear that this would be the most comprehensive work I would have read on the subject to date, with the best analysis from an 'outsider' I would have encountered in my years of writing. For me, the foundation of any action is its integrity or its reasoning; a writer can be classed as shit, but as long as he's not full of shit, he's cool. Reason and rationale count for a lot and Nancy clearly laid out hers, fighting against the arrogant and stiff old grey men and bringing a real, interactive perspective to the way one conducts research. People always write bullshit about how we're supposed to tick, but we watch as much as they watch us, and like the ink blot test, their theories reveal their state of mind more clearly than ours. Nancy tries fucking hard not to fall into that trap and quickly identifies the all crucial parallel role the subculture holds next to mainstream society, addressing the subject in a wider context. Her efforts to 'let the key issues emerge' helped to keep her feet on the ground by not allowing her initial fascination with the subject cloud her judgment too much. Her admission that everyone has a pre-set agenda or viewpoint also nicely fucks with the detached, superhuman, super-objective doctor myth. Destroying this myth empowers the subject and lets them take centre stage in the research, lessening the chance that issues and notions are suggested to the subject rather than coaxed out.

Nancy states that she carried with her the proposition of the CCCS group that subcultures are a symbolic solution to class related problems. It is clear that this proposition does not stay with her throughout. Writing is about taking power, but primarily within the subculture itself or at most the wider

youth culture. A lot of people carry on writing because they've looked at the class thing and said 'Fuck it all.' Joining mainstream society is usually just a means to a financial or some other end.

Nancy touches on crime and criminality but doesn't really explore the concept of 'criminalisation' of the writer by authority or how crime is viewed in different localities. Driving over 30mph. in some areas is a crime, dodging the train fare is a crime, tax evasion is a crime, using a mobile phone while driving can be a crime. Some of these crimes are committed by us everyday, so what is a criminal? The point is, for shit to run smooth, it's important that some people are criminalised.

I also ask questions about the way gender is approached in Nancy's work. Writing definitely is a construction of masculine identity, but whether this is constructed on the backs of women that want to write is questionable. I wouldn't try to categorise all the different types of writers Nancy inter-viewed, but I do know, on the issue of gender, she interviewed at least one wanker who wanted to be hard in front of her. My experience in London, amongst the thinkers, the 'old school', is that everyone comes through on their dedication and ability. So women are seen to add to the culture, but they must play by the same rules as the men. Hard competition is what made writing flourish and anyone that falls short of that ain't respected, male or female. Women entering the scene as 'someone's girl' doesn't help their status.

Most writers I know don't really give a shit about 'misrepresentation' in the media. No one expects anything different or really cares about how we're seen. In fact most writers I know love the spotlight of a mention in the press, whether it's favourable or not. Like shrewd advertisers, we know there's no such thing as 'bad press', especially when we know our thing is seen as 'bad' anyway. This group of disgruntled writers is usually the fringe, right on, 'of course it's art' type, who most people don't respect anyway. The 'silent voice' thing isn't really relevant either because the writers who are confident about what they're doing know that the 'voice' of a bombed train speaks the loudest – we take control. I disagree that the 'validity' of accounts is not important (Chapter 2), as it is obvious that the more opinionated groups within the subculture see it as essential to any true portrayal of events and the culture as a whole. Furthermore accounts being 'valid in their own right' (Chapter 2) makes the whole exercise of 'finding out' and building a 'frame-work' futile.

I need to make myself very clear here. Whatever I have written about Nancy's work involves no serious criticisms, simply observations about a few points, many of which Nancy elaborates on further on in the piece. As a body of research and academic authority on what writers do, why and how they see themselves, this work is flawless, I repeat, Flawless! Nancy's research is sharp, penetrating and almost scary in the way it sheds light on the work-ings of our culture. She has expounded on the subject like a veteran writer. I'm sure if her work were made accessible to a wider audience it would be powerful enough to actually educate new writers who are ignorant of the depth and history behind the culture. Most importantly, Nancy not only approached the subject with the discipline needed to research any subject thoroughly, but also the prerequisite of an open mind, not simply taking

things on face value. For me, a man who could talk about the culture for days, on all levels, this is the deepest and most informative work I have ever read on the subject.

<div align="right">(Prime – written communication, 1997)</div>

Akit

Nancy, I thought your work was safe, 'nuf props, 'nuf respect. Your analysis and portrayal of us mad folk was spot on. But it would be fair to say that your picture was a little bit rosy at times – one of graf as a harmonious underground existence bound together by an unspoken solidarity of us against the rest of the world – pursuing our love of art. I know 2/3 years ago I was totally on this tip, but due to different personal circumstances and the tumultuous world of graf, *my* perceptions have altered and not necessarily for the better. Tradition got played out and the mentality has soured recently. I'm not in any way against graf, on the contrary, I'm even more elitist in my stance. What others think of graf I'm even less bothered by. The more mainstream it becomes, the more incensed I get. It really isn't for others, that's my main point, because a writer has little or no respect. A general disregard is almost necessary, it goes hand in hand. But this general disregard and 'Fuck everyone else' attitude will and does have debilitating effects on most young men (and women!). I'm not saying they all go that way, but I've been part of and an observer of London graf for over five years and the levels of self destruction and fuckedupness some people sink to is unfounded. As I write, there is a division in London I never dreamed possible. A militancy has emerged due to (I think) sheer boredom combined with the attitude you start off with e.g., anyone who doesn't or won't understand graf is an enemy, let alone worthless. An inability to deal with anything other than graf is obviously unhealthy, and once you've fallen into the trap that graf is all you have and know and when faced with a). everyday life and b). having to find an alternative (which is inevitable for most) other than selling out, the attitude held by hardcore writers can become a hindrance – to the point of being a ball and chain. This all sounds very moody and I don't mean we're all doomed, but you talk about self direction in a positive way and I haven't seen much evidence of it recently. That air of disregard is what keeps us going. Writers cringe at the thought of public acceptance. You could put all the bows and ribbons on a writer or their graf, but underneath what it boils down to is 'Fuck you!' It's all or nothing. I just felt that the picture could be clearer with an admittance of the downside. But this is just my view and it's wholly dictated by what's happening here now in London. I'm talking 100% personally and not on graf's behalf, even London graf. I don't expect anyone else you interviewed to make the same assessment of the situation or of your work. Just right now, this overshadows everything. Come ask me again in 6 months and everything may be sweet. But regardless of that I maintain that we're not all lovely and great, not by a long stretch. In fact we can be quite a nasty bunch! Ha! You must be as mad as us to love it so much!

Regarding being female, things never got any better – in general!! I still meet writers and I know what they think or have heard and to make life easier on myself and show I'm not bitter, I'll often proclaim that I've had every writer going and if I haven't had them yet, then I will. They can't really say anything worse than that!! I couldn't win, but I wasn't bothered. I suppose if you can't beat them, join them and all that shit. But it wasn't ever that, I just gave up giving a shit about what they thought about me. It all became quite amusing and I'd relish hearing stories of my sexual escapades with writers, often making a few up myself just to keep the fire burning! Being famous is nice, but being infamous also has a certain ring to it! Only through developing *friendships* with writers, most could see I was genuine and not a genuine slag. I can't remember who says in your dissertation that it's easier for a girl to get away with less. Yes, the rules are bent and a female writer will never be on a par with her male equivalent. Blatantly, I know that a piece I had done would be worth ten pieces simply because it was executed by a girl. The same with tags even, again because it was a girl who put them there. I suppose for the same reasons, I'd be scrutinised tenfold. But I know I did alright. Like I say, they can think what they like. I know what's what and that's all that matters.

But again, 'nuf respect girl. Well done. I liked what you did a lot and you should be chuffed! It's wicked. Everything you addressed was appropriate and your analysis was realistic and correct (although you could have had a bit more about the joys of racking [stealing paint] personally!). But believe it's all good. It was a pleasure to take part and assist. Thanks for including me.

(Akit – written communication, 1997)

Junk

This is the first paper, to my knowledge, that has gone into such depth into the study of a very visible, yet at times, clandestine subculture. I was amazed at the volume of information presented, as in recent years writers have been reluctant (with good reason) to part with information even to other writers. This research was delivered with obvious enjoyment of the subject which, unlike some dry academic exercises, made it interesting to read. I also like the way Nancy does not try to seal this subculture into a capsule, but shows its many facets with further possibilities for studying it. I'm sure this study would make a valuable contribution to creating more studies on this artform.

(Junk – written communication, 1997)

Some writers never got back to me. There are others, whom I have never met or spoken to, who have apparently borrowed my thesis from their friends to have a read. As Elk told me: 'You've become a bit of a celebrity. Everyone's talking about this woman who has written a book on graffiti.' My gender seems to have been quite significant in all of this. Elk mentioned that many writers were surprised when they heard I was a woman. Another writer I spoke to made

a similar comment, suggesting, fairly tentatively, that it is usually men who think this deeply and work this hard on things – like female writers, women lack the dedication and commitment! The least I hope for, then, is to have challenged some of the massively chauvinistic attitudes that prevail within this subculture.

All in all this exchange was a very positive experience, both for me and the writers. It was also an interesting one. I learnt a lot about this subculture from the way writers reacted to my depiction of them. I learnt even more by looking at what it was they picked up on, took issue with, challenged or supported. I learnt the most, though, from the way their attitudes towards me changed. Once I had given back my thesis and my work began to circulate, the distance that had previously stood between us, dissolved a bit. I had a lot more contact with many of them and was regularly invited to their events and shows. I was also asked to contribute to their magazine *Graphotism*. It is as if I have 'paid my dues' and, in their eyes, earnt myself a place within the subculture's boundaries. I am no longer just an outsider with a fleeting interest or a college report to submit, but an individual, as I am told, with something important to say.

Bibliography

Books and journal articles

Agar, M. (1980). *The Professional Stranger: An Informed Introduction to Ethnography*. New York: Academic Press.

Allen, S. (1968). 'Some Theoretical Problems in the Study of Youth.' *The Sociological Review*, 16(3), 319–31.

Ardener, S. (1984). 'The Fieldwork Experience: Gender Orientations in Fieldwork.' In R. Ellen (ed.), *Ethnographic Research: A Guide to General Conduct*. London: Academic Press.

Argyle, M. (1986). 'Social Behaviour Problems in Adolescence.' In R. Silberiesen, K. Eyferth & G. Rudinger (eds), *Development as Action in Context*. Berlin: Springer-Verlag.

Arkin, W. & Dobrofsky, L. (1978). 'Military Socialisation and Masculinity.' *Journal of Social Issues*, 34(1), 151–68.

Bassett, C. (1997). 'Virtually Gendered: Life in an On-line World.' In K. Gelder & S. Thornton (eds), *The Subcultures Reader*. London: Routledge.

Becker, H. (1963). *Outsiders: Studies in the Sociology of Deviance*. New York: Free Press.

Beloff, H. (1991). 'Feminist Psychology and the Study of Men and Masculinity. Part 1: Assumptions and Perspectives.' In C. Griffin & M. Wetherell (eds), *Feminism & Psychology*, 1(3), 361–91.

Berger, P. (1977). *Facing Up to Modernity*. Harmondsworth: Penguin.

Best, J. & Luckenbill, D. (1981). 'Careers in Deviance and Respectability: The Analogy's Limitations.' *Social Problems*, 29(2), 197–206.

Bjerrum Nielsen, H. & Rudberg, M. (1993). 'Whatever Happened to Gender? Female Subjectivity and Change in a Generational Context.' In J. van Mens-Verhulst, K. Schreurs & L. Woertman (eds), *Daughtering and Mothering: Female Subjectivity Reanalysed*. London: Routledge.

Blackman, S. (1998). 'The School: "Poxy Cupid!" An Ethnographic and Feminist Account of a Resistant Female Youth Culture: The New Wave Girls.' In T. Skelton & G. Valentine (eds), *Cool Places: Geographies of Youth Cultures*. London: Routledge.

Bloch, H. & Niederhoffer, A. (1958). *The Gang: A Study in Adolescent Behaviour*. New York: Philosophical Library.

Blos, P. (1962). *On Adolescence: A Psychoanalytic Interpretation*. New York: Free Press.

Bola, M. (1995). 'Questions of Legitimacy? The Fit between Researcher and Researched.' *Feminism & Psychology*, 5(2), 290–3.

Brake, M. (1985). *Comparative Youth Culture: The Sociology of Youth Cultures and Youth Subcultures in America, Britain and Canada*. London: Routledge & Kegan Paul.

Brettell, C. (1993). 'Introduction: Fieldwork, Text and Audience.' In C. Brettell (ed.), *When They Read What We Write: The Politics of Ethnography*. Westport, Conn.: Bergin & Garvey.

Brewer, D. & Miller, M. (1990). 'Bombing and Burning: The Social Organisation and Values of Hip Hop Graffiti Writers and Implications for Policy.' *Deviant Behaviour*, 11, 345–69.

Campbell, B. (1993a). 'Lessons from the Riots.' In A. Coote (ed.), *Families, Children and Crime*. London: Institute for Public Policy Research.

Campbell, B. (1993b). *Goliath: Britain's Dangerous Places*. London: Methuen.

Castleman, C. (1982). *Getting Up*. Cambridge, Mass.: MIT Press.

Chalfant, H. & Prigoff, J. (1987). *Spraycan Art*. London: Thames & Hudson.

Clarke, J. (1976). 'Style.' In S. Hall & T. Jefferson (eds), *Resistance through Rituals: Youth Subcultures in Post-war Britain*. London: Hutchinson.

Clarke, J., Hall, S., Jefferson, T. & Roberts, B. (1976). 'Subcultures, Cultures and Class: A Theoretical Overview.' In S. Hall & T. Jefferson (eds), *Resistance through Rituals: Youth Subcultures in Post-war Britain*. London: Hutchinson.

Clifford, J. (1986). 'Introduction: Partial Truths.' In J. Clifford & G. Marcus (eds), *Writing Culture: The Poetics and Politics of Ethnography*. Berkeley, Calif.: University of California Press.

Cloward, R. & Ohlin, L. (1961). *Delinquency and Opportunity*. London: Routledge & Kegan Paul.

Coffield, F. (1991). *Vandalism & Graffiti: The State of the Art*. London: Calouste Gulbenkian Foundation.

Cohen, A. (1955). *Delinquent Boys: The Culture of the Gang*. New York: Free Press.

Cohen, A. P. (1984). 'Producing Data: Informants.' In R. Ellen (ed.), *Ethnographic Research: A Guide to General Conduct*. London: Academic Press.

Cohen, S. (1987). *Folk Devils and Moral Panics: The Creation of the Mods and Rockers*, 3rd edn. Oxford: Basil Blackwell.

Coleman, J. C. (1980). *The Nature of Adolescence*. London: Methuen.

Coleman, J. S. (1961). *The Adolescent Society*. New York: Free Press.

Coleman, W. (1990). 'Doing Masculinity/Doing Theory.' In J. Hearn & D. Morgan (eds), *Men, Masculinities and Social Theory*. London: Unwin & Hyman.

Connell, R. (1989). 'Cool Guys, Swots and Wimps: The Interplay of Masculinity and Education.' *Oxford Review of Education*, 15(3), 291–303.

Cooper, M. & Chalfant, H. (1984). *Subway Art*. London: Thames & Hudson.

Coote, A. (1993). 'Introduction.' In A. Coote (ed.), *Families, Children and Crime*. London: Institute for Public Policy Research.

Corrigan, P. (1976). 'Doing Nothing.' In S. Hall & T. Jefferson (eds), *Resistance through Rituals: Youth Subcultures in Post-war Britain*. London: Hutchinson.

Corrigan, P. & Frith, S. (1976). 'The Politics of Youth Culture.' In S. Hall & T. Jefferson (eds), *Resistance through Rituals: Youth Subcultures in Post-war Britain*. London: Hutchinson.

Crapanzano, V. (1986). 'Hermes' Dilemma: the Masking of Subversion in Ethnographic Description.' In J. Clifford & G. Marcus (eds), *Writing Culture: The Poetics and Politics of Ethnography*. Berkeley, Calif.: University of California Press.

Csikszentmihalyi, M. (1975). *Beyond Boredom and Anxiety: The Experience of Play in Work and Games*. San Francisco: Jossey Bass.

Davis, D. (1993). 'Unintended Consequences: The Myth of "The Return" in Anthropological Fieldwork.' In C. Brettell (ed.), *When They Read What We Write: The Politics of Ethnography*. Westport, Conn.: Bergin & Garvey.

Davis, J. (1990). *Youth and the Condition of Britain: Images of Adolescent Conflict.* London: Athlone Press.

Downes, D. & Rock, P. (1982). *Understanding Deviance: A Guide to the Sociology of Crime and Rule Breaking.* Oxford: Clarendon Press.

Edley, N. & Wetherell, M. (1993). 'Constructing Masculinity.' Paper delivered at Social Psychology Conference, Jesus College, Oxford, September.

Edley, N. & Wetherell, M. (1995). *Men in Perspective: Practice, Power and Identity.* London: Harvester Wheatsheaf.

Eisenstadt, S. (1956). *From Generation to Generation: Age Groups and Social Structure.* New York: Free Press.

Eliade, M. (1958). *Rites and Symbols of Initiation: The Mysteries of Birth and Rebirth.* New York: Harper & Row.

Ellen, R. (ed.) (1984). 'Introduction.' In R. Ellen (ed.), *Ethnographic Research: A Guide to General Conduct.* London: Academic Press.

Emler, N. & Reicher, S. (1995). *Adolescence and Delinquency.* Oxford: Blackwell.

Epstein, J. (ed.) (1998). 'Introduction: Generation X, Youth Culture, and Identity.' In J. Epstein (ed.), *Youth Culture: Identity in a Postmodern World.* Malden, Mass.: Blackwell Publishers.

Erikson, E. (1968). *Identity: Youth and Crisis.* London: Faber & Faber.

Evans, C. (1995). 'Dreams that Only Money Can Buy: Sub-culture and Authenticity. Is the Classical 1970s Model of Sub-culture of any Use in the 1990s?' Paper presented at Conference on Theory, Populism and Sub-Cultural Dress, Victoria & Albert Museum Research Dept., 11 November.

Feiner, J. & Klein, S. (1982). 'Graffiti Talks.' *Social Policy* (US), 12(3), 47–53.

Ferrell, J. (1996). *Crimes of Style: Urban Graffiti and the Politics of Criminality.* Boston, Mass.: Northeastern Press.

Fielding, N. (1994). 'Cop Canteen Culture.' In E. Stanko & T. Newburn (eds), *Just Boys Doing Business: Men, Masculinities and Crime.* London: Routledge.

Fine, G. (1987). 'One of the Boys: Women in Male Dominated Settings.' In M. Kimmel (ed.), *Changing Men: New Directions in Research on Men and Masculinity.* Newbury Park, Calif.: Sage.

Flannigan-Saint-Aubin, A. (1994). 'The Male Body and Literary Metaphors for Masculinity.' In H. Brod & M. Kaufman (eds), *Theorising Masculinities: Research on Men and Masculinities.* London: Sage.

Ganetz, H. (1994). 'The Shop, the Home and Femininity as a Masquerade.' In J. Fornäs & G. Bolin (eds), *Youth Culture in Late Modernity.* London: Sage.

Garfinkel, H. (1967). *Studies in Ethnomethodology.* Englewood Cliffs, New Jersey: Prentice-Hall.

Geertz, C. (1983). *Social Knowledge: Further Essays in Interpretive Anthropology.* New York: Basic Books.

Gill, R. (1995). 'Relativism, Reflexivity and Politics: Interrogating Discourse Analysis from a Feminist Perspective.' In S. Wilkinson & C. Kitzinger (eds), *Feminism and Discourse.* London: Sage.

Gilmore, D. (1990). *Manhood in the Making: Cultural Concepts of Masculinity.* New Haven, Conn.: Yale University Press.

Glaser, B. & Strauss, A. (1967). *The Discovery of Grounded Theory: Strategies for Qualitative Research.* Chicago: Aldine.

Glaser, B. & Strauss, A. (1971). *Status Passage.* London: Routledge & Kegan Paul.

Glazier, S. (1993). 'Responding to the Anthropologist: When the Spiritual Baptists of Trinidad Read What I Write about Them.' In C. Brettell (ed.), *When They Read What We Write: The Politics of Ethnography*. Westport, Conn.: Bergin & Garvey.

Goffman, E. (1968). *Asylums*. Harmondsworth: Penguin.

Goward, N. (1984). 'The Fieldwork Experience: Personal Interaction and Adjustment.' In R. Ellen (ed.), *Ethnographic Research: A Guide to General Conduct*. London: Academic Press.

Griffin, C. (1985). *Typical Girls? Young Women from School to the Job Market*. London: Routledge.

Griffin, C. (1993). *Representations of Youth: The Study of Youth in Britain and America*. Cambridge: Polity Press.

Grossberg, L. (1997). 'Another Boring Day in Paradise: Rock and Roll and the Empowerment of Everyday Life.' In K. Gelder & S. Thornton (eds), *The Subcultures Reader*. London: Routledge.

Gutterman, D. (1994). 'Postmodernism and the Interrogation of Masculinity.' In H. Brod & M. Kaufman (eds), *Theorising Masculinities: Research on Men and Masculinities*. London: Sage.

Hall, S. & Jefferson, T. (eds) (1976). *Resistance through Rituals: Youth Subcultures in Post-war Britain*. London: Hutchinson.

Hamilton, D. (1994). 'Traditions, Preferences and Postures in Applied Qualitative Research.' In N. Denzin & Y. Lincoln (eds), *Handbook of Qualitative Research*. Thousand Oaks, Calif.: Sage.

Hamilton, S. & Darling, N. (1989). 'Mentors in Adolescents' Lives.' In K. Hurrelmann & U. Engel (eds), *The Social World of Adolescents: International Perspectives*. Berlin: Walter de Gruyter.

Hammersley, M. (1989). *The Dilemma of Qualitative Method*. London: Routledge.

Hammersley, M. (1991). *Reading Ethnographic Research: A Critical Guide*. Harlow, Essex: Longman.

Hammersley, M. (1992). *What's Wrong with Ethnography? Methodological Explorations*. New York: Routledge.

Hammersley, M. & Atkinson, P. (1983). *Ethnography: Principles in Practice*. London: Tavistock.

Hantover, J. (1978). 'The Boy Scouts and the Validation of Masculinity.' *Journal of Social Issues*, 34(1), 184–95.

Harré, R. (1990). 'Exploring the Human Umwelt.' In R. Bhaskar (ed.), *Harré & His Critics*. Oxford: Basil Blackwell.

Harré, R. (1993). *Social Being*, 2nd edn. Oxford: Blackwell.

Harré, R. & Secord, P. (1972). *The Explanation of Social Behaviour*. Oxford: Basil Blackwell.

Hart, D. (1992). *Becoming Men: The Development of Aspirations, Values and Adaptional Styles*. New York: Plenum.

Hearn, J. & Collinson, D. (1994). 'Theorising Unities and Differences between Men and between Masculinities.' In H. Brod & M. Kaufman (eds), *Theorising Masculinities: Research on Men and Masculinities*. London: Sage.

Hebdige, D. (1979). *Subculture: The Meaning of Style*. London: Methuen.

Hebdige, D. (1988). *Hiding in the Light: On Images and Things*. London: Routledge/Comedia.

Hebdige, D. (1997). 'Posing . . . Threats, Striking . . . Poses: Youth, Surveillance, and Display.' In K. Gelder & S. Thornton (eds), *The Subcultures Reader*. London: Routledge.

Heidensohn, F. (1989). *Crime and Society*. Basingstoke: Macmillan Education – now Palgrave.

Hendry, L., Shucksmith, J., Love, J. & Glendinning, A. (1993). *Young People's Leisure and Lifestyles*. London: Routledge.

Henriques, J., Hollway, W., Urwin, C., Venn, C. & Walkerdine, V. (1984). *Changing the Subject: Psychology, Social Regulation and Subjectivity*. London: Methuen.

Henwood, K. & Pidgeon, N. (1993). 'Grounded Analysis, Subjectivity and Social Psychology.' Paper prepared for symposium on Subjectivity, Reflexivity and Qualitative Social Psychology, BPS Social Psychology Section Annual Conference, Jesus College, Oxford, 22–24 September.

Henwood, K. & Pidgeon, N. (1994). 'Beyond the Qualitative Paradigm: A Framework for Introducing Diversity within Qualitative Psychology.' *Journal of Community & Applied Social Psychology*, 4, 225–38.

Henwood, K. & Pidgeon, N. (1995). 'Remaking the Link: Qualitative Research and Feminist Standpoint Theory.' *Feminism & Psychology*, 5(1), 7–30.

Herek, G. (1987). 'On Heterosexual Masculinity: Some Psychical Consequences of the Social Construction of Gender and Sexuality.' In M. Kimmel (ed.), *Changing Men: New Directions in Research on Men and Masculinity*. Newbury Park, Calif.: Sage.

Hirschi, T. (1969). *Causes of Delinquency*. Berkeley, Calif.: University of California Press.

Hollway, W. (1984). 'Gender Difference and the Production of Subjectivity.' In J. Henriques, W. Hollway, C. Urwin, C. Venn & V. Walkerdine, *Changing the Subject: Psychology, Social Regulation and Subjectivity*. London: Methuen.

Hollway, W. (1989). *Subjectivity and Method in Psychology: Gender, Meaning and Science*. London: Sage.

Hudson, A. (1988). 'Boys Will Be Boys: Masculinism and the Juvenile Justice System.' *Critical Social Policy*, Issue 21, 7(3), 30–49.

Jefferson, T. (1976). 'Cultural Responses of the Teds: The Defence of Space and Status.' In S. Hall & T. Jefferson (eds), *Resistance through Rituals: Youth Subcultures in Post-war Britain*. London: Hutchinson.

Jefferson, T. (1993). 'Crime, Criminology, Masculinity and Young Men.' In A. Coote (ed.), *Families, Children and Crime*. London: Institute for Public Policy Research.

Jessor, R. (1986). 'Adolescent Problem Drinking: Psychological Aspects and Developmental Outcomes.' In R. Silbereisen, K. Eyferth & G. Rudinger (eds), *Development as Action in Context*. Berlin: Springer-Verlag.

Josselson, R. (1980). 'Ego Development in Adolescence.' In J. Adelson (ed.), *Handbook of Adolescent Psychology*. New York: Wiley.

Kandel, D. (1986). 'Processes of Peer Influence in Adolescence.' In R. Silbereisen, K. Eyferth & G. Rudinger (eds), *Development as Action in Context*. Berlin: Springer-Verlag.

Katz, J. (1988). *Seductions of Crime: Moral and Sensual Attractions in Doing Evil*. New York: Basic Books.

Kearney, M. (1998). '"Don't Need You": Rethinking Identity Politics and Separatism from a Grrrl Perspective.' In J. Epstein (ed.). *Youth Culture: Identity in a Postmodern World*. Malden, Mass.: Blackwell.

Kimmel, M. (1987). 'Rethinking Masculinity: New Directions in Research.' In M. Kimmel (ed.), *Changing Men: New Directions in Research on Men and Masculinity*. Newbury Park, Calif.: Sage.

Kimmel, M. (1990). 'The Masculinity of Sociology.' In J. Hearn & D. Morgan (eds), *Men, Masculinities and Social Theory*. London: Unwin & Hyman.

Kimmel, M. (1994). 'Masculinity and Homophobia: Fear, Shame and Silence in the Construction of Gender Identity.' In H. Brod & M. Kaufman (eds), *Theorising Masculinities: Research on Men and Masculinities*. London: Sage.

Kohl, H. (1972). *Golden Boy as Anthony Cool: A Photo Essay on Naming and Graffiti*. New York: The Dial Press.

Lachmann, R. (1988). 'Graffiti as Career and Ideology.' *American Journal of Sociology*, 94(2), 229–50.

Letkemann, P. (1973). *Crime as Work*. Englewood Cliffs, New Jersey: Prentice-Hall.

Levinson, D. (1978). *The Seasons of a Man's Life*. New York: Alfred A. Knopf.

Liddle, M. (1993). 'Masculinity, "Male Behaviour" and Crime: a Theoretical Investigation of Sex Differences in Delinquency and Deviant Behaviour.' Paper presented at Conference on Masculinity and Crime, Centre for Criminal Behaviour, Brunel University, 14–15 September.

Lincoln, Y. & Guba, E. (1985). *Naturalistic Inquiry*. Newbury Park, Calif.: Sage.

Luckman, T. (1982). 'Individual Action and Social Knowledge.' In R. Harré & M. von Cranach (eds), *The Analysis of Action: Recent Theoretical and Empirical Advances*. Cambridge: Cambridge University Press.

McCaughey, C. (1993). 'The Word on the Street.' In A. Coote (ed.), *Families, Children and Crime*. London: Institute for Public Policy Research.

McRobbie, A. (1980). 'Settling Accounts with Subcultures: A Feminist Critique.' *Screen Education*, 34, 37–49.

McRobbie, A. (1994). *Postmodernism and Popular Culture*. London: Routledge.

McRobbie, A. & Garber, J. (1976). 'Girls and Subcultures: An Exploration.' In S. Hall & T. Jefferson (eds), *Resistance through Rituals: Youth Subcultures in Post-war Britain*. London: Hutchinson.

McRobbie, A. & Garber, J. (1991). 'Girls and Subcultures.' In A. McRobbie, *Feminism and Youth Culture: From Jackie to Just 17*. London: Macmillan – now Palgrave.

Mailer, N., Kurlansky, M. & Naar, J. (1974). *The Faith of Graffiti*. New York: Praeger.

Marcus, G. (1986). 'Contemporary Problems of Ethnography in the Modern World System.' In J. Clifford & G. Marcus (eds), *Writing Culture: The Poetics and Politics of Ethnography*. Berkeley, Calif.: University of California Press.

Marsh, P. (1982). 'Rules in the Organisation of Action: Empirical Studies.' In R. Harré & M. von Cranach (eds), *The Analysis of Action: Recent Theoretical and Empirical Advances*. Cambridge: Cambridge University Press.

Marsh, P., Rosser, E. & Harré, R. (1978). *The Rules of Disorder*. London: Routledge & Kegan Paul.

Marsland, D. (1980). *Towards a Sociology of Youth*. Regional Training Consultative Unit, Occasional Paper 5.

Marsland, D. (1993). *Understanding Youth: Issues and Methods in Social Education.* St Albans: Claridge Press.

Matza, D. (1964). *Delinquency and Drift.* New York: Wiley.

Matza, D. & Sykes, G. (1961). 'Juvenile Delinquency and Subterranean Values.' *American Sociological Review,* 26(5), 712–19.

Merton, R. (1938). 'Social Structure and Anomie.' *American Sociological Review,* 3, 672–82.

Merton, R. (1972). 'Insiders and Outsiders: A Chapter in the Sociology of Knowledge.' *American Journal of Sociology,* 78, 9–47.

Messerschmidt, J. (1993). *Masculinities and Crime: Critique and Reconceptualisation of Theory.* Lanham, Md: Rowman & Littlefield.

Messerschmidt, J. (1994). 'Schooling, Masculinities and Youth Crime by White Boys.' In E. Stanko & T. Newburn (eds), *Just Boys Doing Business: Men, Masculinities and Crime.* London: Routledge.

Messner, M. (1987). 'The Life of a Man's Seasons: Male Identity in the Life-Course of the Jock.' In M. Kimmel (ed.), *Changing Men: New Directions in Research on Men and Masculinity.* Newbury Park, Calif.: Sage.

Messner, M. (1991). 'Masculinities and Athletic Careers.' In J. Lorber & S. Farrell (eds), *The Social Construction of Gender.* Newbury Park, Calif.: Sage.

Miles, R. (1991). *The Rites of Man: Love, Sex and Death in the Making of the Male.* London: Paladin.

Miller, W. (1958). 'Lower Class Culture as a Generating Milieu of Gang Delinquency.' *Journal of Social Issues,* 14, 5–19.

Mishkind, M., Rodin, J., Silberstein, L. & Striegel-Moore, R. (1987). 'The Embodiment of Masculinity: Cultural, Psychological and Behavioural Dimensions.' In M. Kimmel (ed.), *Changing Men: New Directions in Research on Men and Masculinity.* Newbury Park, Calif.: Sage.

Morgan, D. (1994). 'Theatre of War: Combat, the Military and Masculinities.' In H. Brod & M. Kaufman (eds), *Theorising Masculinities: Research on Men and Masculinities.* London: Sage.

Murdock, G. & McCron, R. (1976). 'Consciousness of Class and Consciousness of Generation.' In S. Hall & T. Jefferson (eds), *Resistance through Rituals: Youth Subcultures in Post-war Britain.* London: Hutchinson.

Murray, K. (1989). 'The Construction of Identity in the Narratives of Romance and Comedy.' In J. Shotter & K. Gergen (eds), *Texts of Identity.* London: Sage.

Olesen, V. (1994). 'Feminisms and Models of Qualitative Research.' In N. Denzin & Y. Lincoln (eds), *Handbook of Qualitative Research.* Thousand Oaks, Calif.: Sage.

Parker, H. (1974). *View From the Boys: A Sociology of Downtown Adolescents.* Newton Abbot: David & Charles.

Parsons, T. (1942). 'Age and Sex in the Social Structure of the United States.' *American Sociological Review,* 7, 604–16.

Phillips, A. (1993). *The Trouble with Boys.* London: Pandora.

Phillips, S. (1999). *Wallbangin': Graffiti and Gangs in L.A.* Chicago: University of Chicago Press.

Pleck, J. (1981). *The Myth of Masculinity.* Cambridge, Mass.: MIT Press.

Pleck, J. & Thompson, E. (1987). 'The Structure of Male Role Norms.' In M. Kimmel (ed.), *Changing Men: New Directions in Research on Men and Masculinity.* Newbury Park, Calif.: Sage.

Polk, K. (1994). 'Masculinity, Honour and Homicide.' In E. Stanko & T. Newburn (eds), *Just Boys Doing Business: Men, Masculinities and Crime*. London: Routledge.

Powers, S. (1999). *The Art of Getting Over: Graffiti at the Millennium*. New York: St. Martin's Press – now Palgrave.

Raphael, R. (1988). *The Men from the Boys: Rites of Passage in Male America*. Lincoln, Neb.: University of Nebraska Press.

Reason, P. (1994). 'Three Approaches to Participative Inquiry.' In N. Denzin & Y. Lincoln (eds), *Handbook of Qualitative Research*. Thousand Oaks, Calif.: Sage.

Redhead, S. (ed.) (1997). 'Introduction: Reading Pop(ular) Cult(ural) Stud(ie)s.' In S. Redhead (ed.), *The Clubcultures Reader: Readings in Popular Cultural Studies*. Oxford: Blackwell.

Reimer, B. (1994a). 'The Media in Public and Private Spheres.' In J. Fornäs & G. Bolin (eds), *Youth Culture in Late Modernity*. London: Sage.

Reimer, B. (1994b). 'Youth and Modern Lifestyles.' In J. Fornäs & G. Bolin (eds), *Youth Culture in Late Modernity*. London: Sage.

Reiner, R. (1992). *The Politics of the Police*, 2nd edn. London: Harvester Wheatsheaf.

Remy, J. (1990). 'Patriarchy and Fratriarchy as Forms of Androcracy.' In J. Hearn & D. Morgan (eds), *Men, Masculinities and Social Theory*. London: Unwin & Hyman.

Reynolds, V. (1982). 'Behaviour, Action and Act in Relation to Strategies and Decision-Making.' In R. Harré & M. von Cranach (eds), *The Analysis of Action: Recent Theoretical and Empirical Advances*. Cambridge: Cambridge University Press.

Romanowski, P. & Flinker, S. (1986). 'Graffiti.' In N. George, S. Banes, S. Flinker & P. Romanowski (eds), *Fresh: Hip Hop Don't Stop*. New York: Random House.

Rutherford, J. (1988). 'Who's that Man.' In R. Chapman & J. Rutherford (eds), *Male Order: Unwrapping Masculinity*. London: Lawrence & Wishart.

Schwandt, T. (1994). 'Constructivist, Interpretivist Approaches to Human Inquiry.' In N. Denzin & Y. Lincoln (eds), *Handbook of Qualitative Research*. Thousand Oaks, Calif.: Sage.

Secord, P. (1990). ' "Subjects" *versus* "Persons" in Social Psychological Research.' In R. Bhaskar (ed.), *Harré & His Critics*. Oxford: Basil Blackwell.

Segal, L. (1990). *Slow Motion: Changing Masculinities, Changing Men*. London: Virago.

Shotter, J. & Gergen, K. (eds) (1989). 'Introduction.' In J. Shotter & K. Gergen (eds), *Texts of Identity*. London: Sage.

Silbereisen, R. & Eyferth, K. (1986). 'Introduction: Development as Action in Context.' In R. Silbereisen, K. Eyferth & G. Rudinger (eds), *Development as Action in Context*. Berlin: Springer-Verlag.

Smith, D. (1981). 'New Movements in the Sociology of Youth: A Critique.' *British Journal of Sociology*, 32(2), 239–51.

Smith, J. (1994). 'Towards Reflexive Practice: Engaging Participants as Co-researchers or Co-analysts in Psychological Inquiry.' *Journal of Community & Applied Social Psychology*, 4, 253–60.

Spencer, W. (1994). 'Mutual Relevance of Ethnography and Discourse.' *Journal of Contemporary Ethnography*, 23(3), 267–79.

Stanko, E. & Newburn, T. (eds) (1994). 'Introduction: Men, Masculinities and Crime.' In E. Stanko & T. Newburn (eds), *Just Boys Doing Business: Men, Masculinities and Crime*. London: Routledge.

Thomas, A. (1990). 'The Significance of Gender Politics in Men's Accounts of the "Gender Identity" .' In J. Hearn & D. Morgan (eds), *Men, Masculinities and Social Theory*. London: Unwin Hyman.

Thornton, S. (1994). 'Moral Panic, the Media and British Rave Culture.' In A. Ross & T. Rose (eds), *Microphone Fiends: Youth Music, Youth Culture*. London: Routledge.

Thornton, S. (1995). *Club Cultures: Music, Media and Subcultural Capital*. Cambridge: Polity Press.

Tyler, S. (1986). 'Postmodern Ethnography: From Document of the Occult to Occult Document.' In J. Clifford & G. Marcus (eds), *Writing Culture: The Poetics and Politics of Ethnography*. Berkeley, Calif.: University of California Press.

Van Maanen, J. (1982). 'Introduction.' In J. van Maanen, J. Dabbs & R. Faulkner Jr, *Varieties of Qualitative Research*. London: Sage.

Van Maanen, J. (1988). *Tales of the Field: On Writing Ethnography*. Chicago: University of Chicago Press.

Vidich, A. & Lyman, S. (1994). 'Qualitative Methods: Their History in Sociology and Anthropology.' In N. Denzin & Y. Lincoln (eds), *Handbook of Qualitative Research*. Thousand Oaks, Calif.: Sage.

Virgil, J. (1988). *Barrio Gangs: Street Life and Identity in Southern California*. Austin, Tex.: University of Texas Press.

Walsh, M. (1996). *Graffito*. Berkeley, Calif.: North Atlantic Books.

Wax, R. (1979). 'Gender and Age in Fieldwork and Fieldwork Education: No Good Thing is Done by Any Man Alone.' *Social Problems*, 26(5), 508–22.

Werthman, C. (1982). 'The Function of Social Definitions in the Development of the Gang Boy's Career.' In R. Giallombardo (ed.), *Juvenile Delinquency: A Body of Readings*, 4th edn. New York: Wiley.

West, C. & Zimmerman, D. (1987). 'Doing Gender.' *Gender & Society*, 1(2), 125–51.

Westwood, S. (1990). 'Racism, Black Masculinity and the Politics of Space.' In J. Hearn & D. Morgan (eds), *Men, Masculinities and Social Theory*. London: Unwin & Hyman.

Widdicombe, S. & Wooffitt, R. (1995). *The Language of Youth Subcultures: Social Identity in Action*. Hemel Hempstead: Harvester Wheatsheaf.

Wilensky, H. & Lebeaux, C. (1958). *Industrial Society and Social Welfare*. New York: Russell Sage Foundation.

Wilkins, L. (1964). *Social Deviance*. London: Tavistock.

Willetts, D. (1993). 'Social Norms and Criminal Justice.' In A. Coote (ed.), *Families, Children and Crime*. London: Institute for Public Policy Research.

Williams, J. & Taylor, R. (1994). 'Boys Keep Swinging: Masculinity and Football Culture in England.' In E. Stanko & T. Newburn (eds), *Just Boys Doing Business: Men, Masculinities and Crime*. London: Routledge.

Williams, T. (1989). *The Cocaine Kids: The Inside Story of a Teenage Drug Ring*. Reading, Mass.: Addison-Wesley.

Willis, P. (1977). *Learning to Labour: How Working Class Kids Get Working Class Jobs*. Farnborough: Saxon House.

Willis, P. (1990). *Common Culture*. Buckingham: Open University Press.
Wulff, H. (1995). 'Introduction: Introducing Youth Culture in Its Own Right: The State of the Art and New Possibilities.' In V. Amit-Talai & H. Wulff (eds), *Youth Cultures: A Cross Cultural Perspective*. London: Routledge.
Yablonsky, L. (1962). *The Violent Gang*. New York: Macmillan – now Palgrave.
Young, F. (1965). *Initiation Ceremonies: A Cross Cultural Study of Status Dramatisation*. Indianapolis: Bobbs-Merrill.

Magazines, newspapers, newsletters and police reports

British Transport Police Annual Report, 1990
British Transport Police Annual Report, 1991
British Transport Police Records, January 1992–January 1994
Developing Metros, 1991
Freestyle Newsletter 5
Graphotism Magazine 2
Graphotism Magazine 3
Graphotism Magazine 5
Graphotism Magazine 6
Londonz Burning Magazine 1
Londonz Burning Magazine 2
New Yorker, 26 February 1990
New York Times, 25 August 1972
New York Times, 6 February 1982
On The Go Magazine, December 1993
The Real State Magazine 6
Urb Magazine 37, 1994
Vibe Magazine, October, 1994

Films

Style Wars (1985). Henry Chalfant and Tony Silver, Producers.
Wild Style (1983). Charlie Ahearn, Director. First Run Features.

Author Index

Agar, M. 14, 20, 29
Allen, S. 39
Ardener, S. 60
Argyle, M. 160, 184–5
Arkin, W. 123
Atkinson, P. 57, 59–60

Bassett, C. 196
Becker, H. 26, 63, 97, 126
Beloff, H. 7
Berger, P. 10
Best, J. 64
Bjerrum Nielsen, H. 224
Blackman, S. 6, 97
Bloch, H. 36, 108, 160, 188
Blos, P. 180
Bola, M. 7, 60, 62
Brake, M. 42, 45, 96, 100, 128, 141,
 143, 180, 200, 216
Brettell, C. 26
Brewer, D. 2, 163

Campbell, B. 107, 114, 119, 121,
 124
Castleman, C. 2
Chalfant, H. 2, 161, 182, 186,
 188
Clarke, J. 6, 37–9, 43–4, 94, 151,
 153, 177, 179, 221
Clifford, J. 21–2, 26–7
Cloward, R. 33
Coffield, F. 107
Cohen, A. 5, 33–7, 92–3, 149
Cohen, A. P. 53, 59
Cohen, S. 3, 41–4, 92, 153
Coleman, J.C. 32
Coleman, J.S. 68, 180
Coleman, W. 98
Collinson, D. 7, 97, 217
Connell, R. 121, 127, 224–5
Cooper, M. 2, 171
Coote, A. 107, 123, 228
Corrigan, P. 34, 38, 44, 149

Crapanzano, V. 21
Csikszentmihalyi, M. 114, 118

Darling, N. 186
Davis, D. 26
Davis, J. 40–1, 180–1, 187, 219
Dobrofsky, L. 123
Downes, D. 35–7, 40–1, 126

Edley, N. 97, 224
Eisenstadt, S. 32, 39, 68, 180
Eliade, M. 101, 143, 160, 188,
 228
Ellen, R. 11
Emler, N. 88, 96, 103, 126–7, 219
Epstein, J. 5
Erikson, E. 180, 224
Evans, C. 151
Eyferth, K. 181, 187, 219

Feiner, J. 2, 186, 188, 197, 202
Ferrell, J. 2, 4, 118
Fielding, N. 119, 121, 139
Fine, G. 131
Flannigan-Saint-Aubin, A. 101, 103,
 105, 141
Flinker, S. 2
Frith, S. 38–9, 44, 149

Ganetz, H. 181–2, 200
Garber, J. 45, 128
Garfinkel, H. 13, 18, 20
Geertz, C. 14, 28
Gergen, K. 226
Gill, R. 24–5
Gilmore, D. 97, 101
Glaser, B. 55, 228
Glazier, S. 27
Glendinning, A. 186
Goffman, E. 65, 72
Goward, N. 55–6, 59
Griffin, C. 41, 45–6, 94, 100, 181

Grossberg, L. 156
Guba, E. 51
Gutterman, D. 141, 226

Hall, S. 6, 37, 39–40, 44, 94, 151,
 179, 230
Hamilton, D. 13
Hamilton, S. 186
Hammersley, M. 4, 15–16, 28–9, 42,
 57, 59–60
Hantover, J. 228
Harré, R. 10–17, 28, 30, 64–6, 68,
 72, 85, 92, 96, 108, 122, 188, 191,
 203, 214, 222
Hart, D. 221
Hearn, J. 7, 97, 217
Hebdige, D. 2, 41, 43–4, 158, 175
Heidensohn, F. 34–7, 45, 96, 126,
 149
Hendry, L. 186
Henriques, J. 187, 226
Henwood, K. 11–12, 14, 16
Herek, G. 141
Hirschi, T. 34–6
Hollway, W. 11, 29, 187, 225–6
Hudson, A. 45, 96–7, 148

Jefferson, T. 6, 37, 39–40, 44, 94,
 107, 126, 151, 179, 230
Jessor, R. 219
Josselson, R. 180

Kandel, D. 186
Katz, J. 108, 110, 114, 126
Kearney, M. 6, 97
Kimmel, M. 97, 104–5, 141–2, 148
Klein, S. 2, 186, 188, 197, 202
Kohl, H. 2, 188, 204
Kurlansky, M. 2

Lachmann, R. 2
Lebeaux, C. 35
Letkemann, P. 64
Levinson, D. 186, 221–2
Liddle, M. 98, 225
Lincoln, Y. 51
Love, J. 186
Luckenbill, D. 64
Luckman, T. 13
Lyman, S. 11, 25

McCaughey, C. 98, 107, 124–5, 221,
 225
McCron, R. 42
McRobbie, A. 7, 45–6, 94–5, 128,
 139, 150–1, 170–1, 180–1, 187,
 230–2
Mailer, N. 2, 70, 97
Marcus, G. 24
Marsh, P. 14, 64, 66, 72, 85, 96,
 203, 214, 222
Marsland, D. 32, 39–40, 43, 180
Matza, D. 34–5, 211, 222–3
Merton, R. 28, 33
Messerschmidt, J. 46–7, 97–8, 104,
 107, 121, 127, 139, 142, 225
Messner, M. 104, 106, 141, 216,
 223, 228
Miles, R. 103
Miller, M. 2, 163
Miller, W. 5, 33–6, 108, 149
Mishkind, M. 216
Morgan, D. 123–4, 139, 228
Murdock, G. 42
Murray, K. 192

Naar, J. 2
Newburn, T. 96–8
Niederhoffer, A. 36, 108, 160, 188

Ohlin, L. 33
Olesen, V. 29

Parker, H. 24, 55, 64, 222
Parsons, T. 35, 180
Phillips, A. 102
Phillips, S. 2, 64
Pidgeon, N. 11–12, 14, 16
Pleck, J. 97, 141, 223, 225
Polk, K. 121, 211, 216
Powers, S. 2
Prigoff, J. 2

Raphael, R. 101–2, 105–7, 121, 123,
 228
Reason, P. 29
Redhead, S. 230
Reicher, S. 88, 96, 103, 126–7, 219
Reimer, B. 154, 187
Reiner, R. 119, 121
Remy, J. 143, 160

Reynolds, V. 13
Roberts, B. 6, 37, 39, 44, 94, 151, 179
Rock, P. 35–7, 40–1, 126
Rodin, J. 216
Romanowski , P. 2
Rosser, E. 64, 66, 72, 85, 96, 203, 214, 222
Rudberg, M. 224
Rutherford, J. 97, 123, 148, 223, 225, 228

Schwandt, T. 28
Secord, P. 11, 13–15, 30
Segal, L. 123, 142, 228
Shotter, J. 226
Shucksmith, J. 186
Silbereisen, R. 181, 187, 219
Silberstein, L. 216
Smith, D. 40, 38
Smith, J. 29
Spencer, W. 156
Stanko, E. 96–8
Strauss, A. 55, 228
Striegel-Moore, R. 216
Sykes, G. 34

Taylor, R. 106, 139
Thomas, A. 222
Thompson, E. 141, 223, 225
Thornton, S. 134, 150–1, 163, 170–1, 173, 177
Tyler, S. 22

Urwin, C. 187, 226

Van Maanen, J. 12, 15, 21, 24, 26, 28, 49
Venn, C. 187, 226
Vidich, A. 11, 25
Virgil, J. 64

Walkerdine, V. 187, 226
Walsh, M. 2
Wax, R. 57–9
Werthman, C. 85, 102, 210, 220, 222
West, C. 97, 224
Westwood, S. 97, 104, 106, 216
Wetherell, M. 97, 224
Widdicombe, S. 3–4, 18–20, 41, 152, 187, 226
Wilensky, H. 35
Wilkins, L. 126–7
Willetts, D. 116
Williams, J. 106, 139
Williams, T. 64, 85, 160, 223
Willis, P. 43–4, 92, 106, 114, 127, 177–8, 180, 183, 214–16, 229–30
Wooffitt, R. 3–4, 18–20, 41, 152, 187, 226
Wulff, H. 230

Yablonsky, L. 108, 125, 223
Young, F. 101, 188

Zimmerman, D. 97, 224

Subject Index

Note page numbers in **bold** refer to illustrations.

Adolescence 34, 48, 72, 180–1, 219, 224–5, 230
 and control 8, 43, 109, 120–1, 153, 160, 175–8, 181–3, 188, 198, 201–3, 214, 225–6, 234
 and independence 6, 43, 180–8, 201, 223, 225–6, 228, 232
 and power 6, 8, 39, 44, 46, 53, 109, 153–4, 158, 160, 163, 175–7, 179, 181–3, 198, 201–3, 214, 216, 225–6, 228
Adolescents 5–6, 32, 39–40, 42–4, 46, 68, 93, 121–2, 160, 178–89, 221–2, 228–9
Adrenalin *see* Buzz
Agency 5, 12–15, 20, 28–9, 125–7, 173, 176–8, 180, 186, 225–7, 229–30
All city 77, 167
Anomie 33, 36
Arrests 54–5, 76, 89–90, 95–6, 122–5, 133, 190–1
Authenticity 19, 83, 132–8, 169–71, 173–4

Blockbuster letters 82, **200**
Bombing *see* Tagging
Buzz 73, 101, 103, 114–15, 126, 169

Canvases 90, 164, 166–7, 172
CCCS 3–5, 20, 32, 37–46, 94–6, 149–52, 171, 176–7, 179, 226, 229–30
Cheap fame 132
Conventions *see* Rules
Crews 112, 124, 146, 206, 212–13
Crime, amplification of 121–3, 126–7
Cross out war 211–14, 231

Dedications **214**
Discourse analysis 13, 17–20
Disrespect 56
 mark of 120, 138–9, 144, **206–11**, 212
Dub 77, 84, 209, **210**

Ethnography 8
 and postmodernism 15, 20–7, 31
 practice 49, 50, 52, 59, 62, 230
 principles 4–5, 11, 14–15, 28
Ethogenic theory 12–17, 96

False consciousness 42–3, 229
Fame 30, 50, 65–6, 68–71, 74, 85–6, 90–2, 94, 117, 124–6, 132, 136–7, 159, 193, 195, 220, 222–3, 228, 239
 claiming fame 74–85
Female subcultural member
 as incapable 98–101, 129–30, 144–5
 as minority 45, 95–7, 100, 127–8
 obstacles to acceptance 131–41, 144–8, 193, 239
 as threat 8, 128, 141–50
Fly by night 78
Folk devils 3, 92, 125, 154
Functionalism 8, 32–7, 47, 149, 180

Galleries 50, 72, 90, 164, 166–7
Getting up 74–80, 135–6, 194, 223
Graffiti subculture
 as adult free world 180–7
 as liminal world 8–9, 179, 191–3
 as man's world 59–62, 97–101, 127–50, 193
 as secret world 54–5, 156–63, 239
 as separate world 153–4, 162–3, 176, 187–8, 190–3
 as superior world 57, 154–6, 238

Halls of fame 90, 138, 164
Hegemony 6, 94, 156, 176–88,
 229
Hierarchy 64, 66, 86, 89, 91, 105–6
Hip hop 2, 161

Illegal graffiti
 as career 63–93, 217–23
 as masculine resource 6, 96–108,
 123–7, 149, 197–217, 221–4,
 228
 as warfare 107–24, 211–13
 as work 63–9, 74–5, 77, 80, 85–9,
 91–3, 217–23

Initiation rite 101–2
Insider Input 19–20, 26, 29–30,
 234–40
Internet 51, 196, 231

King 77–8, **79**, 193, 207, 226

Labelling theory 96–7, 125–7, 173
Legal
 work 89–90, 126, 164–70, 172,
 174, 220
 writer 8, 51, 72–3, 86, 92, 112,
 163–4, 169–70, 174–5
Lining out 120, 192, 210–11, **212**,
 213

Magazines 5, 240
 my use of 51, 53–5
 as unifiers 91, 111–12, 231
Making a name *see* Getting up
Marxist
 methodology 40–4
 theory 3, 8, 32, 37–40, 44, 47, 94,
 150, 177, 229
Masculinity
 and age 46–7, 221–5, 228–9
 as career 222–5
 and challenge 101–3, 106, 121
 and class 7, 35, 46–7, 224–5
 and crime 46–7, 97–8, 107, 127
 as 'other' than 105, 141–2
 and race 7, 46–7, 224
 and recognition 103–6, 222
 and respect 96, 104, 124, 222

and subcultures 6, 33, 36, 45–6,
 48, 96, 127–8, 149–50
Mods 38, 92
Moral career 65–6, 72, 77, 92
Moral panic 92, 173

Paying one's dues 88, 132, 190–1,
 240
Piece 67, 72, 74–5, **80**–5, 104, 109,
 117–18, 122, 139, 144, 158 165,
 196, 209, **210**, 211, 213, 215, 239
Piece battle 215
Piecer 80–2
Police (British Transport, Graffiti
 Squads, authorities) 50, 54–5,
 70–1, 73, 90–1, 108, 111, 129,
 191, 198
 as enemy 113, 115–18
 as equals 119–20
 and masculine construction
 121–5, 139
 outwitting police 111–12, 115–19,
 122–3
 as source of respect 124
Positivism 12, 25
Postmodernism 8, 15, 21–7, 31, 35,
 94, 187, 229–30
Punks 43, 151, 152, 171

Ravers 92, 150, 171
Relativism *see* Postmodernism
Research
 and authority 9, 20–31, 53, 57
 and representation 11–12, 21, 27,
 31, 234
Resistance 5–6, 38, 41, 43–5, 94, 96,
 144, 150, 158, 171, 173, 176
Resistance Through Rituals 37, 40,
 230
Respect 60, 65–6, 68, 70–2, 74,
 76–7, 81, 83–5, 91–2, 94, 96–7,
 104, 107, 119, 124, 126, 133, 162,
 173, 190–1, 204, 214, 216, 220,
 223, 226, 228, 237
Retirement 70, 88–9, 92
Rite of passage 101–2, 106, 228
Rockers 92,
Rules 70, 74–5, 132–3, 170, 180,
 184, 187, 192, 201–11

Self will *see* Agency
Selling out 172–5, 238
Semiotics 20, 40–3
Skinheads 38, 192, 200–1
Sport 104, 106–7, 216, 225, 228
Strain/anomie theory 32, 33–7, 47
Style
 clothing 18–19, 96, 152–3, 177,
 200
 graffiti 71–2, 82–3, 89, 104, 109,
 130–1, 158–9, 165–9, 173, 186,
 198–201, 213, 219–20
Subcultures
 and class origins 3, 5–8, 32–48,
 92–6, 149, 151–2, 162, 179, 229
 definition of 8, 150–3, 162–3
Subjectivity 11–13, 15–17, 21–2,
 28–39
Symbolic
 capital 65, 104
 solutions 6, 32

Tagging 66, 68, 74–7, 79–84, 87, 89,
 102, 109, 132, 171, 203–7, 209
Tag name 66, 69–70, 71, 74, 109,
 120, 185, 192, 194–8, 210–11,
 216, 218–19, 226
Teddy boys 37–8, 92

Threestroke 77
Throwup 68, 74, 77, **78**, 84, 117,
 196
Toy 120, 132, 145, 184–5, 212, 222
Train
 subway/underground/overground/
 freights 68–9, 73, 77, 80–1,
 83–5, 87, 102–4, 109–18, 121,
 132, 135, 137, 140, 144, 148,
 160–1, 165–7, 172, 174, 201–3,
 219, 231
 yards 51, 67, 70, 77, 83–4, 86, 89,
 103, 106–7, 113–18, 129–30,
 139, 143–4, 186, 221
Train jam 110

Virtual
 communication 203–13
 construction 196–217
 identity 194–6, 213, 216–17,
 226
Voice 3–4, 9, 14–15, 18–20, 22–6,
 27, 29–31, 41, 55–6, 154, 177,
 226–7, 230, 232, 234, 237

Whole car top to bottom 84, **85**,
 120
Wildstyle 82, 158, **159**, 199